20UNDER40:
Re-Inventing the Arts and Arts Education
for the 21st Century

We are entering a decade of unprecedented transition in arts education leadership. There will be a profound change in who is taking the daily responsibility for running all kinds of arts education programs and organizations. But, further, the responsibility for the health of the field as a field will be in new hands. Edward Clapp's 20UNDER40 project is a "call to voice" for this next generation of leaders. It is timely and of critical importance that these new voices are heard. 20UNDER40 will be essential reading for all of us who care about the state of arts education in the years ahead.
> –Steve Seidel: Director of the Arts in Education program, Harvard University, Graduate School of Education

With all the research and reporting on Next Generation leadership in nonprofit organizations, there have been few efforts directed towards emerging arts leadership and for that matter, from young arts leaders themselves. This is an important work that will document this era in emerging arts leadership by those who are experiencing it first hand—an incredibly dedicated and engaged group of young adults.
> –Victoria Plettner-Saunders: Arts and Leadership Development Consultant

20UNDER40 is one of the most scintillating and exciting arts compilations to come along in years. Chapters written by an impressive array of arts leaders, and expertly curated by Edward Clapp, candidly expose the strengths and challenges that all arts institutions inevitably face in the coming decades. What sets this collection apart is not only that its writers are our "next generation" of arts institution leaders, but that they give us a strong dose of honesty, authentic first hand experience, and iconoclastic vision that the arts world needs now more than ever. These chapters show us that, like the rest of the world, we are dealing with tectonic shifts in the ways that art is made, elevated, shared, supported, and critiqued. The underlying message? Let go of your conventional wisdoms about what arts leadership is, or be dragged into a new world where your knees will surely be scraped!
> –Phoebe Eng: Executive Director, Creative Counsel

Fresh perspectives often require new language to address both intrinsic and extrinsic approaches to solving contemporary problems. Some who have the desire, energy, and expertise lay beneath the surface of arts leadership today; yet others embrace the courage to self-identify. Current leaders who have incorporated the spirit of the arts into their leadership practices certainly have nothing to fear and much to gain from those who are the next wave of

arts leaders. *The contributors to* 20UNDER40 *seek to bring to arts leadership their spirit of conscious use of the self to create their work—a spirit that has in turn—helped to shape them as artists and future leaders. Leadership is dependent upon fundamental relationships built with others. Clapp and authors of essays in this volume offer fresh ideas to bridge the future to arts leadership by building upon and contributing to those fundamental relationships.*

–R. Barry Shauck: Head, Art Education, Boston University;
President, The National Art Education Association

The future of the arts and arts education now has a voice, provided by 20UNDER40 *and Edward Clapp. This voice is at once innovative, insightful, confident, and knowledgeable, and all of us who care about the future of the arts should be encouraged and attentive as this dialogue among tomorrow's leaders unfolds.*

–Russell Willis Taylor: President and CEO, National Arts Strategies

Younger generations working in the field of arts education are making powerful and visionary contributions in all of its dimensions: policy, program, teaching, research, advocacy. They are exercising leadership. What is lacking is systematic recognition of their contributions and an infrastructure within the field—comparable to other professions—that enables them to move into national visibility and formal leadership roles in institutions and organizations. The 20UNDER40 *project will be a significant context for their work to be made more public, their futures more secure, and the field dramatically enhanced.*

–Dick Deasy: Founder and Former Director of the Arts
Education Partnership

20UNDER40 *couldn't be more timely. Art and art education are being dramatically reshaped by changing technologies, changing audiences, and a changing economy. It is just the right moment to encourage a new generation of arts educators to step up and give voice to their visions for the future of the field. As an emerging young leader himself, Edward Clapp is the person to make this happen. I predict that the collected essays in* 20UNDER40 *will jumpstart a new conversation.*

–Shari Tishman: Director, Project Zero, Harvard University

As the current generation of leadership prepares to "pass the baton," we face an accumulation of new and unfinished business that the next generation of leaders will have to address in order to establish arts learning as an enduring

value proposition in American education. Edward Clapp's collection of essays from emerging leaders in the field, 20UNDER40, should provide important insights into the future direction and role of the arts in helping to build the skills and habits of mind young people will need to be successful in learning and life.

–Richard Bell: National Executive Director, Young Audiences, Inc.

The future is on the line for the next generation of arts leaders in America. 20UNDER40 hands the mic to those who have the most at stake in describing—and fighting for—an arts ecosystem that is far more vital than the one they've inherited. No one speaks with more authority, more passion, and more imagination about what the future will look like than these leaders. This book isn't just about what's next for the arts in America, it's about what's next for America itself.

–Marc Vogl: Program Officer for the Performing Arts, William
and Flora Hewlett Foundation

Edward Clapp's 20UNDER40 is a critical first step in creating a dialogue that does not yet exist in the diverse field of the arts and arts education, but it is crucial to the thoughtful improvement in quality of and access to the arts and arts education over the next 20 years. He has begun an important process that the entire field will benefit from: artists, teachers, teaching artists, arts administrators, school administrators, even local, state, and federal policymakers. 20UNDER40 could be the beginning of an impactful intergenerational dialogue that helps the field become active instead of reactive.

–John Abodeely: Program Manager of National Partnerships in
Education, John F. Kennedy Center for the Performing Arts

Since 1999 the Americans for the Arts Emerging Leaders Network has addressed the frustration felt by young arts professionals. In concert with the work of this network, the 20UNDER40 anthology will give young leaders a platform to discuss the future of the arts and arts education. Before we know it, emerging leaders will be emerged leaders. It's time for the arts to evolve as a field, and the 20UNDER40 anthology is crucial to this process.

–Stephanie Evans: Coordinator of the Emerging Leaders
Network, Americans for the Arts

20UNDER40 is a gift not only to the arts and arts education but also to those of us who have worked in this field for thirty plus years. The voices of young leaders will augment the future with critical insight and the new perspectives

necessary for the sustainability of the field.
> –Dale Davis: Founding and Executive Director, The Association
> of Teaching Artists

20UNDER40 embodies the kind of fresh energy and creative thinking required of a new generation of young leaders. I don't know an emerging arts professional in Boston who hasn't heard of this project and found inspiration in Edward Clapp's vision for bold ideas and thoughtful debate. The 20UNDER40 project provides a much-needed forum for this group to imagine, collaborate, influence, and begin to see themselves in the driver's seat. It's an essential next step.
> –Hathalee Higgs: Founder, Emerging Arts Leaders of
> Massachusetts; Director of Development, Massachusetts
> Advocates for the Arts, Sciences & Humanities

Slashed arts education funding, the media's lampooning of arts as superfluous, censorship, and a stopgap of arts production—the current state of the arts is marked by crisis and stagnation. But beneath the crisis something miraculous is happening, something that Edward Clapp is shrewd to document and encourage. Emerging arts leaders are pioneering ways to better employ arts in education, and ways to bridge arts innovation to infrastructure and social goods. 20UNDER40 not only documents progress made, but further encourages emerging arts leaders to investigate, imagine, and ultimately transform our needed, but tenuous, arts landscape.
> –Jasmine Mahmoud: Editor, *The Arts Politic*

20UNDER40 represents a contemporary twist on an age-old discussion.
> –Sherburne Laughlin: Director of the Program in Arts
> Management, American University

Selected from hundreds of proposals, the essays in 20UNDER40 represent a teaspoon in the ocean of ideas, talent, passion, thoughtfulness, and creativity found in the next generation of arts leaders. While spotlighting challenges and opportunities of the present and future, what this anthology really brings out are three things that I've suspected all along: young leaders are keenly aware of where we have come from, they possess the tools and dedication necessary to take on the most difficult challenges of our field, and the future of arts leadership is strong. By providing a major outlet for young arts leaders, 20UNDER40 is a tremendous step in increasing the diversity of perspectives and voices within the arts—something that is always needed!
> –Jonas Cartano: Director of Programs, Chorus America

20UNDER40:
Re-Inventing the Arts and Arts Education for the 21st Century

EDITED BY EDWARD P. CLAPP

PROJECT ADVISOR ERIC BOOTH

RESEARCH ASSISTANT ANDREA SACHDEVA

WITH EDITORIAL ASSISTANCE FROM:
ARNOLD APRIL, MICHELLE BELLINO, THOMAS CABANISS, HILARY EASTON,
ARLENE JORDAN, MARLINDA MENASHE, SUSAN MIVILLE, CAROL PONDER,
GEORGIA POPOFF, AND JOHN SHIBLEY

authorHOUSE®

AuthorHouse™
1663 Liberty Drive
Bloomington, IN 47403
www.authorhouse.com
Phone: 1-800-839-8640

Inquiries regarding copying permissions, purchase of bulk copies,
and purchase of individual chapters for academic course packs or
other educative purposes may be directed to the editor:

20UNDER40 c/o
Edward P. Clapp
P.O. Box 454
Somerville, MA 02143
USA

http://www.20UNDER40.org

First published by AuthorHouse 09/08/2011

ISBN: 978-1-4520-6740-7 (ebk)
ISBN: 978-1-4520-6738-4 (sc)
ISBN: 978-1-4520-6739-1 (hc)

Library of Congress Control Number: 2010913616

Due to the changing nature of the Internet *20UNDER40* makes no guarantee concerning
the accuracy or appropriateness of online sources referred to within this text.

Printed in the United States of America

This book is printed on acid-free paper.

DEDICATED TO ART

Table of Contents

Foreword: An Overview from An Over Forty

Eric Booth

I met Edward Clapp in a typical setting, typical for both of us. I was a consultant hired to lead a worthwhile project at an arts education organization. He was one of the twenty-thirty-something-year-olds on the administrative staff of that organization, assigned to work with me. The project laid the groundwork for dramatic change within the well-established traditions of the organization. We launched inquiries into purposes and practices with all the key stakeholder groups, a fairly delicate and fascinating undertaking. It was a project about serious institutional change—that was not so typical for the arts/arts education fields. Edward was one of eight staffers charged to help, and he was not only excited by the boldness of our project, he was visibly lit up by it.

Also typical—Edward had to listen hard to the plan that I, the established Baby Boomer consultant, had proposed. He had to judiciously select his moments to speak up and offer his suggestions. He had to eat his frustrations if I and others in charge didn't quite get or agree with his point. Apart from this special project, his regular job with this organization was not nearly demanding enough for his smarts; his participation in this institutional change project was tenuous and limited. This typical setting was clearly not one designed to respect the contributions and nurture the commitment of young leaders. And I was one of the good guys—an old fart who actually valued new ideas whoever offered them. Given all that, Edward had a lot of creative light in him, highly visible to me, and circumstances kept most of it under a bushel. My work brings me inside leading arts organizations and arts learning programs around the country (and overseas), and I always take special note of potential young superstars that I meet, hoping to help their trajectory in some way. Edward was definitely one.

We kept in touch over subsequent years. I was delighted to learn he had entered the Arts in Education Master's Degree program at Harvard under Steve Seidel—as I was also excited to hear that he was developing a fully-fledged *change-the-world* imperative, and he saw the need for doctoral studies as a necessary next step. I knew he had the grit for it, and I supported him in every way I could.

In our occasional contact, I became aware of Edward's frustration that the arts sector was not welcoming to the ideas and suggestions he and his peers had to offer. His views of the arts education field, sometimes

delightfully immoderate, resonated with my own sense of a well-intentioned, but disorganized and fragmented community.

Indeed, we talk a good game about collaboration and openness to new ideas in the arts, but the input from our younger professionals is neither sought nor honored as a regular practice. The "generational perspectives" that prompt generalizations about age cohort groups seem pretty accurate; even in the seemingly "sensitive" field of the arts and arts education—Baby Boomers run the show and ain't leaving as previous generations did, both because we want to keep working and financial realities require us to do so. Many young entrants to the field claim we eat our young—overworking, underpaying, and disrespecting the talent we need to grow and evolve.

To arts leaders of my age cohort, Gen Xers and Millennials may seem different, and even annoying in some of their habits. They are often judged to be impatient, self-absorbed, self-important, and naïve-but-arrogant by older leaders. The result is an existing Boomer-shaped leadership that isn't as bad as I am making it sound but one that routinely doesn't listen to young leadership well, that doesn't afford them the respect and challenge their smarts warrant, and that doesn't provide robust channels for advancement. We are losing too many of our best and brightest, and wearing down those who stay. As a field, we admit we have a future leadership and generational change problem, but apart from a few good programs, we mostly just whine about it. For decades I have helped the fortunes of young talent everywhere I could, and I did a little more than whine, I barked about this as a crisis—widely and ineffectively. Edward didn't yap in frustration as I did, he envisioned a solution, and has worked for years to deliver it.

Edward first wrote me about his idea for a book that provided voice to the ideas of young leaders in the fall of 2008. I immediately loved the concept and offered to help in every way. His idea was so elegantly simple and directly on target. We talked through every aspect of the project, from the lofty to the mundane. Senior folks like me love to be consulted by the young. We like to offer advice, make suggestions, and guide. I loved doing this with Edward, but, truth be told (and Edward is such a gentleman that this is the first time I am admitting this truth), he had already figured out and acted upon most of what I had to suggest.

I did mention, however, the incredible amount of time I knew it would take to pull this book project off right, and how little money would support the process, and how little would probably end up in his pocket and the pockets of the writers at the end. We had to talk through these realities, but it was clear from the first that Edward (and subsequently his authors) are driven by a passion to influence and even transform the field they

love. Those with prejudices that young leaders are more mercenary than previous generations, take note. As ominously as I warned Edward about the amount of work *20UNDER40* would entail, I grossly underestimated the amount of his time, lost income, stress, and determination it would take to get this book into your hands.

There were some surprises along the way for both of us. As we distributed the "Call for Chapter Proposals," he engaged in some online dialogues to spark interest. He was surprised (and hurt at first) to have some over-40-year-old professionals react negatively to the very notion of a book giving voice to the ideas of the young. I wasn't surprised, although the vehemence of some individuals did raise my eyebrows. I knew that many people who had devoted large parts of their lives to the arts sector felt frustrated, under-respected, and under-utilized by a field that is badly organized to tap and reward talent. Some become bitter after decades of service to a field that underpays and under-acknowledges its dedicated, passionate lifers (as well as its young talent). And indeed, much of the flak that Edward took came down to Baby Boomers saying, "How dare you give beginners a vehicle that allows their voices to be heard, when I haven't had that. Is my twenty years of experience chopped liver?" In truth, there were not that many irate antagonists, but they were vocal. Edward realized that not everyone was going to celebrate his vision of contributing fresh ideas, even to a field that admitted it was stuck. I worried the resistance might diminish his boldness. It didn't. At first he was angry, but soon his response morphed into greater resolve. Also, other young leaders gained courage as online dialogues evolved, and began to speak up for themselves and confront older leadership with the fact they did feel squelched in their jobs, and they did feel Edward was tapping a truth that mattered greatly to them. I reminded Edward, hopefully, that greater controversy equals greater sales.

I got a surprise about the number of official chapter-idea submissions he would receive. During the submission period, the entries were few. We worried that the project was in for trouble—young people responded enthusiastically when they *heard* about the book project, but would they follow through with actual submissions? With about a week to go to the submission deadline, to take the edge off our concern, I wagered Edward ten bucks that he wouldn't get over 75 submissions. He was sure he would. Coming down the homestretch, I was fearful I would win the bet. And then, amid the procrastinator's frenzy I have often seen in his generation, the submissions began coming in. Coming down to the last day, they began pouring in. As we hit the deadline, the total topped three hundred, a number unimaginable to me. It seemed unprecedented in the field. It hit me that night—this is not a project, this is a movement.

That is how Edward saw it too. He has proceeded as if this project were riding the rising wave of a movement. He has attended to the project well, curating, editing, promoting, answering a million questions. But at the same time, he has begun nurturing a nascent wider movement. He is asked to speak and present at national conferences regularly. He is often asked to be a spokesperson for his generation. He is taking this on, as much as the completion of his doctoral studies and 20UNDER40 allows. He is hardly a generational chauvinist; he envisions a dynamic synergy between generations as the goal of our field when it gets healthy. Indeed, as his completed chapter drafts came in, and the editing work of polishing the chapters of so many first-time young authors became too much for his time against deadlines, he happily accepted my suggestion that we tap experienced over-40-year-old writers in the field to guide these young writers into their most effective voice. It worked beautifully, and models the best kind of mentoring and career-building Edward aspires to bring to the field.

Mentoring and nurturing young talent isn't easy. Young leaders are green and make mistakes. Arts educators wax eloquent about the value of risk-taking and mistake-making in arts learning, but lord help you if you do that as a young administrator. It takes an enormous amount of care and energy to nurture young talent in a way that prepares them well to take over and solve the problems we have faced and made. It is worth the effort—maybe not in each individual case, but as a habit of mind for the field. We are all educators all the time, young and old, in the direct ways we instruct and in the indirect ways we teach our true values and beliefs through what we do rather than what we say. Thus, many leaders in our field teach in contradictory and confusing ways. In my youth we called that hypocrisy and swore not to trust anyone over 40, because the over-40s of that era didn't walk their talk, and seemed averse to the brilliant ideas about change my friends and I espoused.

I hope readers of this book, of whatever age, can read with the values of inclusivity, of recognition of quality no matter whence it appears, of open hearted respect and welcome that are so prominent in our programmatic values. As you meet the young leaders who have worked so hard to contribute to the future of our shared field, rise up to meet their offering and avoid a critical lens that dismisses any chapter because of flaws or points that don't affirm prevailing views. I turn to Edward and these leaders with eager gratitude to find new thoughts, bold aspirations, actionable suggestions that welcome the young as the contributing leaders they want to be and are. I hope readers are inspired to do what Edward did, what these authors did, what the 304 submitting writers did, what those who contributed to

blogs about the project did—read, absorb, respond, reflect, engage, and contribute with the same kind of boldness this project embodies.

A final note: in my view, we are all emerging leaders, regardless of chronology. The pace of change in our culture and the stuckness of our field demand a new kind of leadership to accomplish the change required by our times. If we persist with an us vs. them attitude toward leadership within the arts, we will never unify our energy to change the status quo. We are all learning together, and these younger leaders have much to teach us about how to lead. I think of the word *expert*. It has connotations of credentialed authority. One earns the right to be viewed as an expert through experience, accomplishment, degrees and awards, and through respect of other gatekeepers. It smacks of 19th and 20th century norms. A close etymological analysis of the word reveals its ancient truth that illuminates its 21st century identity. Etymologically, an expert is not one who has amassed a lot of experience as our connotation holds; etymologically, an expert is one who is adept at experiencing. Expertise is not about chronology or credentials, it exists only in the moment, and is as much about perception, perspicacity, and imaginative reach, as it is about background. *20UNDER40* invites us to engage with the true expertise of these young leaders, to expand the definition of expertise to one that will serve our field well, and to rejoice in the creative vitality, deep commitment, and generous smarts of Edward and his under-40 colleagues.

Eric Booth
July 2010
New York, NY

Introduction

Edward P. Clapp

Sometime back in the spring of 2006 I was riding the subway from Midtown to Brooklyn to check out a teaching artist's residency in a public school. At the time I was working for an arts education organization in New York that placed teaching artists in various educational environments throughout the city. On this particular day I was with a colleague from my office on our way to observe one of our artists at work.

About midway through our ride my colleague leaned over to me and said, "I gotta tell you something man."

I knew this couldn't be good. Whenever someone preps you for what they have to tell you in lieu of just coming out and saying it—it's trouble.

"What's up?"

"I'm outta here," he said.

"What d'you mean?" I objected—but it was useless. I knew exactly what he meant.

The arts organization that he and I worked for—despite its highly regarded reputation, long standing history, and robust funding—had a track record for turning over up to 75% of its junior staff within any given twelve month period. The colleague in question, however, had been at our organization longer than I had. He was definitely someone who believed in the work we did, someone who strived for excellence and cared about the impact our teaching artists had upon the young people they encountered—but, just like the rest of us, the extent to which he could develop and implement programmatic ideas of his own were limited.

As our subway car rattled over an elevated platform through Gowanus, though it was futile, I protested his decision. I had made this speech before to a handful of other colleagues, but this time it was different. If by some slim chance I could convince this guy, this one single arts administrator, to stick it out, I felt as though I would have been making a difference.

In the process of my pleading my colleague said something to me that shut me up in a way I'll never forget. "Listen man," he said, "when you're 32 years-old and you make $35,000 a year and a night job at Taco Bell sounds like a good idea, there's something wrong."

Ok. I couldn't argue with that one. I knew that my colleague was about to get married and I knew he and his fiancée were interested in buying a house and having kids. I also knew that he'd graduated from a top tier college and had the student loans to match his degree (as did many of us).

No one was getting any younger and after having worked in the same arts organization for close to five years, my colleague's salary had barely gone up 15%. Sure, his title had changed, but our employer could change his title all they wanted—there was nowhere left for him to go in this organization.

Laying out the facts like this makes it sound like this scenario is just about money. It's not. It's also about fulfillment. For young arts professionals like my colleague, money is definitely part of the equation, but it's not necessarily the first thing on one's minds.

If you're in a job where you have little decision making power, you aren't able to act on your ideas, there's little opportunity for advancement, *and* you get paid a marginal salary—then my colleague is right: "there's something wrong."

A few weeks after our subway conversation my colleague had quit—he'd already landed a gig for nearly twice his salary at a company outside the arts sector. And you know what? A couple of months after that—I quit, too.

The story I've presented above is just one example of the frustrations young arts professionals experience throughout their work in the field. While it's easy to dismiss this narrative as bad luck and poor management at an isolated institution, I have heard the same stories, the same frustrations, and the same loss of one's colleagues repeated over and over in the conversations I've had with my peers. After I left the institution mentioned above, I began to research why a career in the arts seemed to be particularly challenging for younger professionals.

Through this research I found studies that suggested there was indeed a subtle exodus of young leaders from the field taking place—and the reasons these individuals were dissatisfied with their work in the arts were not unlike those which drove my colleague out: lack of a livable wage, lack of a clear career path, and lack of autonomy and agency.[1] Despite the obvious first two, it was this last "lack" that most captured my attention.

In the keynote speech he frequently presents at various stops on the arts conference circuit, funder and arts advocate Ben Cameron suggests that today's young arts leaders are simply "not interested" in serving as "mere custodians" of an arts sector they've inherited. According to Cameron, these individuals are indeed dedicated to the arts, but their commitment to the field hinges on having the same agency and opportunity to re-invent the arts that Baby Boomers experienced when they were young.[2]

Others have noted this lack of agency experienced by young arts leaders as well. In her article, "Boomers, XYs and the Making of a Generational Shift in Arts Management," arts and leadership consultant Victoria Plettner-Saunders quotes Arlene Goldbard who highlights the fact that

Baby Boomers served as early pioneers in the arts sector and established the majority of the arts and cultural institutions we know today, therefore, "to contemplate leaving [these institutions] (as they eventually must) is pretty much on a par with abandoning their children."[3]

With such a tight Baby Boomer grasp on the reins of leadership in the field, it makes sense that younger generations of arts professionals feel as though they don't have the opportunity to act on their agency. All agency in the field seemingly lies with the Baby Boomers who maintain the top positions in the majority of arts organizations.

As I continued to discuss this topic with others, I found that younger arts leaders not only experienced a lack of agency, but also a lack of voice. A broader look at the arts sector revealed a paucity of younger voices being represented as presenters and participants at the field's conferences, in the pages of the field's literature, and around the table at the field's senior staff meetings.

"If only someone could figure out this agency thing," I thought, "and develop a platform for young arts leaders to voice their ideas about the future of the field…"

DEVELOPING A SOUNDBOARD FOR YOUNG VOICES

On June 15, 2009 my long-time friend and colleague Margaret McKenna and I cracked open a bottle of wine and clinked glasses as she keyed in the code that launched the *20UNDER40* website. Amidst our celebrating I sent out a series of emails to friends, colleagues, and listservs announcing the publication and its call for chapter proposals.

Overnight the news of *20UNDER40* spread virally across the Internet. Within twenty-four hours the anthology was mentioned on dozens of blogs and was even noted on the home page of Minnesota Public Radio. By the next morning *20UNDER40* had received its first official submission.

The purpose of *20UNDER40: Re-Inventing the Arts and Arts Education for the 21st Century* is simple: to give voice to young arts leaders by serving as a soundboard for their thoughts and ideas about the future of the field. In its initial call for chapter proposals, the anthology announced that its goal was to address the impending generational shift in arts leadership by publishing twenty essays about the future of the arts and arts education as envisioned by young arts leaders under the age of forty. By doing so, *20UNDER40* aspires to bring the thoughts and ideas of young arts leaders out of the margins and into the forefront of our cultural dialogue. Prospective authors were challenged with the task of either identifying problems in the field and

suggesting innovative solutions; highlighting needs and articulating new visions, or; debunking longstanding theories and posing new models and frameworks for the future.

Despite the simplicity of *20UNDER40*'s intended goals, two key questions quickly rose to the surface during the early stages of the project: what's a "leader?" and why "under 40?"

20UNDER40 was not looking for theoretical essays *about* leadership, instead, it sought the insights of individuals *exhibiting* leadership by articulating their visions for the future of the arts. In essence, the anthology correlated *leader* with *change agent*. But neither in the call for chapter proposals nor anywhere else were the terms *leadership* or *leader* defined any more clearly than that.

My current understanding of what makes one a leader has largely been sculpted by my work with the *20UNDER40* project—particularly my interactions with the authors represented herein. Asked to specifically define the word "leader" today, I would suggest that a leader is one who challenges core assumptions, thinks adaptively about complex problems, incorporates knowledge from multiple domains, and empowers others to move towards conceptual change.[4] A leader is not an authoritarian who develops an agenda and commands people to do his or her bidding, but instead, someone who can rally people behind a cause in which groups of individuals work together to collectively develop innovations and/or collaboratively solve problems. This definition of leadership largely pulls from the work of Ronald Heifetz and his colleagues who suggest that leaders push people beyond their comfort zones, employ adaptive expertise, and return problems back to the people who have them.[5]

Leaders think differently. Leaders speak up. Leaders motivate others. Leaders have courage. I believe *20UNDER40*'s authors, as well as dozens of other younger arts professionals I have come into contact with while working on this project, exhibit these very characteristics.

The second question often addressed to me as the editor and director of the *20UNDER40* project is one that has sparked a small amount of controversy: why "under 40?"

20UNDER40's call for chapter proposals stated that eligible authors must be under the age of forty by the deadline for submissions (August 31, 2009). The date for this age cap seemed arbitrary to many, as it suggested there was a definitive line between who was considered young and who was considered old. Before long cries of ageism, bias, and exclusion emanated from early detractors of the publication. As a response I argued

that *20UNDER40* did indeed exercise bias by restricting eligibility to younger arts professionals under the age of forty, but this was a form of *positive* bias geared towards including a collective group of individuals in a broader conversation from which they were largely excluded.[6] While this explanation addressed the issues of bias exercised by the publication, I still hadn't attended to the root question: why "under forty?"

The idea to highlight the top twenty somebodies under the age of forty in any given domain is nothing new. Articles in local newspapers, trade publications, and business journals frequently publish lists of the top twenty so-and-sos under forty in a given profession.[7] It baffled me to think that the arts sector would respond so negatively to this concept. In the gallery world, savvy curators and collectors are always in search of the new and eager to highlight fresh, young talent. Since 1999 the publication *Photo District News* has been publishing their picks for the thirty most promising photographers under the age of thirty, and the *New Yorker's* 2010 Summer Fiction issue just published a list of the magazine's top twenty literary artists under the age of forty.[8] Putting a new spin on the concept of highlighting emerging talent, the New Museum in New York recently mounted an exhibition titled "Younger than Jesus," that focused exclusively on the work of visual artists who, at the time of the exhibition, were all younger than Jesus at the assumed time of his death.[9]

Why under forty? A flip response would be "because everyone else is doing it." Speaking more seriously though, the reason to highlight the ideas of arts leaders under the age of forty is because keeping this demographic's voice on mute not only frustrates young leaders and causes them to become disenchanted with their work in the arts, it also denies the field of the much needed 21st century insights that these individuals uniquely possess.

LESSONS LEARNED AND LEARNING IN PROGRESS

At the close of the submission deadline *20UNDER40* had received 304 chapter proposals written by 319 self-identified young arts leaders—all under the age of forty. Only twenty of these proposals were fleshed out as the full chapters in this book. With an acceptance rate of less than 10%, this made being published in *20UNDER40* more competitive than being accepted into the nation's most selective universities. Time and again Eric Booth, serving in the role of project advisor for myself and the anthology, suggested we figure out a way to somehow honor the ideas within the full breadth of proposals that were submitted to the publication. In order to do this, *20UNDER40* research assistant Andrea Sachdeva spent countless hours poring over the submitting authors' biographies and proposal abstracts

to broadly discuss the general themes that young arts leaders addressed in their proposals, as well as who these people are as a unique cohort of individuals. Andrea's research report "Becoming Un-Tongue-Tied" appears at the end of this publication and reveals a great deal about the interests of this unique demographic.

By taking a closer look at the hundreds of abstracts and biographies that were submitted to the anthology, it has become clear that there is much to be learned from the broader issues surrounding the *20UNDER40* project. In fact, when I've been invited to speak about the anthology, one of the most common topics I have been asked to discuss is what I have learned from my work on this project.

What I've learned about what I've learned is that what I'm learn*ing* is changing all the time. While exploring the who, what, where, why, and how of young arts leaders has led me to many questions, what's become clear to me is that I still haven't learned enough about who young arts leaders are, what challenges they face, what unique perspectives they have to offer, and over all—what makes these individuals tick. Being that this is a population of people who will dramatically influence the future of the arts—I feel it is valid to suggest that research geared towards understanding and supporting young arts leaders should be among the field's top priorities.

While exactly what I've learned about young arts leaders continues to be a work in progress, some more concrete observations I have made include the following:

No Matter How You Say It, Someone Ain't Gonna Like It

Let's just get this one out of the way upfront: there's no proper way, no *politically correct* adjective, clause, or phrase that accurately identifies the age of a cohort of people—young or old—that won't inadvertently make someone upset. To call older arts leaders "senior leaders" is suggestive of arts management from a nursing home perspective, to use the terminology "veteran leaders" suggests these individuals are survivors of some great and mythical war, and to use the terminology "seasoned leaders" suggests that the most "seasoned" amongst us are not unlike thick cuts of meat that have been marinating in a sauce for, perhaps, too long. Of course, no one wants the adjective "old" attached to them either and once the word "mature" is introduced, well that implies the inverse being "immature," and there's a whole host of people that aren't cool with that either.

Speaking of those folks, some younger arts leaders have argued the adjective "young" suggests a sense of childishness and under-development—a pre-pubescent innocence or ignorance. Of course, the

term "emerging" doesn't work either. One can be 75 years-old and entering the arts sector for the first time—is she not an emerging *arts* leader? At the same instance, one may have been working in the field in different capacities for the past fifteen years and only be 29 years-old—dare you call him "emerging?!"

Let's just say this: there are young*er* leaders and there are old*er* leaders. Everybody cares about the arts—and that's all there is to it.

So Much to Say, So Little Opportunity

There are thousands of young arts professionals eager to participate in the process of field-wide change—and I've only heard from a small slice of them—and even a smaller slice of that small slice is represented here in this book. When given a chance to speak, many younger arts professionals suggest radical ideas for what the future of the arts may look like, how it may operate, whom it may involve, and the depths to which it may reach. Unfortunately, too often the voices eager to articulate these ideas are muted, not given the opportunity to be heard.

Just as there is no lack of young people ready to devote themselves to the arts, so too is there no lack of older practitioners who in many cases have already committed decades of service to the field. Not unlike their younger colleagues, these individuals also have bold new ideas concerning the future of the arts, and they too are often denied the opportunity to be heard.

An Artful Insecurity Complex

I have observed that the arts sector doesn't do a very good job of providing *anybody,* no matter how old they are, with the appropriate venues and opportunities to challenge the field's core assumptions, engage their colleagues in critical discourse, or prototype new ideas. In their *Harvard Business Review* article "Your Company's Secret Change Agents," Richard Tanner Pascale and Jerry Sternin identify what they call "positive deviants: people who are already doing things in radically different—and better—ways" within a given institution.[10] Though it is certainly not true everywhere, too often I have heard people suggest that in the arts (as in business) positive deviants, the agents of change capable of altering the future of an organization or even an industry, go uncelebrated for their deviant thinking, are encouraged to maintain the status quo, or are even upbraided for their out-of-the-box inclinations.

As a result of suppressing rather than celebrating a spirit of "deviance," the arts sector suffers from an insecurity complex and operates from a

position of fear. This isn't a Baby Boomer thing, nor a Gen X thing, nor a Millennials thing—it's an all of us thing. Young arts professionals fear that they don't have the authority or experience to suggest new ideas. Older arts professionals fear that by giving voice to savvy younger arts leaders they'll somehow be passed by or overlooked and their two-to-four decades of experience in the arts will all be for naught. And everybody, all together, fears challenging dominant paradigms, fears losing their funding, fears losing their audiences, fears losing their relevancy. We're afraid to lose our jobs—because the economy is tight, because we have that mortgage to pay for, or children to feed, because our student loans are starting to solidify like cement blocks around our feet, or because our 401(k)s just took a dive and our kids are about to start college.

What do people do when they're scared?

They play it safe. They keep up their guard. They protect what's theirs. They minimize their risk. They lay low. They hold back.

In my experience I've found that even the most innovative young arts leaders I've engaged with are great at going 80% of the way there, but balk at the opportunity to push past their limits and truly assert their most ambitious ideas about the future of the field. I don't see this "holding back" as a shortcoming of any one or another arts leader. Instead, I see it as a symptom of practice in a field that resists new ideas.

The thing is though—more often than not, that extra 20% is in there. A little encouragement and the full 100% of an idea pops out. A little conversation and actual *investment* in someone and before you know it things are buzzing—and you're at 125%.

Unfortunately, very few people in the field stand up and make a point— err, make some noise—about the fact that the arts sector doesn't nurture, foster, prepare, or support its current and/or future leaders as much as it should. Too few of us feel safe enough, or supported enough, to raise such alarms out loud—i.e.: in front of other people in an engaging atmosphere with consequences wherein questions can be asked and conversation is required. Again, I don't see this lack of taking a stance as cowardice. Instead, I see it as a symptom of a field that makes itself unavailable to self-critique.

Making the Shift from "Dealing With" to "Learning From"

It's time to do something, and it's time to do it as a unit. It's true. I'm "young-arts-leadership-guy." That's the label that has been placed upon me—and rightfully so, as it has been the young arts leaders under the age of forty that I have championed and rallied to support. Nonetheless,

it's become clear to me—indeed, it's become absolutely essential—that the future of the arts sector lies in its ability to access the talents, skills, knowledge-base, and expertise of multiple generations working in concert with one another in order to exchange technical and cultural knowledge within and across age cohorts.[11]

Overall, it is time we stop looking at one another as individuals representing difference that needs to be dealt with, but instead as individuals who are indeed *different*—but are therefore more valuable to one another as people we can learn from. The generational schism is real. But it's time we stop trying to "manage" or "deal with" generational differences (as the popular "leadership" literature of the times would have us do) and instead embrace our generational differences as opportunities for teaching and learning—as opportunities for personal development and field-wide growth.[12]

All Together Now...

Through the process of engaging in this work I have been fortunate enough to have been invited to speak, participate on panels, or facilitate workshops around the US and abroad by individuals and organizations interested in engaging their constituents in a dialogue around the future of the arts and the roles young arts leaders may play in that future. Both online and through my speaking engagements I have been privileged to meet so many people passionate about arts practice, arts education, arts administration, arts research, arts advocacy, and arts policy. Though you all haven't necessarily found a way to communicate beyond the silos within silos that segregate you, I can assure you that your aims are more common than disparate, your energies are equally invested, your arms are equally open, and your hearts are universally true. The arts will enjoy a future that is ripe with opportunity, prospect, and potential, if only we can figure out a way to hurtle over the visible obstacles that hamper us—and overcome the zap of the invisible fences we can't even see.

How to Use this Book

The chapters presented herein represent some of the most innovative ideas about the future of the arts articulated by a devoted cadre of authors whom I have been most privileged to have worked with over the course of the past few months. Amongst these individuals are dancers, filmmakers, musicians, singers, video-artists, graduate students, professors, teaching artists, administrators, scientists, scholars, business owners—even a

television show host. As their impressive biography notes reveal, these individuals have long been arts leaders and agents of change.

The chapters these authors have written intelligently tackle the challenges we now face in the arts while offering bold solutions and renewed hope for the future. Several authors have even gone so far as to present exciting new theories, models, or frameworks for practice emanating from their astute observations of the field, their years of experience in the arts, and their unencumbered visions for what's possible. The entrepreneurial spirit of these individuals has served as an inspiration for me ever since I've come into contact with their ideas. It therefore gives me great pleasure to bring the work of these authors to a wider audience.

In developing the flow for this anthology I resisted the temptation to categorize the chapters and break the full collection into digestible sections. This decision was based on my observation of the field's current practice of isolating one aspect of arts enterprise from another. Sectioning the chapters into specific parts would have further promoted the silo-ing of the arts that I believe does more harm than good. Instead, I chose to present an even *spread* of ideas that allows for an organic transition from one concept to the next.

At the beginning of every chapter readers will find an abstract that serves as a summary of the concepts addressed therein. These synopses are meant to provide the reader with a snapshot of any given chapter, allowing one to bounce from chapter to chapter, from concept to concept, in a sequence that makes most sense to each individual reader.

This book, however, is meant to be read as a whole—to promote a cross pollination of ideas throughout the arts sector and to encourage readers to look beyond the walls that separate arts practice, education, administration, research, advocacy, policy, and public experience.

This book is also meant to be discussed. At the end of each chapter readers will find a URL that links directly to a discussion forum on the *20UNDER40* website. Just as each chapter has its own URL, so too does each chapter have its own interactive online discussion forum. As a 21st century reader, you are encouraged not just to absorb the ideas presented herein, but to engage with a broader audience in critical dialogue surrounding these issues. By participating in these online conversations you will connect to an ever-expanding network of people collectively advancing the dialogue around the future of the arts.

As noted earlier, *20UNDER40* is not the final word, but rather the beginning of a new conversation in the arts and arts education. One of the many purposes of this new conversation is to involve as many people as possible

in the dialogue. To this end, *20UNDER40* seeks the help of its readers in reaching new audiences, finding the voices that need to be participant to this discussion, and then folding those voices into the conversation.

I encourage each young arts leader reading this text to not only recommend it to their peers, but to consider giving copies of this anthology to their bosses and/or professors as well. I likewise encourage senior arts leaders to distribute copies of this book amongst their staff, just as I encourage executive directors to provide copies of this book for each member of their board of directors. Consultants and leadership coaches, I urge you to share copies of this text with your clients, suggesting they adopt some of the bold new models presented herein. Professors, I encourage you to place this anthology on your required reading lists, to make specific chapters elemental parts of your syllabi, and to weave discussions of the text into the fabric of your courses.

It is only through inclusive dialogue consisting of the broadest array of voices that we can begin to exchange diverse ideas and perspectives, challenge our field's core assumptions, and develop ambitious new strategies to propel the arts and arts education forward. Consider *20UNDER40* the first word in this new discussion. I leave it to each of you to continue the conversation.

Edward P. Clapp
July 2010
Somerville, MA

NOTES:
1. Solomon, J., & Sandahl, Y. "Stepping Up or Stepping Out: A Report on the Readiness of Next Generation Nonprofit Leaders." (2007).
2. Cameron, B. "New Perspectives for New Times." Keynote address. Performing Arts Exchange, Louisville, KY, September 27, 2007.
3. Saunders, V. J. "Boomers, XYs and the Making of a Generation Shift in Arts Management." *CultureWork* 10, no. 3 (2006), <http://aad.uoregon.edu/culturework/culturework35a.html>.
4. Clapp, E. P. "Envisioning the Future of Arts Education: Challenging Core Assumptions, Addressing Adaptive Challenges, and Fostering the Next Generation of Arts Leadership." Paper presentation. UNESCO World Conference on Arts Education, May 25-28, 2010, <http://www.20under40.org/Clapp_Core_Assumptions.pdf>; Heifetz, R. A. & Laurie, D. L. "The Work of Leadership." *Harvard Business Review* 75, no. 1 (1997): 124-134; Heifetz, R. A. & Linsky, M. *Leadership on the Line: Staying Alive through the Dangers of Leading.* Boston, MA: Harvard Business School Press, 2002; Heifetz, R. A.

Leadership Without Easy Answers. Cambridge, MA: The Belknap Press of Harvard University Press, 1994.

5. Ibid.

6. Clapp, E. P. "Mistaking Inclusion for Exclusion: Fighting Bias with Bias." *The Arts Politic* 1, no. 2 (2010), <http://theartspolitic.com/2010/04/13/mistaking -inclusion-for-exclusion-fighting-bias-with-bias/>.

7. Clapp, E. P. "Will the Real *20UNDER40* Please Stand Up..." (2010), <http:// edwardpclapp.wordpress.com/2010/06/25/wil-the-real-20under40-please -stand-up.../>.

8. *Photo District News* describes its annual 30 under 30 as: "30 photographers under 30 years of age that inspired us without the power of a famous name or an award-winning portfolio, but simply with powerful images." (2008), <http://www.pdnonline.com/pdn/esearch/article_display.jsp?vnu_content_ id=1003714660>; see also the *New Yorker's* 2010 summer fiction issue: <http:// www.newyorker.com/fiction/20-under-40/writers-q-and-a>.

9. "Younger than Jesus" is part one of the New Museum's triennial series "The Generational." Cornell, L., Massimiliano, G., Hoptman, L., & Sholis, B. (Eds.) *Younger than Jesus: The Generation Book.* New York, NY: Steidl/New Museum, 2009. See <http://www.newmuseum.org/exhibitions/411>.

10. Pascale, R. T. & Sternin, J. "Your Company's Secret Change Agents." *Harvard Business Review.* HBS#2874, (2006).

11. For more on the concept of sharing knowledge and expertise within and across age cohorts, see Clapp, E. P. "Omni-Directional Mentorship: Exploring a New Approach to Inter-Generational Knowledge Sharing in Arts Practice and Administration." In Schott, D. (Ed.) *A Closer Look 2010: Leading Creatively.* San Francisco, CA: National Alliance of Media Arts and Culture, 2010. <http://www.namac.org/leading>, and; Clapp, E. P. & Gregg, A. "Structures for Change: Recommendations for Renewed Practices to Support Leadership Qualities in Young Arts Professionals." (This volume).

12. Ibid.

20UNDER40:
Re-Inventing the Arts and Arts Education
for the 21st Century

Inventing the Future of the Arts:
Seven Digital Trends that Present Challenges and
Opportunities for Success in the Cultural Sector

Brian Newman
Sub-Genre Consulting Group

While predicting the future is difficult, it is worth analyzing current trends for possible clues as to what factors may help sculpt the decades to come, and how these factors may impact the cultural sector. This chapter will analyze seven trends that have the potential to profoundly influence the future of our arts organizations. While many are thought of as digital trends, they equally affect even the most unplugged of cultural institutions. Arts organizations should be directly involved in addressing these trends, as they will greatly shape the future of not just the arts, but of all culture.

Digital technology has been a disruptive force for many industries. Its effects on the business of music, print, and now film have been profound, decimating entire sectors of the media arts industry and altering the landscape for its production, dissemination, and enjoyment. In the past decade, established industry players in the media arts have made many mistakes, but arguably their gravest was in thinking that digital technology was just another new development that they could adapt to fit into their existing business models. Instead, digital technology has brought fundamental changes that continue to require a complete re-envisioning of business practices. Those in the arts who think that the changes wrought by digital technology will confine themselves to the media arts are sadly mistaken, because these are likely fundamental shifts in the cultural landscape that will dramatically change not just the arts, but all of society.

Arts organizations are not adequately addressing the profound

technological shifts affecting our culture. Most arts organizations are being reactive and are trying to fit digital into their existing ways of operating, which mimics precisely those mistakes that led to crises in other industries. The arts sector must look strategically at the changes brought about by digital technology, as they portend serious challenges to the future of such organizations as we know them. Addressed properly, these challenges are equally opportunities.

While predicting the future has a notoriously low success rate, there are seven key challenges brought about by digital technology that will arguably have the greatest impact on the arts sector, and its leaders would do well to think broadly about how these factors will shape the future of the field. By recognizing these trends, the arts sector can respond with new approaches and quite possibly help lead our broader society's reaction to the paradigmatic change that will likely be brought about by digital technology.

1. DOWNSIZED AND MERGED

As the economy continues to bring bad news to the arts sector, the field as a whole must contend with a new notion—that digital technology fundamentally changes business practices, often downsizing once large industries and favoring lean, start-up initiatives or those organizations that can quickly change with the times. For example, when Craig Newmark invented the online, largely free, classified advertisement site Craigslist, he upended the entire business model of the newspaper industry, supporting operations through paid classified ads, effectively downsizing an entire $1 billion sector to one $100-million company.[1] What does this trend towards leaner operations mean for established business practices in the arts? Arts institutions may be forced to downsize similarly to compete with upstart businesses and new business models.

It is likely that the combination of these new business models and the resultant decline in tax revenues from these shrinking sectors will greatly limit the ability of government to maintain minimum service levels, much less support the arts. Already, state governments in search of increased revenues are contemplating vast changes to the benefits of nonprofit status, and many foundations have had to curb support for such supposedly "non-essential" activities as arts and culture.

As government and foundation revenue shrinks, arts institutions will increasingly look to earned income, but fundamental shifts in consumer behavior make this a challenging arena as well. Consumers have less overall spending power, but also have many more options for their cultural and

entertainment experiences. These competing options are no longer just the theater across town, but also the many downloadable performances from across the world. As consumers increasingly find their content online, they expect to find yours there as well, watching your performance online instead of attending it live. While this itself can be a revenue stream, it is also one where consumers' expectations are for free and/or cheaper access, meaning online profit margins will likely be lower than any reduction in overhead costs. As these stresses combine, the nonprofit arts sector will likely have to rethink business practices, and contend with radically different economics.

Unfortunately, it's not a stretch to say the nonprofit arts sector looks like a field of zombies—undead, potentially harmful shells of their former selves, haunting the landscape, unable to live or to die. Quite simply, funders, board members, and leaders in the arts need to take a hard look at reality and make some painful decisions. More organizations need to merge to save costs, end duplicative services, and achieve greater impact. Many more organizations need to be shut down entirely, having either served their mission well or having long ago abandoned any real hope of having a meaningful impact. These conversations aren't easy, but they need to be had on a field-wide level. Even those organizations that are healthy enough to survive will need to consider downsizing their costs and refocusing their energies as the dwindling support for the cultural sector is likely a permanent shift away from robust public, foundation, and individual financing of the arts.

A thinned-out and downsized nonprofit arts sector is probably inevitable and may actually bring greater good. Planned for properly, such downsizing can allow organizations to react more nimbly to change, reduce service duplication, and possibly have greater impact through targeted programs. Strategically downsized organizations will more readily make this transition and might create more sustainable arts businesses.

Mergers are often thought of as drastic measures to cut expenses or end duplicative services, but they can also be planned for to better prepare organizations to face new economic and cultural realities, strategically fill gaps, and lead to new programming and greater services. In fact, a downsized arts sector does not necessarily equal less artistic programming. As many arts administrators know, budget tightening can often help one to focus on mission and expand services and programming through new, creative solutions. Streamlining one's organization can also lead to entirely new paradigms that increase artistic production, taking advantage of the economics now afforded by digital technology, such as access to ever-cheaper modes of production.

Of course, downsized organizations will only become stronger, remain competitive, and possibly lead change through rigorous planning. Potential strategies for successful change might include: analysis of emerging audience trends and adjustment of programs to these new realities; elimination of outdated programs; assessment of organizational technology skills; identifying internal talent assets; harnessing the power of digital natives and shifting resources to staff development in these areas; leadership development; identifying points for strategic innovation; and a commitment of resources to developing new business models.

2. The Rise of For-Profit and *With*-Profit Endeavors

Today's combined economic and business practice turmoil also creates a perfect environment for strategic outside players to unseat established organizations. It's not that the established players in the music industry, for example, didn't see that change was coming due to digital technology. The changes brought about by digital technology are so disruptive precisely because in order to embrace the new paradigm, one must undercut an existing, often very profitable business model.[2]

For a company like Warner Brothers (or any other record company) to embrace digital downloads they had to abandon the then-cash-cow CD market. But the profit margins on CDs remained too strong for Warner Brothers to abandon them for the smaller profit margins of digital downloads—and so, smaller, upstart players entered the market that bigger companies couldn't embrace. Then a very large, but very strategic outside player, Apple, entered the sector and changed the entire business model for buying and selling music.

Likewise, it is difficult for established arts organizations to embrace change that might undercut their business models, but this leaves much room for others to enter the sector. One could argue that such a shift is already occurring today. For example, the amount of promotion, fundraising, sharing, career-building, and market-creation of such new online arts discovery services such as YouTube (sharing video), Flickr (sharing photos), Spotify (sharing music), Pandora (finding music), KickStarter (micro-donations from fans to artists) and Etsy (an online marketplace connecting craftspeople to consumers) alone, all of which started very small and outside the nonprofit arts, have likely had more impact on the arts than any six nonprofit cultural organizations can claim in the last five years.

It isn't impossible to imagine such services being created, much differently, in the nonprofit arts sector. For example, if a film festival had

thought broadly about the combination of cheap access to the means of production and distribution and the growing forces of participation and disintermediation, it could have created YouTube. The site might look somewhat different, offer more curatorial sidebars and probably have a less catchy name (nonprofit arts organizations can't seem to ever coin a cool name), but it arguably should have been possible. While YouTube has provided a great service for many filmmakers and media artists (along with many less exalted artists, such as cat videographers) one can imagine that a nonprofit arts organization might have also shaped such an online media site into a more rewarding platform for artists—and it's not too late to build on such for-profit innovations to better serve the arts.

There was a time in the arts world when small arts organizations contributed to this sense of innovation. Organizations such as Nexus Press in Atlanta served as incubators for cutting edge book artists regionally, and the Off-Off-Broadway theater scene acted much the same way, pushing the field forward, taking chances and launching many careers. Today, however, that sense of excitement and innovation is sorely lacking from the arts sector. This is a sad irony, because at one point the nonprofit arts world was more grass-roots, nimble, and entrepreneurial (Steppenwolf Theater started out as a small collective of artists, for example), but developed its current rigidity at least partly by imitating corporate models. Innovation, risk-taking, and flexibility have migrated back to the for-profit sector, and cool new ideas aren't brought to fruition as nonprofits, but as Internet start-ups that capitalize on the access to funding and the risk-taking, free-for-all atmosphere of the new digital economy.

Similar innovations could be developed in the nonprofit arts sector today, but due to the risk averse, highly structured funding environment that has evolved in the nonprofit arts sector, it is more likely that several organizations will get funding from a foundation to think about and strategically plan for the future of their field. While they workshop their ideas for the future, two people in a garage will probably out-think them in two weeks and launch the next big thing that further disrupts the ecology of the arts.

Building a culture of entrepreneurship in the sector will require fresh thinking and innovative approaches to funding and support that aren't readily apparent. Few nonprofits have unrestricted income with which to explore new, especially risky, programs and fewer still have enough general operating support to hire and pay the usually higher salary expectations of the skilled workers to build such new ideas. Most foundations won't fund a new nonprofit until it has been around for three years. They require grant proposals that take longer to write than most entrepreneurial business

plans and they often discourage any risk-taking, preferring "tried and true" programs. In contrast, a sense of experimentation often, and importantly, without true strategic planning but rather a sense of "let's just try it because it's cool" is what works for most innovative companies and is what's missing (and actively discouraged) from within the nonprofit arts. Ironically, this is what many arts organizations expect from their artists—experimentation and risk—and artists seem to flourish given this freedom. Unless this sense of exploration is recaptured, most innovation will likely be led by the for-profit sector.

If neither non- nor for-profit models seem to work perfectly, perhaps the arts sector should explore new ventures at the junction of the two, combining the assets of the for-profit and nonprofit sectors to realize both financial and social profits. This new space, perhaps called *with*-profit, as in social goals "with profit potential," promises a rich field for the arts sector to explore. Such experiments could be undertaken by existing or new nonprofits on their own, in partnerships with existing for-profit organizations, or by creating new for-profit subsidiaries and/or affiliates of nonprofit arts companies. With-profit endeavors could use nonprofit funding to accomplish that which the market won't support, while for-profits would step in to capitalize on those items that have commercial appeal. For example, perhaps nonprofit arts funding could be used to seed the development of 12 new plays, with a commercial arm (or separate entity) ready to step in and take the one project with the most promise to market. Of course, this would need to include some remuneration to the nonprofit and would require some clever legal thinking, but it could be applied to any number of art forms.

A with-profit partnership would allow a nonprofit to continue to serve its underlying mission, and maintain its tax status, while providing a vehicle for exploration of profit-making activities. For-profit partners (or divisions) could bring in investments, explore more robust marketing and program development with other for-profit companies and maintain an eye on the "double bottom line" of profits and mission. Such alliances are not uncommon in the health and science sectors and should be considered by arts organizations as well.[3]

With-profit collaborations have been explored by some arts institutions. The most famous example might be the Public Theater in New York City, where daring nonprofit productions became a laboratory for Broadway, at times with much success. I have personal experience with such alliances from my time as president and CEO of the Tribeca Film Institute. The Tribeca Film Festival was produced and organized by the for-profit company Tribeca Enterprises. The Institute, while founded simultaneously

with the Film Festival, was established as an independent nonprofit with a separate governing board of directors and a similar, albeit nonprofit, mission. While the nonprofit benefitted from the exposure of the Tribeca Film Festival and even coincided many of its activities with the Festival, it ran other year-round programs that were wholly separate from the Festival and in some ways, surpassed it in scope.

3. DISINTERMEDIATION—THE AUDIENCE AS CURATOR

Also known as the rise of the crowd, digital technology has disintermediated culture, and this profoundly changes the top-down systems of the arts. For quite some time, arts institutions have talked about making art accessible to the masses. What was often meant, however, was that art resided here in this museum, with a special aura and we, the experts, will educate you, the masses, about its importance so you can come here and experience more of it.

Today, this talk continues, and true, a certain populism can be found in the blockbuster shows of Impressionism or Tim Burton, but disintermediation isn't just about pleasing large crowds; it also means that audiences can gather around the long-tail of content. If audiences like obscure, niche works, they no longer have to wait for someone to bring it to them, but rather can pool themselves together online and form an audience for that art, often by connecting directly to the artist. If one isn't sure whether their tastes are shared by others, they can now find out by starting a blog, advertising it on social networks, and building an audience for, say, European free jazz pretty quickly. If no local institution is bringing this work to a particular town, the digitally networked townsfolk can build their own tour, bypassing traditional booking agents, performing arts networks, and other middle-men to bring the artist directly to them. The fans no longer need to wait for a review in *Artforum*, receive a blurb via newsletter from their local orchestra, or wait longingly for their regional theater to stage a certain production. They can speak directly to one another, follow the opinions of those they trust, sample video and audio of performances or exhibits (often taken by amateurs), and coalesce around the art that they like.

Utilizing digital technology, audiences can now connect globally and discover new art forms and artists they would never before have found. They can also seek out more racial, ethnic, political, and religious diversity when they don't see it reflected in their local arts organizations' programming (or staffing). Having gotten used to the idea of digital content being available on demand, anywhere on any device—immediately, consumers will begin

to demand this disintermediation and immediacy from other art forms and live arts experiences as well.

Arts institutions need to embrace this disintermediation. This doesn't mean tearing down the walls and firing all the curators, but rather arts organizations should utilize the better aspects of this trend. Perhaps your theater company should maintain a wiki where audiences might suggest works they'd like to see. Museums might allow patrons to vote, rate, and tag online copies of exhibition pieces creating an alternate curation where as a user, one could trust the museum notes in the exhibition or those of the 15 year-old kid from Omaha who just visited for the day and posted her own ratings and notes on her iPhone for others to see. True, many arts organizations have been experimenting with disintermediation and participation for some time (perhaps this is an ongoing experimentation for most), and many are having some success. That said, the field as a whole must contend with this phenomenon more directly and develop best practices because digital technology has compounded this expectation.[4]

Today's consumers expect that their content will be available on every platform simultaneously, watching their favorite film through Netflix, XBox, Amazon, iTunes on their cellphone, TV, or any other device. They don't care about the established systems for discovery and access, and this too means that arts organizations must adapt and will need to collaborate and share more readily.

An audience member often follows the artist, so perhaps the Brooklyn Academy of Music (BAM) should notify me when Grupo Corpo plays next in New York, even at a rival venue, not just when they next play BAM—and perhaps that venue would push their patrons back for another show. Perhaps subscriptions should be offered that allow one access not just to MoMA, but to multiple institutions, perhaps in multiple cities. Ticket selling systems of the future should likewise push content to arts patrons not just at their current locations, but also to where they might be next. These systems should be "smart" enough to notify audience members of their favorite playwright's next show, or their favorite actor's new film. This sense of collaboration will be difficult because it challenges existing notions of competition and loyalty, but discovery of the arts is now disintermediated, and arts organizations that embrace these changes will thrive.

During my tenure at the Tribeca Film Institute, we attempted one such experiment within the web platform of *Reframe* (www.reframecollection. org). The project website was structured to help scholars and students find films for educational use. While we hired curators who created lists of the "best" films on certain subject matter, we also allowed any user to become a curator him- or herself. If a curator wanted to recommend a film that wasn't

participating in the *Reframe* project, we would use an electronic interface to pull this content into the system, allowing juxtapositions that we as the organizers would never expect. While users appreciated this feature, many distributors were often perplexed at this crowd-sourced curation, as it went against established notions of audience consumption of media (namely, that there were different audiences for each sector, which seems anecdotally untrue). While this was one small experiment, it illustrates that audiences may help arts presenters establish new notions of value should they be given the opportunity.

4. "Talkin' With My Generation": The Rise of Participatory Culture

This sense of disintermediation has expanded into what is called participatory culture. Audiences can now easily participate actively in the art they consume, and expect to be able to do so. This is an historic return to the way art used to be practiced—by and for all. Ancient cultures valued communal art making and practice, with the arts integrated into community activity. Recent research by Lynn Connor has shown that in classical Athens, for example, most actors in plays were amateurs and audiences participated vigorously before, during, and after performances. Even north of Athens and a millennium later, she notes, the idea of an artist didn't even exist, with craft workers who were citizen-artists being prevalent in the Middle Ages.[5] For too long, however, art has been placed on a kind of altar—to become a painter, a musician, a dancer, or a filmmaker one had to learn "the rules" and follow the canon. Sure, punk rock existed, but to make "fine art" music, such as classical music, one had to learn an almost secret language. One had to take dance lessons, learn ballet, and compete. One had to go to film school and spend a lot of money on equipment. Art was no longer something to be produced by everyone, but something that one had to aspire to learn perfectly. And because it was hard, art became something that was largely consumed.

From today's perspective one can see that the one-way street of art consumption was an historic aberration, and one society's good to toss. Audiences no longer want to just consume their art—they want to be involved, to engage in the conversation around art and creativity and perhaps participate in its production. People connect through social networking sites such as Meetup.com online to meet offline and discuss shared interests, talk about a book or a film, listen to music, or sit together and crochet. There are now "tweet-ups" where people use the short message service Twitter to tweet their friends for shared events; flash-mobs where

people connect online to perform group events like gathering in New York City's Union Square Park and dancing collectively (and silently) to whatever is on their iPods; or one can use Foursquare (a location based check-in service) to connect with friends in cafes or galleries or discover a nearby "hot" venue from a geo-location. Others upload their films on the website Open Source Cinema so that audiences can download their content, remix it, and upload their own new creations (remix culture in itself being an important trend to follow). Technology facilitates the human need to connect, share, and participate—and this is great news for the arts.

In a 2005-2006 Knight Foundation study of its funding for symphony orchestras over the previous decade, the foundation learned that all of their initiatives to increase attendance at the symphony—things like subsidized tickets and better marketing—had been a failure.[6] They learned, however, that the single greatest predictor of attendance at orchestral performances was having previously played an instrument. People who'd had piano or other musical lessons, or dabbled in music at some point, felt a more visceral connection than those who hadn't, and they would therefore seek out a greater variety of musical experiences. Through digital technology and sharing culture, legions of kids now have access to entire recording studios for free, cheap cameras, and programs to teach them any instrument imaginable. These young digital consumers don't think of themselves as amateurs, but as creative beings, contributing to culture. If the Knight study is correct, then each of these individuals will feel a greater connection to the arts and likely explore more within their interests. In film, the YouTube mash-up creator may begin to seek out classic cinema, or avant-garde works because they now understand it better and feel a connection. They are participating with the arts, searching for a dialogue, and it is incumbent upon existing cultural institutions to tap into this energy and change how it operates to allow for a more participatory arts experience.

Organizations must address this shift in their programming and outreach and even in how they create and curate their shows. They will need to let the audience become more than just spectators. This doesn't mean that all arts experiences must be participatory, as not all audiences desire the same levels of interaction, but rather that greater levels of interaction should be possible for those who increasingly expect such participation. While some arts organizations are beginning to experiment with programming that involves the audience, or that at least makes the experience more participatory, such as bringing the audience into rehearsals or having them add to a musical performance with their cellphones, the field as a whole should make every effort to make their experiences more participatory. The value in some of the most successful web businesses today, companies like

Amazon, Craigslist, Google, and Wikipedia, derives from the participatory contributions of their users. Users of Amazon gain insight into prospective purchases from the reviews left by other consumers. This value accrues to Amazon. It becomes a more trustworthy site from the participation of its users. Facebook, one of the fastest growing companies online today, builds almost all of its value from the participatory activities of its users. This new level of interactivity, sometimes referred to as web 2.0 culture, is growing and becoming more prevalent in the interactions of most people online.[7] Arts organizations would do well to follow the lead of such companies and incorporate more participation into their organizations, perhaps gaining more value by encouraging dialogue and audience contribution than they can offer on their own.

5. COMMUNAL CONVERSATION TRUMPS MARKETING

When people join a social network, they do so for a variety of reasons including connecting with colleagues, sharing information, or possibly to find friendship, romance, or work. If you glance at most arts organizations' websites, however, it appears that the administrators think social networking is just about marketing. Themselves. Constantly. If an organization is event-based, one usually finds a flurry of postings just before and during the events it offers, but rarely afterwards—unless it's a tweet saying "hey, thanks for attending, see you next year." This couldn't be further from what audiences want, which is an ongoing dialogue and real sense of connection.

Arts organizations must participate in the building of online communities in a natural way or they will become, as many already have, just so much more noise in the Internet social sphere. This isn't easy for arts organizations, or for most artists and other people, because real dialogue is hard. In fact, this is precisely the area where one often learns that one's real queasiness around social media isn't technical—almost anyone of any age group can learn how to use social networks. What's hard is conversation, whether that's in the lobby or online. The entire architecture of most museums, theaters, and arts organizations seems intended to minimize the chance that a staff member could engage in even brief conversation with the public. The architecture of the Internet, however, requires true, engaged conversation.

The advent of computers has changed what consumers and audiences expect. People seem to no longer respond to one-way communication that doesn't value their input. No one expects to have a dialogue with their television because it is a one-way, static device. A computer connected to the Internet, however, is a two-way (or more) communication machine.

Marketers are learning that they can't just broadcast a message and relentlessly market themselves. Rather, they must truly engage people online—being willing to listen as well as talk—or they will be ignored entirely.

Until arts organizations realize they must actually participate in a dialogue with their community, they can't create a proper presence online. While that dialogue will necessarily be different from one institution to another, reflecting different ideas of what constitutes dialogue, it must be genuine, ongoing, and it must have some compelling voice—be it from everyone on staff/commission or just the artistic director or performers. Arts organizations should also begin thinking about how this will evolve over time—likely becoming more participatory, more enriching, and more argumentative at the same time, and likely leading to entirely new art forms which could be co-created by those organizations who take the lead.

6. IN A WORLD OF FREE, THE FUTURE LIES IN *FIND*

In a digital world, a copy is just zeros and ones and thus—copies are free. Copies then become superabundant, easy to make and share and harder to track. This makes piracy of content much easier, but it also allows for the legal dissemination of content. Chris Anderson, an editor of *Wired*, has noted that digital technology has led to a culture where many items and experiences are increasingly available for free.[8] Many companies are finding that they can use free as one aspect of their business model, often through advertising and sponsorship support or through the use of free content to attract people to pay for an upgraded "freemium" version.

It is important to note that this does not mean that free itself is a business model—that wouldn't be sustainable—but rather that free access can be one part of a multi-tiered business strategy. Raise enough sponsorship and it could be mutually beneficial to you, your audience, and Target to make museum entrance free one night a week (which is not a novel concept).

What would freemiums look like for nonprofit arts offerings? Perhaps a free membership that gets one access to early-bird discounts (that aren't as great as those from a paid membership), newsletters, blog postings, and other free content which encourage one to become more active and pay for a membership. Or perhaps it just means extending concepts such as free entrance but paid admission to special exhibitions. Free content might be viral video of last night's performance with a digital coupon at the end for discounted admission to an upcoming event, or maybe it's one free show a week. Regardless of what one thinks about the concept of free, it is clearly a trend, and as consumers get used to paying less and less for

quality content it will undoubtedly impact what they are willing to pay as audience members and patrons of the arts.

Of course, at the end of the day, there truly is nothing for free. Someone pays to produce the content, or to host the video of the performance and deliver it over the Internet. Every arts administrator knows the costs of artistic production well, and a quick criticism of the free model is to point out that artists need to be paid. While this is true, perhaps there might be new models to be explored that take advantage of the economics of free. In fact, many artists have begun experimenting already, and some are finding success.

Zoe Keating, an avant-garde cellist, was able to join the top ranks of Twitter with more than 1.3 million followers, and can now ask her fans to donate money directly to her so she can make and record her music. Many give just to support her work, some "pre-buy" a download, ensuring quick, often advanced access to her music.[9] Keating is now able to sustain a career, even though one can listen to all of her songs for free on her website and find all of them on pirate networks. Musicians like Jill Sobule and Josh Freese are building their careers not just by offering advanced downloads, but by giving additional gifts for larger donations. If a fan donated $10,000 to Jill Sobule's campaign for *Jill's Next Record* they could even join her in the studio and sing on her album. Similarly, drummer and songwriter Josh Freese offered anyone who gave him $500 to produce his work the option to visit him at home and share a steak dinner at the local Sizzler restaurant.

These artists aren't alone; thousands of others use online tools such as Kickstarter to go directly to their fans and raise money to make their work. Others have found that free music access increases their fan base, allowing them to make more money from live shows and appearances than from album sales. Or they make money from merchandise. The filmmakers behind the movie *The Cosmonaut* are on track to raise their €400,000 indie film, mainly by selling t-shirts, stickers, and novelty items from their website. Does everyone want a €3 pencil originally used by Russian cosmonauts? No, but many fans will donate €3 and keep the gift as a souvenir, and then tell their friends when the movie is released. Artists are moving (back again?) to a patronage model—but this time, one where their fans and audiences help fund their work. Not just through purchases, but through donations and other support to help create works of art. Arts organizations such as The Hyde Park Art Center in Chicago are experimenting with member commissioning of new work and the national service organization Meet the Composer has established their entire organization on the idea that audiences can likewise commission new compositions.

Arts organizations would do well to participate in the free movement

soon. Luckily, the answers to the dilemmas of free content seem to be very much in the favor of arts organizations. Digital has changed the nature of value. In the past, value came from scarcity—it was expensive to make a film, or to buy a Matisse—but in a world of ubiquitous copies, the audience is overwhelmed with choice. Attention becomes the scarce resource, and as the amount of content online multiplies daily, audiences increasingly need, and will pay for, someone or something to help them wade through the digital mountains of garbage to find what they actually want.

If the history of the Internet thus far has been defined by search, its future resides in find. Online, as in the offline world, audiences turn to a trusted source to help them find what they want. This means that guides, librarians, and curators are more important than ever before. Organizations must add value to this connection, so they aren't viewed as just another middle-man. This nicely dovetails with most arts organizations' positions as a nexus of the art and the audience and as a curator helping audiences find the best work. This is an area where traditional arts organizations have historically excelled. Contemporary arts organizations who focus their energies on being curatorial in a more participatory, communally-minded way should likewise be poised to excel in the digital (even free) economy.

7. The New, New Media Literacy: Electracy

Digital technology has changed many things, but it has done more than give society nifty new gadgets and new ways to connect. Noted theorist Greg Ulmer has proposed that through digital technology civilization has shifted from orality to literacy to electracy—where all thought, processes, writing, storytelling, and business practices are based on or mediated by electronic, visual, motion media communication.[10] This is not media literacy, but rather a paradigmatic shift which the cultural sector should not just be aware of but should be leading, as the changes electracy will bring about may profoundly alter the world.

Linguist Walter Ong described the change from orality to literacy and how this altered society's perception of the world.[11] This paradigm shift changed the nature not just of communication, but of religion, art, politics, and other processes. Culture could now be written down and passed along, instead of repeated through folk-tales. People could worship their God directly, not just through the clergy. News could spread via print, altering the shape of nations. Detailed instructions could be put in a book and learned not through lengthy apprenticeship but through study. All the world's knowledge could be archived and stored in physical libraries. The

very notion of who and what human beings are transformed as cultures became literate.

Likewise, humanness will change as populations shift from literate to electrate societies. Knowledge, religion, culture, and power will be altered in ways that can't yet be comprehended. The tensions this shift will bring are already visible, for example, in the debates among parents and teachers over the impact of gaming on children's literacy or when critics bemoan what is lost in the transition from print to e-book readers such as the Nook and the Kindle. The shift to electracy also threatens existing structures and challenges ideas of ownership through copyright, the nature of much work, the value of many goods, and will likely influence widely accepted notions of currency. Electracy gives new powers both to rebellion and to state control. It alters the notion of communication and the nature of privacy. Of course moving towards electracy also affects what people create and how they interact with their culture. The full scope of these permutations are only now becoming apparent but will likely continue to manifest as society develops and responds to the next iteration of the evolution of digital technology.

Where this leads next is uncertain. While literacy shaped laws, education, religion, culture, and politics it was also shaped by these same forces. So too will electracy be altered by society's current beliefs, fears, and very often, by who is in power.

When decisions are being made about digital technology, decisions are also being made about the future of how society will think, conduct business, interact, make and enjoy art, and how individuals will behave as social beings. There is much danger that many of the possibilities of digital will be thwarted by incumbents who are threatened by the changes digital might bring. One sees this most clearly, thus far, in the battles over network neutrality, copyright, security, and privacy. These issues are important to arts leaders—because the decisions that take place today will likely affect the possible future(s) the cultural sector may experience tomorrow, as well as the legacy it will leave behind.

CONCLUSION: IMAGINATION NECESSARY

Perhaps the greatest threat to the digital future is society's lack of imagination. What is needed most now is an ability to imagine what might come next, instead of trying to bend digital change to fit preconceived notions of the world. Herein lies the heart of why the arts sector must take the lead in these debates by experimenting with what's next in technology.

The arts enable us to imagine what's possible, connect with our core

human traits, and express them creatively. They enable us to understand change and address fears. Yet the arts are largely absent from the conversation about the future at this time, standing on the sidelines adapting these changes to their current practices instead of leading the transformation. This is for the worse, because instead of a new era of possibilities we are in danger of a new era of sameness. If all we get from digital technology is a fancy new TV that can show 3-D movies, pull down an endless library of content, and let us chat with our neighbor about which products to buy from the show we're watching, we have failed. We fail if we settle for just accessing every book ever made on the screen of our phone. Or for being able to navigate the Louvre with an iPhone application. These ideas are precisely what pass for visionary by those controlling the future of culture now.

The arts sector is well positioned to put forth innovations that harness the demand for participatory culture, for relationship and community building, and for connecting audiences more directly with artists. Such innovations can help people find the art and culture they desire and curate experiences that lead to discovery. They can help insure that democratic critical discourse remains an important facet of our cultural experience. Unless the arts sector takes an active role in creating the future, a new era of digital sameness may be the best we get, and our society will be the poorer for it.

The changes brought by digital technology can be looked at as something scary—possibly endangering a way of life we know today. To run from these changes, or resist them, is pointless and will leave the future in the hands of others who will not likely share the cultural sector's vision for the importance of the arts to the civic sphere. Alternately, these changes can be viewed as liberating, full of promise, and possibly capable of improving our society. Computer theorist Alan Kay has said that the best way to predict the future is to invent it. The best way to shape that future is to be one of the inventors, and that's what's needed from the arts now. Arts leaders, of all generations, should embrace this spirit of innovation, take advantage of this opportunity to radically reinvent our sector and, quite possibly, improve society while we're at it.

Join the Conversation
Contribute to a dialogue pertaining to the concepts discussed in this chapter by directing your web browser to the following URL:
http://www.20UNDER40.org/chapters/chapter-1/

NOTES:

1. Burnham, B. "Chris and Malcolm are Both Wrong." Union Square Ventures blog, (August 9, 2009), <http://unionsquareventures.com/2009/08/chris-and-malco.php>.
2. Christensen, C. *The Innovator's Dilemma: The Revolutionary Book that Will Change the Way You Do Business.* New York: HarperCollins, 2003.
3. For more research on the overlap between the for-profit and nonprofit sectors, see Arthurs, A. Hodsoll, F., & Levine, S. "Managing the Creative—Engaging New Audiences: A Dialogue Between For-Profit and Nonprofit Leaders in the Arts and Creative Sectors." The Getty Leadership Institute and National Arts Strategies, 2004. Author's note: Ms. Arthurs was also a board member at Tribeca Film Institute where I served as president & CEO.
4. For excellent analysis of both experiments in disintermediation, participation, and the development of best practices see Simon, N. "The Participatory Museum." (n.d.), <http://www.participatorymuseum.org/>.
5. Conner, L. "In and Out of the Dark: A Theory about Audience Behavior from Sophocles to the Spoken Word," in Ivey, W. & Tepper, S. (Eds.) *Engaging Art: The Next Great Transformation of America's Cultural Life.* New York: Routledge, 2007.
6. Wolf, T. "Magic of Music Final Report: The Search for Shining Eyes." Knight Foundation. (June 12, 2006), <http://www.knightfoundation.org/research_publications/detail.dot?id=178219>.
7. Shirky, C. *Here Comes Everybody: The Power of Organizing without Organizations.* New York: Penguin Press, 2008.
8. Anderson, C. *Free: The Future of a Radical Price.* New York: Hyperion, 2009.
9. Lacy, S. "Zoe Keating: Web Fame that Actually Translated to a Career." TechCrunch. (September 27, 2009), <http://techcrunch.com/2009/09/27/zoe-keating-web-fame-that-actually-translated-to-a-career/>.
10. Ulmer, G. *Internet Invention: From Literacy to Electracy.* New York: Longman, 2003.
11. Ong, W. J. *Orality and Literacy: The Technologizing of the Word.* London: Metheun, 1982.

The Epoch Model:
An Arts Organization with an Expiration Date

David J. McGraw
University of Iowa

We have designed our arts organizations to last forever without any option for graceful exits. But what if an arts organization could be designed with a predetermined end-date? How would such an approach change the way we measure organizational success in the arts? Companies that adopt the Epoch Model—an organizational structure that plans for the limited-lifecycle of an arts group—benefit not just their artists and audiences, but also revitalize their local communities and the broader arts sector.

Can arts organizations live forever? It is both a hallmark of their design and a measure of their success. The older the organization, the more prestigious it is assumed to be by both audiences and supporters. It is also foolishly assumed that a good arts organization will never decline. In fact, most arts groups have no plan for their eventual end. Their mission statements, their *raisons d'être*, are so broad and grand that they can never actually achieve them. An organization with an unachievable mission has no choice but to continue or else appear to have been a bad idea from the start. In the cultural sector we cling to the belief that great art lives forever, and we force that lofty goal onto our organizations. Anything short of organizational immortality is seen as a failure.

Should arts organizations live forever? The surge of new arts organizations following the birth of the National Endowment for the Arts (NEA) in 1965 was truly amazing. Orchestras have grown in numbers from approximately 100 in 1965 to 1,800 in 2008.[1] Similarly, there were fewer than 100 professional theatres across the country at the time of the NEA's

founding whereas today there are over 2,000.[2] But now this same surge threatens the arts ecosystem.

Today's arts world is an old-growth forest with mighty institutions dominating the scene while new companies struggle to catch any nourishment through the canopy of leaves. It is time to ask some hard questions: how can groundbreaking art be created by multi-million dollar institutions whom hundreds, if not thousands, of people rely upon for long-term income? Is it any wonder that established arts organizations are criticized for being risk-averse?

Why would arts organizations want to live forever? So much of art is about creation and new work. Many artistic leaders have a revolutionary streak that leads them to work for change.[3] Too many arts groups that were pioneers in their fields have since settled for the nostalgia of their early years. In January of 2008, several leaders from smaller arts organizations in Boston proclaimed themselves "artyrs" and staged a "die in" in protest of the Boston Foundation's support going almost exclusively to large, established organizations. In an article for the *Boston Globe*, Geoff Edgers notes:

> It's a joke, of course, meant to poke fun at the Boston Foundation's recent report on the state of the arts community.... [however] the spoof... plays off the [F]oundation's suggestion that some small organizations consider an "exit strategy" rather than try to soldier on.[4]

In order to inspire new arts leaders, the arts sector needs to create not just the next generation of organizations but also new ways to operate these companies. Just as younger generations of Americans possess different career goals and expectations about job security, new arts organizations should measure success differently than their predecessors. This chapter proposes an alternative organizational model that acknowledges not only the growth but also the intentional closure of a fledgling arts organization, allowing the founders to see the organization through to its completion. This new model will benefit not only the board of directors and executive leadership, but also the organization's constituents and its local community.

THE NATURAL LIFESPAN OF AN ARTS ORGANIZATION

Sir Richard Eyre, former director of the Royal National Theatre, remarked at a 2001 conference in London, "We have to acknowledge that theatre companies have a finite life span and that few manage to sustain artistic ardour beyond seven years."[5] Sir Eyre further explained, "While theatre as an art form will remain inextinguishable, its survival will not depend on

the buildings, institutions and companies that have been established for the needs and aspirations of different generations."[6] How can the arts be served by groups that traded innovation and growth for organizational stability?

The renowned dance choreographer Merce Cunningham understood the dangers that an innovative company would face after the passing of its founder. Previously, the dance world watched Martha Graham's choreography become tied up in the courts as factions battled for control of the company's repertoire after Graham's passing.[7] In such situations, even if the executor of an estate is clearly established, as was the case with Cunningham's collaborator John Cage, organizations that were founded as experimental companies risk becoming monuments in the wake of their founders.[8] So the Merce Cunningham Dance Company created a plan to close once its namesake could no longer be active in the daily operations of the company. The Living Legacy Plan, established a month before the choreographer's death in July 2009, allows the Merce Cunningham company to celebrate its work in a final victory tour, receive support as they transition to new careers, record Cunningham's oeuvre for future audiences, and create a trust to oversee access to his work by future artists.[9] The board of directors and executive director Trevor Carlson designed a fitting closure for the company rather than let it drift, frozen in time. As Nancy Umanoff, executive director of the Mark Morris Dance Group, explained, "Merce's plan is precedent-setting and will serve if not as a specific model, then as motivation and inspiration for everyone to start dealing with the realities of the situation."[10]

Unfortunately, arts organizations and arts advocacy groups that close on a high note are few and far between. Part of the challenge is identifying when the group has served its purpose and when to step aside for other organizations to take the lead. The Free Southern Theater, an African-American theatre company founded in 1963, realized in 1979 that it had achieved its initial goals and had reached the end of its usefulness, so it decided to throw a funeral for itself, complete with a jazz procession through the streets.[11] The closure of an arts organization need not be a cause for mourning for what might have been as much as a celebration of all that it has accomplished.

THE EPOCH MODEL

If organizational immortality were not the primary indicator, or even a major indicator, of a successful arts organization, it could have a profound impact on the way the field designs arts companies. While a legacy plan provides a sense of closure after the loss of the founder, many companies

begin to decline well before the founder's passing. Rather than trudge through years of decline, arts organizations can be designed to close in their prime, just as an athlete chooses to retire while at the top of his or her game. This alternative design for an arts organization offers numerous advantages over the traditional model:

- A single founding vision can guide the organization from start to predetermined finish.
- Productions, exhibitions, and initiatives can be selected to follow an artistic arc rather than merely filling generic programming slots year after year.
- The company can plan its organizational growth and contraction with an eye towards its end.
- The founders can have a successful tenure with no sense of abandonment for leaving an organization they created.
- The planned end of the organization will create a "changing of the guard" with opportunities and resources for both new arts organizations and emerging arts leaders.
- An organization's membership can challenge itself to fulfill its mission with greater urgency, knowing that this collaboration is a fleeting opportunity with a defined commitment from each member.
- Audiences will know that they cannot take the organization for granted and that the organization represents a specific period of time, or epoch, of the artistic life of the community.
- All stakeholders will be able to celebrate a "mission accomplished" at the anticipated close of the organization.

The Epoch Model is an arts organization with a defined lifecycle: it is designed to begin and end based on a single strategic plan within a single period of the artists' lives. This radical concept will force the field to rethink the accepted conventions of how the arts are managed. A shared trait of many works of art is their ephemeral nature, so it follows that the arts sector must break from the old model and build a new one: an arts organization with an expiration date.

THEATRE 2020

To better illustrate the advantages of this concept in practical terms, it will prove useful to utilize a specific example. The Epoch Model can succeed in a variety of artistic genres; but for the sake of this hypothetical case I will discuss an imaginary theatre company. While the best length for an

organizational lifespan is open to experimentation, this company will follow Eyre's recommendation of seven years.

Imagine a group of young artists and local arts leaders who want to start a new theatre company in their hometown. The community may have a limited history of supporting arts organizations, but the founders believe in the project and commit themselves to a seven-year run. The board of this hypothetical company decides to begin producing theatre in 2013 and so they name their group Theatre 2020.

Advantages for the Board of Directors

Theatre 2020 can begin, grow, and end under a single board of directors. In order to plan its operations, produce theatre for seven years, and then settle all final accounts, the actual commitment of the board would likely be nine years, not an uncommon commitment for a volunteer board. Consider the tremendous sense of satisfaction for board members to oversee the organization from start to finish. Due to the finite commitment of the board tenure, members will not be faced with guilt or disappointment at abandoning an arts organization, even after years of service. Many arts organizations use board membership term limits to counter this guilt, but the Epoch Model offers an even better alternative in that board members know the length of their commitment when they join and can be confident that the organization will not fall into decline when they leave. There is still the option to replace individual board members or to augment the size of the board, but the risk of the organization straying from its founding mission decreases dramatically. Initially, the novelty of a defined lifespan model may attract some board members. Yet so too will the idea that one cannot delay in joining this board—this opportunity will not present itself again.

Advantages for Executive Leadership and Senior Staff

The Epoch Model will also allow the board to recruit stronger executive leadership than they might otherwise have, given their budget and location. If the board wants to create an arts organization with limited resources in an area that does not have a strong arts infrastructure, they may have a very difficult time attracting up-and-coming artistic and managing directors. One solution is to offer a seven-year contract with clear support for organizational growth, the opportunity to have a successful tenure, and the knowledge that the executive leaders will be integral to the identity of the organization. Contracts would be written to allow either party to break the agreement if it is not a good match, but the expectation is that

the leadership would commit to a full seven years of service. For many early career leaders, this arrangement would offer the ideal paradox: job security and the opportunity to experiment. In return, the board is able to recruit more desirable candidates and set the expectation of how long this promising leader will stay with the organization. The lure of selecting productions based on the larger arc of the organization would be very enticing to any arts leader.

The Epoch Model offers incentives that make it easier to recruit senior staff as well. In his 2006 article, "Follow the Leader," social psychologist Gerd Gigerenzer argues that collaborative business teams benefit from starting all members at the same time so that there are no unfair or artificial advantages of having seniority over peer positions or "being patronized as a younger sibling."[12] Rarely does the arts community think of a Founding Development Director or a Founding Director of Finance, but why not? Imagine if a Development Director had the ability to help plan the organization and to coordinate development goals alongside a single unified strategic plan. A Director of Finance under this model not only has the normal benefits of implementing a new financial plan but also the knowledge that she or he can see the financial operations through to completion.

The Marketing Director has the most to gain from the Epoch Model. In addition to the novelty of creating brand awareness for such a unique company, every production will have a sense of urgency, as limited supply can increase demand. In fact, the organization may see cultural tourists from outside its region as news spreads of this relatively short collaboration of rising artists. Limited runs tend to draw more publicity and can pique the curiosity of even casual art-goers. When Christo and Jean-Claude installed the Gates Project in Central Park, part of the allure for the four million visitors was the fact that the arts experience would only exist for sixteen days.[13] With a nod to Margo Jones changing the name of her Theatre '47 to Theatre '48 on New Year's Eve, the immediacy of Theatre 2020 and its inevitable countdown lends itself well to marketing initiatives.[14]

Another recruitment advantage of the Epoch Model is that the company can hire individuals with unique blends of skills that may not fit into a traditional job description. Because it doesn't have to worry about replicating a particular combination of skills possessed by any one individual once that employee leaves, Theatre 2020 can hire a director of development who is also skilled as a stage director or a director of finance who has experience leading youth programs.[15] Jobs can be tailored to individual strengths and staff members will not be pigeonholed into positions that only utilize part of their skill sets. Both the simultaneous

start for all senior staff and the flexibility of job assignments will create a flattened hierarchy and a much more organic structure.

Advantages for the Local Economy

The Epoch Model also acts as a safeguard against another trend plaguing the American arts community. Our society values ownership over the rental of property: prestige is granted to an organization when it purchases a building it had been leasing. Larger organizations in ever-larger buildings claim that they can be landlords, adding this nonessential part of a nonprofit to their list of assets (and liabilities). Yet ownership of property, particularly new performing arts centers, has become a millstone weighing down organizations as they struggle in a weak economy. The Nonprofit Finance Fund conducted a survey of 1,315 members in March 2010 and discovered that a third of nonprofit organizations which purchased their facilities experienced significant financial decline due to the increase in fixed expenses—another third just barely broke even.[16] While the national recession has impacted many arts organizations, formerly robust groups, such as Shakespeare & Company in Lenox, Massachusetts, compromised their fiscal standing in the weakened economy by borrowing heavily and increasing their operating expenses.[17] The acquisition of new property and construction is cited as the primary cause of Shakespeare & Company's current cash-flow crisis.[18] Arts organizations should be deemed successful when they connect with their audiences and achieve their missions, not when they transform themselves into shrewd property managers.

Since Theatre 2020 will only be in operation for seven years, there is little reason to purchase its own building. But a seven-year commitment could be very attractive to a potential landlord. The organization could help revitalize a neighborhood while allowing the landlord to renegotiate for a more competitive price with the next tenant. The leadership can pick an area for the present needs of the community rather than long-term property values or future risks for the organization. In the current real estate scene, many communities have weakened business rental markets. Under this alternative model, the landlord could commit now to a new arts tenant at a significantly reduced rate while planning for redevelopment once the market rebounds. For example, in 2009, a Cleveland developer purchased nine foreclosed houses to create an "artists village," thus revitalizing a particular neighborhood and increasing its property value.[19]

This is not to say that an arts space will necessarily be demolished at the end of its lease. The physical structure may remain, only the construct of an individual company will disperse. The Englert Theatre in Iowa City,

Iowa, the Maryland Theatre in Hagerstown, Maryland, and the Briggs Opera House in White River Junction, Vermont, are just three of the many American theatres that were converted to serve other purposes, fell into disrepair, and then were restored by their communities to become performing arts venues. Given how the current economic crisis has affected the commercial real estate market, it is likely that many arts spaces will just remain vacant until new companies emerge.

Personally speaking—as a young theater artist I grew up working in theatres that used to be churches, grocery stores, cinemas, and schoolhouses. Perhaps the next generation of artists will reclaim... old arts spaces.

Advantages for Succeeding Organizations and the Broader Community

Although the Epoch Model might appear to offer only temporary good, it can lay stronger foundations for future arts groups than a traditional organization, both locally and within the larger arts community. Some professional artists who moved to the community for the organization may choose to stay and integrate. Volunteers and early career artists now possess the experience to operate their own arts companies. The executive leadership may move on, but this is also a victory as it creates opportunities for the next generation of leadership. Rather than create a vacuum, it guarantees career growth as the end of one company spawns new leadership opportunities and new goals for the next organization. Or as Sir Eyre explained, "Like everything else in life, with death there is a birth."[20] Those rising executive leaders, sporting resumes with a successful tenure, can create new collaborations and keep their art fresh with even greater challenges, which will bring even more recognition to the community that gave them their start.

There will also be tangible benefits for the community in the planned closing of this hypothetical theatre. In a nonprofit's articles of incorporation and subsequent by-laws, all assets after settled debts are donated back to the state or to the local community.[21] Arts groups that close after a long decline have very few assets available after paying their debts, as these debts were often the reason for their closure. The Epoch Model, which closes by choice and not by necessity, is in a position to donate much more to the community that has supported it. The theatre in our example can gift the lighting instruments, sound system, costumes, props, and scenery to other performing arts groups and schools. Office equipment can be gifted to area nonprofits. Following the trend of "green" enterprise, an arts organization can be strategic in how it recycles its assets. These physical assets will be in good condition as they have only seen seven years of use. Best of all, the

receiving arts groups and nonprofits will know when these gifts will arrive and plan accordingly, potentially even planning to move into the newly available space. In fact, Theatre 2020 can make this divesting of assets part of its closing celebration as it gives back all that it has received from the community.

The Myth of the Need for Stable Arts Organizations

A persuasive argument against the Epoch Model is that if there is need for a new arts presence today, will there not still be a need in seven years? And if the organization is successful in reaching its community, will not the need be even greater? Too many organizations confuse the need for art with the need for their particular company to exist. Despite emergency fundraising pleas, the death of an individual organization is not the death of an art form, nor will it deprive a community for very long. For example, when Fayetteville, North Carolina, lost its only art museum, the *Fayetteville Observer* published an editorial the very next week calling on the local arts council to both fill the current void by bringing in traveling art shows and to lay the groundwork for a new museum.[22] In fact, a planned turnover of arts organizations may encourage more young artists to stake their claim within their own communities. Many established arts organizations shun local rising talent, relying on itinerant arts leaders from major cities to set up shop and study the community to create art that somehow has a local connection. As Rebecca Novick suggests in her *20UNDER40* chapter, "Please Don't Start a Theater Company! Next Generation Arts Institutions and Alternative Career Paths," many younger artists have little hope of earning leadership positions within the established arts organizations in their communities and are relegated to "a shanty outside the fancy building."[23] The Epoch Model can reinvent what it means to be a community-based company and have a profound impact on what it leaves behind.

Other Applications for the Epoch Model

The Epoch Model can also be applied to the visual arts in the form of a limited residency for a group of artists connected by shared experiences over a specific period of time. Collaborative residencies already exist within some host organizations such as AS220 in Providence or the Cocoon Gallery at the Arts Incubator of Kansas City, but the Epoch Model structures the organization itself as a single residency. Much like the performing arts model, a municipality could choose to revitalize a community by "seeding" a neighborhood with established artists for a defined period of time, both to make new artistic experiences available to residents and to inspire local

artists. The key, again, is to not create an ongoing collaboration that will grow stale and decline as the founders move on but to make it a one-time commitment of time and resources that will represent a unique period of the artists' careers.

The model could also readily be adapted for arts education and advocacy groups. The catalyst for many advocacy groups is a specific need or crisis, but, if the group is successful in meeting its initial goal, it often splinters as some founders consider the task complete while others choose to identify an even more difficult challenge. As is the case with board members, founding members can dedicate so much of their time and resources towards the initial goal that they are unable to sustain the evolving organization for the long term. Some arts advocacy groups decay from within as members lose their zeal. But closing the organization can become problematic as the group's mere existence becomes associated with the overall mission, so the loss of the organization could be mistakenly equated with public apathy for the cause. The Epoch Model allows the group to sustain itself and its constituents through tough struggles with the knowledge that everyone's commitment is restricted to a period of time. Such a restriction reinforces the urgency of the group's mission.

CHALLENGES AND NEW OPPORTUNITIES

Given these advantages, what is the biggest challenge for a group that adopts the Epoch Model? Funding. Many foundations and government agencies require an organization to have an established record of creating art to be eligible for grants, which could affect how quickly a short-lived organization can grow.[24] Andrew Taylor, Director of the Bolz Center for Arts Administration, identifies this major obstacle: many grant opportunities are designed to make an arts organization more self-sufficient and independent in its operations, rather than to provide "seed capital and hands-on support" for innovative models.[25] As the organization nears its predetermined end, it will become increasingly difficult to secure funding, given that operations will not result in long-term growth. Individual project grants are still possible, but it may become difficult for funders to separate the organization's planned end with a smaller project's goals.

Perhaps the 501(c)(3) nonprofit format, with its focus on organizational stability at the expense of innovation and growth, is not the best structure for the Epoch Model. This new model may be better suited for business structures such as the low-profit limited liability company (L3C). An L3C is similar to a limited liability company in format but marries the primary functions of both commercial and nonprofit companies. Its primary goal is

to achieve a socially beneficial objective, but it recognizes a secondary goal of achieving a profit in the process. The L3C is designed to grow and adapt to the needs of the community more quickly than a 501(c)(3) organization, while offering a financial incentive to its founders to be successful. The L3C model complies with IRS regulations for program related investments, which would enable foundations to have financial dealings, including the potential for partial ownership, of a commercial arts group that served a charitable goal.[26] Therefore a community foundation could financially support a new arts group in an economically depressed area of town in order to create local jobs. Despite these clear advantages, the L3C model might not be the best solution for smaller companies with limited initial funders and short timelines for harvesting investments.[27] Its open structure could also complicate the planned closure of the company if all parties do not continue to support the original plan. As the debate continues over the viability of the nonprofit model, arts groups need to consider hybrids and other management structures.

Case Studies: Countdown to Zero and The Nine

While it is common for small collaborations to spring up around short timelines due to the specific schedules of their members, organizations created to follow the fundamental principles of a defined lifespan are rare. One variation of the Epoch Model is being tested by Countdown to Zero, a political theatre collective based in Denver, Colorado. Brian Freeland and Julie Rada founded the group to present ten plays in a countdown of "politically-charged and provoking work."[28] Once they present the tenth play, they will disband the group. As Freeland explained:

> A series of ten plays would give us the freedom to potentially always have the opportunity to do the work as we saw fit. After ten, it was our hope that we would either find another vehicle to do new work or someone else would pick up the gauntlet and run with it in a more permanent fashion.[29]

In other words, the founders have asked supporters for a temporary commitment but they are leaving the door open to future collaborations.

Rather than define themselves by a given time commitment, Countdown to Zero is choosing to place a limit on the amount of art it will produce. Ms. Rada explained why they chose the format of a countdown:

> The idea of doing a countdown was a way of giving it shape and form.... We are not bound by any schedule. We are not bound to a board of directors or expectations of a season. We have the freedom to be as responsive as we want to be. We may find that we want to do four or five

pieces and then go a year with no work because nothing has risen to the surface.... So the idea of a countdown was a way to give that shape and room.... In our development of our company, everyone was interested in how revolutionary a model that is for arts organizations. How unusual it is to not do something in perpetuity, feeding on ourselves that would defuse our message. We also have to be very choosy about the work we do, with only ten, we have to know that that is what we want to say.[30]

A similar experiment in organizational design is being attempted in Chicago. Bries Vannon has created The Nine, which he describes as "an artistic product, not an artistic organization" that stages nine works without a predetermined schedule. The Nine asks its audience to:

...forget everything you know about seasons and subscriptions and boards of directors and accept that you are watching a canvas be[ing] painted one section at a time. And when that one canvas is full, we will all, artist and audience alike, turn and walk away—together, but leaving the canvas behind to slowly fade on its own time.[31]

The Nine is its own ephemeral work of art.

Countdown to Zero and The Nine follow the Epoch Model principle of not being designed to last "in perpetuity." They also seek to increase the importance of each project by having such a short run of productions. Yet their decision to not be tied to a particular schedule restricts staff positions and training opportunities and makes them more nomadic by necessity. They do not have a resident space so the organization has very few physical assets to divest at their closing. The Epoch Model could embrace the flexibility and freedom of these alternative groups while still offering some of the daily support of a traditional arts organization.

CHANGE IS INEVITABLE, BUT CHANGE CAN BE STRATEGIC

A distressingly large number of arts organizations have no clear plan for leadership succession: a recent survey by the Theatre Communications Group revealed that only 15% of surveyed theatres possess such a plan.[32] As more arts leaders remain in executive positions for ten, twenty, even thirty years, the rise of new leadership is halted. Moreover, these excessive tenures make it increasingly difficult for members or supporters to envision the arts group being managed in any other style. Would it not be better for an organization losing its founder to celebrate its successes, disband, and reinvent itself entirely rather than try to paste a new face onto the existing structure and hope that the new leader can be everything that the old one was but more?

The current economic crisis will surely claim the lives of a number of arts organizations. But one cannot help but wonder if it might be like a wildfire clearing out the old growth so that a new forest can emerge. Entrepreneurship, a concept held aloft by the business world, requires a churning and collapse of old systems so that new models can arise. According to government data, only 40% of American start-up companies in the commercial realm survive even five years.[33] Even if the current economic crisis claims a quarter of all American arts organizations, is this really cause to think that the arts will die out? The arts themselves will survive and new arts companies will be more nimble and better equipped to adapt to the changing world. As Gary Steuer, director of Philadelphia's Office of Arts, Culture, and the Creative Economy, notes, "We are just moving into an era where an array of different models exist to make and support art and creativity."[34]

The traditional arts company model favors organizational stability over artistic growth, providing long-term employment over pushing artists and advocates to new heights, and protecting legacy over creating opportunities for the next generation of arts leaders. The Epoch Model recognizes the natural lifecycle of a collaboration of dedicated artists, gives greater ownership and control to the founding members, and balances the organization within its community. While this alternative design is not intended for all organizations, it calls all of us to reexamine how we manage our arts groups. Are arts organizations truly serving their missions or have they chosen mission statements that serve personal desires to exist? Like the Merce Cunningham Dance Company and the Free Southern Theatre, arts organizations must recognize when to leave the stage. May all arts organizations have the courage to close their own doors when their time is up and march out into the streets in celebration—mission *accomplished*.

Join the Conversation

Contribute to a dialogue pertaining to the concepts discussed in this chapter by directing your web browser to the following URL:
http://www.20UNDER40.org/chapters/chapter-2/

NOTES:

1. Bauerlein, M., & Grantham, E. (Eds.) *National Endowment for the Arts: A History 1965-2008*. Washington, D.C.: National Endowment for the Arts, 2009: 228.
2. Ibid: 251.
3. Stevens, S. K. "Helping Founders Succeed." *Centerpiece Series*, Theatre Communications Group (1999), <http://www.tcg.org/pdfs/ACF1993.pdf>: 3.

4. Edgers, G. "Small Arts Groups are Dying to be Heard." *The Boston Globe.* (January 12, 2008).

5. Reynolds, N. "Subsidy Theatres Attacked by Eyre." *The Daily Telegraph.* (March 2, 2001).

6. Ibid.

7. Lubow, A. "Can Modern Dance Be Preserved?" *The New York Times.* (November 5, 2009).

8. Ibid.

9. Taylor, K. "Merce Cunningham Announces Precedent-Setting Plan for Future of His Dance Company and His Work." Press Release, Merce Cunningham Dance Company. (June 9, 2009), <http://www.merce.org/p/documents/CDFLegacyPressRelease.pdf>: 1-3.

10. Lubow, A. "Can Modern Dance Be Preserved?" 2009.

11. Hill, J. "A Farewell Without Mourning: A Jazz Funeral for Free Southern Theater." *Southern Exposure,* 14 (1986): 76.

12. Gigerenzer, G. "Follow the Leader." *Harvard Business Review* 84, no. 2 (2006): 58-59.

13. Hardymon, F., Lerner, J., & Leamon, A. "Christo and Jeanne-Claude: The Art of the Entrepreneur." Cambridge, MA: Harvard Business School Case Study, 2006: 11.

14. Jones, M. *Theatre-in-the-Round.* New York: Rhinehart & Co., 1951: 63.

15. Rebecca Novick. Personal communication, July 6, 2010.

16. Miller, C. "The Four Horsemen of the Nonprofit Financial Apocalypse." *The Nonprofit Quarterly.* (Spring 2010).

17. Nonprofit Finance Fund. "An Independent Assessment of the Current Financial Situation of Shakespeare & Company, Inc." (October 14, 2009): 25.

18. Healy, P. "Job Cuts Come to Shakespeare & Company." *The New York Times,* Arts Beat blog. (October 14, 2009).

19. Alter, A. "Artists vs. Blight." *The Wall Street Journal.* (April 17, 2009).

20. Reynolds, N. "Subsidy Theatres Attacked by Eyre," 2001.

21. Internal Revenue Service. "Publication 557: Tax-Exempt Status for Your Organization." (2008), <http://www.irs.gov/publications/p557/index.html>.

22. Editorial Board. "Editorial: Revival-Restore? Replace? Either Way, We've Got to Have Art." *Fayetteville Observer.* (June 6, 2010).

23. Novick, R. "Please, Don't Start a Theater Company! Next Generation Arts Institutions and Alternative Career Paths." (This Volume): 67.

24. Undercofler, J. "Cultural Entrepreneurship." Posting on State of the Art blog. (May 22, 2010), <http://www.artsjournal.com/state/2010/05/cultural-entrepreneurship.html>.

25. Taylor, A. "Preparing the Cultural Entrepreneur." Posting on The Artful Manager blog. (May 24, 2010), <http://www.artsjournal.com/artfulmanager/main/preparing-the-cultural-entrepr.php>.

26. Community Wealth Ventures, Inc. "The L3C: Low-Profit Limited Liability Company." Research Brief. (2008), <http://www.

americansforcommunitydevelopment.org/supportingdownloads/CWVBrief
-Updated.pdf>: 1-3.

27. Simon, N. "Notes on Structure Lab: Legal and Financial Models for Social Entrepreneurship." Posting on Museum 2.0 blog. (May 3, 2010), <http:// museumtwo.blogspot.com/2010/05/notes-on-structure-lab-legal-and. html>.

28. Julie Rada. Interview, December 3, 2009.

29. Brian Freeland. Interview, December 3, 2009.

30. Julie Rada. Interview, December 3, 2009.

31. Vannon, B. "About the Nine." (2010), <http://www.theninechicago.com /index. php?id=5>.

32. Voss, Z. G., Voss, G. B., Shuff, C., & Rose, I. B. "In Whom We Trust IV: Theatre Governing Boards in 2007." *Centerpiece Series*, Theatre Communications Group (2007), <http://www.tcg.org/pdfs/publications/centerpiece/ centerpiece_1207.pdf>: 2.

33. Nucci, A. R. "The Demography of Business Closings." *Small Business Economics* 12 (February 1999): 25-39.

34. Steuer, G. "Bridging the Nonprofit/For-profit Arts/Creative Industry Divide" posting on ARTSblog. (March 11, 2010), <http://blog.artsusa. org/2010/03/11/4394/>.

Structures for Change:
Recommendations for Renewed Institutional Practices to Support Leadership Qualities in Young Arts Professionals

Edward P. Clapp
Harvard Graduate School of Education

Ann Gregg
Weill Music Institute, Carnegie Hall

In order to capitalize on the talents, skills, and unique generational perspectives of younger arts professionals, the authors make several recommendations for change in organizational practice, management, and culture. Based on findings from a 2007 pilot study investigating the current workplace experiences and future interests of young arts professionals, these recommendations include: valuing all individuals as leaders and agents of change; viewing individual leaders as instruments of greater, common purpose; fostering a polymathic approach to practice; addressing a need for omni-directional mentorship, and; investing in time for experimentation, exploration, and play.

INTRODUCTION

Throughout the field of the arts and arts education there is a great need to nurture young arts professionals to better prepare them for the leadership positions they will assume in the near future. While the impending generational shift in arts leadership has been a popular topic of conversation in recent years, few if any actions have been taken to alter and renew practice in a manner that capitalizes on the talents, skills, and unique generational perspectives of younger arts professionals.

Suffice it to say, the field of arts education is not alone in its struggle to

understand how to best nurture up and coming leaders. While we recognize that all professional industries are likewise struggling to address issues associated with the impending generational shift in leadership, we also know that the nature of the arts sector brings to bear distinct variables that uniquely affect administration, leadership, and practice.

Noting that the research and literature on addressing general shifts in leadership largely emanates from the corporate sector (and to a lesser extent, the general nonprofit sector) we sought to come to a greater understanding of who tomorrow's *arts* leaders are/will be and how the field can be restructured to better mesh with the career and workplace needs and interests of these individuals.[1] To take this first step, we embarked on a pilot study that aimed to answer the following research questions: (1) *how do young arts professionals envision the future of the field of the arts and arts education?* (2) *how do their visions for the future differ from current practice?* and (3) *how can individual institutions, as well as the greater field, proactively embrace and incorporate these visions to better engage and capitalize on the talents, skills, and unique perspectives of young arts professionals?* Our study yields a total of five primary findings upon which we have based our recommendations:

1. Valuing all individuals as leaders and agents of change.
2. Viewing individual leaders as instruments of greater, common purpose.
3. Fostering a polymathic approach to practice.
4. Addressing a need for omni-directional mentorship.
5. Investing in time for experimentation, exploration, and play.[2]

In this chapter we first outline the approach we took towards generating the feedback that would form the basis of our findings, then illuminate each finding in detail before offering recommendations for practice and suggestions for further research. Though our findings were developed out of conversations with young arts leaders, we ultimately conclude that these findings (and the implications for practice they suggest) are certainly applicable to the arts, but likely relevant to non-arts industries and professional domains as well.

RATIONALE OF THE STUDY: RESPONDING TO THE ARTS LEADERSHIP DISTRESS SIGNAL

Now a decade into the 21st century, the field of the arts and arts education faces unique challenges in our technology-driven world made increasingly more complex by globalization. Despite the need for new thinking throughout

the arts sector, the field is dominated by a set of core assumptions that have largely been established by an older generation.[3] Rather than challenge the field's core assumptions and advocate for conceptual change, many frustrated young arts professionals more attuned to our contemporary cultural economy are opting out of careers in the arts and arts education to pursue other professions that afford a more viable existence, a clearer career path, and more opportunity for autonomy and self-direction.[4] The result is a drain of young talent from the arts and arts education at a moment when the field needs new ideas and dynamic young leaders the most.

There has been much discussion in the arts sector about the future of leadership within the field, and while several national arts conferences have either chosen the topic of next generation leadership as their core themes, invited keynote speakers who have highlighted leadership change as a focal topic, or included workshop sessions dedicated to these issues, very little research or literature addresses the impending generational gap in arts leadership.[5]

In order to thrive in the 21st century, it is imperative that the arts sector begins to foster young arts practitioners to move into leadership positions. Without the unique perspectives of the next generation of arts leaders, the field is at risk of losing its relevancy in the decades to come. Given the urgency of these issues and the uncertainty of the arts sector's future, three questions rise to the surface: *who will be our new leading arts thinkers, administrators, policy makers, and practitioners? in what social, cultural, and political landscapes will these individuals operate?* and *how can the arts sector attract and retain talented young professionals, and then nurture those individuals to become domain-changing 21st century cultural leaders?*

In an attempt to answer these questions, we conducted a pilot study geared towards identifying the workplace needs and interests of young arts and arts education professionals based on their imagined future of the arts sector—and the roles they wished to play within it.

METHODS OF RESEARCH AND ANALYSIS: GAINING THE PERSPECTIVES OF YOUNG LEADERS

In order to gain the perspectives of young arts professionals we designed and facilitated an exploratory workshop for twenty young leaders (individuals between the ages of 20-35) held May 5, 2007 at the Project Zero classroom in Cambridge, MA.[6] Individuals participating in this session represented a variety of small and large arts and arts education organizations based in the cities of Boston, MA; Cambridge, MA; New York, NY, and; Providence, RI. This was a convenient sample of young arts professionals who self-

identified as future field leaders, according to their personal definitions of "leader" and "leadership."

Before arriving, participants were asked to consider the following question: *What is your vision for the role of arts education in society twenty years from now and how do you, as a future leader in the field, want to participate in that greater vision?*[7]

During the workshop, participants were led through a brief thought experiment designed to empower each individual to think of him or herself as a leader capable of professionally accomplishing anything he or she desired. Participants were invited to project themselves forward in time and write brief narrative descriptions of what they envisioned their lives would be like in the year 2027—twenty years into the future. Participants then hung their hand-written narratives on a gallery wall and were encouraged to read what others had written to develop a contextual understanding of who was in the room—and what their colleagues had envisioned for their collective future.

Following this activity, participants were asked to amend their nametags to more accurately reflect the titles, roles, and responsibilities they had imagined for themselves in the year 2027. Participants were then "transported" twenty years into the future to an elite arts sector cocktail party. As hip lounge music began to play, participants were handed glasses of sparkling cider and instructed to *schmooze* with one another, each playing out the professional life he or she had envisioned for him- or herself in the year 2027. Each person in the group was encouraged to meet as many people as possible… and not to be shy when it came to bragging about their accomplishments. Following this futuristic cocktail party simulation, participants were "brought back" to the present day and engaged in dialogue about (a) who they met in the future, (b) what were the hallmarks of the field twenty years later, and (c) how did the 2027 arts sector differ from that which we know today?

The main ideas gathered from this discussion served as the basis for collaborative group activities geared towards pulling out more nuanced differences between the current state of the field and our participants' ideal arts world of the future. Having established these differences, participants then engaged in a series of small and large group discussions designed to address the question: *now that we've imagined a future arts sector and identified the differences between that ideal world and where we are today, how do we get there?*

Throughout the workshop, data was collected from participant-generated artifacts including their original day-in-the-life narratives and other lists, notes, diagrams, and images. Facilitator field notes likewise

documented participant dialogue. While the assembled artifacts and notes pointed to multiple topics, issues, and concerns, several emergent themes surfaced throughout our analysis. These themes then served as the basis for the top four of the five findings and recommendations described below. As we began to facilitate repeat workshops emulating our initial study at conferences around the country, a fifth finding began to emerge. Because of the relevance of this fifth finding to our overall study, we therefore have added it to our original four key points.

Learning From Young Leaders: Five Primary Findings

Our final list of five key findings addressing the workplace needs and interests of young arts leaders is as follows:
1. Valuing all individuals as leaders and agents of change.
2. Viewing individual leaders as instruments of greater, common purpose.
3. Fostering a polymathic approach to practice.
4. Addressing a need for omni-directional mentorship.
5. Investing in time for experimentation, exploration, and play.

Valuing All Individuals as Leaders and Agents of Change

During our conversation with young arts leaders, the first step we took was to eliminate any sense of a hierarchical structure by elevating all of our participants to the highest level of practice they could imagine themselves achieving. Some individuals had nearly a decade of experience in the field, while others had little or no experience. In our forum, all voices were equally weighted. All participants were seen, and saw themselves, as leaders.

Our facilitation was deliberate in fostering a leadership mentality. By valuing each individual as a leader from the starting frame of the day, we brought our participants' ability to think of themselves as leaders and agents of change to the forefront of their consciousness—empowering them to be more creative, ambitious, and adventurous in stating their personal goals for the future.

Many participants recognized and appreciated this approach, commenting that this simple act of empowerment was rarely present in their professional lives. This was especially true for participants in either entry-level or middle management posts within their organizations. Excluded from the decision making processes of their institutions, lacking autonomy, and unable to exercise the talents and skills they show up with everyday, young arts professionals on the middle to lower end of the arts totem

pole struggled to see a brighter future for themselves in the field. These individuals suggested that the lack of empowerment in their workplace environments impacted their ambition, vision, and work ethic.

Once charged as leaders, participants were able to transport themselves twenty years into the future and imagine that they had become everything they had ever hoped they would be. In envisioning the roles they would play in 2027, participants positioned themselves as executive directors of cultural institutions as well as academic department heads of schools and colleges, gallery owners, elected officials, influential community activists, social entrepreneurs, world famous artists, and even celebrity chefs. Each individual developed a leadership role for him or herself that was suited to his or her multiple talents and interests. In the process of doing this, our participants not only lived out a greater vision for themselves as individuals, but also reinvented the arts sector as a holistic and dynamic new field.

While some of our participants expressed an interest in becoming leaders of existing arts organizations, others were more interested in founding a host of radically new arts institutions. Some of these individuals had founded "creative teacher institutes," redefined high schools that included strong arts and international foci, and created "arts campuses" that combined the resources of museums and performing arts institutions with secondary education. Others had developed community gardens that fused the arts with organic living and neighborhood development while still others established multi-national communications companies that linked individuals in disparate fields for the purpose of developing new products and services to solve larger social issues. In later abbreviated presentations of this workshop at national conferences and other venues, young arts leaders saw themselves developing holographic museum experiences as well as working on aesthetic projects in outer space and on other planets.

As facilitators, we have been surprised that many of our participants' aspirations for the future are actually doable *today*. Even space travel is not so far off. Richard Branson, for instance, formed the first commercial space company in 2005 with plans to fly civilians into space by 2015. Would it be so outrageous to propose new arts initiatives aboard the first civilian suborbital space flights on Virgin Galactic—just five years from now?[8]

While we have been largely inspired by our participants' visions for the future, it's interesting to note that when our cocktail party simulation has been conducted with multi-generational participants, young arts professionals have tended to be more hesitant to articulate their greater ambitions and entrepreneurial spirit. In a recent session including participants ranging in age from 21-65 years-old, one younger participant

spoke to us afterwards and said, "I wanted to say I was the head of the NEA in the future, but I didn't want to sound too ambitious." Why is it that when young arts professionals are amongst their peers, they feel free to articulate their wildest ambitions, but when working amongst more senior professionals in the field, many of these same individuals turn reticent and timid?

When given a chance to exercise their agency amongst their peers, our participants saw themselves not only as field leaders but as agents of change acting upon their entrepreneurial spirit. This clearly exhibited desire to search for the "new" is a valuable innovation and problem solving resource that young arts professionals can contribute to their current organizations. In practice, we anticipate that *acknowledging* emerging leaders as *actual* leaders will serve as a motivating factor for young arts professionals to move beyond disempowered states of compromised vision, granting them the ability to express the agency necessary to pursue their greater ambitions.

Viewing Individual Leaders as Instruments of Greater, Common Purpose

As participants "schmoozed" with one another at our hypothetical cocktail party, sparks flew as connections and partnerships developed. Though our participants saw themselves in a broad array of professional roles, they didn't see themselves as being on separate tracks from one another, but rather as being diverse players working for a greater, common purpose.

Participants noticed that it wasn't only leadership roles that were different in their imagined future, the collegial environment of the field had also changed: resources and ideas were more readily shared, programming was less fragmented, and groups of people at all levels of practice were in conversation with one another—supporting one another's work, building on diverse ideas, and collaborating on broad-reaching projects and initiatives. One participant saw herself as "belonging to a community of people" rather than operating in isolation. Even amongst this small peer group, it was delightful to see the connections individuals made to create shared experiences, even under disparate circumstances and across seemingly non-related activities.

As would be expected, digital technology and social networking played a major role in how our participants' imagined themselves connecting with others, exchanging ideas, and sharing resources and information, but there was more substance to this brand of connectivity than mere technological networking. Our participants placed significant weight on the importance of collaboration, transparency, and interpersonal relationships developed in the service of pursuing common goals.

Regardless of their current facility with technology and social networking sites, the young arts professionals we assembled felt isolated from their peers and alienated from larger discussions in the arts. Our participants showed interest in connecting with colleagues across the country and around the globe to gain new insight into their practice—but they were also surprised to meet people working across town—or even across the street—whom they had never encountered before. These new meetings revealed that individuals working towards mutual ends in very close proximity to one another were arduously replicating services and addressing similar obstacles unbeknownst to one another—wherein they could have been collaborating and combining resources to pursue a wider vision to greater effect.

This need for community points directly to the current absence of belonging to a larger network of dedicated practitioners and a lack of communication amongst such individuals working diligently, though relatively isolated from one another, towards common goals. The arts sector's professional journals and annual conferences provide opportunity for such networking and communication, but the argument can be made that young arts professionals either have little access to or feel alienated from these resources—or that these resources are outdated and ill-suited for the networking/community needs of 21st century arts professionals.

Suffice it to say, the young arts leaders we spoke with wanted to act as instruments of greater, common purpose linked to a diverse array of professional colleagues in meaningful and productive ways. It is through these connections that our participants felt that field-wide change was possible via the cross pollination of diverse ideas and combined effort.

Fostering a Polymathic Approach to Practice

In predicting their professional lives in 2027, our participants entirely broke from the traditional roles often associated with the arts sector. Rather than wear any one professional hat, participants imagined themselves as wearing many hats—representing several professional domains. Gallery owners were practicing artists and classroom teachers who ran community gardens and lectured on culture and politics on the university circuit. Arts professors were educational theorists in conversation with neuroscientists and cognitive psychologists in between penning books of poetry and cultural theory. Virtuoso musicians were performing around the world, hosting their own celebrity chef programs, and acting as communications consultants fusing the arts with other industries such as medicine, law, finance, and the sciences.

The world our participants envisioned in 2027 included heightened communication amongst individuals, partnerships and collaborations across domains, political involvement and community activism stemming from the arts, and a new global perspective on the very concepts of arts and culture. Participants saw themselves as being active not in just one aspect of the arts—but in many. They likewise saw themselves taking part in several domains outside of the arts. In each of these capacities, participants were not expert at one thing and a novice at several others, but were mutually successful in multiple areas of practice across a variety of professional industries. In 2027 our participants were not *super-human*, they were active *polymaths*: individuals possessing wide-ranging knowledge and expertise.

In their current roles, however, some participants suggested that their diverse talents and interests were not being honored within their organizations. Instead, they spoke of being pigeonholed to serve narrowly defined positions within rigid hierarchical structures.

If our exercise with young arts leaders is any indicator of the future, then the field of the arts and arts education—and the broader professional landscape—will be one of a plurality of purposes wherein contributors will not be labeled as one type of practitioner or another, but will be polymathic professionals capable of multiple conversations, active in diverse avenues of practice.

Our work with young arts professionals does not recommend that organizations should structure positions to meet every individual's talents and ambitions. Instead, our study suggests that organizations have much to gain from acknowledging each of their employee's multiple interests and by providing opportunities for individuals to exercise their various talents and skills whenever possible. A failure to acknowledge and access the diverse talents and abilities young arts leaders bring to the field may result in a loss of potential for arts institutions to make valuable connections to non-arts industries, further silo-ing the arts, and disenchanting the field's highest, polymathic potentials from contributing their full range of knowledge, skills, and expertise.

The Need for Omni-Directional Mentorship

Throughout our study we continually heard participants mention the lack of mentorship in their lives. Rather than just conclude that senior field leaders should more actively mentor younger leaders, the group stressed the importance of what we call *omni-directional mentorship*.[9]

Omni-directional mentorship is a constant passing of knowledge from

one individual to the next within and across age cohorts for the purpose of raising the capacity of all participants in the field at every level. This type of mentorship is omni-directional because it accounts for traditional top-down mentorship, mentoring up, and lateral mentorship between colleagues and peers acting at similar levels of practice.

Traditional top-down mentorship

Many of our participants longed for mentors to help guide them through their careers in the arts, education, and in other avenues of entrepreneurial pursuit. This traditional approach to mentorship expressed by our participants was the familiar variety of professional counsel wherein a wizened field leader nurtures a promising young protégé. In this sense, institutional and technical knowledge are passed down from the experienced to the novice in a very directional top-down manner. Knowledge and expertise flow from the mentor to the mentee—from up above, to down below.

But more than recognize the need to find mentors of their own, the group went on to push the conversation of mentorship further by suggesting that, as young professionals empowered as leaders, it was their obligation to serve as mentors to others.

Mentoring-up

In addition to expressing the lack of senior field leaders investing in them professionally, our participants also felt as though they held unique perspectives and possessed important knowledge and skills that were either under-utilized or completely ignored at their current institutions. Mentorship, from our participants' perspectives, was not only valuable down a hierarchical chain, but upwards as well. In this sense, our participants placed great importance on "mentoring-up," especially as it pertains to providing older field leaders with 21st century insights.

Mentoring-up, as expressed by our participants, involves imparting knowledge and skills to a senior professional from below. One of the many things that make mentoring-up unique, is the type of knowledge and skills being shared. Whereas traditional top down mentorship involves the conveyance of institutional and technical knowledge (how to do something, or the history of how things have been done), mentoring-up places a stronger emphasis on *cultural* knowledge.

Teaching one's boss how to use social networking sites is one example of a technical skill a young arts leader can teach an older field professional. However, mentoring-up involves the more nuanced conveyance of an

understanding of *why* and *how* to use such technology. It is this cultural knowledge that young arts leaders can uniquely offer their senior leaders.[10]

Lateral mentorship

As mentioned earlier, the young arts leaders we assembled expressed a need to act as instruments of greater, common purpose more broadly connected to their colleagues working throughout the field. The future arts sector our participants imagined was less competitive and more collaborative. In this sense, individuals (and organizations) actively pursued opportunities to mentor each other, learn from one another's diverse strengths, and readily share expertise and best practices to move the field forward. These individuals recognized the diversity of worldviews that combine to form our increasingly more globalized social surround. For this reason, our participants felt it was important to learn from their colleagues acting at comparable levels of professional practice, but potentially operating from a myriad of different worldviews. This approach to knowledge and skills sharing, which we've termed *lateral mentorship*, once again places a priority on the exchange of cultural knowledge between individuals.

The application of an omni-directional approach to mentorship—combining traditional top-down mentorship, mentoring-up, and lateral mentorship—turns arts management and administration into a teaching and learning experience wherein "all leaders must be learners, and all learners must be leaders."[11]

Investing in Time for Experimentation, Exploration, and Play

British educationalist and author Michael Armstrong has frequently rallied against the all-consuming school-days of children in favor of more time for play, more time for children to experiment, more time to create—more time to waste time.[12] The young arts leaders who we have met through workshop sessions elaborating upon our pilot study have come up with the same gripe as Armstrong—in their lives as young arts professionals, there isn't enough time to experiment, explore, and play. Of course, rarely does a young arts leader express this need in such a way. Instead, many of the people we have spoken with have suggested that their work in the arts is so demanding there is little room for them to experiment or play with new ideas, be innovative, or have room for failure.

When such a high priority is placed on successfully executing programs with the scant funding availed to them and the bare minimum

of time allotted to any given project—young arts professionals have few opportunities to test out new approaches to common problems, or devote time to the necessary day dreaming required of creativity and artful ideation. Our workshop participants have suggested that efficiency is frequently stressed over invention, imagination, and innovation in their arts organizations—and failure was rarely an option.

To achieve a desired effect in the arts—no matter the discipline—it is necessary to try, try, and try again. Failure is not only part of learning—it is integral to the revision process that builds towards artful work. This process of trial and error, of writing and revision, of mark-making and erasure, is what develops the capacities of the artist in multiple ways: honing craft, stimulating imagination, encouraging risk taking, and developing a personal voice/style.

While still a major priority for young arts leaders in the first decade of the 21st century, the necessity for having time to experiment is neither a new idea nor one that is unique to the arts. In his 1932 essay, "In Praise of Idleness," Bertrand Russell advocates for what he refers to as more "leisure time" not just for the elite, but for all members of society, especially the working class.[13] Russell suggests that it has been leisure time intelligently spent, not toil, which has led civilization to its greatest discoveries, richest inventions, and most powerful works of art. But leisure and play are not to be confused with dawdling and laziness. The young arts leaders in our workshop eagerly desired the time necessary to experiment with new ideas geared towards doing their work better, or to be more specific—young arts leaders want to be more *artful* in their roles as arts educators and/or administrators.[14]

The importance of time for exploration, experimentation, and play became increasingly apparent during our reflection on our workshop facilitation process. We frequently encouraged innovation through play—utilizing a mock cocktail party simulation and a variety of role playing exercises as opportunities for our participants to explore their potential, experiment with new concepts, take risks, revise their ideas, and continue to contribute innovative thoughts to the discussion.

Implications for Practice

Implementing new structures to address the five findings we have identified above will take strategy, time, and energy. While we have heard much anecdotal evidence of organizations that employ one or more of these findings, such a restructuring of practice across the entire arts sector that considers all five of these findings will require a commitment to creating

a learning culture that supports all individuals in their growth and development of their capacity to lead.

Imagine, for a moment, a young arts professional who is empowered to think of him- or herself as a leader, asked to be included in problem solving discussions, shares the findings of that work with colleagues throughout his or her organization, presents those findings at formal and informal convenings with other arts professionals, brings in expertise not only from within his or her experience in the field, but also from non-arts domains, receives mentorship from multiple directions while sharing his or her knowledge with just as many others, and is granted the time and resources to pursue not one solution, but test many?

In such a world where the findings expressed herein are placed into practice, a culture of leading and learning may generate creative results while engaging all staff, not just young professionals. We therefore advocate for arts institutions to consider amending their operational structures and administrative practices to synthesize the totality of our five findings into a new institutional culture. Below are some concrete suggestions geared towards creating such a culture:

1. *Treat all young professionals like leaders:* Acknowledging and respecting young arts professionals as leaders will enable those individuals to develop the mindset and capacities necessary to help propel themselves, their peers, and their institutions forward.

2. *"Flatten" institutional hierarchies whenever possible:* The less hierarchical tiers there are to an institutional structure, the less likely it will be that individuals will feel divided from one another and from an organization's mission.

3. *Involve young leaders in upper-level decision making:* Involving young arts leaders in upper-level decision making processes builds capacity in young people and enables these individuals to bring their unique entrepreneurial spirit and generational perspectives to the forefront of an institution's strategic planning, while at the same time increasing institutional investment on their behalf.

4. *Provide networking opportunities for young arts leaders:* Employers must provide the resources for junior staff to engage in broader field discussions by sending them to field-wide conferences and other networking events. Conference organizers must provide resources and networking events for young arts leaders within their conferences so younger attendees may feel welcome to fully engage at such convenings.

5. *Discover, celebrate, and utilize the diversity of skills and talents of young arts leaders:* Today's young professionals come to their work

in the arts not with one, but many interests, talents, skill sets, and broad ranging areas of expertise. Arts organizations would be best served to discover their young arts leaders' talents, and then provide opportunities for these individuals to utilize all of their abilities.

6. *Promote the practice of omni-directional mentorship:* Senior arts professionals should invest in the development of their junior staff while also actively learning from these individuals. Likewise, opportunities for lateral mentorship within and across organizations should be encouraged in order to bring the widest breadth of knowledge and expertise to their work.

7. *Make mentorship explicit and an expectation of everyone:* While organic teaching and learning exchanges within and across generational cohorts should be encouraged, mentorship should also be made explicit—even an expectation of professional life. In order for mentorship to be effective, one can neither expect mentors/mentees to simply bump into one another, nor just sit back and wait for synergistic mentoring relationships to happen.

8. *Encourage dialogue and engagement outside of one's organization:* Rather than compete with other organizations, arts institutions should encourage a collaborative exchange of knowledge and expertise between colleagues at like (and non-alike) organizations.

9. *Look outside the arts:* The future of the arts depends on the incorporation of knowledge and expertise from multiple domains. Bringing the arts into exciting conversations across professional fields will break down barriers between industries, inspire innovation in multiple sectors, and engage a wider array of participants in the arts.

10. *Provide the resources and time for young arts leaders to experiment, explore, and play with new ideas:* Progress in the arts is not possible without the necessary time spent experimenting with new ideas. Allow young arts leaders the opportunity to experiment with new models and celebrate the minor failures necessary to achieve greater success.

Institutions taking steps towards adapting a combination of these strategies will not only engage the young arts leaders within their current positions, but will contribute towards a more dynamic, innovative, and successful field.

LIMITATIONS OF THE STUDY AND SUGGESTIONS FOR FUTURE RESEARCH

While we feel there is great substance to the findings of our study and the implications for practice we have derived from them, as researchers we recognize that our alternative approach to data gathering (a simulated cocktail party twenty years in the future) and analysis cannot be mistaken for formal empirical research. We do, however, see our pilot study as serving as the springboard to more thorough investigation and analysis. In this regard, we recommend further studies into the workplace needs and interests of young arts professionals that:

- Incorporate the views and perspectives of a greater swath of young arts professionals representing the most diverse population (e.g.: geographic, racial, ethnic, gender, etc.) as possible;
- Look through both an arts-general as well as a discipline-/domain-specific lens to better understand what young arts professionals jointly value, as well as how the perspectives of individuals in specific disciplines (e.g.: dance, creative writing, new media, etc.) or specific domains (e.g.: education, policy, museum administration, for-profit galleries, etc.) may differ from one another;
- Employ a diversity of qualitative and quantitative methods, and;
- Compare findings amongst individuals in the arts sector to a control group of individuals acting in other non-arts industries and professional domains.

Ultimately we suggest that future research, regardless of its chosen method, engage its participants in activities that are artful by nature. Being that the essence of young arts professionals is to actively experience, present, and educate in the arts, it would seem counter-intuitive for one to attempt to glean information from this population in a manner that did not place the arts at the center of its investigation.

CONCLUSION

In his popular keynote speeches conducted across the country, noted arts advocate Ben Cameron has frequently stated that there is no lack of young people eager to devote themselves to the arts, but without being given the same agency and autonomy that Baby Boomer arts leaders experienced when they were young, today's young arts leaders are simply "not interested." Cameron goes on to declare that young arts leaders do not want to be "mere custodians" of an arts sector that is being handed down to them, instead, they want the opportunity to re-invent the sector of their own accord.[15] In our pilot study of young arts leaders we found that

what Cameron says is indeed true, but at the same time, young arts leaders do not possess radical desires to entirely raze existing arts structures and start from scratch. Instead, theses individuals have an interest in building upon the accomplishments of their forebears; changing aspects of the field where need be and maintaining elements of practice that have proven to be successful—while also having the flexibility to invent new structures and elements of practice to mesh with the demands of our 21st century cultural economy. Without properly supporting these individuals the greater vision of our most talented and intelligent young arts leaders will go untapped.

As facilitators of discussions with young arts leaders we have been privileged and energized to bear witness to many creative visions imagined for the future of our field. In order to make these visions realities, it is important to change our practice today to most effectively help young arts professionals daringly lead the arts and cultural sector tomorrow. If even a sliver of these imagined visions were to come into being, we would be closer to living in an arts rich world that is intelligent, diverse, purposeful, aesthetically palpable, technologically connected, unfettered by borders, and inherently valued by all.

Join the Conversation
Contribute to a dialogue pertaining to the concepts discussed in this chapter by directing your web browser to the following URL:
http://www.20UNDER40.org/chapters/chapter-3/

NOTES:
1. While there are numerous texts emanating from the corporate sector that address the issue of generational change/conflict in the workplace, few such texts exist in the arts sector. Two recent books that address these issues from the nonprofit sector more broadly include Kunreuther, F., Kim, H., & Rodriguez, R. *Working Across Generations: Defining the Future of Nonprofit Leadership.* San Francisco, CA: Jossey-Bass, 2008, and; Brinckerhoff, P. C. *Generations: The Challenge of a Lifetime for Your Nonprofit.* St. Paul, MN: Fieldstone Alliance, 2007. Neither of these texts, however, are arts focused, nor particularly geared towards younger audiences, nor are they primarily written from the perspectives of younger professionals.
2. In addition to the four original findings we gleaned from our pilot study, this fifth finding that emerged from reproducing this study in different forms with various audiences has proven to be significant enough for us to add it to our complete list.
3. Clapp, E. P. "Envisioning the Future of the Arts and Arts Education: Challenging Core Assumptions, Addressing Adaptive Challenges, and Fostering the Next Generation of Arts Leaders." UNESCO World Conference on Arts

Education. Seoul, Korea. May 27, 2010. <http://www.20under40.org/Clapp_Core_Assumptions.pdf>; Leahy, C. "A Conversation with Victoria J. Saunders." (2007), <http://www.littap.org/events/facing_pages_2007/Saunders_Interview.doc>; Saunders, V. J. "Boomers, XY's and the Making of a Generational Shift in Arts Management." *CultureWork* 10, no. 3 (2006), <http://aad.uoregon.edu/culturework/culturework35a.html>.

4. Cameron, B. "New Perspectives for New Times." Keynote address. Performing Arts Exchange, Louisville, KY, September 27, 2007, <http://www.southarts.org/atf/cf/%7B15E1E84E-C906-4F67-9851-A195A9BAAF79%7D/PerformingArtsExchange2007keynote.pdf>.; Leahy, C. "A Conversation with Victoria J. Saunders," 2007; Solomon, J., & Sandahl, Y. "Stepping Up or Stepping Out: A Report on the Readiness of Next Generation Nonprofit Leaders." (2007).

5. A recent study by the William and Flora Hewlett Foundation serves as the best and most recent look into these issues, see Hessenius, B. "Involving Youth in the Arts: Focus Group on Next Generation Leadership." William and Flora Hewlett Foundation. (2010), <http://nextegenartsleadership.wikispaces.com/>; Several less rigorous informal survey studies on emerging arts leadership have also been conducted by the Emerging Leaders Network of Americans for the Arts; older reports on succession planning in the arts specific to the state of Illinois include: Illinois Arts Alliance/Foundation. *Succession: Arts Leadership for the 21st Century*. Chicago, IL: Illinois Arts Alliance/Foundation.

6. In addition to the authors, Nancy Kleaver (DreamYard Project, Bronx, NY) helped to design and facilitate the above mentioned workshop session.

7. Though originally geared towards arts education professionals, our study ultimately incorporated the perspectives of individuals working throughout the broader arts sector.

8. Virgin Galactic. (n.d.), <http://www.virgingalactic.com>.

9. For a complete discussion of the concept of omni-directional mentorship see Clapp, E. P. "Omni-Directional Mentorship: Exploring a New Approach to Inter-Generational Knowledge Sharing in Arts Practice and Administration." In Schott, D. (Ed.) *A Closer Look 2010: Leading Creatively*. San Francisco, CA: National Alliance of Media Arts and Culture, 2010, <http://www.namac.org/leading>.

10. For more on the how and the why of digital technology in the 21st century arts sector, see Brian Newman's chapter (this volume) "Inventing the Future of the Arts: Seven Digital Trends that Present Challenges and Opportunities for Success in the Cultural Sector."

11. Clapp, E. P. "Omni-Directional Mentorship: Exploring a New Approach to Inter-Generational Knowledge Sharing in Arts Practice and Administration," 2010: 77.

12. Armstrong, M. Class lecture. Harvard Graduate School of Education. Cambridge, MA. November 10, 2008; See also Armstrong, M. *Closely Observed Children: The Diary of a Primary Classroom*. London, UK: Readers

and Writers in Association with Chameleon, 1980, and; Armstrong, M. *Children Writing Stories.* Berkshire, UK: Open University Press, 2006.

13. Russell, B. *In Praise of Idleness and Other Essays.* London, UK: Routledge, 1994/1932.

14. In the realm of education, there is a great deal of literature devoted to the notion of "productive play." It is curious to note that these same concepts that many arts educators advocate for their students are lacking in arts administration.

15. Cameron, B. "New Perspectives for New Times," 2007.

Redefining "Artistic" Administration

Sue Landis
Weill Music Institute, Carnegie Hall

Jessica Rivkin Larson
New York University

How may artistic strategies be harnessed to enhance administrative practice? In this chapter the authors report on a study of what leading artists and arts administrators address as key aspects of successful practice. Artists in their study identify questioning, critical listening, focused vision, and intelligent risk-taking as significant aspects of their work. Leading arts administrators agree that these characteristics are critical to success in the field. The authors conclude that by adapting these capacities young arts leaders may become truly "artistic" administrators capable of the greater innovation necessary to move the arts sector forward.

INTRODUCTION

Arts administration is business. It is programming, strategizing, budgeting, fund-raising, and marketing. It is about defining a vision that relies heavily on communication—with staff, artists, board members, partners, constituents, and consumers. It is being curious, challenging assumptions, and taking risks that can reinvent an organization or art form. Definitions of "artist" vary from "one who creates art," to "one who practices an art form," to "a person who works in one of the performing arts." By these broad definitions, any arts administrator can be considered an artist. Many arts administrators, in fact, come to their administrative work through active participation in a particular art form. However, because of time constraints and professional demands, balancing art making with the work

of administration proves difficult. Frequently, when arts administrators make the transition from being a practicing artist to being an administrator, they too often give up their artistry as well as the unique approach to creative practice that accompanies it.

Artistic work requires many characteristics organizations and employers should celebrate: dedication, passion, and interpretive or creative ingenuity. Foregoing the title of artist for administrator, however, often leads one to think of him- or herself as less creative, innovative, or passionate.

As singers-cum-administrators we faced the pull of this shift in our own professional lives, which caused us to wonder how we could better incorporate the traits we loved in our artistic pursuits into our administrative roles. Rather than discard the skills necessary to perform or generate original works of art, we sought to investigate how these skills could be harnessed by arts administrators to make the work of arts administration more effective, more fulfilling, and more fun. This curiosity led us to our current study that asks the primary question: *How can arts administrators integrate the strategies and skills employed by artists to enhance their professional practice?*

Participants and Process

To explore the intersection of artistry and arts administration, we interviewed eight professional artists and arts administrators who have reached maturity and success in their fields. All of these individuals are established arts professionals over the age of 40, each possessing years of service to the field. While the work of each of these individuals is centered in New York City, many of the arts professionals we spoke with reach national and often international audiences. To gather a range of perspectives on the place of artistry in administrative work, we specifically chose individuals across three categories: (1) practicing professional artists who do not necessarily engage in administration; (2) arts administrators who came to their work in administration through professional arts practice, and; (3) arts administrators who came to their work in arts administration through amateur participation and a deep interest in their respective art forms.

The three artists we spoke with who work professionally under that title are Franta, a visual artist, Marilyn Horne, the internationally renowned American mezzo-soprano opera singer, and Christina Delfico, Emmy-nominated executive producer for Sesame Workshop. Both Janet Eilber, artistic director of the Martha Graham Center for Contemporary Dance and Clive Gillinson, Carnegie Hall's executive and artistic director had professional performing careers in dance and music respectively before

making the transition to administrative work. Lastly, Todd Haimes, artistic director of the Roundabout Theatre, Andrew Hamingson, executive director of the Public Theater, and Glenn Lowry, the Museum of Modern Art's (MOMA) director, have all participated in the arts as amateurs, but never as professional artists.

Clive Gillinson was a cellist with the London Symphony Orchestra before becoming their orchestra manager and then executive and artistic director of Carnegie Hall. Gillinson's experience as the finance director of the orchestra's board and his background and interest in mathematics made him an ideal candidate for the manager role and his later position at Carnegie Hall. Janet Eilber was a prima ballerina for the Martha Graham Center for Contemporary Dance before establishing her own dance company in Los Angeles and then returning to New York to manage the Martha Graham Center archives. Neither Gillinson nor Eilber had visions or intentions of transitioning to administrative work when they began their artistic careers.

Other administrators, including Todd Haimes, Andrew Hamingson, and Glenn Lowry, came to their work in arts administration through auxiliary involvement in the art forms they now oversee. Rather than pursue arts practice as a profession, these individuals were active "behind the scenes" in the arts: Haimes and Hamingson worked on plays and musicals they loved as part of the shows' production crews, and Lowry studied art history and continues to pursue amateur photography. Interest in and passion for these art forms drove their pursuits, but these arts professionals have maintained arts practice in their lives as a hobby rather than a vocation.

Despite having close relationships with the arts, most of the arts administrators we engaged, even those who have been professional or semiprofessional artists earlier in their careers, do not currently identify themselves as artists. When asked, "do you consider yourself an artist?" Lowry, Hamingson, and Haimes clearly replied "no," while Gillinson and Eilber suggested that while they will always be a cellist or dancer respectively, they do not still consider themselves to be "artists."

In analyzing our conversations with these individuals, we searched for commonalities between the methods driving the artists' work (Franta, Horne, and Delfico), and those of the arts administrators. Despite varying preferences in work environment, subject, and daily approach to their practice, the following themes emerged from each conversation with our artist-identifying interviewees around the skills necessary to be an artist: the need to communicate and the ability to actively listen; a desire to explore and to understand the world around them; the importance of focused

attention and vision; and the audacity to take risks. The arts administrators we spoke with echoed these characteristics, identifying communication, curiosity and questioning, and vision and risk taking as significant aspects essential to their administrative work.

Findings

The shared qualities we have identified through our study: excellence through questioning; expression by listening, and; vision and risk apply across arts practice and administration. To be successful, every organization must set a mission, communicate effectively, evaluate its strategy, and take calculated risks. However, we have found that the artist's perspective on these professional characteristics differs from the way these characteristics are traditionally understood. It is this unique artistic understanding that we apply to "artistic" administration and use to propose new approaches to administrative work in the arts.

Excellence through Questioning

Challenging the status quo and consistent questioning emerged as the most common traits shared by the artists and administrators we spoke to in our study. Each of our interviewees possesses an insatiable need to analyze, challenge, and investigate, and the humility to understand how to grow and learn from his or her experiences. Painter Franta expressed this concisely: "When I am painting, everything is boiling."[1] Franta is passionate about the act of making art and is committed to creating the best paintings he can. He examines and re-examines his work after each step, constantly thinking about the best way to move forward. According to our interviews with artists, these individuals utilize every aspect of their experience when engaging with their art form, while simultaneously striving for even deeper understandings of their work. Marilyn Horne did not simply learn each role she has performed over the years—she devoted herself to the understanding of it. She dove deep into the history, various interpretations, translations, and differing performances of each opera and role she worked on until she completely understood her individual contribution in the vast history of the piece. Only after she fully explored a given role and questioned her assumptions about it could she feel successful and confident in her interpretation. Even after this deep exploration, Horne still reflected on and altered each successive performance. Artists, like Horne, are never satisfied with their current state of work or understanding.

In her biography Martha Graham is quoted as saying, "No artist is pleased. There is no satisfaction whatever at any time. There is only a queer

divine dissatisfaction, a blessed unrest that keeps us marching and makes us more alive than the others."[2] The phrase "divine dissatisfaction," as Janet Eilber understood from Graham, her mentor, illustrates the pleasure artists take in their constant ambition to do better and to understand more. Eilber lived this "divine dissatisfaction" as a dancer and this mantra continues in her administrative work. She admits that she calls only a few of her performances over the course of her entire artistic career "great." "Great artists give a unique performance because they have figured out how to imbue their technique with unique, personal decisions. Martha taught me to play to my strengths. And in doing that, it freed me to make my own choices."[3] Only through intense study of her technique was Eilber able to even begin to strive for "great" and unique performances. The rarity in reaching greatness in her dancing did not dissuade her; rather it motivated her to deepen her exploration of her field.

Eilber approaches her administrative decisions with the same intense exploration: "You get trained to consider as many choices as you can think of."[4] As she is faced with wide-ranging decisions for her organization, she considers a similarly vast set of possible solutions—all while considering the unique mission of the Martha Graham Center. As she learned from Graham, this approach focuses her on the specific strengths and expertise of her organization as she makes unique (and often great) decisions.

Clive Gillinson believes that perpetually striving for perfection and excellence is something that great artists are born with, and this always goes hand in hand with insecurity. He explained:

> The people who are the true greats are the ones who never, even for one minute think, "That is the best way I can do it in my life." They always think tomorrow can be even better. "I've learned from today, now what can I do tomorrow?"[5]

Each of the artists and administrators interviewed seems to find pleasure, perhaps even comfort, in striving to do better. When asked about his work at MoMA, Glenn Lowry responded similarly, "I never feel successful."[6] As he explained, each project he engages in contains elements that could have been completed more effectively or produced more value. In his work and his organization, there are always more opportunities to learn and new ways to improve.

A "divine dissatisfaction" approach to administration challenges the traditional meaning of success. In most businesses, success is measured by comparing an outcome with stated goals. If a project reaches its goal, it is considered successful. A company can learn best practices from the experience, and does so to enhance the next project. In contrast, the

artists and leading arts administrators we interviewed define success as reaching the next level of understanding rather than just the completion of a project. Each new project is an opportunity to re-evaluate yesterday's approach and best practices. Of course, administrators should feel proud of accomplishments and work towards completing projects, but if arts administrators were to adopt a more *artistic* perspective on success that valued learning and a desire to constantly do better, they would also take pride in questioning and evaluating their methods, decisions, and outcomes. As young leaders progress in their career in the arts, focusing on learning and improvement rather than tangible successes will enhance their ability to adapt as the environment and cultural sector changes. Learning how to question will teach young arts administrators how to constantly evaluate their work regardless of the specific scenario, which in turn will lead to enhanced quality in the arts experiences the field's organizations will be able to cultivate and present.

Expression by Listening

Artists are expert communicators. Communication is not just a desire, but an absolute necessity for them. For many of our interviewees, the process of creation or interpretation is often more important than the final product. Franta explains that he can paint for hours, but his aim is not to share his paintings, rather it is to release his thoughts from his head onto a canvas. Conversely, whereas many artists share their ideas, thoughts, questions, and emotions by creating original works, we found other artists who focus their energy on interpretation. These artists communicate by re-creating the original works of others. Marilyn Horne spoke to us of the years she spent researching and rehearsing the operas of Rossini and Handel, so that she could share her educated understanding of these composers' works with audience members around the world. For Horne, every step of this preparation was essential, as it allowed her to intelligently and effectively communicate with her audience. Franta, Horne, and Delfico are driven to express themselves through their art, and this outward communication is what we expected to hear from professional artists.

However, as our conversations progressed, we found an unexpected complement to our interviewees' need for outward expression. For the artists in our study, it is active listening and not outward expression, that more significantly informs their work. This characteristic is closely related to the constant evaluation discussed above, and our artists believe it heightens their work. Franta, Horne, and Delfico all suggested that listening to both internal and external perspectives is crucial to bettering their work.

When Christina Delfico approaches a new television project, she asks her team "what three things do [we] want to say?"[7] As she listens to advisors and experts talk about a given topic, Delfico brainstorms possible dialogue, characters, songs, jokes, and animations based on the information she gleans from her team. Delfico is then able to marry the three main ideas garnered from a group brainstorming session with her artistic vision. Similarly throughout her career, Marilyn Horne recalls technical and interpretive discussions with her husband and longtime collaborator, Henry Lewis, about the repertoire that she performed. She additionally consulted with conductors and directors regarding the details of her roles to create exciting and authentic performances. Using experience, instincts, and developed intuition, artists also must listen to themselves. For Janet Eilber, it was only through learning from Martha Graham that she felt free to make her own artistic choices. Eilber notes that for a dancer to progress he or she must simply stop following directions and make his or her own personal choices. This type of critical listening can be the deciding factor in whether a dancer plateaus or improves. Ultimately, each artist is solely responsible for her own work and performance, but Horne and Eilber agree that only through active and evaluative listening can an artist reach their potential and fully communicate through their art.

Administrators must tackle complex problems, articulate vision and mission, and program cohesive presentations of visual art, music, dance, and theater throughout each season. Each administrator we spoke with attributes the success of his or her organization to the same balance of listening, questioning, instructing, and instinct expressed by the artists. As Clive Gillinson, quoting what a colleague once said to him, eloquently put it: "You have two ears and one mouth—you should use them in that proportion."[8] With that in mind, he promotes an environment of questioning balanced with a shared vision and mission that focuses each of his decisions at Carnegie Hall. It is through this balance that Gillinson is able to extract the best ideas and strategies from the staff.

Andrew Hamingson began his career delivering pizzas. Not just any pizzas, but pizzas from a chain that cared deeply for its customers. Listening and acting on feedback was a key part of the company's strategy. While it may seem like the job furthest from being an Executive Director of one of the best-known theaters in New York City, Hamingson credits his current success with the lessons he learned in customer service and communication at the beginning of his career.

Todd Haimes of Roundabout Theatre echoed this need. When putting together a new production, Haimes said the work begins with finding the right director for a show, then adding the right staff to support the

director, then adding in the actors. By the time the production is in a rehearsal period, there could be close to 150 individuals contributing to the production. With that many people all working toward a common goal, interpersonal skills are essential. Haimes learned how to use such skills to know when to talk and when and how to most effectively listen.

Listening and questioning are intimately linked. The constant re-evaluation artists and administrators conduct is only effective if they can truly listen and act upon the answers they arrive at after deep questioning. Therefore, while expression constitutes an important part of communication, critically listening is even more significant in the field of arts administration.

In the arts sector there are a large variety of constituents and stakeholders for administrators to consider, and each of them has passionate opinions to express. Arts administrators must work with board members, employees, production crews, artists, agents, audiences, donors, sponsors, critics, fellow organizations, and many others to complete their work. Therefore, as in artistic tasks, outward expression must be informed by a process of critically listening to various perspectives in order to find the best options for each project. Listening like an artist requires integrating one's own instincts with the perspectives of others one trusts and carefully analyzing such communication to find the actionable items that may produce the best possible results.

Vision and Risk

Focused vision allows for intelligent risk-taking. Both of these characteristics were identified by our interviewees as vital to the success of artistry and administration, and both are reliant upon meaningful communication and constant exploration. Artists push the limits of what is known. They challenge accepted norms as well as their own accomplishments. In this sense, they are forced to use their unanswered questions and knowledge gained from research and internal curiosity to either engage in alternative approaches to practice or implement new projects. However, this evaluation and answering of questions is performed only with laser-focused vision set on specific objectives. Vision, often seen as an organization or project's mission or an artist's purpose, depends on effective communication. An administrator must convey his or her vision to an organization's staff and stakeholders, and artists must convey their vision to their audiences via aesthetic expression. Neither artists nor arts administrators can succeed without focused objectives. It is not until one's objectives have been defined that he or she can make the informed risky decisions that have the potential to move the field forward.

The balance between vision and risk was inherent in Janet Eilber's dance career. She described "finding those constraints that allow you to be free and creative."[9] She recalls "dancing on the edge... it should always feel risky."[10] As a dancer, riskiness was necessary for the success of each performance she participated in, and this often occurred onstage in front of an audience. Therefore, to lessen the uncertainty of these risks, Eilber always required intense focus and understanding of the context in which she was taking such risks. For Eilber, this included the ability to set boundaries and focus on a specific objective in order to take intelligent risks.

Similarly, visual artists, according to Glenn Lowry, "are huge risk takers. They put themselves on the line everyday... but artists are rarely reckless."[11] The balance between risk and recklessness is easily bridged by identifying focused objectives and sticking to a specific mission. Doing as such allows artists to take effective risks that are more likely to lead to successful experiences and artful innovation.

Administrators share the need to balance these characteristics— perhaps even more so than artists. Artists are often expected to take risky actions in the name of their art, while administrators have board members, staff, and audience satisfaction to consider. Todd Haimes noted, "knowing which risks to take is a creative process."[12] As artistic director, Haimes must consider each new project or option within the context of Roundabout Theatre's mission. For example, in 1993, Haimes expanded the theater's mission to include the production and presentation of musicals as well as plays. Roundabout's audience had been loyal because of the theater's existing expertise, and adding these larger productions to the mission was costly. However, over the last two decades, Roundabout has produced some of the most acclaimed musical revivals on Broadway. Because Haimes was pointedly focused on the existing and potential strengths and objectives of his organization, he was able to take a calculated risk while being confident in its chances for success. Similarly, shortly after Clive Gillinson assumed his role as artistic and executive director at Carnegie Hall, he conceived of the idea of citywide festivals. Although Gillinson initially was criticized for this idea, the festivals have proved to be both exciting and profitable for all organizations involved. While many obstacles appeared at first, the project clearly fit the Hall's mission to "bring the transformative power of music to the widest possible audience..." and Gillinson possessed the focused vision necessary for the project.[13] Because of this, he effectively spread his enthusiasm to the staff and many other New York organizations. What began as a risk succeeded through focused vision.

The artists we spoke with stressed the importance of having singular, intense focus. Their vision grows from expert practice in their field, and due

to this well-defined scope they are able to push their own limits and that of their art. These individuals are constantly taking risks, but these risks are always intelligent and thoughtful while still leaning towards innovation. Arts administrators similarly can take this approach to developing mission and purpose in their organizations. To continue progressing in the arts sector, administrators must take risks, present new works, attempt a new approach for audience engagement, etc. However, as arts organizations often have missions that are qualitatively significant and not quantitatively measurable, it is sometimes difficult to evaluate these new ideas. Therefore, taking the artist's approach of first finding focused vision and then measuring all risks within that context will give administrators a smarter way to understand new opportunities—and take more calculated risks.

Conclusion

Many arts administrators have arrived at their administrative roles through formal or informal participation in a given art form. They were singers, painters, instrumentalists, and actors before beginning to work behind the scenes. However, in their current roles, they rarely identify themselves as artists. As the arts industry continues to evolve in this ever-changing financial environment, the next generation of arts administrators must adopt and exploit the characteristics they share with the artists they present to become successful leaders. Through expert questioning and analysis, critical listening, and focused vision and risk-taking, arts administrators can enhance their practice and push the field forward.

By employing a process of constant re-evaluation and questioning, artists embark on a deeply personal journey. "Divine dissatisfaction" drives these individuals to continue to learn, to question, and to better their practice. The artists and administrators interviewed here define success through learning, not accomplishment. As administrators, we need to encourage staff to challenge themselves and continue their own learning. Artists constantly challenge their decisions, their approach, and their outputs to better themselves and their practice. Appreciation and pride in institutional accomplishment are important attributes of healthy arts organizations. However, adopting a more artistic or critical approach to administrative projects will teach young administrators how to evaluate and become more critical of their practice. This skill fostered in young arts leaders is essential to the progress of our field. Without innately evaluative and questioning field leaders, the arts sector cannot grow.

Effective communication allows artists and administrators to innovate and better their work. "Great art is capable of inspiring large numbers of

people because it triggers many responses," Glenn Lowry states.[14] Art is a form of outward expression, which, as Lowry says, triggers increased communication. Through this mass of expression, young arts administrators must learn to absorb the many perspectives great art inspires. Aspiring arts administrators must harness the artists' understanding that only through active listening will the field grow and develop. Increasing the arts sector's adaptability will become more important over time as this industry fluctuates, and critical listening in particular will allow young leaders to be flexible in any situation. Through the process of effective communication, young arts administrators will be prepared to lead innovative projects by balancing outward expression and critical listening skills.

Absence of focused vision leaves both artists and arts administrators staggering. Arts organizations must be driven by a clear objective around which constructive dialogue and innovative thinking can occur. Without this nucleus, new ideas and potential risks have no point of comparison, and quickly become reckless instead of calculated. Administrators must utilize this "laser focus," as Janet Eilber described it, not to the detriment of new ideas, but as a context in which to evaluate them.[15] Executives must additionally encourage this way of thinking at all levels of an organization. Every staff member must consider their actions and new ideas gained through increased exploration within the mission of the organization and the future of the field. Contextualizing this onslaught of ideas as an organization and field will turn casual brainstorming into groundbreaking innovation.

Driven artists and administrators strive for excellence. In the arts sector, we will always be challenged by limited resources, but arts administrators can increase their efficiency and success by fully using all of their artistic instincts. Evaluation, critical listening, and intelligent risk taking propel innovation. As individuals tapped into the inventive spirit of the arts, young arts leaders already possess these characteristics in great abundance. We must now be cognizant of our arts-specific skills and abilities and use them with increasing frequency and in creative ways to fully harness their benefits. In order to drive the arts forward, young arts leaders must evolve from being administrators of the arts to becoming truly *artistic* administrators.

Join the Conversation

Contribute to a dialogue pertaining to the concepts discussed in this chapter by directing your web browser to the following URL:

http://www.20UNDER40.org/chapters/chapter-4/

NOTES:

1. Franta. Interview, February 3, 2010.
2. de Mille, A. *Martha: The Life and Work of Martha Graham.* New York: Random House, 1991: 264.
3. Janet Eilber. Interview, February 9, 2010.
4. Ibid.
5. Clive Gillinson. Interview, January 29, 2010.
6. Glenn Lowry. Interview, February 2, 2010.
7. Christina Delfico. Interview, February 3, 2010
8. Clive Gillinson. Interview, January 29, 2010.
9. Janet Eilber. Interview, February 9, 2010.
10. Ibid.
11. Glenn Lowry. Interview, February 2, 2010.
12. Todd Haimes. Interview, February 1, 2010.
13. Carnegie Hall. "Annual Report 2008-2009." (n.d.), <http://www.carnegiehall.org/pdf/Carnegie_Hall_0809_Annual_Report.pdf>.
14. Glenn Lowry. Interview, February 2, 2010.
15. Janet Eilber. Interview, February 9, 2010.

Please Don't Start A Theater Company!
Next Generation Arts Institutions
and Alternative Career Paths

Rebecca Novick
Theater Director and Arts Consultant

*In the past fifteen years, the number of nonprofit theater
companies has doubled while audiences and funding have
shrunk. Across the arts sector, thousands of young artists
are flooding the field, hoping for sustainable careers in the
arts while even our most venerable institutions are looking
shaky. Neither the field nor the next generation of artists
is served by the unexamined multiplication of companies
based on the same old model. This chapter introduces
some models for a new kind of arts institution, explores
alternative paths for emerging and mid-career artists, and
proposes a new definition of sustainability.*

I was twenty-three when I arrived in San Francisco, fresh from assistant-directing at the Royal Court in London and eager to start my theater career. I was brimming over with enthusiasm, and maybe just a little hubris. Shortly thereafter, I founded Crowded Fire Theater Company, full of plans for it to quickly become the next major regional theater. My generation of theater artists grew up on the stories of how our current crop of institutions were founded—Sam Shepherd and his collaborators starting the Magic Theater in a Berkeley bar, Tony Kushner premiering *Angels in America* at the Eureka, Bill Ball asking cities to compete to house ACT—why shouldn't my company be the next success story? I had no question about what that success would look like—it would look like a building with staff and a season, with subscribers and youth programs, and a healthy mix of earned and contributed income.

It turns out I was not alone in this ambition. A recent National Endowment for the Arts study found that the number of nonprofit theater companies in the United States has doubled in the past fifteen years.[1] When this study was released, it was hailed around the field as good news, as a sign that there was growth in both supply and demand for theater. But in that same period, there was a dramatic decline in theater attendance as well as a substantial decrease in foundation funding for the arts.[2] So, who will go to see the work at all these new companies? Who will fund them?

These statistics actually illuminate a crucial nexus for the field, a location of both profound failure and potential transformation. The proliferation of small theater companies sits at the intersection between the necessity to imagine different structures for making theater and our field's failure to provide career paths for the next generation of artists. Since the Ford Foundation's investments kicked off the regional theater movement fifty years ago, there has been tremendous collective buy-in to what has now become a fossilized model of a particular type of nonprofit theater. Within this structure, there is now a critical lack of opportunity for emerging artists and leaders, leaving the next generation of artists no alternative but to start companies of their own, companies that often replicate the problems of established theaters on a smaller scale.

In preparing this article I spoke to a number of theater artists at different stages in their careers, both inside and outside institutions, as well as to arts program officers at major foundations. I heard broad consensus on the problems facing the field—shrinking audiences, declining relevance, problematic quality of the work, over-investment in administration, lack of opportunities to sustain an artistic career—and an encouraging range of solutions. People are experimenting with hybrid art forms and hybrid income models, with new methods for community engagement, and a new balance between money for the art and money for administration. In addition, they're asking important questions about the concepts of sustainability and duration, exploring what it's like to invest in the life of a project or the career of an artist, rather than in the idea of a perpetual institution.

In the pages that follow, I'll explore some of what I learned in these conversations and from my own experience as a director, a company founder, and an arts administrator. First, I'll offer the stories of six companies who are finding success by challenging conventional structures. Next, I'll suggest alternative paths for emerging and mid-career artists and examine what resources we might offer to help them move to the next stage in their careers. Finally, I'll take a look at what we mean when we wish for a "sustainable" life as an artist and how that relates to these new models

and our changed environment, suggesting a new ecological framework for measuring success. Throughout, I've included ideas for changing practice in the field and suggestions for individual artists. While the focus of this chapter is theater, readers will find many relevant connections to the arts sector as a whole.

PART ONE: WHAT COULD WE BUILD INSTEAD

In the ten years after I founded it, Crowded Fire had a lot of artistic success. We made creative and exciting work, we premiered the work of interesting and important playwrights, and we succeeded in growing the company year after year. But I wonder now if our accelerated path into the nonprofit structure, mimicking those stories we all had in our heads, stopped us from imagining a different kind of success. I wonder how much more powerful the productions might have been if we hadn't had to put so much effort into learning how to be nonprofit managers or how much more we might have discovered if we had applied the same creativity to organizational structure that we did to our art.

Conversations in the field, accelerated by the sobering effects of the 2008 recession, have begun to move towards critical examination of the nonprofit regional theater model. But advice and support for younger artists and, even more crucially, the structure of funding opportunities and decisions, continues to encourage replication of this very same model. It's as if every artist who didn't get or didn't want a job at a regional theater built a shanty outside the fancy building, but then what began as a temporary shelter turned out to be a permanent addition to the landscape. Shanties are useful, maybe, to keep out the proverbial rain, but they're not a very sustainable solution to any individual's career dilemmas or to the many artistic and structural problems facing our field. Neither the field nor the next generation of artists is served by an unexamined multiplication of mini-institutions.

Whether or not one believes that the thirty-to-fifty-year-old regional theaters can continue to make the conventional structure work for them, it's abundantly clear that these organizations, now in every city of any size, have sewn up much of the available capital, either literally (in endowments) or practically (through dedicated foundation funding and committed major donors). Newer organizations, trying to copy the model without access to these funds, have much less prospect of success. It's clearly time for a different vision.

To gain some new perspectives, I spoke to individuals representing six organizations that are combining successful art-making with visionary ideas about different organizational structures.

Artists at the Center of the Budget

Elevator Repair Service (ERS) and The Neo-Futurists are two highly regarded experimental theater ensembles that have grown by putting artists at the center, adding administrative structures only after carefully examining whether the administrative model supports the artistic mission.

Understanding that their rigorous process of developing work over long periods of time has been key to their artistic success, ERS has carefully directed its expanding budget towards employment structures that support this way of working. This has first meant a commitment to pay—and pay well—the performers who are developing and performing a piece. Then, in order to maintain relationships with artists who have other interests, they give people the ability to step in and out, allowing for as much flexibility as possible. When the company needed more administrative support, explains Aaron Landsman, a playwright and long-time actor with ERS:

> We looked around and saw that the artists in the work had [administrative] skills already. So we worked with people who already had committed to ERS artistically. That keeps us all more employed, and keeps the integrity of the work front and center.

Concerned about burn-out for their artistic director, they determined to find enough money to pay him what Aaron calls "a real living wage— enough money to pay rent and save something." He continues, "that felt like a decision for us about sustainability; we wanted [our artistic director] to be able to keep making this work."

The Neo-Futuristss's model is also based on providing substantial income for its core group of performer/writers, generated by performing in their popular late night show (which runs fifty weeks a year) and by opportunities to tour and teach. In return for sharing many administrative duties (the company has just one paid administrator), company members get stable income for artistic work and opportunities to develop pieces for production in the "primetime" season. Sharon Greene, long-time ensemble member explains:

> I believe a big component of our longevity is that we reward artistic success with more artistic resources. And we don't define success as money, we define it as artistic risk that interests us. This keeps the company artistically rewarding for people year after year.

Different Communities Demand Different Models

Bindlestiff Studio was a thriving community-based Filipino performing arts venue when it suddenly lost its space to redevelopment efforts. In order to receive city support for a new space, Bindlestiff was forced to rapidly

incorporate. Olivia Malabuyo was an artist with the group who took on the newly created role of managing director. She talks soberly about the consequences of being forced into a structure that didn't suit the group's mission, community, or skills in order to meet arbitrary requirements for municipal funding:

> We were an all-volunteer organization with a strong relationship to community and a built-in audience. Our unconventional model was working for us until the city forced us to become a nonprofit. That's when the art started to move from the center and become more peripheral to the definition of what Bindlestiff was.

Conflicts inevitably arose, planning for the new building stalled, and it took many years for the organization to recover.

Olivia next worked for Los Cenzontles Mexican Arts Center, where she discovered a different income model, one that sustains the organization via its deep roots in the ethnic community it serves. Dedicated to training young people in heritage forms of Mexican music, dance, and crafts, the organization has a wide array of education programs and a professional teen touring group. Classes, touring, and CD sales provide robust earned income streams, minimizing dependence on fundraising. Olivia argues that organizations rooted in specific cultural communities have the opportunity to integrate audience-building with youth development, and education with performance in ways that serve the work while strengthening the organization. Fundraising can have its place in the mix, she says, "but I previously thought foundations should be the first to invest and now I believe that the ability to find community-driven earned income is key."

Context Matters as Much as Content

It's been seven years since Todd Brown and his partner began transforming a small house in San Francisco's Mission District into what is now the Red Poppy Art House: a gallery and presenting space, a training program for artists interested in self-producing, and a hub for neighborhood-based arts events. "As an artist myself," says Todd:

> I'm interested not only in content (my own work) but in context. I want to empower artists as space-holders, as creators of the artistic context. Instead of the old model of building a big cultural center, I imagine a thriving cultural neighborhood with diverse, scattered artistic hubs that each become an epicenter for different communities.

Navigating between the for- and nonprofit models, Todd is passionate about supporting the organization through the most flexible income mix he

can devise—selling paintings, applying only for very particular grants, and depending on a host of committed volunteers. Recently, a funder requested that he submit a three-year fundraising strategy, and Todd instead sent along a "three year fund-lowering strategy" in which he elaborated his plans to gradually reduce administrative costs even more as he strengthens his structure of administrative volunteers.

The Virtues of Temporary

13P is a group of thirteen playwrights who came together with the commitment to produce one play by each playwright and then disband. A key element of their model is giving playwrights a degree of control they rarely enjoy by making each playwright the "artistic director" during the period in which their play is produced. As a group of mostly mid-career artists who already support their playwriting with teaching and other day jobs, these playwrights were not interested in committing to administrative tasks and they have been able to secure enough funds to pay for precisely the producing support that each project requires. "We weren't just out of college wanting to put up our plays because no one else would," explains Sheila Callaghan, one of the playwrights:

> The point wasn't simply to self-produce. The main point was to get to choose your own team. The success of the organization is built around the strength, contacts, and community of each individual, not around the reputation or aesthetic of a theater company.

Six years into their successful experiment, they're still uninterested in building a permanent institution. "Why implode?" says their website. "Our mission is very simple, and we want to complete it and call it a day. 13P isn't really a theater company; it's a 13-play test of a new producing model." This test has been radically successful, both for the careers of each playwright and for the model it offers the field.[3]

Home Is Where the Play Is

Sojourn Theater is an ensemble company dedicated to creating new work that inspires civic dialogue. Sojourn is nominally based in Portland, Oregon, where the one paid employee resides and where much of its work takes place. However its artistic director, Michael Rohd, is on the faculty at Northwestern University and other ensemble members live around the country. A few years back some multi-year grants led the company to experiment briefly with a few traditional administrative trappings (an office space, an administrative assistant) and to pay Michael a full-time salary for a brief period. However, says managing director Alisha Tonsic:

> Because the money was going away, we were able to see that structure wasn't right for us. We wanted to find ways to support the company without trying to maintain a structure that didn't feel connected to the core of the rest of the way the company worked.

The company decided that Michael would accept a university position, providing him with a full-time salary and a flexible enough schedule to continue to create work with the company and elsewhere. This meant that future projects would have to accommodate people's schedules and their far-flung locations, but it also meant that university resources became available to the company. Ensemble artists are paid well for weeks spent creating and performing work and different artists are able to commit different amounts of time each year. The nature of the company's work has always meant collaborating closely with community partners, which has allowed each project to plant its own roots in a location. This has the added benefit of eliminating whole categories of administrative tasks. Thanks to their deep community engagement, Alisha says, "we've always sold out our shows, and we've never had to do any marketing."

Funders Speak Out

The idea that individuals can pick and choose which elements of different models work for their organizations and their communities, that one can build fluid, flexible employment structures and have projects last as long as it makes sense for them to, doesn't really seem like rocket science. How did the nonprofit theater model become so ossified? The funders I interviewed, all arts program officers at major foundations, were forthright about foundations' complicity in perpetuating the problem. "Why build a building and such heavy-weight infrastructure for this thing [theater] that is both under-funded and ephemeral? This just doesn't make much sense," says Moira Brennan at the MAP Fund. Diane Ragsdale at the Mellon Foundation agrees:

> Funders and others have had such a limited idea of what a theater should look like, we've institutionalized the process to such a degree that we've constrained these organizations in terms of how they're structured, how they make work, who they make it for. We've lost track of what we really need to put on a good show. Do we need 150 administrators?

The Hewlett Foundation's Marc Vogl concurs: "Funders have been in service of perpetuating the structure we know. But focus on the work has to come first." The Hewlett Foundation, Marc reports, has begun to aim for more nuance in their funding decisions, beginning, for example, to

support fiscally sponsored organizations and "understanding that because organizations do different work, they may need different structures to support their work." Diane says it even more simply: "Wouldn't it be great if [funders] could look at decisions the way a bank lender or venture capitalist would, asking just 'Is this a good idea? And is this person talented and competent enough to implement it?'"

PART TWO: NEXT GENERATION CAREER PATHS—APPRENTICESHIP AND BEYOND

So you finish college and you move to a city. No one will hire you yet so you get some friends together and do a show. It goes well. You decide to do it again but this time you want to raise some money and you want the press to come, so you pick a name and start a theater company. Let's be honest, they're right not to hire you yet. And probably it's a good idea if nobody very important comes to the first couple of shows because this is an art form you can only learn by doing for real with a paying audience. This is the theater company created as training ground.

Challenges for Beginners

I titled this chapter with the tongue-in-cheek advice "Please, don't start a theater company!" Of course, it's more complicated than that. For one thing, what should beginning artists do instead? Theater artists have a particularly hard task at the beginning, since there are so many elements that have to be in place to practice this art form. No matter how hands-on a BFA or MFA program is, there still comes a moment when an individual has to make his or her first show in the real world and there should be accepted structures in place to support this key phase of skill development.

When artists at the beginning of their careers start companies, it's often because they can't find any other way to put on plays. That's certainly why I started Crowded Fire. Doing so offered me opportunities I would never have had otherwise and brought me a degree of visibility I could not have attained without the backing of an institution. But if starting a company like I did is no longer a smart way to begin, then we need other ways for artists at the beginning of their careers to develop skills and find their voices.

Welcoming Apprentices

Apprenticeship is an old word for a necessary stage in developing a craft. What if, like medical students serving out their residencies, artists newly

entering the field could expect a period of long hours and poor pay, but knew that *after that* there would be other options? I think there would then be enormous enthusiasm to simply make as much work as possible with whatever money one could scrape together, and fewer people would divert their creative energies to building small-scale imitations of the larger theaters. Decades ago, many theaters had apprenticeships for artists that functioned exactly like this, with these positions often leading to staff jobs. Now, these programs have largely been replaced by unpaid internships, most of them focused on the administrative tasks which are the ones for which there are paying positions available.

The Rock Band Model

We should encourage apprentice artists to self-produce work, or band together and produce each other's work. We should not demand that they cloak that straightforward practice in the trappings of a made-up company simply to attract funding or press notice. Moreover, we should encourage artists to operate like bands do—coming together to play a few gigs then dissolving as people's interests diverge, perhaps performing regularly with a few different groups, and experimenting with different styles and genres. Forming a permanent company at this stage is a bit like getting married too young, before you've had the chance to discover your own identity or what you're really looking for in a collaborator. Donating time, securing free space for performance, throwing parties to raise money, asking for donations from family and friends, and selling t-shirts or cookies are all time-honored methods to secure the resources to produce at this level—methods that don't depend on engaging with the complex structures of nonprofit fundraising.

Producing Support

Established theaters can invest in the development of young artists by sharing their resources. They can give space, lend out equipment, provide production management support, advertise shows, have a late night series specifically for beginners, or consider redesigning internships to include practice producing.

Flexible Funding Possibilities

Funders need to stop advising young artists to replicate the standard nonprofit model. This advice gets passed along both explicitly in training programs and workshops and implicitly through questions on grant applications and review criteria used to make funding decisions.

For example, requiring a minimum budget size prioritizes growth over caliber of the work, and asking about diversified income streams forces artists to add extra work in areas of fundraising that may be fruitless for them. Funders should give money directly to artists, or if legal restrictions preclude this, they should participate in regranting programs like Theatre Bay Area's CA$H, which supports work by emerging artists and small companies with no requirements for nonprofit status.[4] Artists can also pursue funding by working with a number of possible fiscal sponsors, most notably the national service organization Fractured Atlas which now sponsors 1,750 projects across the country.[5]

Thoughts on Access, Diversity, and Quality

Is there a "glut" of new artists entering the field? Theater internship programs are besieged by applicants, new play festivals have to bring on extra staff to read all the incoming scripts, and BFA and MFA programs now graduate hundreds of new artists each year.[6] Established theater professionals, entrenched in long-term scarcity, deplore the naiveté of the "wannabe" artists flooding the field and are quick to insist that there is no possible way to provide employment for all of them. But in a time of shrinking audiences, how can we reject the one group of people who are excited about the theater? These are people who want to participate in the essential project of telling the stories of our culture. They're going to find the means for creative expression, if not in the theater then in other more accessible media. Moira at the MAP Fund comments, "There's an increased sense among individual makers that you can be an artist if you want to be. We don't want to discourage this self-expression." Marc at Hewlett agrees: "Who are the villains in this story? Not the artists and people who want to do new things. We can't wish for people to stop making things, that's not the problem."

Of course, not everyone who wants to be an actor or a playwright or a director has an equal amount of talent and many will never develop into mature artists working on a professional level. No one is suggesting that all of these aspiring artists are owed equal success. But it's a mistake to pretend that our current system selects only for talent. Rather, gate-keeping as it currently operates in the field selects for economic privilege (like family support that can subsidize an unpaid internship or pay for an MFA program), for lucky choice of life partner (a higher-earning partner's income often subsidizes low arts wages), and for lack of dependents (advancement often demands many weeks on the road, a challenge for parents of young children or those with other family responsibilities). These factors work

against diversity in the upper ranks of the field and discourage participation by many people who might otherwise help revitalize the theater.

Challenges at Mid-Career

So now you've done two shows, then three, then ten. The theater you're making is exciting. And you and your company are starting to attract a lot more notice. You get reviewed regularly. You win some awards. You get some national attention and get invited to speak at conferences. Success, right? Everything you dreamed of? You get some funding, enough to make the productions a little bigger and to pay someone to write the press releases. But it's nowhere near enough to pay yourself a living wage, never mind the artists or any other staff members.

And by now you're twenty-eight, or maybe thirty-five. It's harder than it used to be to work two jobs and stay up all night to make poor theater. Maybe you have a kid. Maybe your day job doesn't give you as much flexibility as your old Starbucks gig did. Your plan to make the company bigger so you can afford to keep working there is looking pretty unlikely and you start to think that maybe it's time to get a big theater job.

So you leave your theater company and check out the world of the larger institutions. You direct for an actual fee and rehearse in the daytime with union actors. You apply for jobs leading midsize theaters and get to look at a lot of budgets and strategic plans, and meet a lot of board hiring committees. Turns out it's the same grass on the other side of the fence—artistic directors at large theaters still spend most of their days fundraising, can't pay artists a living wage, and battle to diversify audiences.

In 2008, I organized a conference at Theatre Bay Area (where I was then on staff) for "emerging leaders." Over 100 artists and administrators with between five and fifteen years of experience converged from around the country, full of passion for this work and frustration at the lack of opportunities for advancement. The dearth of positions that offer both a living wage and some artistic satisfaction make this stage a juncture at which many talented people leave the field. What can theaters do to welcome in these accomplished artists, give them real work to do, and promote them into positions of power? Or if these artists are to stay with the companies they founded and grow them into institutions that can sustain artists and staff as they mature, then funders must be persuaded

to stop insisting on a one-size-fits-all nonprofit structure and offer support to companies who are exploring truly new models.

"What's killing the field," says Diane at the Mellon Foundation, "is that people are beginning to leave it. People make it into large institutions and get stuck in middle management jobs with no access to power and no opportunity to try new things." Many established theaters are still being run by their Baby Boomer founders, and both the Gen Xers who've been in the trenches for a while and the Millennials coming up behind them find themselves shut out of the leadership positions which these founders assumed at a much younger age. Relegated to positions whose titles sound like they should be artistic (associate artistic director, education director, etc.), staff at many institutions report that they have no decision-making power, no influence in season selection, and no opportunity to play an artistic role in productions. The path out of these positions can also be problematic. Rachel Fink at Berkeley Repertory Theater explains: "You don't have the opportunity to expand your skill set beyond your day-to-day job, so it becomes impossible to be competitive for jobs at the next level."

Regional Theaters Making Change

Who's making this process work better now? At the Center Theater Group, there are four senior producer positions; each of the producers takes responsibility for particular projects, working closely with casting, marketing, and production to guide the project to the stage. The Arena Stage offers one-year producing fellowships aimed at people interested in learning specifically how to produce and direct new plays and has recently announced residencies for playwrights that will provide salaries and health benefits for resident playwrights for several years. At Marin Theater Company, the artistic director brought on a colleague with both artistic and managerial skills to be managing director and offered him a guaranteed directing slot each season. And when the Intiman Theatre hired thirty-something Kate Whoriskey as artistic director, they eased fears that she was too inexperienced for the role by creating a year-long transition of power with the outgoing artistic director.

Creative Partnerships

Another possible solution is to support whole companies or projects within larger theaters. "I think if there are new ideas for programs," says Deborah Cullinan of Intersection for the Arts, "then doesn't it make sense to bring them into existing institutions?" From the Wooster Group's simple practice of inviting companies they admire to use their space rent-free, to

Steppenwolf's Garage Rep program which presents a repertory season of premieres by small Chicago companies, there are many ways for the energy and innovation of small companies to combine with the infrastructure of larger ones. If smaller-scale collaborations work out, there's always the possibility of a true merger. When Intersection invited Campo Santo to become a resident theater company the synergy that developed transformed both organizations and led Intersection to create a staff position for Campo's artistic director.

Part Three: Sustain the People not the Structure

With increased competition for audiences and many easier ways for people to tell and share stories, theater is facing threats from many directions. The future of the field depends on making the work on our stages as visionary, as creative, as compelling, and as diverse as it can be. We can't reach this goal unless a wide range of the most creative artists and the most ingenious producers are allowed to develop their skills and are then supported over the long haul so their art can mature. The field must re-focus resources on the challenge of sustaining *artists* rather than sustaining particular institutions. Meanwhile, individual artists seeking long-term careers must be more creative than ever in devising ways to combine making a living with continued artistic growth.

Sustain the Whole Ecology

When funders talk about sustainability, they have generally meant that an institution looks stable enough to continue forever. Diane Ragsdale is no longer sure this is the point: "Why should funders wonder whether this is a twenty-five- or fifty-year plan? Why not just support the two-year plan without worrying that everything must exist in perpetuity?" Isaac Butler, director and noted theater blogger (parabasis.com), observes that excellence and permanence are not always linked: "Who said that the long-term viability of an organization had anything to do with the quality of work?" If the project then is, as Marc Vogl at Hewlett describes, "to sustain not structure but people" then we need a new way of measuring how well we're reaching for the ultimate aim of more extraordinary art.

The 2008 recession has provided a sharp lesson for the corporate sector in the limits of perpetual growth. If we're almost out of forests to cut down and new frontiers to colonize, then the model for how we do business in America is going to have to change. As usual, the artists understood this some time ago. At Sojourn they're defining sustainability in an ecological way, asking how much they can have without destroying the nature of

the work that nourishes them. At the Neo-Futurists they are stewarding their artists like the limited but renewable resource they are. At Todd Brown's Red Poppy Art House they are seeding the neighborhood with small "epicenters" of cultural activity, believing that "if you enrich the soil, then new things will spring out of it." This shared metaphor of an "artistic ecosystem" expresses a deep comprehension that the health of each part is necessary for the health of the whole, suggesting that ecological rather than commercial thinking is the way to understand how art functions.

Become the Architect of Your Own Future

However, talk to an individual artist about "sustaining a career" and they want to know how they're going to pay their rent and afford health insurance. They want to figure out how to find the resources to try new ideas again and again, reaching for the fully realized creations that will only come after years of sustained effort. It's discouraging that the holy grail of a living wage from satisfying artistic work, attainable for only a few in the current system, doesn't look too much more likely in these newer models. "The structure, community, and ethics were all perfect," says Sheila Callaghan about 13P, "but I wish there was a way to have our model with more money available." This may be a problem too big for artists to solve alone. Universal health care would help, said four or five people I talked to. "This field fundamentally doesn't function in a market-driven economy," Todd Brown insisted. "Major reform in government funding," dreamed Isaac Butler. So what's an artist to do while he/she waits (and works) for revolution?

Creative Capital, a foundation devoted to supporting artists' development, insists that artists have to become the "architects of their own future," just as throughout the work world people now craft a path for themselves that doesn't depend on one lifelong employer.[7] The training they provide to grantees emphasizes the creation of a strategic plan for one's artistic career, a plan that lays out all the ways to generate more time and resources for creating the work that is most meaningful to an individual artist. Starting a company can be a way to get one's work out into the world but it's easy to become trapped by the demands of running a business. Some of the most successful and productive artists I know enjoy flexible long-term arrangements with a few different companies, experiment with different producing models for each project, and depend on a number of different skill-sets to make a living.

Help the Artists Keep Making Art

The artist's path will inevitably be different for each person: some artists want to find a home within an institution, some want to build their own new one, and some prefer the itinerant life of the freelancer. But in each case, there's *more* the whole arts sector can do to help *more* artists devote *more* energy to making art than to staying in business. Despite the field's obsession with youth and the new, what matters most is to give artists the sustained support that will allow their work to mature. Brilliant early work is a wonderful thing, but where would we be without Shakespeare's last plays, or the end of August Wilson's great cycle? Artists need support not just in starting out, but in carrying on, not just as apprentices, but as journeymen and master craftsmen as well.

Fractured Atlas is doing more to support artists by offering health insurance and fiscal sponsorship to thousands of members. Organizations like Intersection for the Arts and Springboard for the Arts have incubator programs and training for artists and organizations.[8] Programs like Creative Capital and the Center for Cultural Innovation make grants directly to artists and support their grantees with career development services.[9] Arts funders are changing their grant-making priorities and arts institutions are shaking up their structures. Small companies are exploring new ways to provide real money in return for creative work and to offer deep opportunities for artists to engage with communities.

Every artist I spoke to told me that it doesn't take much to sustain a life in the theater. No one got into this trying to be rich. But you don't stay twenty forever and after that you do occasionally need to buy shoes, or go to the doctor, or send your children to preschool. And one day you might like to send them to college, or buy a house, or even retire. The middle-class dream shouldn't be out of reach for theater artists, especially when every city now includes several hundred theater administrators who receive the benefits of permanent employment while the artists by and large are still camping outside the gates.

It doesn't matter whether we work in a small community setting, in an experimental ensemble, or in a big fancy building, we all started doing this work because we believe in the transformative power of live performance. I would never wish away my experience founding and running Crowded Fire. Like any difficult enterprise though, starting a theater company is an endeavor best pursued because one deeply wants to pursue it, not because it seems like the only option for survival. Artists must chart a course for themselves that takes them through experiment and on into mastery. If this includes the creation of another institution, here's hoping it's something extraordinary and new.

Join the Conversation

Contribute to a dialogue pertaining to the concepts discussed in this chapter by directing your web browser to the following URL:

http://www.20UNDER40.org/chapters/chapter-5/

Interviews and research included: Moira Brennan/MAP Fund, Todd Brown/ Red Poppy Art House, Isaac Butler, Sheila Callaghan/13P, Josh Costello/ Marin Theater, Deborah Cullinan/Intersection for the Arts, Dianne Debicella/ Fractured Atlas, Rachel Fink/Berkeley Repertory Theatre, Sharon Greene/ Neo-Futurists, Melissa Hillman/Impact Theatre, Aaron Landsman/Elevator Repair Service, Olivia Malabuyo/Bindlestiff Studio and Los Cenzontles, Diane Ragsdale/Mellon Foundation, Alisha Tonsic/Sojourn Theater, and Marc Vogl/Hewlett Foundation.

NOTES:

1. National Endowment for the Arts. *All America's a Stage: Growth and Challenges in Nonprofit Theater.* Washington D.C.: NEA Office of Research and Analysis, 2008: 4.
2. Ibid: 7.
3. For more on the idea of a limited life-span organization and the many advantages of this model, see David McGraw's chapter in this volume devoted to the topic: "The Epoch Model: An Arts Organization with an Expiration Date."
4. For more information on Theatre Bay Area's CA$H program, see <www.theatrebayarea.org>.
5. For more information on Fractured Atlas's fiscal sponsorship program, see <www.fracturedatlas.org>.
6. Stout, H. "The Coveted Elusive Summer Internship." *New York Times.* (July 2, 2010), <http://www.nytimes.com/2010/07/04/fashion/04Internship.html>.
7. For more information on Creative Capital's artist development programs, see <www.creative-capital.org>.
8. For more information on Intersection for the Arts and Springboard for the Arts's incubator programs see <www.theintersection.org>, and; <www.springboardforthearts.org>.
9. For more information on Creative Capital and the Center for Cultural Innovation's direct grants to artists and professional development programs, see <www.creative-capital.org>, and <www.cciarts.org>.

6

Audiences at the Gate:
Reinventing Arts Philanthropy Through Guided Crowdsourcing

Ian David Moss
Fractured Atlas

Daniel Reid
Consultant

In this chapter, the authors argue that traditional market gatekeepers' lack of capacity to evaluate the rapidly growing volume of art produced and distributed in the 21st century has dangerous implications for the socioeconomic diversity of successful artist-entrepreneurs. Drawing on crowdsourcing, a practice originating from the open-source software movement that centralizes the time and talent of dispersed individuals in productive ways, the authors envision a new model of institutional arts funding that promises a fairer and more meritocratic distribution of resources throughout the arts field. By channeling a portion of its grantmaking budget through a carefully cultivated online community of passionate and committed devotees of the arts, an enterprising philanthropic institution will enhance its ability to nurture the most promising artists and artist-driven organizations to maturity. At the same time, the forum will serve as an incubator of aspiring critical talent and a site for robust discussion of the rich tapestry of creative expression in the public life of our communities.

Spurred on by major technological advances, the number of aspiring professional artists in the United States has reached unprecedented levels and will only continue to grow. The arts' current system of philanthropic

support is woefully underequipped to evaluate this explosion of content and nurture its most promising elements—but we believe that the solution to the crisis is sitting right in front of us. Philanthropic institutions, in their efforts to provide stewardship to a thriving arts community, have largely overlooked perhaps the single most valuable resource at their disposal: audience members.

We contend that by harnessing the talents of the arts' most knowledgeable, committed, and ethical citizens and distributing funds according to the principles of what we have termed *guided crowdsourcing*, grantmaking institutions can increase public investment in and engagement with the arts, increase the diversity and vibrancy of art accessible to consumers, and ensure a more meritocratic distribution of resources. We envision an online platform by which a foundation may crowdsource philanthropic decisions across a wide-ranging network of aficionados, aspiring critics, artists, and curious minds, bolstering its capacity to give fair consideration to the full range of artistic talent available and ensure that the most promising voices are heard.

I. CHOKING ON THE FIRE HOSE: THE ARTS' CAPACITY CATASTROPHE

In 2009, a play I directed off-off-Broadway was one of the best reviewed shows in New York at any level. It got the kind of reception that you're told means your career will start to take off. The talent pool is so huge and the number of spots for artists so small, though, that even my really well reviewed, lines-around-the-block show doesn't really help. I got paid $250 for six weeks of work on that show, and I made one connection with [an off-Broadway theatre]. If I am lucky (and that means really lucky, they have a lot of artists who they develop), in 3-5 years they will produce a show of mine. If they do, my pay for whatever mythical show that might be would probably be between three and five thousand dollars, and it would be for a project I had probably been working on and off on for several years. I'm in the process of leaving pursuing professional theatre to only focus on projects I care about because both the financial realities and the lifestyle created by those realities is not one I want to subject myself, my upcoming marriage, or my (a couple years down the road) child to.[1]
—Theater Director, age 30

An Embarrassment of Riches

The muse works feverishly in the 21st century. In the United States, more than 2 million working artists identify their primary occupation as an arts job, and another 300,000 or so earn secondary income from the arts.[2] Yet those numbers only hint at a far bigger phenomenon: the ranks of those who *create* art, whether or not they earn any money from it, have ballooned to some 20 million adults in 2008.[3] Many of those in this latter category fall under the rubric of what Charles Leadbeater and Paul Miller have called "Pro-Ams," serious amateurs and quasi-professionals who "have a strong sense of vocation; use recognized public standards to assess performance; …[and] produce non-commodity products and services" while "spend[ing] a large share of their disposable income supporting their pastimes."[4] Thanks to historically inexpensive production and distribution technology, more artistic products can reach more people more easily than ever before: as of January 2009, for example, users were uploading the equivalent of 86,000 full-length movies to YouTube *every week*.[5]

The human brain—not to mention the human lifespan—simply cannot accommodate a considered appreciation for so many contenders for its attention. Even if a music lover kept his headphones on for every minute of every day for an entire year, he wouldn't be able to listen to more than an eighth of the 115,000 albums that were released just in the United States in 2008.[6] Because we do not possess the capacity to give equal time to every artistic product that might come our way, we must rely on shortcuts. We may look for reviews and ratings of the latest movies before we decide which ones we'd like to see. We often let personal relationships guide our decisions about what art we allow into our lives. And we continually rely on the distribution systems through which we experience art—museums, galleries, radio stations, television networks, record labels, publishing houses, etc.—to narrow the field of possibilities for us so that we don't have to spend all of our energies searching for the next great thing.

Every time we outsource these curatorial faculties to someone else, we are making a rational and perfectly defensible choice. And yet every time we do so, we contribute to a system in which those who have already cornered the market in the attention economy are the only ones in a position to reap its rewards.

The Arts' Dirty Secret

We regard the market's lack of capacity to evaluate all the available art as a systemic and rapidly worsening problem in the arts today. Artists take time to learn their craft and capture attention; while the market may

support an "up-and-coming" artist to maturity if she is lucky, making the transition to "up-and-coming" requires nurturing that the market will not provide. Before an artist becomes well known, the "market" she encounters is not the market of consumers but rather the market for *access* to consumers. This market is controlled by a small number of gatekeepers— e.g., agents, journalists, literary managers, venue owners—*who each face the same capacity problems described above.* Even the most dedicated and hardworking individuals could not possibly keep up with the sheer volume of material demanding to be evaluated.

This tremendous competition for gatekeepers' attention frequently forces aspiring artists into a position of having to assume considerable financial risk to have even a shot at being noticed. An increasing number are receiving pre-professional training in their work; degrees awarded in the visual and performing arts jumped an astonishing 51% between 1998 and 2007.[7] Others are starting their own organizations; the number of registered 501(c)(3) arts and culture nonprofits rose 42% in the past ten years.[8]

Yet all of this increased training and activity comes at a steep price, one all too often borne by the artist herself. Master's degrees at top institutions can set her back as much as $50,000 per year; internships that could provide key industry connections are frequently unpaid. Artists in the field have been known to incur crippling consumer debt in pursuit of their dreams; the award-winning film documentary *Spellbound*, for example, was made possible because the co-creators maxed out some 14 credit cards to finance production.[9] Indeed, a daunting investment of direct expense and thousands of hours of time *not spent earning a living* are virtual requirements to develop the portfolio and reputation necessary to translate ability into success. However one defines artistic talent, it is clear that talent alone is not enough to enable an artist to support herself through her work.

> *It's not just those with education debt that have a hard time being a full-time artist, but really anyone without a safety net. I know I can count on one hand the number of composers I know in our age bracket whose parents didn't pay for their undergraduate education (at least the vast majority of it).[10]*
> —Composer, age 27

If traditional gatekeepers lack the capacity to identify and provide critical early support to artistic entrepreneurs with little pedigree but plenty of potential, there is a real concern that *to compete for serious and ongoing recognition in the arts is an entitlement of the already privileged.*

For a sector of society that often justifies philanthropic and public subsidy by purporting to celebrate diverse voices and build bridges between people who see the world in very different ways, this is a grave problem.

Portrait of the Artist as a Young Grantee

Grantmaking institutions have a critical role to play in the market for access. Grants represent a very different kind of support from sales of tickets, stories, or sculptures. They may prove crucial for demonstrating proof-of-concept for a new venture—or simply for the development of a style, portfolio, and audience. Most important, they provide a temporary financial cushion that can allow the artist-entrepreneur to manifest her true vision rather than see it continually undermined by scarcity of equipment, materials, staffing, or time. They can make the difference in production values that ensures a serious reception from critical eyes and ears, and allow the artist an opportunity to use time that might otherwise need to be spent earning income to perfect and promote her work. In short, grants are a seemingly ideal vehicle through which to address the fundamental inequities created by the pinched market for access.

> *Sonically, anything you do is going to be compared to established artists whose studio budget has more zeros on the end of it than yours. And the sonic quality of the recording itself is often the first thing critics (and listeners) hear and respond to.*[11]
> —*Jazz Musician, age 34*

Sadly, the lack of evaluative capacity biases the philanthropic market for the arts just as it skews the commercial market. In a perfect world, foundation and agency employees would have the time and money to find grantees by continually seeking out and experiencing art in its natural habitat. In the real world, a notoriously small number of staffers at a given foundation or panel of experts from the community is often hard pressed simply to review all of the art that comes through the door.

Not surprisingly, then, grantmakers take defensive measures to protect against being overwhelmed by an inundation of requests. First, they *explicitly* narrow their scope through eligibility restrictions. Nearly half of foundations that support the arts refuse to accept unsolicited applications at all, and even those that do frequently consider applications only for particular art forms, geographic regions, types of artist, or types of projects.[12] Until 2009, to cite an especially dramatic example, the Judith Rothschild Foundation in New York only made "grants to present, preserve,

or interpret work of the highest aesthetic merit by lesser-known, recently deceased American [visual] artists."[13] Many grant programs additionally refuse to consider organizations without a minimum performance history or a minimum budget level, and a majority will not award monies directly to individuals, for-profit entities, or unincorporated groups.

Funders also narrow their scope *implicitly* through their selection process. The selection is usually made by some combination of the institution's staff, its board of directors, and outside experts called in for the purpose (often in the form of grant panels). Because so few individuals are involved in the decision-making process, triage strategies are unavoidable. Application reading may be divided up among the panel or staff, with the result that only one person ever reads any given organization's entire proposal. When work samples are involved, artists' fates can be altered forever on the basis of a five-minute (or shorter) reception of their work.[14]

These coping mechanisms are perfectly understandable, given the sheer volume of art produced and imagined. But the unfortunate result is that institutional money is distributed with hardly more fairness than commercial money—and this is especially troublesome because of institutional grantmakers' power beyond their purses as outsourced curators of other funding streams. After all, for most individual donors and consumers alike, the art that they even have a *chance* to encounter is likely to be art that has already passed the muster of multiple professional gatekeepers. The capacity problem that hampers grantmakers' ability to choose the most promising artists in an equitable way thus compounds itself as it reverberates through the rest of the artistic ecosystem.

The shortage of capacity and its consequences on the diversity, liveliness, and brilliance of the arts world are not going away. With the proliferation of digital distribution networks making it easier than ever to put creative work in the public eye, the defensive mechanisms that funders employ to limit intake are only going to become more and more strained. A solution is needed, fast. Fortunately, there is a cheap, practical, and responsible way for institutions to better cope with their lack of evaluative capacity: they can use crowdsourcing to harness the passion and expertise of a broader range of people dedicated to the arts.

II. Calling for Backup: Crowdsourcing (to) the Rescue

Typically, institutions select the members of their staffs and grant panels on the basis of passion for and experience with the arts, on the theory that these qualities promote discerning judgments about the merit of applicants. But such traits are by no means limited to this narrow group.

Tapping the thousands of dedicated and knowledgeable devotees of specific art forms who engage in robust discussion of the arts every day would allow foundations and agencies to go a long way towards addressing their own capacity problems—and towards opening the distribution of arts philanthropy to a broader range of deserving artists.

Our proposal draws inspiration from the phenomenon of crowdsourcing, which is the practice of outsourcing some function to the public or a significant part of it. Crowdsourcing has its roots in the open-source software movement, which designed and built complex software through the collaboration of anyone with the time, interest, and ability to contribute to a project. The best known example of this practice may be Wikipedia, which draws on the knowledge and editorial acumen of a huge pool of often anonymous volunteers to create a crowdsourced encyclopedia. Rather than relying on a handful of experts, crowdsourcing enlists dozens, hundreds, or thousands of people to do the work—and, in its purest form, to ensure the quality of the end result. The following pages explore some of the ways the commercial and philanthropic sectors have deployed crowdsourcing to direct money to worthy causes, to harness dispersed talent, and to build community.

Directing Donations

Online philanthropy markets that allow individual donors to contribute to charitable causes and micro-entrepreneurs around the world—websites like Kiva, DonorsChoose, Modest Needs, and GlobalGiving—illustrate the practice of crowdsourcing funding decisions across a large number of donors acting independently. Some of these websites aggregate small donations to fund larger projects using a mechanism for voting with dollars. For example, at Modest Needs, donors purchase points that can be allocated to specific, prequalified projects described on the site (such as the cost of a replacement water heater for a single mother). When a project has received enough donor points, the amount requested is sent to the applicant.[15]

Similar online giving models have been employed at a smaller scale in the arts. For example, ArtistShare allows "fans to show appreciation for their favorite [musical] artist by funding their recording projects in exchange for access to the creative process, limited edition recordings, VIP access to recording sessions, and even credit listing on the CD."[16] Kickstarter allows individual donors to make pledges to creative projects—in the arts, journalism, design, and technology—with defined funding

targets and timing. If enough pledges are received by the deadline, the project is funded; otherwise, the funds are returned to the donor.[17]

These online mini-markets facilitate individual support for artists by providing donors more direct access to the artistic process and environment. In cases where the projects funded can be appreciated online, supporting them is not so different from buying a ticket. An alternative model of crowdsourced philanthropy that has gained more recent prominence allows individuals to exert influence on how *other people's* philanthropic contributions are spent. Two recent major initiatives by corporate foundations employ this "voting without dollars" concept. JP Morgan Chase's Chase Community Giving program gave away $5 million in early 2010 to nonprofit organizations based primarily on the votes of Facebook users.[18] Similarly, PepsiCo diverted the $20 million it might have spent on ads during the 2010 Super Bowl to the Pepsi Refresh Project, a new monthly initiative that invites "ideas that will have a positive impact" to compete for grants ranging from $5,000 to $250,000. Visitors to the site vote to determine the grant winners.[19]

Aggregating Ability

In the examples above, the "crowd" need have no particular expertise to participate fully. (Indeed, one frequent criticism of these models is that a "one person, one vote" or social-network-based approach to philanthropy can all too easily degenerate into a popularity contest with little connection to the merit of the potential recipients.) But crowdsourcing has also proved very effective at harnessing dispersed talent. In the for-profit design world, Threadless, an online T-shirt company, produces designs created and voted on by users of the website. The winning designers receive cash prizes, and the shirts nearly always sell out, generating $17 million in revenue for Threadless in 2006.[20]

Philanthropic foundations, too, have begun to take advantage of the expertise of passionate people from across the country and the world. Philoptima allows would-be donors to offer "design prizes" to anyone who proposes an innovative solution to a problem chosen by the donor, and "implementation prizes" to any nonprofit that submits a promising plan to carry out the solution in its community.[21] (The first design prize on this young site was offered by a new grantmaker seeking to create "a discipline-wide typology of the environmental sector.")[22] Since 2006, InnoCentive has partnered with the Rockefeller Foundation to give global development organizations access to high-quality R&D resources; Rockefeller selects the

nonprofits and contributes award money to a network of scientists to solve a specific "challenge" posed by the nonprofit.[23]

Building Community

By engaging and connecting a broad cross-section of individuals, crowdsourcing also has the potential to create a robust community and locus for lively discussion. The Yelp Elite Squad, chosen by Yelp employees from among the popular local search site's most active contributors, benefit from invitations to exclusive offline events in addition to greater exposure for their reviews.[24] In the nonprofit sector, several websites that make grants emphasize the creation of a forum for the discussion of social issues. Ashoka's Changemakers initiative is a "community of action" that collaborates on solutions through discussion forums, issue groups, and competitions that reward innovative problem solving.[25] Another site, Netsquared, connects nonprofits, grant-makers, and individual social entrepreneurs both on- and offline to foster social change. The organization sponsors in-person meetings for social innovators and engages its community in a grants program for social action projects.[26] The finalists of its grant-making challenges are shaped by these discussions and chosen by community vote.[27]

Putting it All Together: Guided Crowdsourcing

The very best examples of crowdsourced community—the models that illustrate the potential of the concept at its fullest—augment the tools of crowdsourcing with just enough top-down hierarchy to promote an environment of shared opportunity and responsibility. We call this model *guided crowdsourcing*. So far, this technique has not been explored in depth by foundations, arts-focused or otherwise, but it has been developed robustly elsewhere.

As mentioned above, Wikipedia is perhaps the oldest and most famous large-scale example of crowdsourcing on the web. While the site is most often identified with the crowdsourced labor used to generate its principal product, some 14 million encyclopedia entries in 272 languages, Wikipedia is also home to a fiercely dedicated user community that has self-organized into a meritocracy.[28] Though the site is open to editing and revision by anyone, a small army of experienced volunteer "administrators" boast additional powers, such as the ability to make edits about living people.[29] These users are chosen by "bureaucrats," who themselves are selected by community consensus, and disputes among editors are resolved by a volunteer-run Arbitration Committee.[30] These responsibilities not only

keep the community's most passionate members fully engaged; it also puts them to work to improve the community and its project.

Barack Obama's 2008 election campaign used guided crowdsourcing to establish a seamless continuum between motivated volunteers and professional staff. As part of routine campaign operations, professional field organizers would assign new volunteers, who had been recruited online, progressively more difficult tasks to test their fitness for roles carrying greater responsibility. As the campaign progressed, many early volunteers rose to full-time staff positions, providing a clear path of upward mobility for the most dedicated and effective community members. This fusing of top-down leadership with grassroots openness enabled the campaign to achieve its own capacity breakthrough by establishing a viable presence in districts, towns, and whole states that had been considered off-limits by previous Democratic contenders for executive office.[31]

Taking its cue from these successful efforts to shape a broad-based grassroots effort with gentle guidance from the top, a foundation could invent an entirely new model of arts philanthropy—one that matches the explosion of artistic content with an explosion of critical acumen to evaluate it.

III. Philanthropy's Finest: The Pro-Am Program Officer Paradigm

We propose that a grantmaking institution supplement its work with guided crowdsourcing by creating an online grants management platform that will also serve as a social network, multimedia showcase, and marketplace for individual donors. By redirecting some portion of its grantmaking budget through this website, the foundation or agency can leverage the critical faculties of passionate and thoughtful arts lovers to address its capacity problem. A sophisticated set of algorithms will empower the website's community to identify the most qualified and dedicated voices among its own ranks and elevate them to increased levels of influence on a continually renewing basis. In this way, those whose artistic judgments carry the most weight will have earned that status from their peers and colleagues.

How It Works

The process begins when an artist or artist-driven organization (nonprofit or otherwise) applies for a general operating support grant from the sponsoring foundation's arts program—all forms of art are welcome. Rather than being sent to a program officer for review, the applicant's materials—proposal narrative, samples of the artist's work, a list of upcoming events

or classes open to the public—will be posted online. This information will be incorporated into each applicant's public profile on the site.

Members of the public will also be invited to create and maintain profiles. Once registered, they can view materials submitted by grant contenders and share reactions ranging from one-line comments to in-depth critiques. In order to jumpstart the conversation, ensure an initial critical mass of reviewers, and strike a constructive and intelligent tone, the foundation should reach out in advance to knowledgeable arts citizens (perhaps including some of the very gatekeepers mentioned above who might otherwise serve on grant panels) to encourage their participation on the site. The goal is to engage a broad range of art lovers in a robust conversation about the proposals under review—and about the arts more generally—thereby ensuring a better-considered distribution of grant money.

Of course, not all commentators will make equally valuable contributions to the discussion. Just like art, providing critical analysis and consistently thoughtful, informed, and credible feedback requires considerable skill and practice. In short, we want to be able to open up the process to *anyone* without having to open it to *everyone*. What qualities would we desire in those who influence resource allocation decisions in the arts? Certainly we would ask that our critics be knowledgeable in the field they review. We would also want them to be fair—not holding ideological grudges against artists or letting personal vendettas influence their judgment. We'd want them to be open-minded, not afraid to dive into unfamiliar or challenging territory when the time comes. And finally, we'd want them to be thoughtful: able and willing to appreciate nuance, and mindful of how what they are experiencing fits into a larger whole.

Technology now allows us to systematically identify and reward these qualities in a reviewer. On the website, a reviewer increases her "reputation score" by winning the respect of the community. Each user can rate individual comments and reviews based on the qualities outlined above; higher ratings increase a reviewer's standing. To keep the conversation current and make room for new voices, the ratings of older reviews and comments will count for less over time. The reputation algorithm can also reward seeking out unreviewed proposals and commenting on a breadth of submissions. A strict honor code will require users to disclose any personal or professional connections to a project they review, with expulsion the penalty for violators. Reviews suspected of being at odds with this policy can be flagged for investigation by any site user, and the site's administrators will take action where deemed appropriate.

Every quarter, the professional staff of the foundation will review the

reputation scores of community members and choose a crop of users to elevate to Curator status. Selection will be based primarily on peer reviews, but the staff will have final say and responsibility over who is given this privilege. A clear set of guiding principles will be developed and shared to ensure that the choice is as fair and transparent as possible. Curators receive an allowance of "points" to distribute to various projects on the site, usually limited to the discipline or area of the Curator's expertise. Curators are identified by (real) name to other users so as to foster a sense of accountability, and their profiles show how they have chosen to distribute their points. So long as a Curator maintains a minimum reputation score by contributing new high-quality reviews, he will continue to receive new points each quarter.

As a project accumulates points from Curators, it receives more prominent attention on the site. It might show up earlier in search results, appear in lists of recommendations presented to users who have written reviews of similar projects, or be highlighted on the home page. But since Curators maintain their reputation (and aspiring Curators gain their reputation) in part by reviewing proposals that have failed to attract comments from others, the attention never becomes too concentrated on a lucky few.

When it comes time to award the grants each quarter, the collective judgment of the Curators is used as the groundwork for the decision-making process. This approach ensures that organizations cannot win awards simply by bombarding their mailing lists with requests for votes, because the crowd exerts its influence indirectly through Curators selected on the basis of sustained, high-quality contributions. While it is still ultimately the responsibility of the foundation's board of directors to choose recipients, we anticipate that adjustments will be made only in exceptional cases—that, essentially, the heavy lifting will have been done by the crowd.

Meanwhile, the very best contributors—the stars of the site—may be engaged by the foundation as paid Editors. Editors are part-time, contract employees who are sent out on assignment to see and review specific public events in their area associated with proposals on the site. Their reviews are highlighted prominently to give their expert work maximum exposure. This system allows the foundation to send trusted reviewers to distant events without having to pay exorbitant travel costs; meanwhile, the writer receives a financial incentive for exceptional ongoing service to the site and the arts community.

Of course, artists, administrators, and contributors won't be the site's only audience. Since work samples will represent an important part of many applications, the platform will also be a convenient way for the public

to discover new artists and ensembles, guided by the judgments of a myriad of devotees. Each proposal uploaded will give passersby the opportunity to contribute their own money in addition to any comments they may have. As such, the site has the potential to become the first effective online donor marketplace for the arts. The sponsoring foundation could even give donors the option of tacking on a small "tip" to each donation to help defray the site's (minimal) operating costs.

It is worth emphasizing that, despite the many roles website users will play in the grant process, they will not replace the foundation staff. One or more program officers will need to be in charge of the website and accountable to the board of directors for its successful operation. They will oversee the website to ensure that the ongoing discussion remains frank, thoughtful, and passionate—but not vicious or counterproductive. Such a desirable culture will not develop automatically; fostering it will mean setting and continually revising rules and procedures, reminding users of the funding priorities established by the foundation and engaging in dialogue about those priorities when appropriate, selecting Curators wisely on the basis of peer reviews, expelling users who violate the standards of the community, and developing a method to evaluate and report on the grants made through the site, both to the board and back to the users. Furthermore, we do not anticipate that this model would or should supplant a foundation's or the field's traditional grantmaking entirely. "Leadership"-level awards to major service organizations or institutions with a national profile do not face the same kinds of capacity challenges as grants to smaller producing and presenting entities or individual artists, and may require a greater level of expertise in evaluating factors such as financial health and long-term sustainability than a nonprofessional program officer may be able to provide. Thus, we see this approach as one element in a broader portfolio of strategies to optimally support the arts.

Few good ideas come to fruition without resources, and this one is no exception. The platform should be sponsored by a major foundation or institution with a substantial initial investment (we suggest at least $1 million) to signal seriousness of purpose and ensure a meaningful level of support to the artists and organizations involved. Although it would be possible to pilot the system in a limited geographical area or with only certain disciplines at first, the concept can only reach its true potential if a certain critical mass is achieved—enough to make it worth artists' while to ensure representation on the site and worth reviewers' while to contribute their time and curiosity to making it thrive.

We anticipate that this system will be highly sustainable. Once the infrastructure is in place, the website will be inexpensive to maintain, and

may well prove cheaper than more traditional methods of distributing funds. The powerful incentives provided to both artists (access to a source of funding coupled with real-time feedback on their proposals) and reviewers (the opportunity to gain notoriety, influence, and even material compensation for doing something they love) should be sufficient to maintain interest on all sides.

Finally, the greatest beauty of the site is that there is ample opportunity to experiment with various approaches until just the right formula is found. If the original algorithm for calculating reputation scores turns out to be ineffective, it can be changed. If the rules against reviewing the work of friends turn out to be too draconian, they can be adjusted. If the foundation decides it wants to give Curators actual dollars to distribute instead of abstract points, that is an easy fix. Meanwhile, if the system proves successful, the sponsoring foundation could invite other funders to contribute their resources to the pool, making even deeper impact possible.

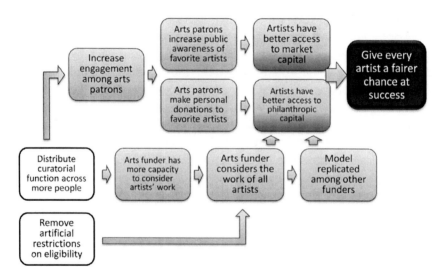

Figure 6.1: Program theory for a guided crowdsourcing platform for the arts.

Summing Up

Our guided crowdsourcing model is designed to integrate many virtues of existing crowdsourcing concepts: giving small-scale projects access to new pools of capital; aggregating the expertise and labor of users; and creating a social space for strangers who share a common interest. When combined

and applied to the arts, this triple crowdsourcing carries several special advantages:

- First, it addresses the lack of evaluative capacity in the philanthropic market, enabling a more meritocratic distribution of grants and thus a more vibrant and socioeconomically diverse artistic community.
- Second, because of the structural role of grantmaking institutions, the website indirectly addresses the lack of capacity in the commercial market: the path to commercial success will be made a little less arbitrary through the work of our volunteer curators.
- Third, the robust community we hope to facilitate will double as a feedback mechanism for artists and artist-driven organizations, enhancing the production of art even before grants are awarded.
- Fourth, the site will serve as an incubator for *critical* talent, identifying and empowering new commentators who can establish a reputation as informed adjudicators, while providing a new outlet for more experienced voices at a time when the job market for critics is rapidly shrinking.
- Fifth, by rewarding contributions that can serve as examples of critical analysis at its best, the site will encourage a more thoughtful and articulate public conversation about the arts. In so doing, it facilitates the establishment of a new breed of Pro-Am curators to match the convergence of amateur and professional in artistic creation and performance.

We expect that, if successful, this model will result in a more equitable distribution of philanthropic funds that always takes into account the actual work product rather than reputation alone; be based on the opinions of acknowledged leaders in the community who continually earn their standing among their peers; and fairly consider the efforts of far more artists and artist-driven organizations than would ever be possible otherwise. If *really* successful, the model could actually increase the size of the philanthropic market by providing what amounts to the first functioning donor marketplace for artists and arts organizations.

While guided crowdsourcing cannot guarantee all aspiring artists a living, by empowering a new and unprecedentedly large group of thoughtful consumers of the arts to help decide whose dreams deserve to be transformed into reality, it can provide more equality of opportunity than could ever be possible under the current status quo—and guarantee the rest of us richer artistic offerings than ever before.

It's time to appoint the next generation of arts program officers: us.

Join the Conversation
Contribute to a dialogue pertaining to the concepts discussed in this chapter by directing your web browser to the following URL:
http://www.20UNDER40.org/chapters/chapter-6/

NOTES:

1. Anonymous. Personal communication. February 21, 2010. All of the individuals whose views appear in this article are critically acclaimed emerging artists under 40 years of age, and are quoted with permission.

2. Gaquin, D. *Artists in the Workforce: 1990-2005*. Washington, DC: National Endowment for the Arts, 2008: 1; see also National Endowment for the Arts. *Artists in a Year of Recession*. Washington, DC: National Endowment for the Arts, 2009, and; Davis, J. A. & Smith, T. W. *General Social Surveys: 1972-2008*. Chicago: National Opinion Research Center, 2009.

3. Williams, K. & Keen, D. *2008 Survey of Public Participation in the Arts*. Washington, DC: National Endowment for the Arts, 2009: 43.

4. Leadbeater, C. & Miller, P. *The Pro-Am Revolution*. London: DEMOS, 2004: 21-22.

5. Van Grove, J. "YouTube is Huge and About to Get Bigger." *Mashable*, (May 20, 2009), <http://mashable.com/2009/05/20/youtube-video-uploads/>.

6. Kot, G. "Future of Music Summit: 115,000 Albums and Only 110 'Hits.'" *Turn It Up*, (October 4, 2009), <http://leisureblogs.chicagotribune.com/turn_it_up/2009/10/future-of-music-summit-115000-albums-and-only-110-hits.html>. This calculation is based on a conservative estimate of 40 minutes in length per album.

7. Kusher, R. J. & Cohen, R. *National Arts Index 2009*. Washington, DC: Americans for the Arts, 2009: 62.

8. Ibid: 49.

9. Waxer, C. "No Cash, No Credit, No Movie." CNNMoney.com, (January 21, 2010), <http://money.cnn.com/2010/01/21/smallbusiness/sundance_credit_cards/index.htm>.

10. Anonymous. Personal communication. February 20, 2010.

11. Anonymous. Personal communication. February 22, 2010.

12. Foundation Center. "Foundation Directory Online" (n.d.), <http://fconline.foundationcenter.org>. Only 1.3% of arts funders in the database accept applications with no geographic restrictions.

13. The Judith Rothschild Foundation. "Grants List." (n.d.), <http://www.judithrothschildfdn.org/grants.html>.

14. NewMusicBox. "Behind Closed Doors: Making an Evaluation." (n.d.), <http://www.newmusicbox.org/page.nmbx?id=65fp03>.

15. Modest Needs. "Questions and Answers for Donors." (n.d.), <http://www.modestneeds.org/explore/faq/giving/>.

16. artistShare. "About Us." (n.d.), <http://www.artistshare.com/home/about.aspx>.

17. Kickstarter. "Frequently Asked Questions: Who Can Fund Their Project on Kickstarter?" (n.d.), <http://www.kickstarter.com/help/faq#WhoCanFundTheiProjOnKick>.

18. Facebook. "Chase Community Giving on Facebook." (n.d.), <http://apps.facebook.com/chasecommunitygiving/home/recap?_fb_fromhash=5d6b4a a551cbdb4dadb31be686b71af2>.

19. Pepsi. "Pepsi Refresh Project FAQs." (n.d.), <http://www.refresheverything.com/faq>.

20. Howe, J. "Join the Crowd." *The Independent* (London), (September 2, 2008): 2.

21. Philoptima. "Open Innovation Challenge Introduction." (n.d.), <http://www.philoptima.org/open-innovation-challenge-intro/>.

22. Philoptima. "Open Design Prizes." (n.d.), <http://www.philoptima.org/philoptima-open-design-prize/1/>.

23. Rockefeller Foundation. "The Rockefeller Foundation and InnoCentive Renew Partnership Linking Nonprofit Organizations to World-Class Scientific Thinkers." (n.d.), <http://www.rockefellerfoundation.org/news/press-releases/rockefeller-foundation-innocentive>.

24. Yelp. "Yelp Elite Squad." (n.d.), <http://www.yelp.com/elite>.

25. Ashoka Changemakers. "Who We Are." (n.d.), <http://www.changemakers.com/en-us/about>.

26. NetSquared. "About." (n.d.), <http://www.netsquared.org/about>.

27. NetSquared. "Challenges." (n.d.), <http://www.netsquared.org/challenges>.

28. Wikipedia. "Wikipedia." (n.d.), <http://en.wikipedia.org/wiki/Wikipedia>.

29. Cohen, N. "Wikipedia to Limit Changes to Articles on People." *New York Times*, (August 24, 2009), <http://www.nytimes.com/2009/08/25/technology/internet/25wikipedia.html?_r=2>; see also Wikipedia. "Wikipedia: Administrators." (n.d.), <http://en.wikipedia.org/wiki/Wikipedia:Administrators>.

30. Wikipedia. "Wikipedia: Bureaucrats." (n.d.), <http://en.wikipedia.org/wiki/Wikipedia:Bureaucrats>, and; Wikipedia. "Wikipedia: Arbitration Committee." (n.d.), <http://en.wikipedia.org/wiki/Wikipedia:Arbitration_Committee>.

31. Exley, Z. "The New Organizers: What's Really Behind Obama's Ground Game." *Huffington Post*, (October 8, 2009), <http://www.huffingtonpost.com/zack-exley/the-new-organizers-part-1_b_132782.html>.

Failures, Losers, and Screenwriter Wannabes: Storytelling for the Screen in the 21st Century

Michelle Bellino
Harvard Graduate School of Education

Michael Bellino
Independent Filmmaker

Recent decades have brought enormous material and structural changes to the film industry, so that the capacity to become a filmmaker is seemingly more within the reach of every individual than ever before. Despite this seeming democratization, screenwriting remains one of the most difficult and elusive careers to break into. This chapter focuses on the unique challenges of pursuing a career in a for-profit arts industry, exploring film's inability to "professionalize" the art of screenwriting, the concept of distribution in digital contexts, and the industry's daunting power differential. Drawing on our experience as a brother-sister screenwriting and filmmaking team, we demonstrate the interaction between the structural dynamics of the film industry and the internal apprehension that all writers face.

It was never only about the feeling we got watching movies. The way they take up space inside you, biting your fingers in the dark and longing to be different, better. The way they make you stand apart from your life, hold it in your hand, and—for as long as you can hold on—surrender to the spectacular and the tragic. It was never about money or fame or Hollywood power. Above all, it was that we had something to say. We were going to go down in film history as the brother-sister team that told the stories of our generation. Real stories, the kind that would hit home for audiences,

movies that would make people drive out of the theatre and really think about their lives.

After years of near successes and many failures, we felt ourselves flailing. Skepticism about our own talent and commitment led us to question the conditions that allow screenwriters and filmmakers to succeed in an industry restrained by its own power inequalities and fears of failure. The conditions of failure are built into the film industry, the way they are built into many arts—especially those that drive profits. We could tell you that the system should change, that everyone should have access to movie story power, but those systemic changes would be impractical in a for-profit industry. We could tell you that the system has changed, that the explosion of new technologies has democratized the industry, but we believe that the growth of technology has instead fractured the art of filmmaking and deepened power divides. What we want to tell you is that individuals who want to *Break In* to the industry need to change along with the field itself.[1] Writing is a craft, but *Making It* in the film world is an equally elusive art—one that often contends with another deep feeling that takes up space inside you. The fear of failure. And it goes deep as potholes.

Our Near(est) Success

We spent hundreds of nights brainstorming seed ideas we thought we could coddle into successful movie concepts. The one-liners were all we needed to get started, as we then wrote on our own to develop the plot and characters. "Smartest girl in high school convinces teachers to cut school for a day to throw rager," or "stripper hides from the mob at an art school (ala *Sister Act*)" were just some of the hooks we thought could help sell our first script. A week later, we reconnected and shared our writing. It seemed that in the time we were apart, we each came to the conclusion that we were writing something we shouldn't. The subject matter wasn't the problem. We both loved high school movies (who doesn't?), and were nostalgic of our own experiences in school, with dating, our parents, and the general coming of age vibe. We shared a repertoire of common memories we were convinced the world would find hysterical, like the time our sister got caught hiding beer in the oven, or the time our dad came home with a surprise perm. And though neither of us had experience stripping, we both went to college for the arts, studying with brilliant and maniacal teachers and students who thought they were *The Next Big Thing*.

No one told us we had to go the way of the Hollywood script, even if it was a low-budget version. But we felt it was a safer approach as first time writers. Consensus advice from dozens of screenwriting books stresses

the need for a plot with a hook and a central character buried in conflict that reveals itself within the first ten pages. We interpreted this to mean that our script had to fit the profile of what already defined a successful film. How else would we *Break In*? Why else would anyone care about our personal stories, unless they were told with the backdrop of an attractive stripper running from the cops during a nude video installation? We were not blind to the fact that a script could be both marketable and personal, but we struggled to take characters from our real, personal world to a level where they did something absurd enough for Hollywood to say, "we've never seen *that* before!" "Creative" people often emphasize authenticity of voice and telling the story they deep down want to tell, while "industry" people tend to make decisions based on market trends. And somehow, writing a script that blended both elements seemed insurmountable. The "write what you know" theory had too much literal meaning for us, and any time we embellished a character's actions or events affecting them, we doubted whether we could write convincingly what we held as "truth," and more importantly, what an audience would consider believable.

One script of ours came close to reaching what we deemed the Hollywood balance, however, and that was *Last Call*, a comedy about three brothers who owned a rowdy college bar. Neither of us had ever bartended, but we did engage in the college bar scene on countless occasions and witnessed the management—or rather, mismanagement—of that world. In the following months, we wrote about every bar experience we or someone we knew had had. We collapsed character identities, reordered events, and cleaned our screenwriting style. We wrote and rewrote until our story was lean. We knew our characters' histories and desires intimately. We read scenes aloud for dialogue. We ordered index cards along the floor to see our story arc visually. Eventually, the story that formed was one we felt was concise, original, entertaining, and most likely borrowing several story conventions from our favorite films of the genre we wrote in—mockumentary. The story had the look built in, with the bar owners being the actual filmmakers, documenting their grand re-opening. This look would be captured on home video, which would make the movie more authentic to viewers and more affordable for producers. The setting of the story was yet another selling point which seamlessly worked with the script; the story took place in one location, in one day, so wardrobe and set expenses would be minimal. Most importantly, we believed it could work as a mainstream film. The characters were real and the scenarios were over the top, yet based in reality.

But when we showed the script to the few contacts we had in the film industry, they expressed their doubts. Our readers felt we captured

a unique voice, perspective, and style, but they questioned whether the plot was strong enough to be a marketable movie. No matter how many screenwriting books that promised story, plot, characters, and voice are the key to the industry—especially for first-timers—the industry reminded us that it is all about profit. We weren't shocked that marketability was a concern, but we were frustrated that no one wanted to take the risk, which we thought was minimal since the movie had "low-budget" written all over it. Unfortunately film development executives are thinking less about production budgets, and more about whether the film is worth the company's resources over the long haul once the film is complete, which includes distribution and marketing. Again, it was something we understood was part of the process, but it was frustrating nonetheless.

We decided to take things a step further and make a demo film, in hopes that when executives watched it, they would get the tone we were going for and realize it would have audience appeal. We revised a select group of scenes from the feature length script so they flowed together in story form, even adding an ending to enhance the viewer experience. After months of preparation and pulling every favor we had amongst actors, crew, family, and friends, we coordinated the "perfect shoot day." We watched the words we wrote on paper become worlds on camera. After four months of tedious post-production (more favors), we had a short film that we were proud of—one we were convinced would put our pitch over the top.

With our industry contacts, we secured a meeting with a reputable production company in Hollywood. Mike screened the film for two executives, carefully studying them as they laughed the whole way through. When the demo ended, they congratulated Mike and asked what our bigger intentions were. Mike told them we wanted to make a feature length version of the film, and that the tone aspired to the subtly over the top humor of *Spinal Tap* and *Reno 911*. When the execs asked if we had a treatment (a detailed synopsis) for the story, Mike pulled out two copies of the script. Things took an odd turn when the execs expressed that a film like this, which thrived on improv acting, would be pitched more successfully with a treatment rather than a script. They told Mike that if they gave a script to investors, they might fall in love with specific lines or jokes that may not make it into the film. As Mike listened, he questioned whether we were being given good advice or the runaround.

Writing a treatment was nothing we couldn't handle, but our interpretation of a treatment for a feature was that it was a step that preceded the polished script. A blueprint for our eyes only, so that we could build the final script with dialogue that would make the reader laugh aloud, while breezing past the descriptions. That was the process we learned from

every source we consulted in our self-directed screenwriting education. Did Hollywood change *The Rules*? Did improv films require a different pitch? Mike nodded politely, but he was dying inside. This felt like a big step backwards.

The demo was supposed to propel us to the next stage of, "OK, where do I sign?" But instead it threw us back to the computer where we were un-telling the story we worked so hard to tell. Once the studio had our treatment, they were elusive and overbooked. Soon after, several of our principal actors became committed to various television projects, some more successful than others. We were happy for them, but the prospect of making a feature-length *Last Call* without studio support seemed to slip farther away every time we turned on the TV. We decided to shelve *Last Call*. Part of it was giving up, we admit, but it was hard not to. We did what we were told—we moved on to our next project and did not look back.

Ok, there was *some* looking back.

The De-professionalization of Film and the Paradox of Success

After ten years of working our asses off, we're still trying to achieve our goal of making a "real" movie. We've yet to make a film, let alone sell a script that anyone wants to make. We've had a few important people read our scripts, but no one has been ready to take on the risk of telling our stories. And when that didn't happen, the cycle of self-inflicted excuses began playing in our heads. We're not smart enough, funny enough, lucky enough, good enough. We didn't waste time complaining about others who succeeded. Ok, that's a lie. That's all we did. But we did it constructively; we'd say, "Man, that sucks that a movie like *INSERT HIGH SCHOOL TEEN MOVIE* is a huge hit. The version we scripted was so much more original, funnier—and smarter!" It would then wistfully dawn on us that the success of *SAID TEEN MOVIE* demonstrates that the market is still strong for the stories we want to tell.

We're not famous. We're nobodies. In other words, we're failures, losers, wannabes. No rights to carry the "filmmaker" badge.

But what makes someone worthy of that title? It lies like a splinter under people's names on their resumes and business cards, even their Facebook profiles. The word implies that you hold a position of power, either on the financial or creative side of a film project, or possibly both. It also tells someone that they can Google your name and see if you're full of shit. If you're a smart filmmaker who hasn't sold anything yet, Googling your name and "filmmaker" should still bring up a variety of hits, and we're

not talking about those creepy sites that sell your personal background information.

Historically, the US Hollywood and independent film industries have been among the most difficult careers to break into. But with the explosion of digital technologies, the capacity and accessibility of becoming a filmmaker is more within the reach of every individual. In the 1980s, the video camera became an affordable device for consumers; soon, anyone with a video camera began practicing the skills and instincts of Hollywood directors and cameramen. In the '90s, nonlinear editing technology replaced reel-to-reel systems. Editors no longer had to physically slice each frame of film in order to splice together the perfect edit. And in the late '90s, the Internet emerged as a host for uploading and sharing video content. Most recently, democratically-minded "Do it Yourself" (DIY) and user-generated content driven websites such as YouTube and Funny Or Die have transformed the concept of distribution, allowing filmmakers of all calibers to access criticism and acclaim from millions of viewers around the globe. Each level of innovation sparked a creative and financial debate in the commercial world, disrupting the exclusivity of Hollywood and fueling the ongoing revolution of the film industry to make independent filmmaking more mainstream.

It is important to recognize the material and structural changes that have taken place in recent decades, as well as how these shifts position those trying to *Break In*. Filmmakers today have every tool at their disposal in order to film, produce, edit, and even "distribute" their work to mass audiences. But while these are seemingly positive steps towards filmmakers creating awareness for their work, we question whether or not the process of *Making It* has in fact changed, especially when it feels like filmmakers who are already successful (justly) take advantage of newly formed independent spaces to display their work.

Perhaps the innovation of YouTube, Funny or Die, and DIY sites have fractured the domain of film, creating a deeper division between the hobby of filmmaking and the profession of filmmaking. So when someone calls himself or herself a filmmaker, it begs the question, what gives them the right? What is the difference between a "professional" filmmaker, and someone who is skilled enough to comically edit together clips from *Mannequin* and the voiceover from *Pan's Labyrinth* promos and upload the content to YouTube? If someone wants to be a surgeon but has never gone to medical school, he does not go around calling himself a doctor—even if he has performed some successful operations on his own body. For the record, we're going to state that the term "filmmaker" is the same as writer, screenwriter, film producer, artist, painter, sculptor, etc.

These titles all claim that you are qualified to do what you are claiming you can do, but don't require you to have any education whatsoever that validates it. In sociological scholarship, this means that filmmakers and other creative agents are not "professionals" because their occupation is not considered a "profession." Professions require formal education in the form of certifications, licensures, or degrees, as well as a shared set of values that shapes practice.[2] Clearly, all arts defy this—in fact, the arts purposefully set themselves against perceived norms by pursuing original, innovative work. While physicians have explicitly defined measures of goodness, art's goodness hinges on subjectivity.

The film industry is not the only career path that is cutthroat and un-"professional." But in an industry so motivated by power and simultaneously restricted by fear at both creative and executive levels of decision-making, film is somewhat uniquely *not* merit-based.[3] Countless screenwriting and filmmaking books discuss the need to take advantage of contacts in the business and the critical role of luck and social networking in *Making It*.[4]

The organizational structure of film is such that you are defined entirely by the work you have done and not the work you are poised to do. Obviously, all fields care about what you have done in the past—thus the invention of the resume. But if you submit a writing sample to a book publisher or a popular magazine or an academic journal, you submit the work you want to move forward with. In the film industry, you display your reel, a collection of the work that you have already done. If you have only had the opportunity to work on your friend's music videos and spec commercials, then that may be all you've got. We are oversimplifying this: we know that you can be creative even with the tightest restrictions on content; we know that you can pursue independent projects to display a wider range of expertise; we know that book publishers take a closer look at published authors than unpublished writers. Yet there is something about the film industry's emphasis on prior work that breeds even more self-doubt and fear of failure into the creative process: you have to *establish* yourself as a filmmaker in order to *describe* yourself as a filmmaker.

This tautology is seductive and entrapping. Because of the way the film industry is structured, and because of the social definitions we ascribe to filmmakers (and other non-professionals), who you are and what you can do depends almost entirely on what you have already done, rather than your future aspirations or potential. The problem with this argument is that there is no way in or out of it. If you accept this logic, as we are acculturated to do, you refuse to believe that you have any potential until you have had that potential affirmed by the industry's "gatekeepers."[5] Refusing to accept your potential as a filmmaker means you will not produce the work that

would earn you the title in the first place, because you will not give yourself permission to succeed... until you succeed. Since "interruption comes not from another but from the self itself, or some other self within the self...," new writers need to first accept that you cannot change the organizational structure of the film industry, or even the heavily acculturated notions of success and professionalism, but you can reframe how you interpret your role within the larger system.[6]

PROFESSIONAL UNPROFESSIONALS

Art-based industries are somewhat unique in that "field approval" is focused among such a small group of highly powerful individuals.[7] Meanwhile success, as deemed by gatekeepers of the domain, depends (almost always) on audience response, the public. Field approval requires audience approval, especially in a commercial arts business like film. Despite the seeming democracy of this exchange, the field both dictates and responds to audience demands, meaning that every one of us who participates in the entertainment industry as a viewer is part of this system. This is not necessarily news, but it is worth stating simply: it is not *democracy* driving film, but *capitalism*.

More than one billion movie tickets are sold annually in the U.S. For the most part, movie revenues have increased from year to year, with a 1995 minimum of $5.29 billion. Meanwhile, domestic DVD sales are in the hundreds of millions.[8] The film industry is not exactly suffering, though profits say little about quality. Either way, a profit-driven industry that is actively making profits is unlikely to change. That means that filmmakers trying to *Break Into The Industry* cannot expect organizational transformation, no matter how unjust the system appears; rather, those wanting to *Make It* need to study the organizational demands and adapt accordingly. The system is a business, and the business owes you nothing.[9]

We argue that the arts will never acquire—nor require—an objective criterion that defines quality. But that is only one source of frustration for creative agents; the idea that artists have no obvious professional path is perhaps more unnerving. The not knowing where to go next means there is built-in recognition that this is a bumpy ride. Some say it takes about ten years to decide on a career within the humanities. That statistic remained successfully concealed throughout both of our arts-focused college experiences.

Graduating from our respective arts programs, we were given advice from our mentors about what to do *while* we were *Making It*. Mike's film

teacher told him that if anyone ever offered him a chance to direct, no matter how little the pay, that he should do it in a heartbeat. The teacher, an independent filmmaker himself, most likely knew that no amount of film classes could match the education you get from the real experience of directing, a job that challenges you to meet someone else's goal, not just a personal one. Michelle's creative writing teacher recommended she wait tables or bartend rather than apply for an MFA program or work an editorial job, emphasizing that she needed to keep her ear sharp and stay mindful of the range of human experience if she wanted to become a real writer. We both took this advice seriously, but it led us down paths that seemed to move away from what we wanted. What they don't tell you about holding on to your creative dream while working any job, ranging from mind-numbing administrative work to the potentially more imaginative advertising executive, is that you will constantly contend with the guilt that you are either holding onto a worthless dream that is preventing you from establishing a pragmatic career, or not fully investing yourself in a path that requires everything you can give. Though we held very distinct day jobs, we both felt immobilized at the prospect of working these jobs forever. They were a means to an end, weren't they?

Again, the fear, failure, and fear of failure cycled back into our creative process. It enveloped us like the fleshy, tree-hugging fungus that covered the branches in our childhood backyard. We are not simply talking about "writer's block," but an all-consuming self-doubt about who we are as individuals and where we fit into the larger social world. Fear "can obliterate our desire to go forward... can be so tenacious that all ability to become disentangled seems like an impossible feat. It has the power to erode everything we have worked hard to accomplish."[10]

But this does not mean we have to accept the industry standard for professional. If we do, we end up like screenwriter wannabes. Instead, we can accept that there are varying definitions of success and strive to achieve our own "professionalism" in the absence of industry standards. This confrontation is one of the "multiple opportunities to reject the negative messages that have a way of taking over your creative energy."[11]

Consider, for example, Federico Alvarez, whose four minute and forty-eight second YouTube short, "Ataque de pánico" ("Panic attack") caught the attention of Hollywood film executives within several days of posting. The $300 spot paved the way for a $30 million movie deal.[12] Not all of us can accomplish that, but it offers some hope that YouTube is not a complete dead-end for those who want to hone their craft. It is daunting to think of how your film will stick out amongst the thousands of videos featuring dogs and cats doing stupid tricks, or humans maiming themselves, intentional

or not. But the fact remains that you do have a chance to be heard. You just have to think like a studio: where will you put your film?; who is the audience, and how can you market it to them? At least one element of this answer is quite simple. You need to put your work *everywhere*. Putting your film on YouTube is not enough. You need to create a website. You need to email that website to your friends and hope they get their friends, who you don't know, to email it to their friends. You need to upload your film to every content-based website on the Internet, and be on the lookout for the next one—which there always is. And you need to make sure people can find it. Tag it with every key word you can imagine. Short of lying completely, you'd be surprised how many hits you could get by "misleading" someone to your film. Sure, we would prefer it if our films earn their audiences on their own merits, but with everyone and their dentist wanting to be a filmmaker these days, you need to do whatever it takes. That is the way to take advantage of the distribution revolution that the Internet has created. It is unlikely that Alvarez posted his film on YouTube and sat back waiting for calls and emails. He most likely sent this clip to everyone he knew with special attention to his industry contacts.

TELL YOUR STORY, TELL IT WELL, AND TELL IT FAST—AND MAKE SURE YOU DO YOUR RESEARCH

It may be that you turn the back pages of your favorite industry magazine and there it hits you like a stone in your stomach. Your dream movie has already been made—or at least it has already been dreamed up by someone who moved faster than you.

We're not talking about your college friend who insists that *American Beauty* "stole" his vision of plastic bags blowing in the wind. We are talking about sitting down to write a script about a high school cut-day, and realizing there is a B-movie in production called *Senior Skip Day*. We are talking about crafting a story about three brothers who own a bar, and then seeing the show *It's Always Sunny in Philadelphia*. We are talking about telling a story centering on four college students in art school, and then realizing that *Art School Confidential* was about to hit theatres by the time we looked up from our script. We are talking about digging deep into our personal experience for a story so uniquely ours that no one else could possibly tell it. When we embarked on a script about an unhappy teen with a summer job we had as kids at the Long Island recreation park Adventureland, Greg Mottola had just sold his script called *Adventureland*. That is when it hit us: no matter what we decide to work on, someone else

was moving faster with it. Were we victims of the "thirty day rule," the idea that if you sit on an idea longer than thirty days, you've waited too long?

Was it us, our lack of speed, or was it a deeper problem within the industry, that the marketplace was already flooded with sequels and remakes, inhibiting new talent? Sequels are considered Hollywood's less expensive, more secure opportunity for hits. Sequel success has been growing steadily since the 1980s, with this decade as the most lucrative.[13] Screenwriter John August theorizes that more films are remade from older versions because of fear (of movies failing with audiences) and control (sought by studios and producers looking to circumvent the screenwriting process). Again, these are organizational restrictions that impinge on new writers' psyches, another feedback loop to self-induced failure. Were we wrong to abandon our Adventureland script, or our art school script simply because other films with similar backdrops were coming into the public eye? Perhaps we were too inflexible or disheartened to see a way out of it, but all we saw was the end of our nonprofessional hobby as screenwriters. Why would anyone want two movies (that weren't sequels) with Gravitron and Music Express as sites of a youthful romantic comedy? After that, we invested the next year developing conspiracy-based scripts about writers stealing other writers' ideas through feats of time travel and mind control.

We do not tell these stories to suggest that there is no way to tell the same story more than once, or that we couldn't tell a more authentic story about Adventureland or art school—we tell you this because this is better to know at the outset. The film industry demands a meticulous research lens that ensures you are tapped into the market. This is a complexity that is unique to the film industry—studios buy ideas and hold onto them until the market is right. It is their job to research market trends and determine the best moment to release what they have up their sleeve. But writers need to know what is already out there, to know what they are up against. For us, doing the research alone has been daunting. The sheer volume of what is already out there is enough to make you return the Final Draft software and buy yourself a flatscreen TV. But it goes deeper than the quantity of ideas circulating the market; deeper than the immobilizing prospect that all new ideas in production are essentially old ideas repackaged by influential filmmakers and studios; deeper than your relative powerlessness to compete for work against writers who at least have a script optioned, if not made.

To put it simply, "[w]riters of the 21st century will have to work harder."[14] We will have to work harder to tell the stories we want to tell, but especially to get them heard. With more writers today, and more self-identified producers, screenwriters, and filmmakers, the market is flooded

with talent. The Internet has increased the speed of exchanges and the space to display creative work. And yet the number of films released in theatres has not changed dramatically, because each film continues to be a significant business investment. The gap between those who have power and those who are powerless in film is demoralizing. Studios want known writers—or no writers. Studios want high concept stories with a low budget script written in an original voice, told by someone with a record of success. These are the contradictions that drive the industry. How can unknown writers hone an original voice or tell a unique story in a world of seeming constant remakes and sequels—explicit and implicit repetition of what has already worked in the past, ideas that studios copyright, option, or are currently producing? If the field were different, would new writers be more equipped to fight off failure, frustration, and fear?

In the end, we can only tell you what was told to us, the same ambiguously inspirational advice about focusing on the story you want to tell. The fine print here is that the way you get your story told—and who you get to listen—is up to you. We like Rilke's advice about deciding whether to write:

> This above all—ask yourself in the stillest hour of your night: *must* I write? Delve into yourself for a deep answer. And if this should be affirmative, if you may meet this earnest question with a strong and simple *"I must,"* then build your life according to this necessity...[15]

We also like McKee's advice, more particular to the screenwriter's burden:

> Go to the gym and work out. Writing burns you out, but then you have to get up off your tired ass, put your script under your arm and knock on every door 'til your knuckles bleed. That takes the energy of a five-year old, the concentration of a chess master, the faith of an evangelist and the guts of a mountain climber. Get in shape.[16]

Why did we get into *The Business*? To tell stories, yes, but to also share those stories with an audience, even if it is just our mothers, boyfriends, siblings, or good friends.

No one can predict what will work in a creative industry, and no one in the industry will care about your work as much as you do. But don't let *The Industry* shape your relationship with the field. Overthinking industry demands means a hesitation to take the risks necessary in storytelling. Screenplays may be marketed as concepts, but the good ones are also stories first.

Recognizing that "[d]escribing yourself as a screenwriter can be the

most difficult thing in the world," decide whether you are ready to fail to tell your story.[17] Then tell it well. And move quickly—you have less than thirty days before someone else *Breaks In.*

Join the Conversation
Contribute to a dialogue pertaining to the concepts discussed in this chapter by directing your web browser to the following URL:
http://www.20UNDER40.org/chapters/chapter-7/

NOTES:
1. You may find it pretentious, but we decided to italicize all references to *Breaking In* and *Making It* in *The Industry.* We believe that this draws proper attention to the gap between those who are "in" and those who are "out," demonstrating the power disparity that the film industry thrives on. Clearly, we are "out."
2. The sociology of professions dates back to Barber, B. "Some Problems in the Sociology of the Professions," *Daedalus* 92 (1963): 669-88. Many contemporary scholars continue to draw on Barber's stated attributes of professions.
3. Naturally, business investments as costly as filmmaking ventures carry high risk. Countless anecdotal sources describe the fear that shapes and restricts industry decisions to take commercial and creative risks, however it is difficult to find written sources that elucidate the business caution that takes place within studios. See August, J. "What's With All the Remakes?" JohnAugust.com, (2006), <http://johnaugust.com/archives/2006/whats-with -all-the-remakes> for a discussion of studio hesitation to move forward with new content over sequels that offer more certain successes. For a detailed description of internal and external fears that creative agents contend with throughout the process, see Caldwell, S. & Kielson, M., *So You Want to be a Screenwriter: How to Face the Fears and Take the Risks.* New York, NY: Allworth Press, 2000.
4. Nearly every screenwriting resource includes at least a small section with tips on how to move your ideas into the pitching stages, openly citing the necessity to call in personal favors in order to get meetings, make contacts, and create your own opportunities. Anonymous. *The Hollywood Rules.* Beverly Hills, CA: Fade In Books, 2000 offers an insider look at the film industry, demonstrating the power of social networks. See also Caldwell and Kielson, *So You Want to be a Screenwriter: How to Face the Fears and Take the Risks,* 2000 on the role of luck in succeeding in the film industry. Similarly, McKee, R. *Story.* New York, NY: ReganBooks, 1997 recognizes the need to take advantage of contacts in order to promote success.
5. For a detailed description of the structure of creative systems and the relationship between creative agents, domains, fields, and gatekeepers, see Csikszentmihalyi, M. *Creativity: Flow and the Psychology of Discovery and Invention.* New York, NY: Harper Collins Publishers, 1996.

6. Oliver, M. *Blue Pastures*. New York, NY: Harcourt Brace & Company, 1995: 1.

7. Csikszentmihalyi, *Creativity: Flow and the Psychology of Discovery and Invention*, 1996.

8. The Numbers, (n.d.), <http://www.the-numbers.com/>.

9. Perhaps our chapter stands out in this volume in that we do not propose a particular "solution" to the challenges of the film industry that we present. This is not our attempt to cop out of difficult, creative thinking; rather, it is our recognition that the industry has indeed changed. We view the locus of potential future revolution within creative agents themselves, rather than the system.

10. Caldwell and Kielson, *So You Want to be a Screenwriter: How to Face the Fears and Take the Risks*, 2000: 132.

11. For more on common fear-provoked obstacles to the screenwriting process, see Caldwell and Kielson, *So You Want to be a Screenwriter: How to Face the Fears and Take the Risks*, 2000: 42.

12. Lapowsky, I. "Short Film Posted on YouTube Earns Filmmaker Major Movie Deal," *Daily News*, (December 29, 2009), <http://www.nydailynews.com/entertainment/movies/2009/12/29/2009-12-29_short_film_posted_on_youtube_earns_filmmaker_major_movie_deal.html>.

13. Screen Digest. "Movie Sequels: A Cinema Intelligence Briefing Report," Research and Markets, (January, 2005), <http://www.researchandmarkets.com/reports/238814>.

14. Farris, M. "Interview with Robert McKee," The Screenplayers Writing Tomorrow's Films, (n.d.), <http://www.screenplayers.net/robertmckee.html>.

15. Rilke, R. M. *Letters to a Young Poet*, Translated by M.D. Herter. New York, NY: Norton. W.W. Norton & Company, Inc., 1934: 19. For several years German poet Rilke corresponded with an aspiring poet through letters that offered inspiration about the writing process.

16. McKee, R. "An Interview with Robert McKee," 2009, <http://www.mckeestorychile.com/tex/Mckee_InterviewRobertMcKee_17-feb-2009.pdf>: 7.

17. Caldwell and Kielson, *So You Want to be a Screenwriter: How to Face the Fears and Take the Risks*, 2000: 41.

CTRL+C, CTRL+V:
The Rise of the Copy and the Fall of the Author

Casey Lynch
Savannah College of Art and Design

This chapter will discuss a popular topic in contemporary artistic production: appropriation. The author will first discuss the notion of originality in the contemporary world, calling into question both the ideas of originality and appropriation when viewed as functions of the evolutionary process. The author will then discuss authorship and ownership in our contemporary digital society. In doing so, the author asks the question, "if no act is original, how can we allow 'intellectual property' to be owned?" A look into the nature of digital technology and various Internet phenomena will be used to address this question. The intended result of this inquiry is to further problematize the notions of purity in art, originality, and the intellectual rights of a creative author.

Relative originality, the novelty of an idea at the time of its "origin" is a notion that seems to be paramount when determining the value of a work of art. Ideas of originality and the creative Author became popular during the rise of the Modernist and the Avant-Garde movements in the late 19th century, and can be thought of as Romantic-Humanist surrogates for the Christian motifs of virginity and political and/or theological powers that previously dominated Western art. The purity associated with a virgin (especially *The* Virgin) can be understood as having been replaced with the supposed purity of an original form. Further, the omnipotence of the ruling class or a Divine Creator can be viewed as being replaced by the human creative power of the Artist.

Broadly speaking, 20th century Art imposed two (supposedly) diametric means for expressing purity and creative power: form and concept. The importance of form, as championed by the likes of Clement Greenberg and Michael Fried, is in its ability to be reduced to its primary, most pure state.[1] This pure state defines the essence of art for Formalists. Conceptualists, such as Sol LeWitt and Joseph Kosuth, take the idea, the impetus for a work, as its most important element. For Conceptualists, the idea is the true point of origin. For many of these artists, language became the form of the concept, and its use an act of creation. This use of language as a creative act is analogous to governmental decrees and the creative speech of God in Genesis. In essence, one may assign Formalists, who value the purity of form, as followers of the Cult of the Virgin, and Conceptualists, who value the creative power of the word, as defenders of the creative power of the Author.

Just as the political and religious concepts before them, the ideas of purity, originality, and a creative Author in art have been denied and deconstructed throughout the late 20th and early 21st centuries. Throughout this chapter canonical works of criticism by Walter Benjamin, Rosalind Krauss, and Nicolas Bourriaud, alongside fundamental ideas from biological evolution will be examined and merged in the service of questioning the validity of our common notion of originality. A successive discussion of contemporary issues involving author's rights will reinforce the importance of this question and aid in delineating a more complete understanding of art's function as an act of communication in the Digital Age.

This new, massive arena that art will inhabit comes with its own equally large set of problems and possibilities. Foremost, the ability to claim ownership of intellectual property will be acutely challenged, and the struggle between owners of copyrights and users of such material may cause one side to take the offensive. More positively, a nearly infinite lexicon of forms may become available for artistic expression, affording a larger pool of artists the tools necessary in the service of such expression. The effect of this new era of art may be expressed as a negative correlation: as the connection between art and the dominion of the pure decreases, the ability to produce honest, meaningful work will increase.

To Copy

The introduction of photography and film and its effect on ideas of originality in the early 20th century can be used as an analogy for the impact of digital technology in the 21st century. In *The Work of Art in the Age of Mechanical*

Reproduction, Walter Benjamin utilizes Marxist philosophy in a proposal that claims mechanically reproducible art, namely photography and film, can be "useful for the formulation of revolutionary demands in the politics of art."[2] Although his overall aim is to formulate a prognosis for the way that film should be an agent for the masses (Communism) instead of one for Fascism, one can find a critical analysis of the effect of mechanical reproducibility on the value of art within his diatribe.

Benjamin identifies a critical factor for determining the value of a work of art as its "aura": its "authenticity... the essence of all that is transmissible from its beginning... to the history which it has experienced."[3] Although he openly admits that any work of art can be reproduced, he emphasizes that any copy of an original, even a nearly perfect copy, inherently lacks this element of uniqueness. He further claims that the aura of an object is decreased as its plurality increases. He purports that uniqueness, or singularity, is a crucial element in the cult of the object, in that it allows for the preservation of the traditions of lineage of ownership, restricted exhibition, and publicized authenticity. For Benjamin, these attributes designate art's traditional basis in (religious and political) ritual and its implementation by primitive, feudal, and bourgeois structures. He sees the demise of the uniqueness of the object and the ability of a reproduction to meet the receiver halfway as a positive political act.

Rosalind Krauss furthers the discussion on the lack of originality found in reproducible objects in her essay, *The Originality of the Avant Garde.*[4] Of utmost importance for Krauss is denying the avant-garde's implication of an absolute origin, "a beginning from ground zero." She begins by questioning the validity of using the word "original" in relation to the art of multiples—photography, film, print-making, casting, etc. As an example, she summons the fact that the casting of Rodin's *Gates of Hell* found in a contemporary exhibit at the National Gallery was termed an original even though the edition was completed eighty years after the artist's death.

After pointing out the lack of originality in landscape painting through the deconstruction of the term "picturesque," Krauss secures her position by examining the use of the grid, thought of by many in the Avant Garde to be a true point of origin; a pictorial utopia void of language, reference, and nature, which was completely disinterested, purposeless, and autonomous. She first points out that a grid is inherently forced to repeat and that it is impossible to reinvent, each aspect causing a barricade to novelty. She continues by emphasizing the repetition found at the micro and macro levels of a canvas's structure: the gridded weave of the canvas, and the rectilinear form of it when on stretchers.

Krauss transitions from the idea of the structure of the grid to promoting the post-structuralist idea of decentralized infinite repetition. Fundamental to the idea of Structuralism (thus post-structuralism) is the idea of the sign, in general a word, that (arbitrarily) refers to a signified, a mental idea that corresponds to the supposed real world. She introduces Roland Barthes, a philosopher known for stating that realist art is actually a form of pastiche. She cites him as saying that the mental sign of the real, not the real, is what is depicted in a work, and in this sense, realism is a copy of a copy. Krauss also cites artist Sherrie Levine, who in 1980 photographed Edward Weston's Social Realist photographs from the 1920s, as a model of Barthes thought. Although Levine violates Weston's copyright, Weston is in turn guilty of copying pictorial motifs that can be traced as far back as Ancient Greece. Krauss sides with Barthes, stating that not only realism but perhaps all art is at best a copy of a copy. In her conclusion, Krauss posits a defining difference of Post-Modernism from Modernism: the deconstruction of the idea of origin, and an acceptance of this type of overlapping visual history as "the discourse of the copy."

Nicolas Bourriaud's ideas found in *Postproduction* also examine the notion of originality in the creative process, and can easily be seen as precipitating from the ideas of Benjamin and Krauss.[5] Beginning with Marcel Duchamp as the father of appropriation art—taking the selection of a ready-made object as a creative act—Bourriaud asserts that all acts of selection are acts of creation. He clarifies his position by stating that contemporary art is "going beyond what we call 'the art of appropriation' ...toward a culture of the use of forms, a culture of constant activity of signs based on a collective ideal: sharing."[6]

Bourriaud relates this to the action of a DJ or programmer; someone who is an artist in his own right, yet only a selector and sequencer of readymade music or commands. He goes so far as to claim that any person flipping channels on the television is involved in a creative process of selection. He continues by explaining various means of altering readymade objects, media, and situations in terms of the actions of a DJ: crossfading—presenting two or more forms at once; pitch-controlling—controlling the speed or rate of a form; rapping/MCing—creating a new soundtrack or narration for a form; cutting—isolating fragments of a form and repeating it, and; playlists—selecting preexisting forms to re-present.[7]

Bourriaud cites various artists from the 1990s and early 2000s which he feels are in line with these styles of production, christening them "post-production" artists in reference to the work of back-of-the-house audio/video technicians. He rejects such artists' aim for originality, stating: "The

artistic question is no longer, 'what can we make that is new?' but… 'how can we produce singularity and meaning from this chaotic mass?'"[8]

COPY + PASTE + MUTATION

One can find a myriad of definitions of art, each nuanced in service of the author's critical and aesthetic preference. For the purposes of this essay, art will be identified as an attempt to replicate what is already there, whether it be nature, an idea, or other art. With this definition, one must side with Benjamin in saying that any creative act is flawed in its ability to replicate exactly. As Benjamin explains: "Even the most perfect reproduction… is lacking in one element: its presence in time and space, its unique existence at the place where it happens to [originally] be."[9] Further, a stone figure of a woman is not a living woman; a landscape painting is only two-dimensional, even mass produced objects that seem identical in form and origin have slight variances to each other due to the mechanical tolerance of the machines that produce them. The same differences can be found in the art of appropriation—the art of rearranging or repurposing signs.

Today we live in a world inundated with the ability to "copy-and-paste"—to copy a set of digital information and move it to another location flawlessly.[10] According to Bourriaud, the "remix" was/is the appropriate art of the 1990s and 2000s. Although today's means of "remixing" are novel due to technological advances (i.e. the use of software instead of hardware), the necessity of artists to use what was already there, to borrow from history to create new works, is not. The idea that no one lives in a bubble, that we all have a history to draw from, derails us from the availability to be wholly original, and delivers us from the need to be. Any "novel" idea that we have is at best a *mutated* version of two or more previous ideas. There is a structure, in many ways similar to a *family tree*, which acts as the impetus for any "new idea." It would seem that any discrete "new idea" must be only an illusion, inseparable from the whole history that bore it. At best, we may call something "new" only because it is too complicated to recount its entire history every time we refer to it.

It is the purposeful use of the terms "mutated" and "family tree" that lead us to the idea of evolution. Most simply put, evolution is the process of mutation and reproduction. When entities that can reproduce do, there is a mixture of the parents' genes. Sometimes there is a *chance* mutation that happens in this process. If that mutation is not strong enough to kill the new entity before it reproduces, that mutated trait has a chance of being replicated. If a particular surviving mutation is aberrant enough, or if there is a culmination of mutations that survives a series of replications, a new

species is created. The same can be said for the way that new "species" of art come about.

It would serve us best here to recount another grade school science lesson at this point: classification. Biological classification is "the assignment of organisms to groups within a system of categories distinguished by structure, origin, etc."[11] The seven biological classifications are kingdom, phylum, class, order, family, genus, and species. This system can be applied to the Arts, and in many ways already is. For example, Jackson Pollock may be classified as follows: species - *action painter*; genus - *abstract expressionist*; family - *American*; order - *Modernist*; class - *avant garde*; phylum - *painter*; and kingdom - *visual artist*. It seems that the need to define things in such an explicit manner and the quest for novelty share a symbiotic relationship. As the list of things that have not been named diminishes, it is as if there is a need for new things, and in turn, these new things must be named. As those new things get named, the cycle begins again.

Returning to Pollock as one who created a new style which necessitated a new species classification, we should note that he embodies a great example of the subject at hand in that the style he is famous for, drip paintings, are widely recognized as having impetus in the mistake (of dripping paint). This is an important distinction because the process of evolution does not have a purpose or follow one's will; mutation is an act of chance. Although we may argue that the artist possesses the will to create something new, any artist and anyone who knows artists understands that "new" ways of making come about almost unanimously by way of "playing" or "experimenting" in the studio. By definition, playing and experimenting involve evaluating random occurrences in relation to one's will.

In the artist's studio, a color is tested next to another, a form may be placed, removed, and replaced until it "works"; over a drink with friends or in one's sketchbook, all the possibilities are considered. Whether it is physically or mentally, every aesthetic decision is derived from a process of experimental or playful groupings of preexisting elements. That unexplainable moment of elements "working" is the result of the inclusion of some combinations and the rejection of others. Each decision, thus the entire work of art, is a perfect microcosmic mirror of the process of biological evolution. It follows that every work of art is mostly comprised of ideas and forms that are found in previous works.

If we accept this proposal, that every work of art is in debt to, and at least partially comprised of a history of other works, we can begin to see that there is a continuum on which the level of novelty and difference of every work must be judged. One end of this continuum would be the "ground zero" original work, and at the other would be the perfect copy. As

Krauss points out, there is no truth in statements of a completely original work of art, and as Benjamin states, an exact replica can never be made.[12] We are left with a range of works that fall somewhere in a Bourriaudian middle, a place comprised of works that are derived from the comingling of preexisting art and ideas. It is only when enough traits are changed or a strange enough effect is the result of such pairings and juxtapositions that we are compelled to declare that something "new" has been authored.

Who is the "Author" of a Copy?

What rights does one who is called an "author" have in claiming stake to such a work if in reality he or she is only combining the work of others?

In one form or another, this question has been asked multiple times, in multiple ways, in multiple texts. It became a cornerstone for many post-critical theorists such as Roland Barthes and Michel Foucault. For these thinkers, the author is a separate entity from the person who composed the work. The author is a product of the text associated with him; the author is a product of the interpretation of those who read the texts; and most importantly, the author does not create, he chooses. Foucault describes the author as, "not an indefinite source of significations which fill a work... he is a certain functional principle by which, in our culture, one limits, excludes and chooses."[13] This is a position we may expect Benjamin and Krauss to agree with, and may almost consider as a direct precursor to Bourriaud's ideas.

Despite what seems to be a consensus among contemporary critical thinkers, the idea of a person's right to declare authorship (thus ownership) remains intact, but the need to denote an author has not always been. Prior to the invention of the printing press, most works that carried an author's name did so as a means of expressing the work's history or author*ity*.[14] The idea of owning the right to reproduce a work (of literature) began sometime after the printing press became common enough to print contemporary (non-classical) texts—an event that allowed for the commoditization of such works.

Author's Rights vs. Users' Actions: Sharing, Borrowing, and Giving

If one is to make a living by selling a product, one must be able to prevent others from attaining his or her product without permission. In England, the Statute of Anne (1710) was one of the first laws to protect the right to reproduce a work of literature.[15] It was meant to protect authors and proprietors of texts from having their work printed or published without

permission, as well as to encourage "learned men to compose and write useful books."[16] The first copyright law in the United State of America was the Copyright Act of 1790, a document that protected the right to print maps, charts, and books to individual authors and publishers.[17] The Copyright Act of 1909 furthered these rights to the original producers of music and works of art.[18] In recent history, the ability to copy copyright-protected content has increased due to the rise of digital content, and its availability via the Internet. In this light, various additional laws have been enacted in order to protect the sanctity of the copyright in the Digital Age.[19]

The ability for digital content to be copied exactly and distributed quickly has become a major issue of concern for artists in contemporary times. This, paired with contemporary views on what constitutes a creative act, forces us to seriously reconsider what it means to be an author, to own "intellectual property," and how content providers may distribute and benefit from their work. The acts of *sharing, borrowing,* and *giving* digital media on the Internet can give insight into the depth of these problems.

Sharing

Probably the most common debate on the issue of intellectual property is the pirating of digital content, mainly music, videos, and software. On what is known as peer-to-peer networks, digital files are "shared" over the Internet. Sharing is a euphemism for freely, and often illegally, distributing digital content online. Napster, a pioneer and one of the most infamous names in file sharing, was established in 1999.[20] Although Napster was subsequently shut-down by declaration of the United States Court in 2001, a plethora of other websites have been established to give Internet users a means for sharing digital files. Napster was reopened in 2002, as a legal music downloading site, requiring subscribers to pay a monthly fee, and later returned to offering free music in 2006, paying royalties via advertising.[21]

Since the failure and re-launch of Napster, various companies have tried a range of routes for distributing content legally, with one of the most attended to efforts being digitally licensed music. A song with a digital license will only play on specific devices, like an MP3 player or computer, that share a digital license with the song. The computer company Apple is seen by many as a leader in this field. Apple's online music store, iTunes, allows users to purchase music that can only be played on a certain number of devices, which must be approved by Apple.[22] There are various other

safeguards for digital content used by Apple and other companies, with results that do not yet fully satisfy content producers.

At the beginning of 2010, over a decade after Napster's appearance, music sales continue to be reported as a loss, with illegal downloads still heavily outweighing legal means. Although the online sale of music is growing, and has been for years, this growth has reported to have slowed. It is estimated that as much as ninety-five percent of music downloaded on the Internet is done so illegally.[23] It is hard to say where and how digital content will be bought, sold, protected, and stolen in the future, but it seems clear that producers of digital content must take leaps and bounds technically or philosophically to catch up to users of such content, and their desire to have music (software and videos) for "free."

Borrowing

It seems rather clear that "file sharing" of copyrighted media is against the law: it is the taking or using of one's product without his or her permission. A gray area appears when the content is, for the lack of a better term, borrowed. *Borrowing* happens when content is used as source material, subsequently getting fragmented or altered before it gets reused. This recycling, or remixing, of appropriated material may fall into what is legally known as "fair use." According to The Copyright Law of the United States (Circular 92), factors for determining fair use are:

1. The purpose and character of the use, including whether such use is of a commercial nature or is for nonprofit educational purposes;
2. The nature of the copyrighted work;
3. The amount and substantiality of the portion used in relation to the copyrighted work as a whole, and;
4. The effect of the use upon the potential market for or value of the copyrighted work.[24]

There is no set number of lines, percentage of change, or any measureable standard that must be met in order to warrant fair use, so it remains an issue of debate each time it comes to the table.[25] One need look no further than the monumental U.S. Presidential race of 2008 to find an example of the current dispute over what is considered fair use.

Shepard Fairey is a guerrilla street artist who became world famous in 2008 for his portrayal of then Presidential candidate, Barack Obama. Fairey created the now well-known red, white, and blue illustration of Obama's face with the word "HOPE" under it. The problem that catapulted this

image into the headlines of early 2009 is the fact that the original source of the image is credited to a photograph taken for the Associated Press (AP) by Mannie Garcia, a fact that Fairey did not deny.[26]

What Fairey did claim is that the AP does not have rights to royalties on the image or compensation for damages from its use, as they planned to sue him for. In fact, The Stanford Law School's Fair Use Project preemptively filed suit on the AP claiming fair use in Fairey's defense.[27] Fairey apparently found the image on the AP's website, and began using it without thinking to give credit to its original author, as appropriation is such a common practice in his art. The crux of the claim was that the image had been changed significantly both graphically and, most importantly, with regard to its intent.[28, 29]

As for claims of fair use in the future, as more art is comprised of pre-existing work, it is imminent that the definition of fair use will be bent to its breaking point. Eventually, as Bourriaud suggests, all available media will become simply a lexicon to be used by subsequent artists for further elocution. An honest artist will not be able to point the finger of copyright infringement without first questioning the sources of his/her own work, a venture that is sure to be proven absurd.

Giving

The lack of a necessity for claiming proprietary rights to art is already happening to a certain extent. A new wave of media is being put into the public with simply a desire to be seen, with little care for copying rights. The producers of this content practice the act of *giving*, offering their contributions on the Internet (generally free of charge) as "user generated content." Some generators of this content hope for a level of fame or capital gain, but it seems that many have an understanding of the slim likelihood of either happening, and just want a chance for their voice to be heard, be it politically, religiously, or artistically. User generated content (UGC), is usually hosted on a website geared toward showcasing a specific medium, a few examples being Myspace for music, Flickr for pictures, and YouTube for video. UGC can also be found on many commercial websites in the form of customer feedback.

Sites that host UGC invariably require users to agree to terms regarding copyright and use. Generally, the site forbids posting copyrighted material unless the user is the owner of said copyright. Also, the host is granted full permission to use content uploaded to the site. For example, YouTube's user agreement states:

> For clarity, you retain all of your ownership rights in your User
> Submissions. However, by submitting User Submissions to YouTube,

you hereby grant YouTube a worldwide, non-exclusive, royalty-free, sublicenseable and transferable license to use, reproduce, distribute, prepare derivative works of, display, and perform the User Submissions in connection with the YouTube Website and YouTube's (and its successors' and affiliates') business, including without limitation for promoting and redistributing part or all of the YouTube Website (and derivative works thereof) in any media formats and through any media channels. You also hereby grant each user of the YouTube Website a non-exclusive license to access your User Submissions through the Website, and to use, reproduce, distribute, display and perform such User Submissions as permitted through the functionality of the Website and under these Terms of Service... The above licenses granted by you in User Comments are perpetual and irrevocable.[30]

For many, this is just small print, the part of the contract that no one reads, and possibly wouldn't fully understand if one were to read it. But the merits of small print are not the issue here. The type of artist who would allow another person free range on a work of his/her making is. This type of artist possesses at least one of the following: a personal need to express him-/herself or a message that he/she feels must be heard.

One example of this type of producer is the Iranian protester who uploaded a cell phone video of a fellow protestor, Neda Agha Soltan, as she died from a gunshot wound allegedly delivered by Iranian police. At the time of this essay's composition, just eight months after the incident, it seemed impossible to determine the origin of the video; it had been copied, reposted, "remixed" with other footage, or referenced in other videos over 1,100 times.[31] Although footage or screenshots from the video can be found on essentially every major American news website, the only credit for the footage is given to "Anonymous" or YouTube.[32] The best leads for the "original" video ended with a dead link—a "This video has been removed by the user" screen on YouTube.

It is this lack of origin, this lack of the need for definitive authorship (by both author and audience) that seems to be the destiny for the majority of content that will be found in the future. It will be the media's message, the meaning that is conveyed, that will determine its value, whether as an end product, impetus for action, or raw material.

Epilogue

In the future, just as in the past, art will employ in its service the act of appropriation and the process of evolution. These primary elements of the creative process will perpetuate the delegitimizing of purity, originality, authorship, and ownership in the arts.

Perhaps it is its omnipresence and the seemingly infinite amount of digital content that is available that makes the contemporary means of appropriation seem inevitable. Maybe Benjamin was on to something: that because there is so much content, Art, in general, has lost its aura; it has become less valuable and people feel no need to pay for it, or give its producers credit. Possibly, Krauss was correct to propose that an origin is nowhere to be found. Perhaps, as Bourriaud suggests, Art will become so ubiquitous that it does truly dissolve into just another language, a collection of visual and audible signs that can be rearranged to form different meanings. If these proposals about loss of originality and authorship hold true, then a real corruption of the Romantic-Humanist view of pure artistic creation must be acknowledged and released, the same way that previous religious and political themes were let go.

This does not mean that art is dead. It means that how we think about art must evolve in sync with the way that art is made. *Un-originality must be expected and accepted.*[33] It is not that forgery and plagiarism need to be accepted (although they may be), but that the derivative or *re-arranged* work is accepted as a valid means of expression.

Discussions of art in the 21st century may benefit from a departure from vestiges of the cult of the pure. Origins and creators should be irrelevant in judging the effectiveness or value of a work. Further, the emphasis on purity of form and concept must be redirected to the formal and conceptual elements in a work of art being utilized in service of a communicative function beyond aesthetics. The acceptance of this thesis asks that the function of art be not one of creation or replication, but of communication. The merit of a work of art should be judged on how it affects its viewer/user, and if that effect serves the intention of what the artist has meant to convey. If the un-original work is accepted as valid art in the 21st century, all art can then be made and critiqued solely on empirically formal and sayable conceptual grounds. This system of artistic production and reception has the possibility of allowing more honest attempts at communication, void of the artificial requirements previously placed on communicators by the hegemony of "purity" omnipotent in one form or another during previous artistic eras.

Join the Conversation

Contribute to a dialogue pertaining to the concepts discussed in this chapter by directing your web browser to the following URL:
http://www.20UNDER40.org/chapters/chapter-8/

NOTES:

1. Harrison, C. & Wood, P. "Editor's Notes." *Art in Theory 1900-2000*. Malden, MA: Blackwell Publishing, 2003: 562; Fried, M. "Art and Objecthood." In Harrison, C. & Wood, P. (Eds.) *Art in Theory 1900-2000*. Malden, MA: Blackwell Publishing, 2003: 835.

2. Benjamin, W. "The Work of Art in the Age of Mechanical Reproduction." In Durham, M. G. & Kellner, D. M. (Eds.) *Media and Cultural Studies: Keyworks*. Malden, MA: Blackwell Publishers, Ltd., 2001: 49.

3. Ibid: 51.

4. Krauss, R. *The Originality of the Avant-Garde and Other Modernist Myths*. Cambridge, MA: MIT Press, 1986: 151-170.

5. Bourriaud, N. *Postproduction: Culture as Screenplay: How Art Reprograms the World*. New York: Lukas & Sternberg, 2002. [Translated by Jeanine Hermann].

6. Ibid: 9.

7. Ibid: 39.

8. Ibid: 17.

9. Benjamin, W. "The Work of Art in the Age of Mechanical Reproduction," 2001: 50.

10. Ideally, the transfer of digital information is perfect, but as we all know, on chance occasions, a glitch occurs, causing a change in the "new" information in its new situation.

11. Random House. "Classification." (n.d.), <http://dictionary.reference.com/browse/Classification>.

12. This is a tricky statement because technically, each thing that exists, does so in a unique section of space-time relative to its perceiver. It would follow that everything is unique to everyone. Although it sounds absurd, a further discussion of the theories and laws of Physics, of which will not be attended to here, would confirm this. Ultimately, if everything is unique, then making a value judgment based on originality is inconsequential.

13. Foucault, M. "What Is An Author?" In Harrison, C. & Wood, P. *Art in Theory 1900-2000*. Malden, MA: Blackwell Publishing, 2003: 952.

14. Ibid: 950.

15. Sherman, B. & Lionel, B. *The Making of Modern Intellectual Property Law: The British Experience, 1760-1911*. Cambridge, UK; New York, NY: Cambridge University Press, 1999: 207.

16. House of Parliament (UK). "Statute of Anne." (1710), <http://www.copyrighthistory.com/anne.html>.

17. United States. Congressional Senate. 1st Congress, 2nd Session. "Copyright Act of 1790." (1790), <http://www.copyright.gov/history/1790act.pdf>.

18. United States. Cong. Senate. 60th Congress, 2nd Session. "An Act To Amend And Consolidate The Acts Respecting Copyright, Section 5." (1909), <http://www.copyright.gov/history/1909act.pdf>.

19. Some of these laws can be found in these documents: "The Digital Millennium Copyright Act of 1998," "The Copyright Royalty and Distribution Reform Act

of 2004," and "The Prioritizing Resources and Organization for Intellectual Property Act of 2008." The detailed list of what can be and is copyrighted is in "The Copyright Laws of the United States," especially in section 106. All of which can be accessed at <http://www.copyright.gov/>.

20. Reuters. "Again (This Time Legally) Napster Offers Free Music." *New York Times.* (May 2, 2006), <http://www.nytimes.com/2006/05/02/technology/02napster. html?_r=1&scp=7&sq=napster&st=nyt>.

21. Ibid.

22. Apple. "Terms of Service, 10-iii." (n.d.), <http://www.apple.com/legal/itunes/ us/terms.html#SALE>.

23. Holton, K. & Cowan, M. "UPDATE 1-Recorded 2009 Music Sales Fell Around 10 pct–IFPI." Reuters. (January 21, 2010), <http://www.reuters.com/article/ idUSLDE60K1ZM20100121>.

24. United States Copyright Office. "Circular 92: Copyright Law of the United States and Related Laws Contained in Title 17 of the United States Code." (2009), <http://www.copyright.gov/title17/circ92.pdf>.

25. United States Copyright Office. "Fair use." (2009), <http://www.copyright. gov/fls/fl102.html>.

26. Gross, T. "Shepard Fairey: Inspiration Or Infringement." Fresh Air (National Public Radio). (February 26, 2009), <http://www.npr.org/templates/transcript/ transcript.php?storyId=101182453>.

27. Ibid.

28. Ibid.

29. Fairey has since admitted to falsifying some evidence in the lawsuit, but maintains his right to claim fair use. At the time of this essay's writing, a final decision has not been made on the case. For more, see Italie, H. & Mandak, J. "Shepard Fairey Admits Faking Evidence In AP Case." *The Huffington Post.* (October 17, 2009), <http://www.huffingtonpost.com/2009/10/16/ap-claims -shepard-fairey_n_324482.html>.

30. YouTube. "Terms of Service." (n.d.), <http://www.youtube.com/t/terms>.

31. Search statistics from YouTube.com, results from a keyword search of "Neda Agha Soltan." Search last conducted on February 25, 2010.

32. Websites searched include: abcnews.com, cbsnews.com, foxnews.com, cnn. com, msnbc.com, nytimes.com, and rueters.com. Searches were done on multiple occasions in January and February of 2010, with similar results.

33. A dashed spelling of "un-originality" has been used to emphasize "not originalness" as opposed to the unoriginality of a forgery or plagiarism. The same goes for "re-arranged" in the proceeding sentence; putting an emphasis on the arrangement of preexisting things or situations.

Re-Thinking Critique:
Questioning the Standards, Re-Thinking the Format,
Engaging Meanings Constructed in Context

Mariah Doren
Teachers College, Columbia University

This chapter follows the narrative of how an emphasis on originality in college art teaching is an impediment to a more open dialogue about meaning in artwork. It will examine how the idea of originality is presented to students and how meaning construction and objective assessment work at cross-purposes in traditional critiques. For art practices to function as a process of discovery, unfolding meanings and building value, we need to disengage its practices from linear expectations of originality and ideals of progress that are long standing traditions of assessment in art schools.

INTRODUCTION

In this chapter I will pull apart some traditions in the way we teach art and try to describe why there seems to be such distance between what is valued in the art world and how we assess quality in student artwork. By taking these structures apart and examining them in detail I hope to pinpoint the intersection of these two contexts for evaluating art and suggest ways to develop stronger connections between them. My goal is to question the standards and rethink the format, to re-assess assessment, and bring it in line with contemporary art practices. If I use the idea of valuing ambiguity as a wedge—the place where these two contexts for art making most clearly split—then our investigation might proceed with a search for situations and structures that not just embrace, but can also assess, ambiguity.

Art Doesn't Seem like a Traditional Academic Subject

Many artists and art educators believe there are ways of knowing in the arts that are unique and distinct from other academic disciplines.[1] When I look at an artwork some of the things I value are the sense of surprise, the work's ability to generate multiple potential meanings, and the way it causes me to re-examine things that seemed familiar. Ambiguity, openness, or the unexpected change from expectation "regarding the scope and ambition of an artwork is precisely what is hoped for."[2] Yet when analysis moves from the appreciation of artworks generally to pedagogy in art colleges, something is lost in the translation. When brought into art school, assessment seems to sever the connection to the process of discovering meaning and finding value with the openness that is so prized amongst artists outside of school. It seems like academia pushes and squeezes artistic practices to fit a mold that undermines the very attributes and strengths that are valued in the art world outside of academic institutions. Given the moves in higher education towards more stringent accountability this disconnection is bound to expand.[3]

I will look at assessment, and the practice of critique, in art school because I think it serves as both a point of resistance and an opportunity to engage new ways of thinking about art making. As we move toward making critique reflect contemporary art practices, to make it a useful assessment in art schooling, we need to address how it serves as a method *to help students make better art.* The traditional sphere of art pedagogy has encompassed technique and craftsmanship at one end of the spectrum and creativity at the other. I propose that we look outside these established traditions; when we start to value meaning in a work of art as context driven, contingent, and temporal then we will need strategies in teaching that engage these attributes; openness without losing criticality and ambiguity without complete relativism. What might a discussion about artwork without the goal of uncovering meaning, finding a singular solution, or universal truth look like? One possibility is that what is generated through this dialogue might be something like the performance of the meaning in an artwork. The assessment would be based on the quality of that dialogue, the value of the critique would be only as deep as the nature or structure that dialogue allows.

The Problem with an Air of Mystery

There is a mystique connected to artists in contemporary western culture: art making is often seen as a solitary and introspective practice—a talent one is born with rather than one he or she learns and develops. Throughout

the Modernist era the goal of art making was too often described as the development of an identifiable style—unique, novel yet recognizably one's own. The equation of artistic authority with individualism has led "self expression to be advocated as a major tenet of art education."[4] We are taught that the dominant mode of art making is solitary, a creative "frenzy… full of intuitions, impressions, and fantasy."[5] The line between ideas invested in an art object and the values, experience, and expectations of its maker is not easily drawn. There is an emphasis on novelty, or originality, as a wellspring that comes from deep within the artist. What seems unconsidered in the traditionalist approach is the relationship of the viewer to the art experience.

Art teaching is often modeled on observation and contact with an engaged practitioner—the artist. When the emphasis is on the subject, the artist, and the introspective nature of the art making process, meaning in the artwork is thought to be subjective, open to any interpretation. Understandably, we as art practitioners resist the development of rules or teaching strategies that dictate predetermined results, as we do not practice this in our own making of art. The dialogue developed out of this resistance might be so intimate and individualistic that it is hard to conceive how, or even why, external standards or measurements of progress are appropriate. Arts teaching suffers when linked directly to discussions of meaning in the work and critiques can become vague and idiosyncratic, as assessment in art education is thought to be more successful when it centers on discrete tasks, "the development of particular skills [and] comprehension of bodies of knowledge" as easily measurable criteria.[6] Because of this need, and the academic requirement of tangible assessment, traditional critiques, especially at the foundational level, have emphasized technique and form. The compositional choices the artist made in depicting their chosen subject, the elements of art and principles of design, and the toolbox of techniques often make up the core of the critique because they are easily assessed as learning outcomes. Issues of form and technique are more easily divided, outlined and set into lesson plans than the elusive notion of meaning. In addition, Modernists often valued form as the language of reason. Form might serve as a universal mode of communication because it is based on what is visibly present in the artwork. Because aspects of form are readily verifiable Modernists thought that form should be the basis for gauging value and understanding meaning, its neutrality could transcend contextual and cultural boundaries.

What and How Do We Grade Students?

While grading is a task many educators regard with "dread and distain" assessment and feedback are core components of educational activities.[7] They serve as one method of understanding the relationship between teaching and learning, gauging quality in students' work in relation to what an educator has intended to teach. When we determine learning outcomes or goals for teaching in advance, assessment then defines the specific criteria for each dimension and records or tests for its presence in the students' work. The criteria developed must be not only visible in the students' work in order to measure outcomes, but is ideally predictable, so we can match teaching strategies to desired results.

In discussions of contemporary artwork, the work we see in museums and galleries, some of the things that define quality are the sense of surprise, its ability to generate multiple potential meanings to a viewer, and the way it causes us to re-examine things that seemed familiar. Yet, ironically, these exact qualities can be perceived negatively in an educational context, as they represent the inability to pin down a firm understanding of the meaning in a work of art. This inability to decode or arrive at a clear interpretation of the meaning in an artwork threatens the idea of expertise as it is invested in the academy where "credibility has traditionally been based on claims of objectivity, impartiality, or universality."[8] It goes against conventional theories of assessment where the inability to confirm a hypothesis or predict outcomes for the purpose of schooling might count as failure. Although central to contemporary art practices, ambiguity is most often an impediment to articulating teaching methods and pedagogy, resulting in art teaching that at times seems agenda-less.

The focus on the internal format of the work—the elements of art and principles of design—allows us to gauge value through what is visually present in the artwork. This focuses the critique on the originative powers of the autonomous individual over external agencies or influences. The implication is that meaning in the art object is static, "placed" in the work by the artist and "unlocked" for the audience through the process of critique. To function well, these criteria demand "that whatever is important to understand about art is there in the artwork to be seen without reference to the world that lies outside the work."[9] The art teacher is placed in the position of connoisseur and vested with the authority to unlock these structures. If it is the teacher who builds the bridge between content and student, and the content is the introspective practices of the artist, where does the bridge go? Critiques can confuse psychoanalyzing the artist with decoding meaning in the artwork. We are presented with the paradox of

simultaneously assessing the development of the artist and the meaning of the artwork—a kind of pressure that can cause more traditional critiques to collapse under the weight of trying to decode meaning while simultaneously questioning the validity of decoding.

Given these contradictions, when directing a critique towards issues of meaning in the student's artwork the formulas can become stilted or even didactic: the student stands in front of the group and describes the work. The critique tends to focus on confirming or denying the presence of meaning as presented by the artist. In this model the role of the critic or art professor is often to adjudicate; they "pass judgment... suggest possible avenues to explore and.... prescribe certain ideas," they name successes and failures in rapid succession.[10] Although theories of progressive education ask that students participate in the critique of each other's work, in my experience students often dread critiques and resist participating.[11] If students speak at all they are reluctant to be critical, they might self-edit because of fear of retaliation or use affirmation of their peers as a means of community building. The insertion of dissonant voices in the context of assessment might be perceived as threatening the professor's expertise. Because the underlying context of critique is assessment, students often acquiesce to the professor's authority and try to name the answers they think the professor seeks.[12] Art critiques following this model function neither as an effective teaching method nor as a way of understanding the increasing complexity and conceptual basis for contemporary art where cultural context and ideas referenced but not visible are self consciously integrated in the artwork.[13] These potentials—sense of surprise, re-examination of the familiar, and ambiguity of meaning—are all things that artworks are valued for in other contexts, are avoided or opened only as an avenue assessed by the critic— the art professor and authority figure.

Valuing artwork for its originality assumes art practices are organized around the goal of progress. Within this construct, the ideal of progress is something linear such that an imaginative leap (forward) is possible and would result in creating something new. It presumes personal agency for the artist, as originality and autonomy are linked, but the direction seems simplistically defined; movement is constricted, too narrowly defined within expectations of forward progress. We tend to structure assessment as hierarchical, in a tree structure, where things have clear divisions: roots, trunk, leaves, and blossoms. However, when we do this, the equation made between imagination and originality truncates a discussion about the use of imagination outside this narrow linear path. Under this model, adherence to progress and advancement tends to come at the expense of

using imagination to provide the openness to see alternative possibilities or an alteration of expectations.

DISCONNECTIONS: WHAT WE VALUE AND WHAT WE TEACH

If we return to the notion of ambiguity as important to contemporary art practices, then it is fair to say that the use of critique as assessment in schools often works at cross-purposes with the desire to celebrate the multiplicity of meanings generated by a given artwork. We need to rethink assessment in the arts such that the practices that make artwork things we value and promote outside of academia can be celebrated in classroom discussions of that work. We might use Duchamp's understanding of the creative act as "not performed by the artist alone; the spectator brings the work in contact with the external world by deciphering and interpreting its inner qualifications and thus adds his contribution to the creative act."[14] In 1917 Marcel Duchamp took a common urinal, titled it *Fountain*, signed "R.Mutt" and tried to exhibit the object as art. In this classic example it is not the object, the urinal itself, but the artist's gesture, having the gall to sign it and place it on a pedestal as art, that causes us to stop, step back, re-examine the things around us, and to see them anew. The success of this work relies on our recognition of the urinal as an everyday object, removed from its usual context. This object is by no means original, unique, or different from what came before. The art experience is our reflection upon the combination of the familiar urinal *and* our seeing it in an art gallery. Duchamp's *Fountain* requires a viewer, the urinal must be *seen* out of context, for it to be transformed into a work of art. In this example, we see that meaning is not inserted by the artist into the artwork and decoded by the expert observer; rather, it is derived from the dialogue among and between viewers, object, and author. In this model, a model that has been at the core of contemporary art practices since Duchamp's urinal, all are invited as participants in the creation of the artwork. When we ponder this trajectory of contemporary practices, and *if* we value contemporary practices as integral to the education of art students, we must develop a more inclusive measurement of quality in a work of art, and we need to find ways to include context in a discussion of meaning.

"PERFORMING" MEANING: SOME THOUGHTS

While inclusive participation in the construction of meaning and value is not often part of art school assessment, the idea of performativity is addressed in other theoretical contexts. Judith Butler is a theorist whose work includes a feminist critique of how we understand and over simplify

the construction of gender. Butler introduced the idea of performative gender, that we construct our gender identity in specific contexts and these identities are changeable depending on the discourses in which we invest.[15] We might connect Butler's theory of performativity to an understanding of artwork as defined through the process of separation from the artist, developing meaning only as we bring it into discourse with others. In this understanding, the artwork takes shape through dialogue—at the intersection of the art object, the experience of the viewers, and the ensuing discussion.

In this new formation, understanding meaning involves analysis of the dialogue as much as the object that initiated it, making critiques function like a performative speech act. In the philosophy of language the term "performative" is described by John Austin as being used to explain the formation of a statement that is the "report of the performance of the action... in saying what I do I actually perform that action."[16] The example he uses is when a groom says "I do" during a wedding ceremony where the action of getting married, and all that the action entails, is performed at the moment those words are uttered.[17] In the context of understanding meaning in artworks, Duchamp described how meaning is "not performed by the artist alone, the spectator brings the work in contact with the external world by deciphering and interpreting its inner qualifications and thus adds his contribution to the creative act."[18] Here Duchamp explicitly states that the interpretation or understanding a viewer brings to the object is integral to creating the art experience. This is more than a passive reception of meaning inserted into the artwork by the artist, Duchamp suggests that the viewer's participation is part of the *creative act*, the artwork itself is the active dialogue between the work and its interpreter.

Traditionally, self-expression is seen as the structure undergirding art practices; an interior monologue made manifest in the exterior through the creation of the work of art. The idea of performativity goes beyond notions of subjectivity and individualism as promoted in standard art practices. When Butler described identity not as a fixed and stable thing, but identity as a *process*, she described an understanding of the subject as not predetermined. There is no underlying foundational or *a priori* self, subject, or identity that we might discover if we dig deep enough. One's self is a product of the things we believe that evolves over time and changes in different contexts. If we apply this concept of unmoored identity to meaning in a work of art it challenges not only the static notion of unveiling truth but also the very idea of the possibility of progress and the creation of something *original*. If meaning is understood as something more than placed in the artwork by the artist (and beyond being bound to

a specific context) but actually generated anew at each point of bringing it into discourse, then we need to re-think traditional understandings of originality as linked to notions of progress. In other words, if there is no linear, forward leading path to make "progress on," then it does us no good to value originality as something new and different from what preceded it.

A prevailing logic in academia is to seek the universal, to aim for information or theories that make generalizations. There is a "philosophical view that our intellectual aim is to find common underlying principles, generalizable rules [and] universal definitions" and that this is used as the measure of "coherence and credibility."[19] Following this logic, academics value finding commonalities that help to build consensus. This perspective can result in the reduction of complexity, moving away from multiple viable meanings to more singular or generalizable understandings of truth. Historically the reason we might have sought to separate the artist from the context and the objects they create is that it allows for an "I" that can create something original and a meaning that exists before and after the specific contexts where it is described.[20] The concept of identity is less complex if we treat it as an *a priori* assertion, not uncovered through analysis, rational argument, or questioning. If our essential self, who we are, is fixed then core values or markers of self are unlikely to change. This assumption that a foundational identity exists and is stable, separate from the contexts in which it exists is linked to ideals of progress and has been repeated so many times that its truthfulness is taken for granted. The formula has become naturalized in our society, it gives us a feeling of security and control and perpetuates a myth that progress is measured in a straight line, using identity as a potential fixed point of reference.[21]

Going back to the idea of critique, if the quest to make original art is tied to notions of progress it helps to see identity as unchangeable when measuring its success. However, when we posit identity as non-foundational, but assembled each time we are asked to define *who we are* then we can value difference between groups, and differences that change over time within individuals, as notions constructed in specific contexts. We then stop searching for universally valued themes, truths, or ideals of progress. We might instead use dialogue to develop meaningful understandings without the expectation of originality as evidence of progress. The quest for originality functions like blinders; if we remove these blinders, then possibilities may open up and investigations of meaning may take on a broader scope.

POSSIBILITIES OF OPENNESS IN THE STUDIO CRITIQUE

As an educator I ask how we might develop dialogues that are not dependant on what I see as the "myth" of originality. To start we might reposition the critique so it is not the culminating event, the moment of judgment on the value or quality of a completed project. If we move to a more open understanding of assessment we could treat the moment, the dialogue surrounding the piece, as the art performance to be assessed. Based on ideas of performativity, we might see meaning as generated each time we develop a dialogue about an artwork. In the midst of such a shift we might comfortably concede that the form of this dialogue is unknowable in advance.

Wiggins & McTighe developed the idea of "backwards design" in curriculum development as a way to base teaching on the outcomes of the learning process.[22] Assessment starts with the students' completed work and moves backwards to assess the teaching process. This is a flip on traditional ideas about teaching where the professor sets standards and the students' work is measured against achievement of these predetermined goals. In the context of an art critique using the completed artwork as the starting place for assessment might help focus assessment on the dialogue surrounding the artwork. Assessment could be based on artists' explanations that go beyond description; they could provide a well-supported account of the influences, decisions, and historical precedents for the work in question. Interpretation would require development by the group, and this dialogue would be the point of evaluation, the evidence and analysis given for a deep and inventive interpretation. Wiggins and McTighe described the first steps in the "facets of understanding" as explanation and interpretation.[23] These might provide the structure for assessment criteria.

BREAKING FROM EVERYDAY EXPERIENCE AND COMMON SENSE ASSUMPTIONS

Performativity might help us to understand the nature of meaning construction as non-linear, contextually bound and that the process of this construction is worth investigating through the dialogue of a critique. It helps us to move away from the seemingly direct connection between artist and artwork and to engage the lateral movements of the viewer's participation in this construction of meaning that is initiated by experiencing the artwork. Deleuze and Guattari developed a model to describe the structure of the way meaning is generated as a *rhizome*.[24] A rhizome is a divergent system, described as the opposite of tree-like hierarchical structures; it ceaselessly establishes connections between

semiotic chains, the meaning linked between concepts, organizations of power, circumstances, and ideas more generally. A semiotic chain is the process of making connections between meanings derived from the artwork. Growth is compared to a tuber or grass-like structures where concepts develop offshoots in an order that is not random, but also is not linear, hierarchical, or easily predictable. Either the art maker or the person interpreting the artwork could initiate direction in a dialogue; the roles are interchangeable.[25]

The recognition of the absurd, the ironic, or the surprise in artistic practices is one way art can create a rupture with the everydayness of our subjective experience. An artwork might cause us to step back and re-examine things that seemed familiar, things taken for granted as truth. This experience is a locus of art's transformative potential as things, ideas, or circumstances open up to the possibility of re-thinking or re-invention. Historically, we thought this process was initiated by the artist—artists made artwork that activated the viewer's response. If we describe this activation of meaning as a result of discourse, then the act, as well as the transformation, could in turn be initiated by any of the participants or developers of meaning in the work.

Based on this definition of rupture, the experience would not happen if a work were truly "original," as rupture, or the break from expectation, requires the art object to be connected to things we know. Originality in an artwork might be misunderstood as meaning something unique, distinct from the things that came before, when in fact it is the connection to the all-too-familiar made strange that we may assess and value in artworks. When things, places, or ideas are presented in a new way or changed manner it causes a viewer to re-examine the prior image or understanding—in a way, to check its validity. This act of re-examination is an opportunity for reassessment or change of opinion. Artists use this rupture to influence the viewer, asking them to participate in a reinvestigation of the object or idea in question. We might teach as if the discussion around the work were the "art" itself, if the work supported making people's thoughts in relation to the concept distinct from what came before. Again this strategy seeks to move the assessment of value to something experientially based and not object specific. The emphasis on rupture addresses many contemporary art practices where the art "object" is not necessarily the unit of measure for value. In this model of critique, meanings might unfold and be simultaneously re-problemitized. If we let go of our destination-oriented reliance on originality as the primary measure of value, the openness that results might become an endless cycle of engagement rather than a summative assessment or judgment.

Berger and Luckmann describe the *social construction of reality* as the way forms of knowledge are assumed to be common sense within the context of everyday reality, derived and supported through daily social interactions.[26] People interact with the belief that their individual perceptions of reality are related; they act upon this understanding and as a result, their common knowledge or perceptions of reality are reinforced. We slide easily into a practice where we externalize our subjective experience and mistake it for "truth" and therefore as something unchangeable. According to Marxist philosophers like Antonio Gramsci, our taken-for-granted realities are insidious, more than simple vestiges of our daily experience. Gramsci describes *hegemony* as the way the interests of the ruling class are internalized as common sense and then perpetuated without examining the underlying inequities.[27] Similar to the idea of social construction of reality, Gramsci might describe a political urgency about activities, like the creation of rupture experienced through dialogue about a work of art, as those that might help to shake off this kind of conventional thinking.

If we stop conflating originality with progress, the voice of the artist becomes an opening: picking and choosing salient points of expression, constructing meanings and making commentary that are context driven, subject to multiple interpretations, and changeable over time. The assessment could value not the isolated externalized object, but rather the multiplicity of meanings developed through dialogue and in a community. Using the critique to ask questions which build sequentially from topics initiated by the artist would help them clarify intentions. At the same time the movement away from expectation, the sense of surprise we value feeling in response to an artwork, could be initiated by any member of the community.

Building Meaning through Dialogue: A Valid Way of Knowing

One way that we might approach the critique as a community through dialogue can be found in *inquiry*. In inquiry format the dialogue is structured around a set of rules; the format values the process of inquiry, not the results of any specific investigation. The inquiry proceeds in stages: identifying issues, developing relevant questions, formulating hypotheses in response to the questions, testing hypotheses in dialogue, and confirming, revising, and retesting or abandoning based on results.[28] This is a cumulative process with the descriptive goal of giving account of why something happened. Not looking for objective truth to facilitate assessment might shift the focus in a critique so that we are freed up to value the experience of dialogue about meaning as a valid form of knowing. Practicing this type

of dialogue finds paths and connections that were previously unobserved. We don't move forward until there is agreement on interpretation within the community; the agreement may be provisional, but it does have a high burden of proof and builds off of prior agreements. This way of working improves participants' ability to think about their thinking. The knowledge produced is contingent and provisional, verified through the experience of individuals. The new knowledge created, of the kind that is central to inquiry methods, is the meaning in a given artwork—not uncovered but *built* through dialogue.

WHAT ARE WE SO AFRAID OF?

A fear in teaching has been that without clear and linear structure in critiques assessment may become completely relativistic, and the critique a waste of time. There is a common belief that the acceptance of contingency, especially about our core beliefs, leads to ironic displays and political apathy.[29] On the one hand, in this scenario the acceptance of contingency is seen as admission of defeat, an inability to "master" or contextualize understanding in a concrete external structure. Apathy and relativism result from the absence of a belief in progress. On the other hand, one thing that keeps openness from becoming rampant relativism is the sense of responsibility constructed within an engaged community.[30] There might be room for an exploration through dialogue—developed and sustained over time—in the context of a strong community, a group that has established trust, mutual respect, and caring, that creates space for art as social critique.

A rejection of foundational identity and linear understanding of progress represents an attack on rationality. This has political implications that go beyond understanding the politics that might be addressed in the subject of the artwork. Maxine Greene stresses the value of the imaginative powers that give us a sense of agency. It is our imagination that allows us to see reality as full of variety and alternative interpretations, changeable based on our perceptions.[31] Epifanio San Juan uses the example of Surrealists who explored the use of the subconscious in art not just because they saw these "dreams, fantasies, and irrational behavior as the repository of utopian possibilities," but also because "the marvelous can be released only in the gratuitous instants or privileged moments of rupture when rational awareness is suspended, neutralized, or cancelled altogether."[32] This sense of agency and possibility is a way of thinking that we might learn from engagement in a structured dialogue that investigates meaning as a socially and contextually constructed phenomenon. If art practices are understood

as the dialogue inclusive of the object, the maker, and the viewers, the critique could inscribe the dialogue within an engaged community with potent political implications. We might open ourselves to new definitions and meanings as we engage in a process, position, or attitude of questioning that seeks no conclusions or generalizable outcomes.

In each of these accounts: the rupture as the break from our subjective realities; the rhizome as the non-linear, non-hierarchical structure for building understanding; and the performative nature of meaning in works of art—my goal has been to rethink the way we structure assessment of artworks in a studio art classroom.

TOWARDS A RE-ENVISIONED CRITIQUE: ART PRACTICES UNDERSTOOD AS THE *WHAT COULD BE*

I see two Modernist myths—the importance of self-expression and the promotion of originality as the pinnacle of success—as major impediments to the development of a more open dialogue about meaning and understanding. If we dissolve the expectation of originality, linearity, and progress, critique has a chance to be descriptive and foster a sense of agency within an engaged community.

Engaging the unknowable, the ambiguous, the possibilities of meaning in art practices is an opening that might help us value the sense of newness developed as an experience rather than an outcome. Valuing the viewer, or the groups of art students present during a critique, as co-constructors of meaning in the art experience could help shift the emphasis in teaching art from the development of "articulate" self expression to a sustainable dialogue about meaning, understanding, and value within a strong community. Assessment might focus on the art student's understanding of what they did and its relationship to the vigor of the community's dialogue about meaning. Students might strive to increase resonance between the raw material that is their personal experience, its translation into art object and its recognition and interpretation through an audience—their work's ability to stimulate a dynamic understanding within an engaged community of peers. At the same time, the group would work to improve their facility at using dialogue to generate meaning with an artwork as the basis for discussion. The dialogue developed is not vague, conversational, or uncritical. In traditional inquiry dialogue proceeds methodically: the process starts by identifying a list of issues that seems relevant to a specific artwork. From there the group formulates and prioritizes the questions that will guide inquiry. A hypothesis is developed for each question and these are tested through dialogue. Testing is the process of building meaning:

the group seeks refinement and clarity on the idea presented, the question, and the possible answer based on the artwork. This process also involves testing the hypothesis against experience exterior to the work itself (its generalizability). There will be multiple questions developed as each group confirms, revises, and retests or abandons the hypothesis at hand. At the end of the inquiry process the group summarizes the relevant findings or list of possible meanings.[33]

We can celebrate the ambiguity or multiplicity of meaning when we recognize that the audience or community shares equal responsibility for its development—the questions posed are theirs to choose. There is no singular solution or truth to uncover; the more rigorous or real possibilities are opened the more dynamic the dialogue surrounding the work becomes. In the contemporary art world this sense of openness, ambiguity, or the unexpected change from expectation is prized, and yet so far it has found little traction within the assessment of students work in art school.

The development of one's voice as an artist is an intractable combination of personal expression and contexts that dips in and out of history. It asks for an assessment that constantly re-calibrates, and is not defined in advance. The critique could engage students in a dialogue that valued their experience and ability to interpret images, constructing meaning without privileging a search for universal or singular truths. The development of agility in the context of dialogue about meaning might move art practice towards a more active stance in participation or construction of culture. This idea challenges the expectation of linearity in traditional assessment as the measurement of progress and the goal of education. The process of making meaning through art is subjective but rather than shirk responsibility for meanings generated we might understand our community as having responsibility garnered through exercise of our imaginative facilities. We should not lose this sense of purposefulness or agency that embracing a contextually bound understanding of art might bring. The engagement of our imaginative powers can give us a sense of agency—"to live not as an object but as a subject of history—to live as if something actually depended on one's actions."[34]

Join the Conversation
Contribute to a dialogue pertaining to the concepts discussed in this chapter by directing your web browser to the following URL:
http://www.20UNDER40.org/chapters/chapter-9/

NOTES:

1. Bruner, J. *On Knowing, Essays for the Left Hand.* Cambridge, MA: The Belknap Press of Harvard University Press, 1964; Bruner, J. *Actual Minds, Possible Worlds.* Cambridge, MA: The Belknap Press of Harvard University Press, 1986; Bruner, J. *Acts of Meaning.* Cambridge, MA: The Belknap Press of Harvard University Press, 1990; Schon, D. *Educating the Reflective Practioner: Toward a New Design for Teaching and Learning in the Professions.* San Francisco: Jossey-Bass, 1987.

2. MacLeod, K. & Holdridge, L. *Thinking Through Art: Reflections on Art as Research.* New York: Routledge, 2006: 36.

3. Katz, S. "Taking the True Measure of a Liberal Education." *The Chronicle of Higher Education* 54, no. 37 (2008): A32.

4. Desai, D. "The Ethnographic Move in Contemporary Art: What Does It Mean for Art Education?" *Studies in Art Education* 43, no. 4 (2002): 319.

5. Wolf, D. "Artistic Learning: What and Where is It?" *Journal of Aesthetic Education* 22, no. 1 (1988): 144.

6. Elkins, J. *Why Art Cannot Be Taught.* Chicago: University of Illinois Press, 2001; Eisner, E "Overview of Evaluation and Assessment: Conceptions in Search of Practice," in Boughton, D., Eisner, E., & Ligtvoet, J. (Eds.), *Evaluating and Assessing the Visual Arts in Education.* New York: Teachers College Press, 1996: 14.

7. Nilson, L. *Teaching at Its Best: A Research-Based Resource for College Instructors.* Boston, MA: Anker Publishing Company, 2003: 211.

8. Burbules, N. *Dialogue in Teaching: Theory and Practice.* New York: Teachers College Press, 1993: 3.

9. Parsons, M. "The Assessment of Studio Work and the Distrust of Language," in Boughton, D., Eisner, E., & Ligtvoet, J. (Eds.), *Evaluating and Assessing the Visual Arts in Education.* New York: Teachers College Press, 1996: 59.

10. Elkins, J. *Why Art Cannot Be Taught.* Chicago: University of Illinois Press, 2001: 152.

11. Dewey, J. *Art as Experience.* New York : Minton, Balch & Co., 1934.

12. Brookfield, S. & Preskill, S. *Discussion as a Way of Teaching: Tools and Techniques for Democratic Classrooms.* Hoboken, NJ: Jossey-Bass, 2005.

13. Wilks, S. Aesthetic Education: A New Reflection in the Mirror. *Thinking* 15, no. 4 (2001): 34-44.

14. Duchamp, M. "The Creative Act." Session on the Creative Act, Convention of the American Federation of Arts, Houston, TX, April 1957: 2.

15. Butler, J. *Gender Trouble.* New York: Routledge, 1990.

16. Austin, J. "Performative Utterances," in Stainton, R. (Ed.), *Perspectives in the Philosophy of Language: A Concise Anthology.* Peterborough, Ontario: Broadview Press, Ltd., 2000: 241.

17. Ibid.

18. Duchamp, M. "The Creative Act," 1957: 2.

19. Burbules, N. *Dialogue in Teaching: Theory and Practice,* 1993: 3.

20. Butler, J. *Gender Trouble,* 1990.

21. Ibid.

22. Wiggins, G. & McTighe, J. *Understanding by Design*. Alexandria, VA: Association for Supervision and Curriculum Development, 1998: 1.

23. Ibid: 44.

24. Deleuze, G. & Guarttari, F. *A Thousand Plateaus: Capitalism and Schizophrenia*. Minneapolis: University of Minnesota Press, 1987.

25. Ibid: 7.

26. Berger, P. & Luckmann, T. *The Social Construction of Reality: A Treatise in the Sociology of Knowledge*. New York: Anchor, 1967.

27. Gramsci, A. *Antonio Gramsci: Further Selections From the Prison Notebooks*. Boothman, D. (Trans & Ed.). Minneapolis, MN: University of Minnesota Press, 1995, 1937.

28. Gregory, M. "A Framework for Facilitating Classroom Dialogue." *Teaching Philosophy* 30, no. 1 (2007): 62.

29. Critchley, S. "Response to Richard Rorty," in Mouffe, C. (Ed.) *Deconstructions and Pragmatism: Simon Critchley, Jacques Derrida, Ernesto Leclau & Richard Rorty*. London: Routledge, 1996.

30. hooks, b. *Teaching Community: A Pedagogy of Hope*. New York: Routledge, 2003.

31. Greene, M. *Landscapes of Learning*. New York: Teachers College Press, 1978.

32. San Juan, E. "Antonio Gramsci on Surrealism and the Avantgarde." *Journal of Aesthetic Education* 37, no. 2 (2003): 36.

33. Gregory, M. "A Framework for Facilitating Classroom Dialogue," 2007: 62.

34. Marcus, G. *Lipstick Traces: A Secret History of the 20th Century*. Cambridge, MA: Harvard University Press, 1989: 6.

Choreographing Embodied Anatomy as a Method for Igniting Kinesthetic Empathy In Dance Audiences

Shannon Preto
Dance/Theater Shannon

As a result of an over-reliance on media and digital technology society has become more disembodied. Dance choreographers have fed into this phenomenon by choreographing visually extravagant or technologically enhanced dances with easily quantifiable technique. But by focusing on these two attributes, choreographers have disembodied their dancers and their audiences from the very thing unique to dance. As a result, dance is losing the richly textured and deeply expressive performing presence that is meant to extend into the theater and encircle its audiences. I propose that through embodied anatomy, dance choreographers can re-ignite a kinesthetic empathetic connection to their audiences.

As a choreographer I have a big beef with modern dance these days. My beef is with the trend among dance choreographers to privilege the visual perception of dance above all else—above the dancing body on stage and the observing bodies in the audience. It is my opinion that many contemporary choreographers have come to believe that in order to make dance meaningful it must be enhanced by visual and auditory pyrotechnics. One result of this privileging of media and digital technology in dance is that more attention is given to the visual design of choreography rather than the transmission of intention, feeling, and depth portrayed through dancing itself. It seems to me that choreographers have pared down their dances into mere intellectual exercises—thereby dividing the mind from the body. Lured by the glitz of new media and the pressure to attract

visually savvy audiences, choreographers are leaving behind the visceral experiences of their dancers' bodies as well as their audiences' bodies, or, as I will layout in this chapter, their integrated body/mind sensations and expressions.

It is the kinesthetically expressive body that separates dance from the other arts. And it is the body that is getting lost in the technological flood of today's dance theaters. In this chapter, I suggest that re-engaging with the deep structures and sensations of the performing body through embodied anatomy and connecting with kinesthetic empathy may once again provide a unique and deep-seated corporeal experience for dancers and dance audiences alike.[1]

WHERE DOES THIS BIG BEEF COME FROM?

Lately, when I've experienced dance onstage, I often watch bodies in motion, usually in front of visually rich video. What I am missing is a visceral connection between the choreography and myself. I don't sense any tension happening between the dancing bodies, the bodies and the music, or the bodies and the space. I am overcome by visual and aural stimuli, but don't get that "something extra." This is partly because I am visually distracted and partly because I am not being offered anything that evokes a bodily investment as an observer. This is what I want when I experience dance. I want to invest myself and experience something new—something that stimulates more than my eyeballs and primary visual cortex. I want to experience the textures of the dancing bodies. I want to feel the amount of effort being exerted to execute movement. I want to sense the rough, smooth, scratchy, silky, and wooly qualities of bodies engaged in choreographed interaction. As an audience member, I want to experience the interplay between the visual, auditory, and kinesthetic senses in my brain and my body. Ultimately, I want an embodied artistic experience.

The amount of time people spend in front of televisions and/or computer screens is growing exponentially, but especially for younger individuals.[2] As a result of so much time spent staring at TVs, computer displays, or cellphone screens, these younger generations are hyper-developing their visual and auditory senses. As artists, choreographers have been led to believe that in order to remain relevant, they must shift their working aesthetic to better "reflect" what people are most comfortable interacting with *now*. For many in the field of dance, this fear of becoming irrelevant has led them to succumb to continually presenting "cutting-edge" work that overly incorporates fantastical visual technology. Using these technological tools to stay "fashionable" and "cutting-edge" might

bring younger audiences towards experiencing concert dance—but these younger audiences are not necessarily returning to dance theaters.[3] I believe one reason this demographic is not returning is because the dances they see are not necessarily refreshing their whole body perceptions.

The visually spectacular dance will never be able to compete with the visual richness young people are bombarded with in their daily digital lives. And while I agree that dance must include (or at least consider) all of the tools at its disposal, choreographers must give primacy to the dancing body. It is the dancing body alone that can speak to and provide a vastly different experience from that which audiences may get when sitting in front of a digital screen. Therefore, choreographers have to put all of these deeply resonating and expressing dancing bodies in the foreground and then employ the technological pizzazz to support the body in motion—not over-rule it. Choreographing with the deeply expressive body will result in audiences having a fuller sensorial experience rooted in their bodies, reverberating in their minds, and producing lasting memories to integrate into their daily lives.

How Can We Solve this "Problem?"

In order to provide audiences with more resonant experiences, dance choreographers need to delve more deeply into the performing body to create an expansive artistic expression—one that is felt and experienced with all of one's senses. Think of it as a symbiotic effect—what dancers feel in their performing bodies has the potential to give their audiences something to feel in their observing bodies as well.[4] The "medium" in dance is the human body. And it is in the kinesthetic sense that the exchange of artistic intention occurs. By choreographing towards the kinesthetic sense, the intention is communicated from the dancer's bodies to the audience's bodies. If dance audiences have resonant bodily experiences, I posit that these experiences will ignite audience members' kinesthetic senses and will increase the likelihood of them remembering these experiences when they leave the theater.[5] If the experiences dance audiences have are more memorable, and therefore more meaningful, they will be more apt to return to see dance for its uniquely artful kinesthetic engagement.

Embodying the Anatomy to Deepening our Expression

One method for re-enlivening the bodies of dancers and their audiences is through embodied anatomy. To embody anatomy is to become conscious of the body's internal structures—their locations, processes, and interactions

with one another. Bonnie Bainbridge Cohen describes the embodiment of anatomy process as:

> ...discovering the relationship between the smallest activity within the body and the largest movement of the body—aligning the inner cellular movement with the external expression of movement through space. This involves identifying, articulating, differentiating, and integrating the various tissues within the body, discovering the qualities they contribute to one's movement, how they have evolved in one's developmental process and the role they play in the expression of the mind.[6]

Through embodiment one may heighten his sensations to the flows, the rhythms, the effort, and other qualities his body employs to function and move. One becomes more embodied when he understands how he takes in different stimuli, through his vision, taste, hearing, smell, touch—and kinesthetic sense.

Inherent in this process of embodiment is increasing the skillful use of the body's proprioception. Proprioception is loosely referred to as one's "sixth sense," in that it is an internal system for perceiving the body in motion and in space. When you lift a cup of water to drink from it, the body registers through the proprioception system both the movement of the lower arm and the relationship between the cup and your mouth. By sitting in front of screens and displays, the skillful perception of one's body is diminished. Therefore, I argue that through a focus on multimedia technology in dance, the audience's proprioceptive systems are being further neglected in the very space where they ought to be aesthetically stimulated. If, however, dance choreographers primarily focus on igniting the proprioception systems of their audiences through kinesthetic-based artistic experiences, they may begin to provide an opportunity for audiences to become more aware of "being in their bodies," enlivening their kinesthetic sense. The performative event as one amongst many can be an open and shared space for audiences to refresh their proprioception systems, become more fully embodied, and re-configure their understandings of themselves in the world.

EMPHASIZING EMBODIMENT, AGAIN

What I am advocating for is the integration of the body and the mind into a singular body/mind paradigm. The oblique slash (/) in the phrase "body/mind" is intentional. I aim to level the brain-to-body hierarchy and create a more efficient "interface" between the two.[7] I also use this symbol to convey a meaning of embodiment—wherein neither the brain nor the body takes precedence over one another, but both act as one unit. The hopeful goal

of embodiment is making the body/mind interface more effective for the exchange of physical, intellectual, and emotional communication in the person.

Moreover, the use of the slash emphasizes the concept of embodiment in human cognition. Philosophical conversations around embodiment have been going on for quite some time. These dialogues attend to how and where human cognition occurs. Does it occur only in the brain? Or does cognition occur in the body as well?

Back in the 1600s, the French philosopher René Descartes professed that "the essence of being was thinking, and that the mind was separate from the body."[8] Descartes professed that "being" was dualistic, with the mind and body acting as "two different clocks keeping perfect time."[9] This philosophy privileged the mind over the body, suggesting that "the mind was the seat of consciousness and rational decision making..." and that the "body acted in a mechanical way."[10] It was the mind that was the sole proprietor for running, managing, coordinating, and commanding the person.

Based upon Descartes' ideas, later philosophers have theorized that the body is just a machine and that the brain is "envatted" within it.[11] Such assertions suggest that the brain sits in a pool of nutrient rich fluid orchestrating everything like the motherboard of a computer while the body is passive—like the rest of the computer. This train of thought further suggests that the brain receives input through the senses, "computes" them, and then creates outputs that command the body to act. The body doesn't perceive itself or help to compute the next action. It just completes the commands of the "computerized" brain. Both the Cartesian *Cogito ergo sum* and the "envatment" theories of later philosophers may be summed up with the word "disembodied." This use of the word suggests that the body has no relation to the mind. Nor does the body have any interaction with its environment or any perception of itself. The body is a machine disconnected and "disembodied" from the self.

Contrary to this opinion, other philosophers have refuted the division of the mind and the body and instead suggest that human cognition is comprised of both intellectual musings and bodily perceptions. The beginnings of embodiment can be traced back to the philosopher Maurice Merleau-Ponty. Merleau-Ponty's theories promote the idea that "[p]erception of an external reality comes about through and in relation to a sense of the body."[12] Embodiment gives credence to the role the body plays in perceiving the world. The embodiment "process" is integral for understanding the interchange across the body/mind and world interface.

This idea of embodiment becomes important as dance choreographers begin to attend to increasingly isolated audience members.

Though many people are becoming more digitized, some are becoming refocused on what it means to be human and living fully in the body.[13] Consider the recent turn in computer science toward what is called social and tangible computing. Social computing "attempts to incorporate understandings of the social world into interactive [computer] systems."[14] Tangible computing, amongst many different activities, addresses how various "sorts of approaches can be harnessed to create environments for computational activity in which we interact directly through *physical* artifacts rather than traditional graphical interfaces."[15] [emphasis mine] Examples of social and tangible computing are smart phones and home gaming systems like the highly popular iPhone and the Nintendo Wii. Both types of devices are incorporating either larger gestural or full-body activation for game play, interaction, or communication. These new computational systems are incorporating hardware and software into our lives that increasingly reflects what computer scientist Paul Dourish refers to as *"the ways we experience the everyday world"* [emphasis in original].[16]

In another area of research, some theorists are re-visiting our popular understanding of what empathy is and where it occurs. Because we are now capable of synthesizing information through the Internet from geographically disparate parts of the world, our global community is beginning to have empathy for individuals outside of any one specific location. We are starting to identify with and reflect upon what other people may be experiencing. Much of the research on empathy has resulted from the discovery of mirror neurons. Mirror neurons are found in the brain and are activated when we observe others executing actions similar to actions we have performed.[17] But it isn't only the visual and auditory senses that are being connected to mirror neuronal response. As economist and activist Jeremy Rifkin suggests: "While scientists have noted that visual gestures and expression, as well as auditory resonances, activate mirror neurons, they are also finding that touch does so as well, creating still another sensory path for empathic extension."[18] Therefore, an individual can have a kinesthetic response of shivering in their body as they watch ice melting down someone else's arm. It is this recognition of a kinesthetic, empathic response that is part of making connections between oneself and another's physical experiences.

These three examples serve as evidence of our cultural return towards the body. Dance, as both a product of and a reflection upon our contemporary culture, is beginning to explore the importance of the body as both participant and observer. The notion that dance, as an art form,

may contribute to the resurgence of the socially interacting body is known as kinesthetic empathy.

Identifying in My Body Someone Else's Experience

Kinesthetic empathy is a term coined by Susan Foster, a professor, dancer, and writer in the UCLA Department of World Arts and Culture. In her essay "Kinesthetic Empathies and the Politics of Compassion," Foster defines kinesthetic empathy as "the physical experience of feeling what another body is feeling."[19] In her article, Foster's aim is to "insert physicality into the dynamics of exchange during any moment when a person claims to know something about another's experience."[20]

Scientific research highlights data that supports the notion that our bodies react to stimuli in ways that mirror what they observe. Such studies can also serve as tools to enhance a choreographer's emotional expression of dance.

Calvino-Merino et al.'s 2008 study, "Towards a Sensorimotor Aesthetics of Performing Art," proposes a connection between observation and bodily reactions while watching movement.[21] In this study, the researchers investigated the brain activity of subjects as they watched both a ballet dancer and a Capoeiraista—one who "plays" the Afro-Brazilian hybrid martial arts/dance/music art form Capoeira. With different brain regions "lighting up" during different movements, the researches were able to quantify what movement qualities the brain found particularly engaging. This study was looking at the objective cause and effect of movement on brain activity. It didn't measure whether or not or why the subjects found the movements artistically pleasing, only that the body itself responded. In their conclusion, Calvino-Merino et al. found that "the degree of whole-body movement is a major driver of aesthetic evaluation of dance and also has reliable consensus correlates in sensorimotor and visual form process areas of the human brain."[22] The brain registers activities it perceives even if the mind is unconscious of such activities.

In another study concerning emotion and movement, author Maxine Sheets-Johnstone makes a strong case for the correlation between feelings and bodily movement. Sheets-Johnstone starts out by stating "emotions are grounded in a neuromuscular dynamic."[23] Through her study, Sheets-Johnstone quantified how observers see emotion through movement by breaking down whole-body "gestures" into four general qualities. These four qualities are "tensional," which can be construed as the physical movement of the body; "linear," the body in relation to the space surrounding it; "amplitudinal," the amount of time or meter

the body moves; and "projectional," the amount of energy the body uses. Sheets-Johnstone notes that all four of these qualities are intertwined and the combination "articulate[s] a particular qualitative dynamic."[24] This active, body dynamic may show evidence for emotion as a "kinetic form of the tactile-kinaesthetic [*sic*] body."[25] What Sheets-Johnstone has argued is that as an observer witnesses the dynamic combination of these four movement qualities, the observer correlates the whole-body movement with an emotional state.

These aforementioned studies demand great consideration when choreographing physicality in time, space, and energy. Knowing this kinesthetic connection, choreographers have to pay more attention to the body's vast knowledge and expressive power. These studies give us hints into how movement and dance can consciously and subconsciously affect people. The implementation and crafting of these body-focused findings in a media saturated world is the artistic challenge facing choreographers *now*.

EXPRESSING A FULLER PERFORMING PRESENCE THROUGH EMBODIED ANATOMY

In dance classes, aspiring dancers are often taught to learn and reproduce choreographed movement phrases.[26] What is often missing in such instruction is how the dancers perform the emotional, textural, or tensional qualities of the choreography. What is inferred within technique classes is the assumption that one is either gifted with a strong performing presence or one is not, and that perfectly executing the choreography is "good enough." As a choreographer I believe that the field of dance needs to refocus its technique education on the process of embodied anatomy as a method for extending the dancer's performing presence to encompass the audience, giving them the opportunity for a kinesthetic, empathic experience. As the School for Body-Mind Centering notes:

> Embodied Anatomy is a deep, internal study of the body which goes beyond intellectual and experiential approaches. Movement is explored through the direct experience of our own body systems, tissues and cells. The learning process takes place not just in the mind, but in the body itself and the experience is integrated at the cellular level.[27]

In the process of delving deeply into the anatomy of the body, dance educators can guide dance students towards tapping into the movement characteristics present in the body's anatomical structures. For example, embodying the heart might suggest a movement preference for spiraling upward and to the left/moving with a strong force/maintaining a constant

rhythm. Perceiving and choosing the different tensional, textural, and emotional qualities behind the effort of moving from the perspective of one's anatomy may help a dancer extend her performance beyond the front row. Extending dancers' performing presence will provide dance audiences with powerful kinesthetic experiences to respond to. Through an embodied anatomy process, choreographers may capture this "power." They can then use this power to create lush movement, support a dancer's sumptuous performing presence, and offer audiences genuine opportunities to experience their own bodies. If dance audiences are experiencing how their bodies respond to what they are observing, they are in turn becoming more embodied. The more embodied audiences become, the more kinesthetic empathy they may feel for others as the interface between their brains, bodies, and emotions become more integrated.

Here's What I Am Saying (in Conclusion)

Because technology preferences the visual and auditory senses, dance audiences are given an insubstantial bodily experience. By using the process of embodied anatomy to create and perform the deeper expressions of the whole body, choreographers may reconnect dancers with their audiences and audiences with their own bodies. By re-emphasizing the presence of a dancer's body and subsuming technological effects, choreographers have the renewed potential to create a space for audiences to experience a sense of kinesthetic empathy. Used properly, visual technology in dance should support and amplify kinesthetic expression and choreographic intention. If choreographers can connect a fuller corporeal artistry onstage to their audiences' bodies in their seats, they can provide them with a more personal memory for revisiting their dances and artistic insights.

Join the Conversation
Contribute to a dialogue pertaining to the concepts discussed in this chapter by directing your web browser to the following URL:
http://www.20UNDER40.org/chapters/chapter-10/

NOTES:
1. I use the word "structure" to address the different parts of our anatomy. These structures can be perceived individually or as a part of a whole system. We can sense the heart, the heart as a part of the cardiovascular system, the blood in the cardiovascular system as fluid, etc.
2. *Washington Post.* "Kids Stay Plugged In for Longer, Study Finds," *San Francisco Chronicle*, Section A-8. (January 21, 2010).

3. National Endowment for the Arts. "2008 Survey of Public Participation in the Arts." Research Report #49. (2009), <http://www.nea.gov/research/2008 -SPPA.pdf>.

4. Camurri, A., Lagerlof, I., & Volpe, G. "Recognizing Emotion from Dance Movement: Comparison of Spectator Recognition and Automated Techniques." *International Journal of Human-Computer Studies* 59 (2003): 213-225; Simpson, M. "Mirror Neurons in the Brain: How They Help Dancers As They Train." (2008), <http://www.ballet-dance.com/200806/articles/ mirrorneurons20080600.html>.

5. Fuchs, T. "The Memory of the Body." (n.d.), <www.uniklinik-heidelberg.de/ fileadmin/zpm/psychatrie/.../fuchs.pdf>; Wilson, M. "Six Views of Embodied Cognition." *Psychonomic Bulletin & Review* 9, no. 4 (2002): 625-636.

6. Cohen, B. B. *Sensing Feeling, Action, 2nd Edition*. Northampton, MA: Contact Editions, 2008: 2.

7. Valerie A. Briginshaw uses the oblique "to indicate the conjunction of two concepts creating an interface." Briginshaw, V. A. *Dance, Space and Subjectivity* New York, NY: Palgrave Macmillan, 2009: 1

8. Osborne, R. & Edney, R. (Ills.) *Philosophy for Beginners*. Danbury, CT: For Beginners 2007: 73.

9. Ibid: 74.

10. Dourish, P. *Where the Action Is*. Cambridge, MA: MIT Press, 2004: 18; Osborne, R. & Edney, R. (Ills.) *Philosophy for Beginners*. Danbury, CT: For Beginners 2007: 75.

11. Shapiro, L. *The Mind Incarnate*. Cambridge, MA: MIT Press, 2004: 175.

12. Dourish, P. *Where the Action Is*, 2004: 114.

13. Bennet, D. "Don't Just Stand There, Think." *The Boston Globe,* Ideas Section. (January 13, 2008); Angier, N. "Abstract Thoughts? The Body Takes Them Literally." *The New York Times*, Science Section. (February 1, 2010); Carey, B. "Evidence That Little Touches Do Mean So Much." *The New York Times*, Health Section. (February 22, 2010).

14. Dourish, P. *Where the Action Is*: 16.

15. Ibid: 15.

16. Ibid: 17.

17. Rizzolatti, G. & Craigher, L. "The Mirror Neuron System" *Annual Review of Neuroscience*, (2004): 180.

18. Rifkin, J. *The Empathic Civilization: The Race to Global Consciousness in a World in Crisis*. New York, NY: Jeremy P. Taurcher/Penguin, 2009: 84.

19. Foster, S. "Kinesthetic Empathies and the Politics of Compassion," in Janelle G., Reinelt, J. G., & Roach, J. R. (Eds.) *Critical Theory and Performance*. Ann Arbor: University of Michigan Press, 2007: 245-258.

20. Ibid: 245.

21. Calvo-Merino, B., Jola, C., Glaser, D. E., & Haggard, P. "Towards a Sensorimotor Aesthetics of Performing Art." *Consciousness and Cognition* 17, no. 3 (2008): 911-22.

22. Ibid: 920.

23. Sheets-Johnstone, M. "Emotion and Movement." *Journal of Consciousness Studies* 6, nos. 11-12 (1999): 259-277.

24. Ibid: 269.

25. Ibid: 267.

26. "Phrases" is a dance vocabulary term that describes a series of movements or steps next to each other.

27. School for Body-Mind Centering. "Embodying the Body in Yoga." (n.d.), <http://www.bodymindcentering.com/Programs/EmbodiedYoga/>.

Attracting 21st Century Arts Audiences:
An Administrative Perspective of Arts Participation
from Portland, Oregon

Elizabeth Lamb
University of Oregon, Portland

This chapter investigates the ways in which leading arts administrators in Portland, Oregon understand and encourage arts participation of Gen Xers and Millennials, individuals ages 11-43. By examining administrators' perceptions of arts participation patterns of these age cohorts, the author identifies emerging modes of arts participation and arts programming models. The findings provide insight into programming trends, as well as guiding principles for arts administrators who are developing arts programming for the 21st century arts participant.

Over the past three decades in the United States, economic shifts, technological advancements, and an expansion of entertainment and leisure options have significantly shaped the art world. These shifts have also led to changes in arts audiences: who they are, where they come from, and what they like, as well as their level of education, knowledge of the arts, income, and leisure time.[1] Arts leaders are confronted with these changing currents in culture as they work to understand and respond to evolving arts audiences.[2]

WHERE IS THE CONNECTION? ARTS PARTICIPATION NOW

In recent years, there has been a fair amount of research conducted regarding participation and engagement in arts and cultural activities. Some of this research has been helpful to arts leaders, creating more relevant programming for new audiences.[3] However, there is significant

variation in the research, which makes it difficult for arts administrators to identify the best response to the needs and wants of the 21st century arts participant. For example, the National Endowment for the Arts reports steady increases in arts attendance since 1982.[4] Alternative research by McCarthy et al. attributes the majority of arts attendance growth to increases in population and education levels. Other research suggests that the NEA's survey data is limited by a traditional definition of "arts participation."[5] The NEA's definition does not accurately capture the full spectrum of behaviors representing today's arts participants.[6] In addition, recent research recognizes a need for moving beyond previous studies on socio-economic indicators, to an examination of the varied motivations for arts participation.[7] As arts organizations continue to navigate through social change in the 21st century and build arts participation, arts administrators should strive to better understand their audiences' interests and anticipate their needs.

Why Gen Xers and Millennials, Why Portland?

Gen Xers and Millennials by nature, embody the 21st century response to recent economic, technological, and social shifts.[8] Alternative industry sectors have identified Gen Xers and Millennials, in particular young professionals aged 25-34, as indicators for future sustainability and growth.[9] Specifically, business and economic sectors have identified this demographic as important because they are educated, career-oriented, mobile, creative, and provide businesses a connection to current trends.[10] By researching this group's current arts participation behaviors, arts administrators will be able to advance effective arts programming and cultivate greater arts participation.

By exploring Portland, Oregon's arts culture and the understandings of its Gen X and Millennial demographics' arts preferences through a qualitative case study of six purposively selected Portland arts leaders, this research intends to increase understandings of arts participation, benefiting researchers, practitioners, and policy makers.

As a nationally recognized arts and cultural destination with a record influx of 25-34 year-olds, Portland represents an opportunity to study a microcosm of the greater shift in the national arts and cultural sector.[11] In exploring Gen Xers and Millennials arts participatory behaviors in Portland, this chapter identifies three prominent arts programming themes:

- Fitting the Needs of Now: Employing New and Innovative Business Models.

- "Here it is, Let's Talk About it": Arts Presentation That Expects Interaction.
- The Notion of Experience: Multiple Entry Points of Engagement.

Through the lens of these themes, this chapter concludes with three guiding principles—Relevancy, Accessibility, and Engagement through Interaction—that provide arts administrators with a dynamic framework for developing arts programming more closely related to the needs of 21st century arts participants.[12]

CASE STUDY DESCRIPTION AND ANALYSIS

The six purposively selected administrators in this study comprise a range of expert perspectives and cover a broad understanding of engagement with the Portland art scene. Case study participants were selected from professional recommendations, then vetted through my interests as an active arts participant. Case study participants represent professionals with knowledge of and years of experience in the Portland arts sector.

Interview questions focused on case study participants' perceptions of arts participation in general, their experience working in the arts and cultural sector, their views on change in Portland's arts and culture sector, national trends that reflect Portland's development, the significance of Gen Xers and Millennials in the Portland arts scene, and possible ideas for furthering arts participation in Portland. Arts administrators answered interview questions based on their life experiences and work with organizations and projects throughout their years in the Portland community and elsewhere. Whole organizations were the point of entry, but the depth of information gleaned from these interviews goes beyond the initial scope of the organizations. The following section provides a profile of the case study interviewees and the organizations they represent.

CASE STUDY PROFILES

Portland Institute of Contemporary Art (PICA): Victoria Frey, Executive Director

I selected Portland Institute of Contemporary Art as a study of an event based organization. PICA presents a festival serving thousands, depending upon community members and volunteers for their success. PICA's annual Time Based Art (TBA) Festival is a ten-day event of contemporary, performing, and visual arts held annually in September.

Museum of Contemporary Craft (MoCC): David Cohen, former Executive Director

With a seventy-year legacy, The Museum of Contemporary Craft (MoCC) represents one of Portland's longest standing cultural institutions and is a testament to adaptation. The MoCC has experienced a handful of relocations and operational shifts to remain sustainable and relevant. MoCC exists to promote excellence in contemporary craft, to support artists and their work, connect the community directly to artists, deepen the understanding and appreciation of craft, and expand the craft audience.

PORT: Jeff Jahn, Executive Director

PORT represents an online blog dedicated to Portland arts and cultural happenings. PORT serves as a real-time report, critique, and open forum covering a variety of arts exhibition, publication, and education happenings. Contributing to a regional and international web-based art scene, PORT has gained recognition as a leader in cultural critique and promotion.

Fifty24PDX Gallery: Stephen Pozgay, Gallery Manager

Fifty24PDX operates as the commercial gallery for Upper Playground, an urban apparel and merchandise retail venue specializing in underground, low-brow, street scene art culture promotion. Connected and managed with the retail location, Fifty24PDX shares audience, space, and operating hours with Upper Playground, representing an alternative, hybrid model for arts presentation.

Milepost Five: Gavin Settler, Creative Director

Milepost Five is a government-supported artist working and living compound. With condos for sale and studio apartments for rent, this creative live/work destination includes an on site creative director, a community garden, and large exhibition spaces.[13] Milepost Five represents a response to Portland's need for affordable and creative live/work space.

Tilt Gallery and Project Space (now Tilt Export): Josh Smith, Co-Founder

Specializing in the presentation of alternative, contemporary artwork presentation, Tilt operated in a ground level studio and gallery space at the Everett Street Lofts, a subsidized live/work artist building. Since the case study interview, Tilt became Tilt Export, choosing to leave the brick and mortar space of Everett Station Lofts, to exist, Tilt Export cites, as an "independent art initiative with no fixed location, partnering with

presenting locations around the nation for the support and presentation of experimental work." For this study, Tilt represents a privately-operated exhibition venture, functioning between commercial gallery and nonprofit business models.

CASE STUDY FINDINGS

Through collected case study data, I found Gen Xers and Millennials' art proclivities have had a significant impact on Portland's arts environment. Their interests, cited through literature research, include diversity and authenticity of experience, continuous engagement, socialization, and flexibility of time and commitments.[14] The majority of research participants recognize they indirectly focus on the shared interests of Gen Xers and Millennials. However, many do not focus on or directly target this demographic through arts programming.

From an analysis of case study data, three prominent programming themes emerged: Employing Innovative Business Models, Arts Presentations that Expect Interaction, and Multiple Entry Points for Engagement. By comparing these themes to values associated with Gen Xers and Millennials, this study identifies programming trends intended to inform arts leaders of ways in which to maintain relevancy in the 21st century.

IDENTIFIED ARTS PROGRAMMING THEMES

Given my selection process and criteria, many of the identified programming themes are relatively non-traditional, referencing sectors outside of traditional arts activities (ballet, theater, jazz, symphonies, museums, etc.). Within the context of my interpretation, the following themes have emerged with loosely defined borders, existing symbiotically, and representing distinct trends in arts programming today.

Fitting the Needs of Now: Employing New Innovative Business Models

Not unlike Portland's prominent entrepreneurial businesses, many of Portland's arts organizations have strayed from traditional operational models. By employing alternative methods, such as operating out of live/work spaces, and combining commercial and nonprofit ventures, arts organizations have maintained relevancy and work towards financial sustainability. Commenting on Portland's alternative approaches, Victoria Frey, Executive Director of PICA, believes 25-34 year-olds like to be engaged by new and innovative ideas. This assertion is supported by Johnson and Handson, who describe Gen Xers and Millennials to be driven by reinvention and new ideas.[15] Many of the case studies demonstrated

new perspectives on traditional arts business, creating hybrids of standard practices and models.

The majority of alternative models explored in this study were centered around program structure, content presentation, and operations management. They demonstrated relevancy to organizational missions, audiences served, and places identified within the community. Of all of the case studies, Fifty24PDX and Tilt Export, served as the most prominent examples of alternative business models in the traditional commercial gallery sector.

Operating in tandem as a gallery and urban apparel boutique, Fifty24PDX and Upper Playground occupy the same space, yet both run as independent entities under the greater Upper Playground corporation. Although the retail store and gallery have different methods of delivery, they share content in the promotion and exhibition of underground urban artists. For example, in Fifty24PDX, patrons connect to art content through an exhibition experience, whereas in the Upper Playground boutique patrons may purchase clothing or products with graphics and designs created by artists of Fifty24PDX. As gallery manager Pozgay explained:

> Very few people can afford a piece of art, but a lot of people like art. We're making it mobile and accessible. And the gallery works in the same way, we take artists we work with in the clothing world and we bring them into the gallery. We find ways to expand on those artists' body of work.

Upper Playground promotes artists work through apparel and merchandise, marketing the artists work through the urban culture of the store and website. Accessibility and affordability are prominent elements of this arts presentation model. For example, at the Upper Playground boutique or website one can find urban clothing apparel and accessories, as well as skateboard decks with graphics, photography, and designs developed by several of the emerging underground artists exhibited by Fifty24PDX and other Upper Playground galleries. This model is a perfect example of trendsetting. The collaboration between Upper Playground and Fifty24PDX draws Gen Xers and Millennials in through showcases of unique and relatable artwork that they can purchase to represent their membership within the urban art community.

The Fifty24PDX/Upper Playground relationship is not only forward thinking culturally, but also economically. Beyond increased accessibility to an alternative audience, the collaboration between retail fashion and gallery alleviates pressures to generate income based on art sales alone, freeing up curatorial exploration of presentable works.

Other alternatives to traditional commercial gallery models come

from Tilt Export. Directors and co-curators Josh Smith and Jenene Nagy maintain a passion for highly conceptual and difficult-to-sell work, leading them to develop a hybrid model between for-profit business and nonprofit organization. In an effort to promote highly conceptual, under-represented artwork in the community, a central challenge became finding an affordable space. Operating out of their Everett Station Loft live/work space, supported through alternative jobs and incomes, they were able to maintain programming of their interests, unlimited by the pressures of saleable art.

Recognizing a trend among their peers in online galleries (such as Curbs and Stoops), that collaborate with artists to present and promote risk-taking work without the pressures of overhead brick and mortar expenses, the Tilt curator and artist duo Josh Smith and Jenene Nagy left the lofts to curate other venues through the program of Tilt Export. Recent Tilt Export exhibitions include a solo exhibition by Kartz Ucci titled, "Twenty Love Poems and a Song of Despair." Ucci is an installation artist working with relationships of theory, material, and concept within an expanded field of visual exploration. Through a partnership with Portland Community College's Helzer Gallery, Smith and Nagy were able to curate Ucci's piece, *giving* the artist an opportunity to present project based video and sound installation, a non-sales form, becoming increasingly significant in contemporary art practices.

Choosing to operate outside of the traditional nonprofit or commercial gallery structures, Smith jokingly referred to Tilt's business model as a "not profitable gallery," more specifically, a space/organization driven by curatorial initiative, uninfluenced by art sales-generated profits or traditional nonprofit structures.

Finding nonprofit organizational models too constrictive with enforced structure and tax code standards, Smith and Nagy prefer the flexibility and independence of their alternative business model. Summarizing their reasoning for maintaining a "not profitable gallery model," Smith reasoned that, "it has to do with keeping it light and efficient. It's just the two of us, it's easy to maneuver and be relatively low budget." This alternative model allows the directors/co-curators to present programming they wish to see in their Portland community with Tilt Gallery, and now with the national community online with Tilt Export. While the hybrid business model Smith and Nagy have chosen provides the flexibility they seek, their choice to operate outside of traditional tax-exempt structures does not avail them of important tax benefits or fundraising opportunities that are essential to other nonprofits.

By not focusing on sales, Smith and Nagy invest in offering professional

development opportunities for chosen underrepresented and/or experimental artists. As Smith explained, "we really offer an opportunity for people to expose themselves to professionalism. Most of the other spaces in town that are as accessible as we are in terms of not being sales driven are much less rigorous in their management of themselves." As a component of the professional management, Smith and Nagy work to generate significant press for their artists and cultivate professional opportunities for further exhibitions, publications, awards, and recognition through the expansive network Smith and Nagy have built throughout their careers. The "not profitable gallery" is an example of how Portland's arts scene is breaking out of traditional norms to explore new ideas for profit and artistic expression in the 21st century.

"Here It Is, Let's Talk About It": Arts Presentation That Expects Interaction

Case study interviewees shared an assumption that Portland's arts audiences were smart, independent, and curious. The majority of interviewees also noted that they base programming content on organizational interests, without attending to perceived community needs or interests. To address this omission, several discussed the importance of generating dialogue between audiences and presenting organizations. As case study interviewees talked about arts presentation within a "here it is, take it or leave it" style, they were essentially presenting work they felt passionate about and providing participants with avenues for generating discussion and engagement with the art.

At the heart of this "Arts Presentation That Expects Interaction" programming trend is an interest in greater authenticity and relevancy of content. A presentation model that fosters a sense of experience is based in first hand interaction and connection between presenters, artists, and audiences alike.

Within the context of distinctly different organizational structures, PORT and PICA offer clear examples of the Arts Presentation That Expects Interaction model. PORT's online blogging model allows reporters to present and readers to respond, while PICA's TBA festival structure presents wildly diverse arts content with accessible participant workshops and artist chats.

PORT functions through the Internet as a blog for independent, contemporary reporting and cultural critique. This format allows PORT to subjectively present and discuss ideas and events both in Portland's art world and internationally. Explaining their operational structure, Jeff Jahn, PORT co-founder, stated:

> What I love about the Internet is that it doesn't pretend to be this purely objective news source. We have a slant, everything we do has a slant. We're very upfront about it and we trust our readers enough to let them make up their minds. We just present it.

By presenting content without an objective filter, PORT writers are able to present their expert opinions on topics they find exciting and relevant. Jahn compared PORT's reporting to traditional models of the past stating that it is a "completely different attitude, that's not Walter Cronkite saying 'this is the world.' This is us saying 'this is how we are seeing the world at this point in time in Portland, Oregon, thank you.'" In this presenting model, the blogging format embodies the Arts Presentation That Expects Interaction programming trend. Right alongside PORT's "here it is, thank you very much" attitude, are the blank fields embedded in their website, encouraging reader feedback and conversation. As with the nature of blogs, readers are given the opportunity to comment on each PORT post, PORT writers often respond to reader comments within a day. Given the opportunity to independently research topics and post comments, local and international readers are able to intelligently participate in conversation and further develop PORT's content with ideas and thoughts of their own.

Similarly, PICA's organizational model is largely structured around the audience-presenter engagement framework of their Time Based Art festival. During the festival, PICA presents a wide range of contemporary artists, projects, exhibitions, and performances. Arts presentation represents two thirds of their programming, while the other third comes in the form of audience engagement via salons, artists' lectures, and workshops. Like PORT, PICA's audiences interact with presented content, but outside of the virtual realm. PICA's programming brings together artists and audiences as small groups, large classrooms, and as a community. As Victoria Frey explained:

> It's part of our mission, to create a dialogue with the community, and a dialogue is not us as experts saying "well here's what you should be seeing and this is why," were saying "there it is what do you think?" It's not us as experts-presenters saying "here take it or leave it." It's us as a community saying "let's talk about it."

This Let's Talk About It model is at the core of the Arts Presentation Expecting Interaction programming trend. Arts administrators are noticing there is something very different happening with audiences' participation choices. Audiences want to be involved, learn something, and take something from their experiences. The Arts Presentation Expecting Interaction programming trend, utilized by PICA and PORT, provides

audiences opportunities to have meaningful and engaging experiences, where they are actively contributing, rather than remaining passive spectators.

The Notion of Experience: Multiple Entry Points for Engagement

The final programming trend draws on multiple options for audience engagement with programming content. Several interviewees described this notion through the use of space, programming structure, and educational opportunities. Victoria Frey explains PICA's reasoning for incorporating this programming model, "if we want to broaden the audiences, we have to offer them a vehicle or avenue for them to come in." To address this need, PICA includes programming that might attract less frequent arts patrons, as well as families and larger groups. For example, PICA's innovative Works series offers contemporary performance in a mainstream, late-night, music, bar environment many Gen Xers and Millennials find stimulating on social and cultural levels. Oscar Award winning drag cabaret performer Kenny Mellman jamming to top ten pop songs with his crew is a perfect example of how PICA has incorporated a hybridization of media created for a contemporary art experience that connects to the pop culture fluency of Gen Xers and Millennials. Frey notes that offering multiple entry points allows for a kaleidoscope of arts experiences, giving PICA the ability to "[open] that door and [provide] some sort of a bridge or gateway to that experience."

Multiple entry points for engagement is important when attracting younger audiences who are concerned with spending their leisure time as productively as possible.[16] Like PICA, the Museum of Contemporary Craft (MoCC) works to offer different avenues for their audiences to engage with content through space, programming structure, and education. David Cohen from MoCC stated that, "it's creating different avenues and different kinds of experiences that are multi-sensory again that truly impact people." Cohen explained that the museum was very intentional with the design of their space. The MoCC is limited to one building but utilizes two separate levels for presenting alternative content. Cohen gave the example of two simultaneous exhibitions that incorporated multiple entry points through the use of space and structured programming, "Glass" by Melissa Dyne and "Generations" by Ken Shores. He explained that the first level of the building showcased a contemporary project, while the upstairs featured traditional work. By utilizing varied content, the allocation of space, and programming structure, the MoCC offers audiences the opportunity to engage in something unexpected and different. Embracing this programming trend

through education, PICA and MoCC provide an array of opportunities to connect audiences to content. Through PICA's incorporation of lectures, artists' chats, salons, and workshops into their festival structure, and MoCC's additional learning experiences, these organizations feed the arts audiences' craving for participatory experiences.

Understanding that museums and arts institutions have a different role to play than they had 20 years ago, Cohen discussed how younger audiences have been neglected in terms of arts education. Cohen explained that it was his exposure to the arts and museums as a young child that influenced his interests in the field. With a majority of young people today missing those shared experiences, Cohen asked, "what's our role in educating that group so they're not already predetermined?" In questioning the museum's role as an educator, Cohen noted, "it's a very different audience that's bringing different tools with them, and how are we reacting to that?"

In their attempt to serve the evolving needs of young adult cultural consumers, while also broadening their arts audiences, the MoCC has paid close attention to their methods of delivering information. Cohen explained that the "object, panel, object, panel" presentation model is "not how people want to explore or learn." Supporting Florida's and Johnson and Handson's notion of young people being interested in authentic experience, Cohen explained that people enjoy learning through experiences, and that all people in the arts and cultural sectors should be in the business of providing learning experiences.[17]

Working within the "experience notion," suggested by Cohen, the museum has designed their spaces to offer multiple learning experiences and multiple ways to engage with those experiences. For example, the MoCC always has a video incorporated into its exhibitions, and every Saturday they feature local artists creating in the museum. Speaking to the effect of this type of programming, Cohen said, "we have people sitting [for] two hours watching the potters throw on the wheel, that is very experiential. It's direct and it's about a person." Cohen explained that this programming format helps visitors make real connections to artists within their community. He noted that through this type of experiential learning that offers a variety of entry points, participants have the opportunity to connect with ideas, artists within the community, and the arts organization as an institutional whole. In this context, Cohen concluded that arts organizations who provide audiences with experiential learning opportunities are much more likely to develop sustained support from their audiences.

RECOMMENDATIONS

Case study organizations have successfully attracted audiences of Gen Xers and Millennials as well as audiences from a broad scope of all demographics. Based on common programming themes that emerged form case study interviews I have identified three guiding principles to develop effective arts programming for expanding arts audiences. These principles are: Relevancy, Accessibility, and Engagement through Interaction. Both directly and indirectly, all case study participants articulated these themes as values influencing their organizations' missions, operations, and programming structures. These principles permeated case study data and echoed throughout recent arts participation literature. Reflecting how these principles are intrinsically related, interviewees talked about these principles interchangeably when discussing arts programming and today's arts participant.

As stated in earlier findings, case study participants do not focus specifically on Gen Xers and Millennials in their arts programming. Nevertheless, all case study participants similarly addressed programming trends reflective of identified interests of Gen Xers and Millennials. It surprised me that although these identified guiding principles are not new, arts organizations are still struggling to address them. It also surprised me that these case study organizations are not prioritizing Gen Xers and Millennials as a targeted demographic.

Is the fact that these principle findings are not radical, yet arts organizations are still having difficulty applying them, matched with evidence that arts organizations in Portland, Oregon aren't actively pursuing the interests of a demographic quickly becoming their primary audience, a reciprocal phenomenon? It is my belief as a researcher that further exploration into this trend will yield insights to help guide arts administrators in creating more impactful programming. By addressing the following principles through the lens of Gen Xers and Millennials, the disconnect gap may be bridged.

Relevance

The first guiding principle, relevance, addresses the "does it matter?" factor. A desire to maintain relevance to arts audiences, the Portland community, and greater national and international art worlds developed as a trend throughout case study data. This principle emerged as interviewees addressed the unmet needs within their communities and through conversations within the greater art world. With a myriad of arts and cultural offerings available, it is imperative that arts organizations understand their missions,

what they mean to their respective communities, and how they fit into the greater art world.

Although not a new or radical concept within the arts sector, relevance to community still resonates as a significant principle within the context of this case study research. Fifty24PDX maintains relevance by fostering connections with likeminded individuals passionate about urban art culture and providing products like clothing and skateboards that consumers use to symbolize their membership in an underground cultural community. Arts organizations need to maintain relevance as a primary focus in their everyday operations. An attention to relevance begins with reevaluating one's mission and continues through ongoing day-to-day interaction with one's constituents.

Accessibility

Arts administrators should establish accessibility as a key organizational value. In the most general of terms, I have come to understand accessibility within arts organizations to reference the following:

- Access to place—can arts audiences get to it?
- Access to cost—can arts audiences afford it?
- Access to time—can arts audiences make time for it in their busy schedules?
- Access to staff—can arts audiences, as a community, connect with organizational staff?
- Access to content—can arts audiences connect to the aesthetic/ intellectual experience?

Reflecting on the case studies, accessibility means hosting later hours such as the Fifty24PDX gallery in collaboration with Upper Playground's commercial retail business hours. It means providing salon chats, for example, when PICA connects the public with exhibiting TBA artists, creating an opportunity for the arts participant to learn from and discuss with international cultural leaders. It means operating within an interactive interface that promotes dialogue between creators and consumers, like PORT, an online cultural review and critique forum, which expands the conversation beyond cultural sectors. When arts organizations embrace accessibility as a core value they become responsible and attentive to arts audiences' most basic needs.

Engagement through Interaction

The third guiding principle, engagement, emerged primarily within the context of arts participation. Victoria Frey identified arts participation as engagement, believing that true arts participation required opportunities for participants to become involved with arts content. Frey felt that creative engagement with innovative ideas was what truly successful arts participation was about. When David Cohen identified engagement as a central organizational value, he explained that everyone working in the arts should make it a primary goal to question how they can more deeply engage their audiences. Cohen felt that more deeply engaged audiences are more likely to develop a sense of ownership for the arts and arts organizations.

It is interesting to note how Victoria Frey, David Cohen, and other case study participants discussed the concept of engagement and how the term emerged as a guiding principle for developing effective arts programming within this research. As the researcher, I feel that given a closer analysis of case studies interviews, the conversation has changed; shifting from a general sense of engagement to a deeper and more direct level of engagement unidentified by previous studies.

The case study dialogue reveals Gen Xers and Millennials' arts preferences have transformed the ways in which those in the industry identify arts engagement. We now understand that Gen Xers and Millenials crave a different kind of engagement with the arts; an active type of engagement defined more thoroughly as interaction; a desire to dynamically connect, participate, shape, and affect their art world.

Cohen described this deeper level of engagement—the lively interaction between artist and patron—within the context of the Museum of Contemporary Craft's open studio programs. Invited artists come from disciplines related to current exhibitions and set up studios in the open museum space for a duration of time during regular museum hours. This programming provided an opportunity for arts participants to interact with artists, witness their process first hand, and intimately explore held curiosities about the work. This open studio program fosters engagement on a deeper, more interactive level that other art institutions need to develop further in order to maintain relevancy. Its success reflects a desire held by the public for more interactive engagement and ownership over their experience with arts programming.

To achieve this heightened level of audience interaction and ownership, arts administrators must be attentive to the ways in which Gen Xers and Millennials choose to participate in creative culture. Gen Xers and Millennials want to participate differently than audiences of

the past. Historically, the art world functioned within the boundaries of established, traditional roles—the curator, presenter, exhibitor, or spectator—encouraging engagement of audience interest, however, with little cross-participation. Due to the technological, social, and economic advancements of the last thirty years, these lines have blurred tremendously. This can be seen in the way Gen Xers and Millennials position themselves in their environment. Not only do they wish to view and relate to artwork, but they also want to understand its inner workings and have an interactive role in creating the experience.

I believe that Relevancy, Accessibility, and Engagement through Interaction are critical in order to design arts programming that is in line with the interests of existing and potential arts participants today. It is imperative for each level of an organization to focus on these principles in order to truly incorporate them as organizational values. By thoroughly evaluating an arts organization using these three programming principles, an organization will be more successful in attracting diverse and younger audiences.

CONCLUSIONS

The art world will always exist in a state of flux. Current trends in technological advancements and economic patterns indicate the pace at which the arts and cultural sectors are evolving will not slow down. Emerging Gen X and Millennial arts leaders embody these changes and advancements of the world we exist in today. It is our opportunity as emerging leaders to participate in and guide conversations in the arts and cultural sectors with the goal of developing best practices and methodologies for furthering traditions, while at the same time establishing new foundations of understanding for the emerging arts leaders of tomorrow.

The intention of this chapter has not been to provide concrete answers to questions surrounding changes in audience development or arts participation patterns. Rather, it is meant to provide a framework of understanding for how the arts are evolving and raise questions in need of further exploration. Although the case studies in my research do not directly focus on Generation X and Millennial cultural consumers, these organizations are addressing the interests of this demographic and the lifestyle needs of 21st century arts patrons.

Arts organizations clearly have the capacity to embrace changes in lifestyle trends by focusing on Relevancy, Accessibility, and Engagement through Interaction. Broad in nature and adaptable to individual circumstances—Relevancy, Accessibility, and Engagement through

Interaction—are ideas that if integrated, have the potential to significantly impact the success of arts programming agendas. These guiding principles can help arts organizations cultivate greater participation and sustainable futures as they maintain importance to their audiences and work towards serving arts needs by making art an everyday component of people's lives.

Join the Conversation

Contribute to a dialogue pertaining to the concepts discussed in this chapter by directing your web browser to the following URL:
http://www.20UNDER40.org/chapters/chapter-11/

NOTES:
1. McCarthy, K. F. & Jinnett, K. "A New Framework for Building Participation in the Arts." RAND Corporation, (2001), <http://www.rand.org/pubs/monograph_reports/MR1323/>; McCarthy, H. F., Ondaatje, E. H., Brooks, A., & Szanto, A. "A Portrait of the Visual Arts Meeting the Challenges of a New Era." RAND Corporation, (2005), <http://www.rand.org/pubs/monographs/2005/RAND_MG290.pdf>.
2. McCarthy, K. F. & Jinnett, K. "A New Framework for Building Participation in the Arts," 2001; McCarthy, H. F., Ondaatje, E. H., Brooks, A., & Szanto, A. "A Portrait of the Visual Arts Meeting the Challenges of a New Era," 2005; Peterson, R. A., Sherkat, D. E., Balfe, J. H., & Meyersohn, R. *Age and Arts Participation with a Focus on the Baby Boom Cohort.* Santa Ana, CA: Seven Locks Press, 1996.
3. For the purposes of this study the phrase, "arts and cultural programming" was defined as the planning and delivering of arts and cultural leisure experiences.
4. National Endowment for the Arts. "2002 Survey of Public Participation in the Arts: Summary Report (Report #45)." Washington, D.C.: National Endowment for the Arts, 2004.
5. McCarthy, H. F., Ondaatje, E. H., Brooks, A., & Szanto, A. "A Portrait of the Visual Arts Meeting the Challenges of a New Era," 2005.
6. Walker, C., Scott-Melnyk, S., & Sherwood, K. "Reggae to Rachmaninoff: How and Why People Participate in Arts and Culture." Wallace Foundation. (2002), <http://www.wallacefoundation.org/SiteCollectionDocuments/WF/Knowledge%20Center/Attachments/PDF/Reggae%20to%20Rachmaninoff.pdf>.
7. McCarthy, K. F. & Jinnett, K. "A New Framework for Building Participation in the Arts," 2001; McCarthy, H. F., Ondaatje, E. H., Brooks, A., & Szanto, A. "A Portrait of the Visual Arts Meeting the Challenges of a New Era," 2005; Walker, C., Scott-Melnyk, S., & Sherwood, K. "Reggae to Rachmaninoff: How and Why People Participate in Arts and Culture," 2002.

8. For the purpose of this study the term "Gen X/Generation X" was used to identify individuals ages 29-43, born between 1965-1979. The term "Millennials" was used to identify individuals ages 11-28, born between 1980-1997.

9. For the purpose of this study the term "young adults" was used to describe individuals aged 25-34 years-old who have completed their formal educations, acquired their initial work experiences, and are embarking on their career paths. For more information, see Cortright, J. & Coletta, C. *The Young and the Restless: How Portland Competes for Talent.* Portland, OR: Portland Development Commission, 2005. <http://www.pdc.us/pdf/bus_serv/pubs/young_and_restless.pdf>.

10. Ibid.

11. Kloostra, C. "Top 25 Arts Destinations: From Sea to Shining Sea." *American Style Magazine,* (2007), <http://www.americanstyle.com/ME2/dirmod.asp?sid=&nm=&type=Publishing&mod=Publications%3A%3AArticle&mid=8F3A7027421841978F18BE895F87F791&tier=4&id=93EC7B257A1D4C1E845C2DE114820B50>; Cohen, B. "A Small-Town Feel in an Urban Locale." *New York Times,* (November 4, 2007), <http://www.nytimes.com/2007/11/04/realestate/04nati.html?_r=1&scp=3&sq=Cohen,%202007,%20Portland,%20Oregon&st=cse>; Cortright, J. & Coletta, C. *The Young and the Restless: How Portland Competes for Talent,* 2005; Engardio, P., Symonds, W. C., & Kharif, O. "Slicker Cities: The Real Contest is Among Communities, Not Nations." *Business Week,* (August 21, 2006), <http://www.businessweek.com/magazine/content/06_34/b3998442.htm>.

12. It should be noted this research was initially limited to a study of arts participation behaviors of young professionals, identified as educated and career oriented 25-34 year-olds. However, as the research developed through case study interviews, it became clear the young adults participating in Portland's art scene represent a wider demographic. Thus, I expanded the research to include all of Gen X and Millennials. Doing so has allowed this research to be a more accurate representation of interview conversations.

13. Throughout this study "Live/Work Space" has been defined as residential and/or commercial space where tenants live and work, saving money, combining payment for two separate spaces into one unit.

14. Florida, R. *The Rise of the Creative Class: And How it's Transforming Work, Leisure, Community and Everyday Life.* New York, NY: Basic Books, 2002; Johnson, L. & Hanson, C. *Mind Your X's and Y's: Satisfying the 10 Cravings of a New Generation of Consumers.* New York, NY: Free Press, 2006.

15. Johnson, L. & Hanson, C. *Mind Your X's and Y's: Satisfying the 10 Cravings of a New Generation of Consumers.* New York, NY: Free Press, 2006.

16. Florida, R. *The Rise of the Creative Class: And How it's Transforming Work, Leisure, Community and Everyday Life,* 2002.

17. Ibid; Johnson, L. & Hanson, C. *Mind Your X's and Y's: Satisfying the 10 Cravings of a New Generation of Consumers,* 2006.

The "Why" of Arts Organizations in the DIY Era: Support for the Do-It-Yourself Artistic Generation

Claire Rice
University Musical Society

Michael Mauskapf
University of Michigan

Charlie Hack
Columbia University

Forest Juziuk
Hott Lava

Capturing the attention of the under-40 demographic is one of the primary concerns of today's performing arts organizations as they consider long-term sustainability. How does an industry that has placed primacy on in-person, tangible experiences stay meaningful to a generation with immediate access to entertainment, information, and communication mechanisms? Through three success stories, this chapter argues that a performing arts organization's philosophical motivation must evolve to balance authority with participation. This philosophy requires the active engagement of many in the DIY generation—individuals who want to participate in their arts experience, and use advances in communication to do so.

Capturing the attention and sustaining the engagement of the under-40 demographic is one of the primary concerns of today's performing arts organizations; it is the subject of articles in major newspapers, arts industry conference panels, any number of blogs by arts pundits, and is at the heart

of why this book exists. Not only does this age group need to position itself to assume the leadership reins of arts organizations, but equally if not more important is the need for the arts to build audiences within this demographic, for the long-term sustainability of the field.

Easier said than done. A 2008 National Endowment for the Arts (NEA) study noted a twenty-seven year decline in live performance attendance by 18-34 year-olds. This same study noted an increase in personal participation in the arts (individuals playing music, dancing, or painting on their own), underscoring the relevance of the Do-It-Yourself (DIY) movement.[1] How then does the field of the performing arts, that has long placed primacy on in-person, tangible experiences, remain meaningful to a generation with immediate access to their own entertainment, information, and communication mechanisms?

Cultural institutions are implementing programs to engage this audience, some more successful than others. In 2007 the University Musical Society (UMS), a 131 year-old performing arts presenter in Ann Arbor, Michigan, launched an initiative entitled "The Circuit" that attempted to engage young professionals in its artistic programs by packaging discounted tickets to shows with social events. The results were disappointing, with anemic ticket sales and very few party-goers. For the first and only Circuit event, UMS sold fewer than ten tickets to a jazz concert, and resorted to encouraging participation in the post-performance social event by handing out flyers to young audience members in the lobby after the show.

What went wrong? This chapter contrasts the major reasons for the failure of The Circuit with three successful UMS efforts to connect young adults to the arts in innovative ways. An analysis of these cases will provide insights into key social shifts, new engagement models, and strategies through which arts organizations can become the catalyst for change, rather than its bystander.

Two major societal shifts lie at the heart of arts organizations' difficulty connecting with younger audiences. First, changing methods of communication challenge ways that arts organizations understand publicity and audience engagement. Most of the Circuit's marketing was done through email, mail, and print, and did not build an institutional connection with key young community members. Online social media now affords many opportunities in this area. According to the aforementioned NEA survey, "relatively large percentages of young adults now engage with art through electronic media."[2] As of 2010, 96% of Millennials participate in online social media sites.[3] Given major shifts from print to digital media, an institution must establish a credible online presence that encourages

trust and connection on the part of the audience, otherwise the messages get lost in the Internet's maelstrom of information and choice.

Second, new ideas about participation are transforming individuals' expectations of the arts and their relationship with arts institutions. The DIY movement continues to gain social currency, having profound negative effects on the engagement of younger audiences in established arts organizations.[4] This movement is not a new idea, rather a resurgence: before the advent of large cultural institutions in the late 1800s, personal participation in the arts was more the rule than the exception. Throughout the 19th century, large numbers of Americans enjoyed making music together by singing in church, performing in amateur ensembles, and attending public sing-alongs. The same collaborative spirit was present in the home as well, where families entertained themselves by making music together.[5] In his book *Highbrow/Lowbrow: The Emergence of Cultural Hierarchy in America*, historian Lawrence Levine argues that by the late 19th century, American culture began to fracture into "high" and "popular" realms, each with its own audiences, expectations, and functions.[6] Many current performing arts institutions that present the "high" arts came to the fore during this period, including nonprofit orchestras, opera companies, and arts presenters such as UMS.

The DIY movement might be understood as a response to this division between high art and popular culture. It has influenced a wide range of diverse industries: print (blogs, 'zines), information sharing (Wikipedia), and food (locavore-ism, community gardens) among others, but especially the arts (Etsy, YouTube, MySpace). The democratization of the Internet allows individuals who create their own artistic expressions and ideas to market and distribute themselves online, bypassing any institutional or curatorial stamp of approval. Looking back to the example of The Circuit, another issue was its lack of allowance for this growing interest in personal participation, neglecting to build any sense of ownership in its target audience.

Indeed, The Circuit teaches us that ignoring key social and technological changes prevents meaningful connection with young audiences. Embracing them is critical to the long-term sustainability of the arts. A recent Wallace Foundation conference report on arts engagement underscores longer term seismic shifts which challenge arts organizations beyond the nation's current economic woes: technologies providing spontaneous information and interaction without institutional assistance, and a vast array of choices competing for younger people's leisure time.[7]

These shifts necessitate a parallel change in the work of many cultural institutions. Arts organizations, especially the variety that regularly

present the "high" or "abstract" arts such as classical music or modern dance/theater, are often perceived as stuffy, out-of-touch, and unwilling (or unable) to adapt to meet the needs of a new generation of audience members. Whether this is true or not, the perception persists, creating a dissonance between organization and audience that results in a very real brand management problem for arts organizations around the country. Running the risk of an "ivory tower" public perception, institutions need to connect with and build young audiences to ensure their long-term sustainability.[8]

The three case studies outlined in this chapter demonstrate how performing arts organizations' philosophical motivations should evolve to balance curatorial voice with participation: continuing to celebrate exceptional artists, but also creating space for audience members to express their own ideas. This philosophy requires the active engagement of many in the DIY generation, individuals who want to participate in their arts experiences and use advances in communication to do so. As curators and community leaders, performing arts organizations must collaborate with young people to create experiences that are meaningful to both the audiences and the organization.

Changes in the way that performing arts institutions interact with new audiences are particularly critical in a Midwestern college town like Ann Arbor. A geographic location as such does not always lend itself to an automatic association with exceptional cultural experiences as may happen in other major urban centers. Yet, efforts to engage young people in arts and culture are increasingly vital to encouraging talented Gen Xers and Millennials to remain in the state, especially due to the recession-based challenges facing Michigan. Likewise around the country, inspiring a community to engage in the performing arts has proved to be an effective strategy for increasing overall quality of life. A recent speech by NEA Chairman Rocco Landesman uses the example of Chicago and Mayor Richard Daley, where the city has put the arts on a pedestal equal to or above sports, food culture, and other attractions, as a means of promoting tourism, retaining talented Chicagoans, and encouraging business development. Landesman notes:

> Mayor Daley may love art, but he's a tough guy, and don't think he's not focused every day on the ledger of the city's economy. Create an arts scene downtown, and small towns have downtowns too, and you change the place.[9]

Over the past eight years, UMS has built partnerships with unusual groups to create innovative participatory experiences for the next generation

of artists, audiences, and administrators. In each of the partnerships highlighted in this chapter, UMS brings its long-standing brand identity, solid infrastructure, and commitment to innovation to the table; the partners bring a diverse set of new ideas and the voices of the young creative people in southeast Michigan. Breakin' Curfew 2009, an annual teen-curated and -produced show on the main stage season of UMS, provided young adults with opportunities to learn about and celebrate their own artistic voices within the legitimacy of a respected institutional brand. Arts Enterprise@UM created a "Music 101" series prior to UMS performances, an interactive pre-show experience that contextualized the program for the uninitiated. Forest Juziuk, an Ann Arbor DJ and music aficionado, utilized social media to connect his successful dance party "Dark Matter" and young adults' social dance interests with the power of dance onstage in the UMS presentation of Compagnie Marie Chouinard, a Montreal-based dance ensemble. Following the case studies, the chapter closes with "lessons learned," examples of other arts organizations that are engaging in this type of work throughout the country, and finally, suggestions for broad practical applications of these lessons throughout the field of the performing arts.

CASE STUDY: BREAKIN' CURFEW

For the past six years, the final show on the UMS season has not been the Berlin Philharmonic, nor the Jazz at Lincoln Center Orchestra, but a distinctive group of teen artists, selected by a team of teen curators, playing to a crowd of still more teens. Imagine a full auditorium, the vast majority of its 1,300 occupants under the age of 19, wrapped up in the visceral experience of great live performance by their peers. And all this from UMS, an organization many teens view as catering only to their grandparents' needs for Schubert, Beethoven, or Shakespeare. By all appearances, Breakin' Curfew has fully engaged a significant teenage audience segment in Southeastern Michigan for the past six years, and is UMS's key programmatic initiative that connects with this audience.

Since 2003, the Neutral Zone (Ann Arbor's teen center) and UMS have collaborated on Breakin' Curfew, an annual performance featuring young artists in diverse genres. The Neutral Zone assembles a group of motivated teens, each bringing their unique experiences to create every aspect of the show. Interests within the performing arts vary greatly in this group, but the curators share a natural curiosity and a willingness to learn. The mentors at UMS support this curatorial squad throughout the process, providing institutional firepower and an artistic knowledge base.

Figure 12.1: The crowd gets rowdy at Breakin' Curfew (Photo: Mark Jacobson).

Each September, curators spend untold hours scouring MySpace pages, attending shows and rehearsals (occasionally literally *breaking curfew* to do so!), and networking in pursuit of the best local teen artists. In addition, curators participate in workshops with the various departments of UMS: Development discusses fundraising and relationship building, Production helps curators balance their dreams with the realities of budgeting, and Programming assists curators in honing their artistic philosophy and mission. Throughout the process, UMS offers the curators free tickets to their main stage season, so that they might experience a wide variety of performances—everything from classical orchestras to Malian pop music, and beyond.

The research, workshops, and performances inform Breakin' Curfew curators' decisions about the show, ultimately resulting in a two-act, full-on artistic assault: from ska bands, to contemporary dance, to Mariachi ensembles, to a Bhangra troupe. Teen artists are carefully positioned on the program to sculpt the energy of the experience, keeping in mind thoughtful and efficient stage transitions (like in 2008, when the fiery Scherzo from the Shostakovich *Violin Concerto* transitioned directly into a death metal band). The higher-ups of UMS review the curators' artistic and technical decisions, sometimes making tough but valid criticisms that ultimately strengthen the program.

Once the artistic line-up is set, the curators split into two groups: Marketing and Production. Over the next few months, the Marketing staff focuses on building a teen audience through tools that work for their peers: rampant flyering of anything that sits still, social media such as Facebook and MySpace, viral emails, and good old word-of-mouth. The Production team, under the guidance of UMS, manages the unique technical needs of the roughly sixteen performing groups, gaining exceptional experience in equipment rentals, lighting, sound, stage design, and the various protocols one encounters in doing this work.

In May of each year, the work culminates in what is now an annually sold-out event—the immense celebration of the art and expression of young people that is Breakin' Curfew. At these events, some of the riskiest decisions of the curators often prove to be their best. As the performances power on, the audience is whipped into a frenzy of excitement as students see their peers rocking a concert hall, sharing the experience on their own terms. This teen audience provides equal-opportunity support for a wide variety of performance genres: they scream for both the virtuosic runs in Shostakovich *and* in death metal sets.

So what makes these events so successful? From the start, The Neutral Zone and UMS make excellent organizational bedfellows—finding common ground in their mutual desire to build meaningful relationships with Ann Arbor's teen community. Breakin' Curfew is now on the Neutral Zone's list of exciting permanent programs where teens may harness their own creativity. UMS, in creating a new model for the engagement of what is by most accounts a fickle and difficult-to-reach audience, wins teens over as life-long arts advocates. In a recent survey, 83% of past curators said that the work they did on Breakin' Curfew steered their educational and/or career plans toward the creative fields. And 90% reported that, after their work on Breakin' Curfew, they participate more frequently in live arts and cultural events.[10] This supports both altruistic and business-driven audience development goals for UMS: building audiences for its own programs, as well as broader audiences for the performing arts.

There are some inherent challenges to this work on both sides. UMS staff must learn how to remain flexible given the over-stretched lives of teens, as well as learning how to connect and communicate well with young people. The teens for their part must approach the project with a greater degree of seriousness and commitment than they may have done in other previous extracurricular endeavors. Setting out clear expectations on both sides at the beginning of the process helps both UMS and the curatorial team to learn what is expected of them.

The key to the effort's success lies in the way that UMS approaches the collaboration. It would be easy to treat Breakin' Curfew as a way to

ceremonially throw some kids in a metaphorical sandbox, present them with some money and some ground rules, and marginalize the final product. Instead, the UMS staff sees the project as an opportunity to engage in a discourse with a particularly crucial audience segment (gaining the coveted attention of the Millennials) and to treat them as peers in creating an artistically sound product. The organization throws its institutional weight behind the event: featuring it in season brochures alongside the likes of Yo-Yo Ma, brainstorming about funding sources, providing a large portion of the production budget, and donating several hundred hours of in-kind staff expertise and guidance. This approach brings Breakin' Curfew curators, as imaginative youth, *into* the world of the performing arts, to articulate and present *their* voices, on *their* terms… and all onstage, supported by the brand of a large and well-respected institution. With Breakin' Curfew, UMS validates that what teens are saying matters, and that they deserve a place in arts and culture—thereby increasing UMS audiences and market share, now and in years to come.

In recent years, Breakin' Curfew has only grown as an enterprise. The thematic design is more intricate. The curators reach out farther geographically, drawing on talent from all around Michigan. The show garners increasing attention from local and regional press. And every May, the foundations of one 1,400-seat concert venue, and the foundations of audience engagement in the arts, continue to be shaken—nay, rocked.

Figure 12.2: Lead Producer Charlie Hack rocking out (Photo: Allison Correll).

Case Study: Arts Enterprise

Since 2007, a partnership between UMS and Arts Enterprise (AE) has resulted in the reframing of audience interactions for university students, harnessing student creativity and leadership to inspire grassroots involvement in the arts. AE is an interdisciplinary student initiative that explores the intersections between the arts and business, involving students and faculty from the University of Michigan and, more recently, other college campuses across the country. One of the founders, Kelly Dylla, described Arts Enterprise as:

> ... breaking down stereotypes of what it means to be an artist and what it means to be a businessperson. Both can benefit by learning from each other. Musicians can learn how to enhance their careers by developing a bit of business-savvy, and business students can enhance their educations and lives by learning something about the skill-set of artists, and the arts themselves.[11]

At the University of Michigan, Arts Enterprise offers a number of programs for both business and arts students, including a series of workshops focusing on creative leadership; ongoing social entrepreneurship programs in New Orleans and Detroit; and residencies with leading arts practitioners and thinkers. UMS and AE partner on a variety of these programs: recent examples include *From the Bard to the Boardroom—What Shakespeare and Theater Practice Can Teach Us about Business*, and panels with experienced arts administrators, such as Zarin Mehta of the New York Philharmonic.

Many of these collaborations feature an increased emphasis on participatory experiences for audiences. One such UMS/AE workshop, specifically focused on new methods of engagement, was part of artist and author Eric Booth's 2007 Michigan residency. In a "Very Open Rehearsal," a student chamber ensemble conducted a rehearsal in front of a public audience, while Booth facilitated artist and audience interactions: the audience was invited to make artistic choices (asking musicians to play faster or softer) and ask questions. In these sessions, musicians often learned as much as the audience gained from the experience.

This model proved influential to Arts Enterprise, and two-way learning has since become essential to all of its programs, redefining audience engagement in terms of audience participation—often giving the audience some creative control. AE's Music 101 series is an example that intends to break the fourth wall—the invisible boundary between artists and audiences that often alienates would-be concert-goers. Music 101 encourages artists to share their music with audiences in fun and collaborative settings—one

was held beside a pond at the School of Music—encouraging participatory learning. In turn, students receive reduced-price tickets through partners and sponsors such as UMS. Students are notified of these opportunities through social media sites such as Twitter, Facebook, and through digital ads. Students' reactions to the event are captured through an online survey system hosted by Google. The lasting impact of this program can be seen in new arts lovers, resulting from strong partnerships forged between the university and the community. Arts Enterprise and UMS share the value proposition for this program: it serves as a point of entry to connect students with perhaps unfamiliar performance traditions, thereby building audiences for both organizations.

One of the biggest challenges to this type of work is marketing. The university community is filled with unique and exciting opportunities for students, and connecting with prospective participants is difficult, especially those who are not intimately familiar with either UMS or Arts Enterprise. To connect with this new target audience, Arts Enterprise uses the power of both online social networks and word-of-mouth to encourage new faces at these events. Individual students legitimize the program for other students to help minimize the marketing challenge.

In February 2008, Arts Enterprise held a Music 101 workshop directly preceding UMS's presentation of the jazz pianist Ahmad Jamal and his trio. AE enlisted a student jazz combo to introduce the Jamal concert in brief and demonstrate general concepts of composition, improvisation, and non-verbal interaction through performance. Most importantly, the artists offered audience members the chance to play with them. Though most of the people present had never attended a jazz performance, several brave souls sat at the piano and plunked out some of the basic chords and rhythms (outlined on the keyboard with colored scotch tape) while the bassist and drummer continued to lay down the structural backbone of what ended up being a 40-minute jam session.

According to a survey administered after the concert, the direct interaction that the students had with the music enriched their experience: 92% of the attendees said they were more likely to attend a future jazz performance. One respondent wrote "I never thought of musical performance as a dynamic, interactive, deconstructable process that *I* could grasp, but being able to be a part of that creative process has changed that assumption."[12] In addition to providing half-price tickets to students attending the event, Arts Enterprise and UMS jointly sponsored an informal post-concert meeting at a local pub, allowing participants to further share their experiences.

The Music 101 series is rooted in the current DIY movement and

research on audience engagement. Several years ago, arts consultants from WolfBrown published a series of case studies detailing "Audience and Community Engagement in Practice."[13] The programs included a public school partnership program run by the New York Philharmonic and a marketing strategy for a theater series designed by UMS, both demonstrating a participatory approach to audience engagement—not as a one-off strategy but as a defining characteristic. One key conclusion from the cases states, "Engagement occurs when audiences participate actively in designing and interpreting their experience."[14] According to WolfBrown, the most effective programs for arts organizations are as much about learning as they are about teaching.

The success of Music 101 is embedded not only in the collaboration between Arts Enterprise and UMS, but in the artistic ownership afforded to all participants, regardless of their previous musical experience. Stretching the ears of new listeners by helping them articulate intuitive responses to live music not only enriches *their* experience as consumers (and producers) of performing arts, but the richness of the overall audience community as well.

Case Study: Dark Matter

Dark Matter was created by disc jockeys Forest Juziuk and Aaron Lindell in 2007 as an underground dance party. The young DJs chose to operate outside of traditional venues and specialize in rare and obscure international psychedelic music on vinyl. With modest ambitions, the immediate and positive response to Dark Matter (DM) was startling: attendance climbed upwards of 150 and outgrew its original environs, a "gentleman's club" in the basement of a non-collegiate fraternal order. Finding appropriate space for the growing crowd was difficult.

When UMS approached Dark Matter about collaboration, the DJs jumped at the chance. The two organizations shared a cultural sensibility: albums by UMS artists, such as Gal Costa and Caetano Veloso, are often found in the DJs' record crates. The partnership allowed UMS opportunities to reach young audiences, while Dark Matter benefited from the access that an established cultural organization can offer for larger-scale events. In this partnership, both entities brought their individual strengths to the table: Dark Matter's "street cred" and savvy promotional tools (fancy posters and handbills, online social networking power) promoted UMS events and the associated afterparties, while UMS offered venues otherwise unavailable to DM, as well as overall institutional infrastructure.

This specific collaboration proved highly successful in the spring of

2009. UMS was presenting Compagnie Marie Chouinard, an innovative dance company from Montreal. Convinced that this show would increase the audience's appetite for its own dance floor, UMS approached Dark Matter about collaborating on an after-party. Not every UMS presentation aligns with the DM aesthetic, but the DJs found the surreal imagery and provocative energy of Chouinard were perfect companions to their music and video installations.

There were initial challenges to this event, such as finding a non-traditional venue large enough for Dark Matter that was inexpensive and raw, yet appropriate for both parties. The collaborators were fortunate to procure a former brewery, completely empty save for a sound system and bar. Part of the opportunity inherent in this type of space was also a huge challenge: DM needed to create the entire infrastructure for the party (sound, lighting, furniture) and manage it (security, bar staff). It took some time for everyone to get on the same page as this was Dark Matter's first dabble in a large-scale institutional partnership, and UMS's first collaboration with the young DJs.

In developing the project, UMS and Dark Matter each had their own areas of responsibility, but shared a greater collaborative goal of connecting both institutions to new audiences. Drawing on the Marie Chouinard "look" for the design surrounding the event, a group of friends created a brand that incorporated this central motif along with the psychedelic Dark Matter style and the UMS logo. The "buzz" was palpable beforehand, a combination of DM's rising visibility, UMS's resources, and a repurposed venue familiar to townies. DM promoted a reduced ticket price to the UMS show and a drink offer for ticket buyers on Twitter and Facebook, where Dark Matter has a large following. Adding to the event's excitement, dancers from Marie Chouinard made a special appearance at the party, and audience members were able to chat, dance, and take fun photos with them in the low-light, cocktail-enhanced setting.

Attendance at the after-party broached 500, providing visibility and "untapped" young audiences to UMS, and also bringing a previously unseen UMS audience to Dark Matter... the over-50 crowd! All the invitees received an online link to the event photos the following day; the UMS Facebook page received over 150 hits (its highest number ever), 1,500 photo views, and generated over 200 photo comments. UMS and Dark Matter have sustained their collaboration, working together to build their collective audience around programs of interest to both parties.

Figure 12.3: A shot of the crowd at a Dark Matter after-party (Photo: Mark Jacobson).

Concluding Discussion:

In these cases, UMS counseled teen curators, played piano with University students, and danced with Canadians and young audiences. Now what? Perhaps a combination of all three initiatives: a Music 101 where audience members attempt to play their own Ska before attending Breakin' Curfew with an international dance party afterward… not a terrible idea, actually, but one that misses the broader lessons of the projects. Young audiences need to be given the opportunity to establish their own ideas for arts participation, and venerable cultural institutions need to listen and provide resources for ideas to take root.

The examples in this chapter demonstrate new ways to engage young people in the arts through effective partnership, meaningful connection to creativity, current communication and marketing tools, and ownership by the young voices involved. They teach us how authority and participation can be successfully balanced, building trust, excitement, and energy between performing arts organizations and young adults.

This is where DIY shines in the arts. UMS gave young community leaders support and guidance to pursue their own creative ideas and in this way welcomed them into the UMS home. The continuing partnerships benefit all parties: DIY-ers do not feel the need to circumvent UMS, and UMS gains positive brand identity in a young audience segment.

This does not mean, of course, that there are not problems associated with incorporating the DIY ideology into performing arts institutions. In these types of collaborations, engagement, participation, and relevance might increase, but the quality of the artistic product might not initially be the same as the typical main stage performance. Conservative audience members who have long served as important donors may be upset, and question the value of such a shift. The potential benefits, however, far outweigh the challenges of these difficult questions, which will need to be answered if the arts are to flourish in new, exciting, and engaging ways. One only needs to look as far as Venezuela's El Sistema—a state-sponsored music education program that has helped change the lives of over a quarter million children through inclusion in youth orchestras—to see that artistic engagement and excellence are not mutually exclusive.

The cases in this chapter are only a few of the many programs worldwide that engage young DIY audiences. El Sistema is an exemplary story of holistic participation of young people in the arts, and there are many others as well, including:

- The Los Angeles County Music Center's Active Arts program gives audiences (anyone who wants to!) the opportunity to take dance lessons under the stars, to sing in a large choir, to join drum circles, to play in instrumental ensembles… with almost all of these programs provided free of charge. The program is driven by a large volunteer corps who help shape its design and lead the various activities.

- Almost every major symphony orchestra and opera company in the US has a "young professionals" engagement program that involves afterparty models similar to Dark Matter, though Dark Matter attempts to demonstrate links between young audiences' desire to see dance performance and their desire to dance themselves. Perhaps we'll see ad hoc amateur symphonies at the post-concert events soon!

- New Paradise Laboratories, a theater company in Philadelphia, creates work that breaks down the barriers between artist and audience, integrating live and online performance. In 2009 they created a project called Fatebook, where 13 characters connected with the audience via online social media, and then the audience "met" these characters during live performances, which took the form of parties.

There are myriad other examples of arts organizations experimenting with this type of engagement. The key to success in these collaborations is

the shared ownership of both the arts organization and the external young audiences.

Implications for Practice

How then to build on and further these ideas? Beyond replicating these programs at other arts organizations, there are general shifts in thinking and philosophy that will encourage working with young audiences in substantive ways.

First, an admonition to readers on both sides of this purported "divide." On the one hand, young people should approach arts organizations with thoughtful proposals and creative ideas. An invitation is not necessary, rather, they should create a win-win proposition for both their project and for the arts organization. "The arts" will listen. Arts organizations, on the other hand, should "come down from their ivory towers." There are many young people with the time, energy, and desire to support the arts—just not necessarily through established means. Meetings will move from boardrooms to bars, from conferences to cafes. Arts organizations need to make room for the innovative new ideas that young collaborators will introduce.

Further, it helps to have supportive leadership and decision-makers throughout arts organizations who are not too far removed from the target under-40 demographic themselves. Such younger leaders have extensive networks that help to facilitate strong partnerships, and will likely have some creative ideas of their own about engaging their peers.

Beyond encouraging conversation and idea generation in collaboration with these young audiences, arts organizations need to be careful to manage their social media strategy appropriately. Social media is not a panacea, it's a tool. In this chapter, the partners used social network sites like Facebook and Twitter to generate legitimacy among peer groups for strong programmatic ideas. If the idea is not strong and relevant to young audiences, Facebook and Twitter will not "save" it.

As these programs evolve, they will benefit from longitudinal evaluation. UMS has conducted surveys assessing how Breakin' Curfew has enhanced the creative capacity of those involved, but these assessments need to continue and become formalized evaluation mechanisms over time. Formal assessment of the Dark Matter project, for instance, can provide evidence of the connections between dance on stage and social dance. Anecdotal feedback indicated that the project is improving the brand of UMS within the under-40 demographic, but how does that translate to impact on audience attendance in the short or long term? And, more

urgently, how can an engaging and participatory evaluation be conducted to assess the benefits to UMS from the 500-person dance party?

Finally, what happens in the arts if one takes the DIY idea to the extreme—could pro-ams eventually overtake the professional artist? Does there come a point where there is no longer a need for professional artists, or for arts organizations? These authors believe the answer is *no*. Arts institutions and professional artists can and should work together with invested amateurs to further the state of art making in general.

As a key "post script" to this chapter, we hope that you will join us online to continue this conversation! Our whole point is to move away from a uni-directional "push" of the arts from an institution to audiences, especially as it relates to young people. That likewise relates to what has been written here. It is not intended to be prescriptive or a silver bullet. It is meant to be the beginning of a dialogue. What other participatory arts experiences driven by young people have worked in your area? What are the challenges you face to engaging young audiences on their terms? Join us, won't you?

Join the Conversation

Contribute to a dialogue pertaining to the concepts discussed in this chapter by directing your web browser to the following URL:
http://www.20UNDER40.org/chapters/chapter-12/

NOTES:
1. National Endowment for the Arts. "2008 Survey of Public Participation in the Arts." Research Report No. 49 (2009), <http://www.nea.gov/research/research_brochures.php>.
2. Ibid.
3. Grunwald Associates National Study 2010, as cited on Trendsspotting Blog. (2010), <www.trendsspotting.com/blog>.
4. In this chapter, we offer examples of the DIY movement in practice. We recognize an entire book could be dedicated to the origins and underpinnings of "DIY," but that is outside our scope.
5. Library of Congress, Music Division. "Life in Nineteenth-Century Ohio," in *Performing Arts Encyclopedia*. (n.d.), <http://lcweb2.loc.gov/diglib/ihas/html/ohio/ohio-home.html>.
6. Levine, L. W. *Highbrow/Lowbrow: The Emergence of Cultural Hierarchy in America*. Cambridge: Harvard University Press, 1988.
7. Wallace Foundation. *Engaging Audiences*. New York, NY: The Wallace Foundation, 2009.
8. As recently as 1973, Phillip Hart describes great art as "inherently aristocratic" necessitating "elite leadership." See Hart, P. *Orpheus in the New World: The*

Symphony Orchestra as an American Cultural Institution—its Past and Present and Future. New York: W. W. Norton & Company, 1973.

9. Landesman, R. Keynote Address. Grantmakers in the Arts conference, Brooklyn, NY, October 21, 2009.

10. Data collected via online survey of former curators, administered by UMS and Neutral Zone, January 2010.

11. Kelly Dylla. Personal communication. January 2008.

12. Post-event evaluation for Music 101 administered by Arts Enterprise, April 2008.

13. Brown, A. S. & Dylla, K. "Audience and Community Engagement in Practice: Case Studies." Report prepared in conjunction with the ASOL Orchestra Leadership Academy in Nashville, TN (June 19–20, 2007).

14. Ibid.

Adults, Appreciation, and Participatory Arts Education

Danielle La Senna
The Juilliard School

Arts appreciation courses for non-artist adult learners are a neglected area in the field of arts education. While adult students make up most of the contemporary arts audience, there are challenges to teaching this demographic. Adult students span 80+ years in age and have vastly different educational demands; most younger adults want greater interaction and participation, while many older adults prefer a "sit and listen" classroom. Participation and engagement are necessary for arts appreciation, and as the adult population shifts, more participatory pedagogical models will be necessary to accommodate the next generation of adults and the changing arts landscape of the future.

INTRODUCTION

Arts appreciation has been taught for over 100 years in the United States, and for just as long, people have debated how best to teach it. While the different disciplines have their own histories, there has also been a basic question about whether one must learn how to make art in order to appreciate it. Does one need to know how to play the piano in order to appreciate Chopin or Joplin? Or is learning facts more important? Does one need to know that Duchamp came after Degas to appreciate Dada? This tug-of-war between skills and facts has been at the center of arts appreciation education.

In addition, while there is much conversation surrounding arts appreciation for children, there is comparatively little about adults. Adults, people aged 20 and older, make up the majority of the world's population and are also a rapidly growing student demographic. Adult learning is

a topic rich for mining that has been explored by many—but few have investigated adult learning specifically in the arts.

In general, arts appreciation for children has been a blend of skills and facts; students paint pictures and learn about famous artists or works, study a musical instrument as well as composers. Arts appreciation for adults, however, has mainly focused on facts. For the purpose of this chapter, I am differentiating between arts *practice* (the skills of art-making) and arts *appreciation* (at the present time, primarily facts), and I will focus on arts appreciation education for adults.

Of course, there are countless adults who pursue arts practice who also appreciate the arts. But these are usually people who want to learn a skill (like playing an instrument or sculpting) for their own enjoyment or a career; rarely do people take a sculpting class in order to better appreciate Kapoor. For the most part, adults who enroll in arts appreciation courses seek to enrich their trips to museums, theaters, or concert halls, and to expand their knowledge of important figures, works, and periods in history. These *non-practicing* adults—individuals who do not practice an art form but have a desire to engage with the arts—and the arts appreciation courses offered to them are a neglected area of research in the field of arts education.

In order to attend to this issue it will be necessary to first explore the very idea of appreciation. To truly appreciate a work of art, one must *engage* with it, actively *participate*. However, the current facts-laden approach to arts appreciation education for adults implies a passive role for the student—and for the audience member. I am challenging the traditional notion of what it means to appreciate art and what it means to be an audience member. In my opinion, real appreciation is *aesthetic experience*, where a great work of art is only half of the equation—participation of the viewer is the other essential component.

Some may argue that it is unnecessary to teach someone to have an aesthetic experience; if someone is attending a performance or visiting a museum, they must already have an appreciation for the arts, and will reap the benefits of the works without guidance. It is true that one need not be knowledgeable in order to be affected by a work of art. But those who have seen audience members dozing off or checking their email at a performance, or museum visitors spending only a few seconds with each work of art, would insist that guidance is necessary. These viewers may be witnessing a work of art, but they are not having an aesthetic experience, not truly appreciating the work they are encountering.

I propose that the means for teaching appreciation parallel the participatory nature of aesthetic experience. To be most effective, the

pedagogical methods should model the skill one aims to teach. This means that if one wants to teach someone how to participate with a work of art, then the learning environment must include participation as part of the process. One cannot teach someone how to drive by having her memorize the parts of a car and read an instruction manual; at some point, she will have to get behind the wheel.

The pedagogy of arts practice has been explored to a great extent, and pedagogy of general art appreciation is getting quite a bit of attention in museums, concert halls, and classrooms (mostly K-12). But what has not received enough attention is how pedagogical methods for arts appreciation might differ for adults and children, or for younger and older adults. More specifically, if pedagogical methods necessarily involve participation, one must also consider the implications of teaching multiple generations of adults together, as is often the case in adult education classrooms.

Adult education is unique in that it involves students of various ages within the same classroom, each with different age-related learning needs and expectations. In adult education classes, many older adults prefer a "sit and listen" environment, or, as Don Tapscott calls it, a "broadcast" model.[1] Younger adults, raised on the Internet, video games, and more interactive media, prefer a more "participatory" model of education. Accommodating both of these students in the same classroom is a challenge. As the adult population shifts and more adults begin to demand interactive experiences, the participatory, not the broadcast model, will become the future of education. Coincidentally, this participatory model is perfect for teaching arts appreciation.

A participatory approach to adult arts appreciation education need not have a particular format or involve specific activities or techniques. Instead, it should be flexible, allowing students to participate in the ways that are most meaningful and effective for each of them. Participatory arts education can employ existing models such as Visual Thinking Strategies or the aesthetic education models in use at the Lincoln Center Institute (described later in this chapter). But it should also be open to students' contributions for finding new ways to engage with the arts. Teachers will need to be more than repositories of information or even charismatic lecturers, but also facilitators of discussion and guides for exploration.

WHY ADULTS?

In the field of arts education, there is quite a bit of ink on K-12 education, community outreach for children who don't get enough arts education in school, and in professional arts training. But what about adults? What

about adults who are not learning to be professional artists? What about people who simply want to learn more about the arts, to gain a greater appreciation, but are not interested in taking piano lessons or a pottery class?

There are many reasons why this area of arts education is so important, not least is that this population is a large percentage of the audience for the arts. With dwindling ticket sales and financial support for the arts, it is not enough to focus only on training artists, or exposing children to the arts. The majority of the country's population is adults, and fewer and fewer have had access to comprehensive arts education.[2] No matter how dynamic the performance, no matter how innovative the artist, if the audience is disengaged, they either will not attend the show, or they will miss the dynamism, and the innovation will go unnoticed.

This gap in the field also neglects the fact that adults are the fastest growing student demographic.[3] While adults of all ages are going back to school in droves, it is not just for professional development or career changes. At the height of their careers or in retirement, with disposable income and flexible schedules, many adults are enrolling in undergraduate and graduate programs as well as continuing education courses. This is an important change both in the behavior of adults, as well as society's perception of them—from a notion of adults withering and fading into oblivion with age to the idea of continued health, curiosity, and learning. The arts are a major part of this movement as adults rekindle their long-dormant desires and explore new interests, from taking painting classes or piano lessons to attending performances and visiting museums.

Adults today are living longer than ever before and seek to enrich their lives in areas they might have neglected as they raised families and pursued careers. Many older students in continuing education settings such as the Evening Division at Juilliard have expressed gratitude for having the opportunity now, later in their lives, to study subjects they could not when they were younger. These are students with a genuine interest in learning about the arts; it is not a requirement, as might have been in grade school, but a desire. Many of them are making up for lost time, focusing on something that perhaps was considered frivolous or a luxury at one point in their lives and is now a passion or even a necessity. Students young and old tell of having turned away from the arts, feeling (or being told) that the arts were a hobby or something they did not have time for, only to return to it years later.

Adult arts education is therefore a vital and important sector in the field of education, yet the current approach to continuing and adult education in the arts is terribly outdated. As Millennials graduate college

and become active members of adult society and Baby Boomers become senior citizens, the field of adult education needs to rethink its pedagogical approach to teaching the arts to adults of all ages. In addition, the world is changing rapidly as technology, globalization, and other factors influence every aspect of society. The arts themselves are different today than they were just a few decades ago. Pedagogical approaches to teaching the arts must therefore adapt to keep pace.

APPRECIATION AND ENGAGING WITH ART

For many years now, most adult arts appreciation courses have focused on two main areas: *performance preparation* (providing historical background, reviewing certain elements of a work of art, or holding question and answer sessions with performers or artists in conjunction with a performance or event); or *general appreciation* (providing information that focuses on history, specific genres, works of art, and/or artists). Both of these approaches concentrate on teaching facts and are limited in helping students who seek to better appreciate art.

What does it mean to *appreciate* a work of art? To truly appreciate anything one must be *engaged*. To appreciate a fine wine one must drink it (or at least taste it—you cannot simply look at the label), and I believe it is the same with art. In order to appreciate a work of art, one must engage with it, one must drink it. The definitions of these words offer further insight: *appreciation* of something includes "critical notice, evaluation, opinion"; and *engaged* means to be involved or entangled with something, and, most revealing, to "occupy the attention or efforts of." These are active words; they imply that a person who appreciates or is engaged with a work of art is *doing* something.

Art appreciation is participatory; in order to reap the full rewards of any work of art, the audience's engagement, or effort, is necessary.[4] A work of art is where the artist and the viewer meet. It is just as important for the audience to be present (and I don't just mean in row J seat 23) as for the performer to be on stage. To appreciate art is to have an *aesthetic experience*.

The philosopher Nelson Goodman has written extensively about art functioning cognitively—that engaging with a work of art is about deciphering the multiple meanings of the symbols within it, and is an active, not a passive, process. In *Languages of Art*, Goodman explains that "aesthetic experience is dynamic rather than static. It involves making delicate discriminations and discerning subtle relationships, identifying

symbol systems.... The aesthetic 'attitude' is restless, searching, testing—is less attitude than action: creation and re-creation."[5]

In *Cultivating Demand for the Arts: Arts Learning, Arts Engagement, and State Arts Policy*, Laura Zakaras and Julia F. Lowell outline four skill areas necessary for understanding and enjoying works of art, one of which is "the ability to interpret works of art, discern what is valuable in them, and draw meaning from them through reflection and discussion with others."[6]

This means that to engage with and truly appreciate a work of art, that is, to have an aesthetic experience, one would necessarily have to observe carefully, think deeply, inquire, question, and consider various perspectives and points of view to form an interpretation.

But why is it necessary to teach someone how to have an aesthetic experience? If a person is already an audience member or museum visitor, can't one assume that he or she has enough interest and experience with the arts to reap the rewards?

Yes and no.

In his book *Of Mind and Other Matters*, Goodman writes that "while most of those who use a library know how to read, most of those who visit a museum don't know how to see."[7]

The term "wall cruising" is used among museum educators to describe the phenomenon of visitors passing by works with barely a pause in pace. In his *New York Times* article, "At Louvre, Many Stop to Snap but Few Stay to Focus," Michael Kimmelman explains that photography has replaced sketching at museums, which visitors of the past used "to record their memories and help them see better."[8] Yet photographs take only a second while a sketch requires quite a bit more time.

David Perkins explains that "the 'look and see' understanding of looking at art is incoherent with the realistic demands of the activity. Art often does not yield up its secrets to the casual look... the art in art must be looked *for*."[9]

How many visitors today take the time to "see better," to "look for the art in art?" In our contemporary society that moves at a break-neck pace, who has time to sit with a work for an extended length of time? More importantly, who has the skill to do so? Simply attending a concert or visiting a museum rarely instills the skills for aesthetic experience; more often than not, they must be taught.

There are many ways to learn these skills. For people of all ages, learning how to practice an art form engenders engagement with works of art in that medium: studying the intricacies of music theory enables one to listen more intently, recognize more complexity, and analyze more accurately; learning

the techniques and using the materials to make oil paintings allows one to see colors, shapes, and shades more acutely, observe details more carefully, and infer an artist's process more easily. Art *making* leads to a deeper and more nuanced *appreciation* of that art form.

However, most adults do not see the necessity in being trained as artists in order to appreciate art at a deeper level. While the majority of audience members want to enjoy the works of art they experience and are willing to learn more about these works in order to maximize their experience—they are not willing to take weeks, months, or years of voice lessons in order to appreciate a Mozart opera.

So where does this leave non-practicing adult students? Zakaras and Lowell explain that performing arts institutions have begun to "[offer] educational programs in connection with their performances to satisfy their audience members' desire for deeper understanding of the artworks they encounter. These programs offer important single experiences... they cannot, however, fill the need for ongoing skill development..."[10] These *performance preparation* courses are popular and help audience members feel more prepared to witness a work of art, but they do not teach the skills for aesthetic experience.

While there are certainly adult arts appreciation courses of very high quality, most teach students to depend on the instructor for explication and for guidance about what to attend to in a work of art. This approach, focused on facts, assumes a great deal about the students' abilities to independently engage with a work of art outside of the instructor's blueprint. These students will always need a guide to show them what to look for, what to listen for, and what to attend to.

Adult educators need to reconsider the purpose of teaching arts appreciation. Why are such classes offered? What are the goals of adult arts appreciation educators? If the aim is to empower students to form their own connections to the arts, to enjoy them on an emotional and cognitive level, to seek their own answers to their own questions, and to participate in meaning-making, then the current didactic model for teaching arts appreciation falls short of its mark.

If the goal of arts appreciation courses is to help students have an independent, aesthetic experience with art, then it is not enough to teach students facts about artists and the times in which they lived, highlighting the works that made them famous. Instead, students must be taught the skills and processes of engagement—the *work* of art.[11] Adult students must be taught *how* to have an aesthetic experience, or else all the facts and figures are nothing more than meaningless data that will be forgotten.

Generational Challenges to Pedagogy

Teaching the skills of engagement to adults is a great challenge—the term "adult" encompasses everyone within an 80+ year span. Certainly 25 year-old adults are different than 45 year-old adults who are in turn different from 75 year-old adults. There are many reasons why generations differ, such as historical, sociological, or economic influences. Baby Boomers, for example, are different from their parents' generation because of factors such as immigration in the early part of the 20th century, World War II, the Vietnam War, the Great Depression, and the Civil Rights movement. These events and movements shaped the people who lived through them and gave each generation its own identity. While these kinds of historical events and sociological developments still affect adults today, a large part of current generational disparity has to do with technology.

Younger adults seek interactive communication. They are accustomed to inserting themselves in various situations as they publish their own books, maintain their own blogs and websites, and make their own music that they then distribute, promote, and network online. Through technology, these young adults are circumventing the large institutions that formerly guarded the gates to formal arts production and distribution—and to knowledge acquisition.[11] They pursue their own agendas and seek their own answers, and do not need a record label to offer a contract or a university to give its seal of approval. The old adage, "how do you get to Carnegie Hall? Practice, practice, practice!" is no longer true for young people. They do not wait in line to be granted entrance at the front door; they will go through the back door, the stage door, they will go to a different venue all together—or create their own venues. The younger generations are ready to blaze their own paths, and technology has allowed them to do so.

Don Tapscott notes in his article "Higher Education Is Stuck in the Middle Ages—Will Universities Adapt or Die Off in Our Digital World?" that the all-too-familiar lecture format of classrooms, with the teacher at the podium in front of students sitting passively, does not work for today's young adults. He calls this one-way transmission "broadcast learning," akin to watching television or listening to the radio. Yet society has moved into a digital age of the Internet and beyond. "Schooled on Google and Wikipedia, [today's students] want to inquire, not rely on the professor for a detailed road map. They want an animated conversation, not a lecture."[12] These young adults are bored with "sit and listen" environments like concert halls or outdated classrooms and seek a more participatory experience.

Many, though certainly not all, older adults are less comfortable with this. Baby Boomers, having grown up with television and "broadcast learning," are more accustomed to the "sit and listen" model of audience

and classroom environments. I'd say this is true for previous generations as well.

In my experience in continuing education, at Juilliard and elsewhere, I have observed a trend where most often older adult students seek courses with a lecture format that highlight a professor's encyclopedic knowledge. Many times class discussions and participation or student questions are perceived as interrupting the teacher. Yet younger adult students in these same classes can be found texting under their desks, or accessing the Internet or social networking sites on their laptops. These younger students are either bored with the one-way transmission of the lecture format, or they are investigating the topic from other perspectives, seeking alternate resources. Again, Tapscott explains that this generation wants to be part of the conversation. "[G]rowing up digital has encouraged [them] to be active and demanding enquirers. Rather than waiting for a trusted professor to tell them what's going on, they find out on their own on everything from Google to Wikipedia."[13]

Granted, there are plenty of adult students of all ages who want to know more, who want to own their knowledge, and who seek the skills to interpret and analyze works of art for themselves. However, these students, young and old, typically enroll in different kinds of courses, like arts practice (such as piano lessons or painting classes), or skills and theory (like ear training or color theory). These students purposefully strive for a deeper, analytic skill set in their approach to the arts. Having studied arts *practice*, they have the knowledge, skills, and experience of engaging with the arts in a hands-on way. They come to a work of art with a better understanding of what went into making it, and therefore can participate in the viewing, listening, or experiencing of that work of art more deeply. Arts practitioners of all ages are better prepared to have an aesthetic experience with works of art.

But for those non-practitioners who are content to passively observe, who in fact prefer a "sit and listen" environment, how does one encourage them to engage? And for those demanding a more interactive experience, who might be bored watching a performance on a remote stage, how does one encourage a different kind of participation? And how does one teach a class that includes both kinds of students?

New (and Old) Approaches and a Vision for Adult Arts Education

Over the next 20-30 years there will be a shift in the adult population, from those accustomed to (and who seek) the "broadcast" model, to those

accustomed to the "participatory" model. Faculty must be equipped to handle this transition, and to ultimately accommodate the new adults who demand a more interactive experience.

If non-artist adult students need to be taught how to participate with works of art, and if some older adults are less accustomed to participatory environments, then how does one approach the teaching and learning of a topic that requires participation? If younger adults are already accustomed to participatory environments, how does one teach the different participatory skills needed to engage with the arts? Accommodating both kinds of adults is challenging, especially with a classroom age demographic that can span decades and stretch across multiple generations. This multi-generational classroom is the norm in continuing education, though there is little literature on the topic. Considering the technology-related generational differences cited above, this will be an important area of research in coming decades.

During the impending generational transition period of adult students, adult education settings will need to employ multiple models. Faculty will need to retain certain aspects of the broadcast model, but also to integrate them with other, more participatory models. Along the way, educators must be careful not to alienate older students and faculty who are accustomed to and prefer the lecture format, while still inviting in younger students and faculty who seek participation.

In order to empower current adults to engage independently with the arts, more constructivist models will need to be employed in the classroom; in order to teach students how to participate, pedagogical methods must be participatory. This means that students' learning should stem from their experiences, not from what they are told. This may be uncomfortable for some faculty and students who are used to the lecture, broadcast format. Faculty will need to be more than founts of knowledge, but also facilitators of discussion. Students will need to be willing to offer their own interpretations and be open to those of their classmates.

There are a number of pedagogical methods already in use, mostly in K-12 classrooms, that can be applied to adult education. Visual Thinking Strategies (VTS) is one possible tool for engaging adults who are at various levels of knowledge. VTS is "a research-based teaching method that enables students to develop aesthetic and language literacy and critical thinking skills through discussions of visual images."[12] While this approach has been used primarily with children in the visual arts, the methods of inquiry are being applied across artistic disciplines, age groups, and environments and could be used in the adult arts appreciation classroom as well. Simply asking students what they notice, what they hear or see, or what they think is going

on in a given work helps advance their thinking. Students go from waiting for the instructor to *tell* them what to notice, to seeing for themselves. It is an empowering act, helping audience members gain the confidence to connect with a work of art, and venture to offer an interpretation. In addition, the VTS dialogue process in itself shows students how to spend an extended period of time observing, noticing, considering, connecting, and reflecting, which is the first step towards having an aesthetic experience.

Another option is to incorporate arts practice, or art making, into arts appreciation classes. Faculty could have students try their own hands at writing a poem, drawing a self-portrait, or singing a song in order to explore more deeply a poem by Marilyn Chin, a painting by Kahinde Wiley, or a song by Jennifer Higdon. This technique, by no means new, is based on John Dewey's writings about experiential learning, and has been developed and employed by the Lincoln Center Institute in mostly pre-K-12 classrooms in New York City and around the world. The experiential approach could easily be used with adults in a classroom setting. Even non-artist students can and should get their hands dirty in the process of engaging with the arts.

Beyond this, instructors need to model, demonstrate, and explain to students how they themselves explore works of art, and how they have come to certain interpretations. At the same time, they need to have the students perform their *own* interpretations in class and use evidence to support their opinions. These critical thinking skills are used by people in a variety of situations and disciplines, and should be fostered in adult arts education classrooms if the goal is to teach students how to inquire, interpret, and appreciate the arts for themselves. As mentioned earlier, the methods I have suggested have been used primarily with children, and adapting them for use with adults must take into account these students' cognitive capacities, which are more complex than children's.

Many arts educators have written about aesthetic education and the need to teach students how to engage with the arts. These ideas are not new, but what is new is: teaching them to adults in adult and continuing education settings, focusing on the participatory nature of the arts, and incorporating this essential element into pedagogical approaches to adult arts education in order to meet the demands of future generations of adult learners.

Even more than existing methods, faculty in the future must develop their own ways to engage students. It may even be the case that students will benefit the most when they themselves discover and devise the means for pursuing their own learning. Faculty, and the pedagogical methods they

employ, must be flexible enough to allow for new and experimental models to be explored in arts appreciation classrooms.

Incorporating Media and Digital Technology

The possibilities for using new media and digital technology in the arts appreciation classroom are endless, and while I will explore a few of them in this section, digital technology is an area where flexibility and adaptability are especially important, as things change so quickly. Within even a few years of this anthology's publication, there will be new technologies available. Faculty cannot assume that getting up to speed on the latest technology will be a singular effort. They must be ever-learning and exploring, like their students.

One current option for using new media and digital technology is to have multi-media presentations (as some faculty do now), with images, audio and video clips, and even projected CD-ROMs or websites. This is a way to incorporate existing technology into the classroom during the transition period. This approach to adult arts education introduces older students to new media, makes lectures more dynamic, and further elucidates concepts that are being discussed. However, simply showing a PowerPoint slideshow or even media clips on YouTube is still an example of broadcast learning.

Technology should not be employed merely for its own sake—faculty must know why and how to use new media in the arts appreciation classroom to transcend traditional didactic models of teaching and learning. There must also be room for students to talk about what they are hearing and seeing, to integrate them into what they are learning. Having faculty present examples and then asking questions about how they relate to a given topic can be a great way to start a discussion with those who may not be as comfortable talking in class as others.

Obstacles to Participatory Adult Arts Education

Of course there are challenges to bringing arts appreciation courses into the 21st century. Faculty and students may be on board, but there are other factors involved in making participatory adult arts education a reality.

Most schools and cultural institutions do not invest a considerable amount of resources in their continuing education divisions. These more peripheral departments are usually made up of adjunct instructors who do not receive a contract (or benefits) beyond a one-semester agreement. While professional development for these faculty would be essential to move forward, rarely are funds available. In addition, there is usually a minimal

budget for supplies in these classes, which limits art-making opportunities. The student body in continuing education divisions is ever-changing, as students take classes for one semester, but not another, attend for a few years, and then disappear. Unpredictable student transience makes it difficult to estimate revenue and determine an appropriate budget to support all the initiatives necessary to develop the arts appreciation classroom. In order to bring continuing education classrooms into the future there will need to be a shift in priorities. Arts schools will need to allocate funds to support their continuing education divisions if only to help maintain the audience for their graduates. This would include funds for professional development for faculty as they learn to balance the needs of older and younger students, and learn new ways of engaging students and using digital technology and new media in their classrooms.

As mentioned earlier, every effort must be made not to alienate older students and faculty while encouraging change. Some faculty may be resistant and not see the need to alter what has been successful for so long; some students may not return to classes that are incorporating technology and/or more participatory pedagogical methods. Another challenge is convincing younger students of the value of an arts appreciation class, as they may feel it is sufficient to simply look up what they want to know online.

The road to the future is surely not a smooth one, and adult education divisions must be prepared to innovate and improvise on an ongoing basis as their student population shifts. There are tools and options already available in both pedagogy and technology, but demonstrating a need for them—to students, faculty, and administrators—and acquiring the necessary funds, is the first challenge to overcome. Along the way, there need to be opportunities for administrators, teachers, and students to share their experiences. Creating communities—whether online or locally— would help to advance adult arts appreciation. Such communities could be places where adult education administrators may collaborate, discuss their work, and develop a broad agenda, or where teachers may share their pedagogical methods with their colleagues. If participation is necessary for adult education students in the classroom, is it likewise necessary for adult education colleagues outside the classroom.

CONCLUSION

Despite the field of arts education's focus on arts practice for K-12 children, non-practicing adults are an important demographic that need to be examined further. Arts appreciation classes for adults can be found across

the country and around the world, yet our means for teaching this topic and for teaching this student body are outdated and misguided.

Our goal for arts appreciation courses should be to teach students not just facts about the history or specific elements of the work to attend to, but *how* to have an aesthetic experience with a work of art. We need to teach students the skills of engagement—observation, inquiry, and interpretation, to name a few—through direct interaction with the arts medium at hand. This kind of interaction and participation by the audience is vital for the future of the arts. With the changing arts landscape, we need an audience that can encounter each work of art not with an arsenal of information, but with the skills to truly appreciate it.

These skills will not be learned through a lecture. Students must be taught in a participatory environment—the adults of the future will demand it. We must honor the needs of the arts and of our students, and both require interaction and participation.

Other, non-lecture, pedagogical arts education models are currently being used with children. These methods—modified to account for adults' unique and complex cognitive capacities—can likewise be utilized in the non-practicing adult arts education classroom. But other adult-specific methods of instruction still remain to be devised (and technology incorporated) in order to best serve adults in the decades ahead. Faculty must be flexible enough to experiment in their classrooms with both new and existing methods of instruction—and to guide students in exploring and discovering their own approaches to learning.

As we teach the skills of aesthetic experience, of engagement and participation, we will be arming the adults of the future with the ability to appreciate new works of art, and potentially to transfer these skills to the world at large. The arts themselves have gone beyond museums and concert halls; the very nature of the arts, their acceptable locations and media are changing every day. Works of art are found on sidewalks and in landscapes, online, and in people's pockets. Teaching adult students of all ages to interact with the arts in a flexible, thoughtful way using critical thinking skills will create a more thoughtful and engaged audience for the changing arts that will be produced in the future.

Join the Conversation
Contribute to a dialogue pertaining to the concepts discussed in this chapter by directing your web browser to the following URL:
http://www.20UNDER40.org/chapters/chapter-13/

NOTES:

1. Tapscott, D. "Higher Education Is Stuck in the Middle Ages—Will Universities Adapt or Die Off in Our Digital World?" Alternet. (n.d), <http://www.alternet. org/story/140703/higher_education_is_stuck_in_the_middle_ages_--_will_ universities_adapt_or_die_off_in_our_digital_world/>.
2. With the tenuous access to arts education (according to the GAO's report on Access to Arts Education, 2009) and the decline in time spent on arts education (as per the CEP's report on Curriculum and Instruction in the NCLB Era, 2007) in K-12 schools, future generations are entering adulthood with less experience with the arts.
3. Aslanian, C. B. *Adult Students Today.* The College Board: New York, 2001.
4. This idea of the necessity of audience engagement was most famously expressed in John Dewey's *Art as Experience.* "For to perceive, a beholder must create his own experience. And his creation must include relations comparable to those which the original producer underwent.... Without an act of recreation the object is not perceived as a work of art." Dewey, J. *Art as Experience.* New York: Penguin Group, 1934: 54.
5. Goodman, N. *Languages of Art.* Indianapolis/Cambridge: Hackett Publishing Company, Inc., 1976: 241-2.
6. Zakaras, L. & Lowell, J. F. *Cultivating Demand for the Arts: Arts Learning, Arts Engagement, and State Arts Policy.* Santa Monica: RAND Corporation, 2008: 96.
7. Goodman, N. *Of Mind and Other Matters.* Cambridge: Harvard University Press, 1984: 177.
8. Kimmelman, M. "At Louvre, Many Stop to Snap but Few Stay to Focus," *New York Times,* (August 2, 2009).
9. Perkins, D. "Art as Understanding." In Gardner, H. & Perkins, D. (Eds.) *Art, Mind, and Education: Research from Project Zero.* Urbana: University of Illinois Press, 1989: 119.
10. Zakaras, L. & Lowell, J. F. *Cultivating Demand for the Arts: Arts Learning, Arts Engagement, and State Arts Policy,* 2008: 69.
11. Booth, E. *The Everyday Work of Art: Awakening the Extraordinary in Your Daily Life.* Naperville: Sourcebooks, 1997.
12. Tapscott, D. "Higher Education Is Stuck in the Middle Ages—Will Universities Adapt or Die Off in Our Digital World?" (n.d).
13. Ibid.
14. Wallace Foundation. *Engaging Audiences: Report on The Wallace Foundation Arts Grantee Conference Philadelphia, PA, April 1-3, 2009.* New York: The Wallace Foundation, 2009: 8.
15. Visual Thinking Strategies. [Home page]. (n.d.), <http://www.vtshome.org/>.
16. Freire, P. & Macedo, D. P. *Literacy: Reading the Word and the World.* Westport: Greenwood Publishing Group, Inc., 1987.
17. Freire, P. *Education for Critical Consciousness.* London: Continuum International Publishing Group, 2007.

18. Hetland, L. & Winner, E. "Cognitive Transfer from Arts Education to Non-arts Outcomes: Research Evidence and Policy Implications." In Eisner, E. & Day, M. (Eds.) *Handbook on Research and Policy in Art Education.* National Arts Education Association, 2004.

The Art of Higher Learning:
The Creative Campus and the Evolving Phenomenon
of University Arts Engagement

Eric Oberstein
Afro Latin Jazz Alliance

Following the 104th American Assembly conference in 2004, colleges and universities re-conceptualized the role of the arts in higher education, looking to the arts as a means of engaging their communities in a cross-campus, interdisciplinary fashion. Various currents facilitated this new momentum, including shifts in higher education goals at the turn of the Millennium, the emergence of funding entities interested in embedding the arts into the life of the academy, the evolution of the performing arts presenter into active producer and educator, and the development of university-based strategic planning initiatives around the arts.

In the spring of 2004 the American Assembly, a national non-partisan public affairs forum, sponsored a conference at which university administrators, campus-based arts presenters, faculty, and arts leaders came together to discuss the "Creative Campus," the evolving notion of a university as a major center for interdisciplinary engagement with the arts. University administrators and presenters from across the country recognized that they were part of a community of individuals invested in effecting change on their campuses through the arts. This community was faced with the following question: how can we develop new ways of using the arts as a means to reach out to the diverse constituencies of our institutions?

I assert that this gathering of stakeholders was a significant ingredient that contributed to a renewed interest and focused dialogue on the

relationship between the arts and higher education. There were also several other simultaneous currents that fueled discourse around the Creative Campus, including the prioritization of interdisciplinary learning in higher education and the emergence of funders interested in supporting new modes of student engagement, especially through the arts. Furthermore, campus-based presenters redefined themselves as active producers, helping to mobilize and collaborate on campus-wide arts projects as well as arts strategic planning initiatives at their respective institutions. Ultimately, in this chapter I aim to investigate two primary research questions: in what ways are university performing arts presenters and educators re-conceptualizing the role of the arts in a university setting, and why now? I also provide some personal thoughts as to what's next—essentially, where is this movement heading and how can young arts leaders propel it into the future?

When discussing creativity and the arts, it is important to establish a set of definitions to frame the conversation. In this essay, the arts refer to modes of expression commonly thought of as artistic disciplines, including music, visual arts, dance, drama, film, creative writing, and other aesthetic domains. In the context of the Creative Campus, creativity refers to a process by which institutions of higher education aim to develop fresh approaches to interdisciplinary collaboration and learning, encouraging new avenues for communication, dialogue, and discovery. Because the Creative Campus discussions were built around the intersection of the arts and higher education, the stakeholders discussed here are invested in focusing on the arts as a critical ingredient in the development of a Creative Campus. In *Art, Mind, and Brain: A Cognitive Approach to Creativity*, Howard Gardner, psychologist and pioneer of the theory of Multiple Intelligences, sees artistic thinking as an important part of the creative process.[1] Philosopher Maxine Greene asserts, "Creativity is putting things together in novel ways, having your own stamp and your own voice."[2] In this context, the arts help individuals on college campuses find that voice, either manifested in new expression or new modes of experimentation.

Following an exploration of the currents contributing to renewed interest in the Creative Campus, I focus specifically on the Association of Performing Arts Presenters' (APAP) Creative Campus Innovations grant program, funded by the Doris Duke Charitable Foundation, as a lens to look at the interdisciplinary projects of eight campus presenters from across the country. I interviewed representatives from each institution and focused on the eight grantees, in particular, as there is a diverse set of liberal arts and research institutions represented, varying in size and geographic region,

including a community college as well as both small and large private and public universities.

Among the findings of this study are the importance of campus ownership, adaptiveness and collaboration, and partnerships with faculty and artists. In my discussion of the future, I ask a series of questions that I believe are critical when considering the Creative Campus. I believe it is in our best interest to problematize and address the potential blind spots of the Creative Campus just as we ponder its vast potential, to ensure that we acknowledge the many complex sides of this exciting and transformative work. Finally, I establish some hypotheses as to where this movement is heading and its implications especially for young arts professionals. As institutions of higher education and emerging arts professionals reassess the nature of their relationship, I believe both entities will find new and equally beneficial ways of working together.

Why Now?

One of the primary questions about the recent activity around the arts at American colleges and universities is: why now? Why are universities investing heavily in and realigning their strategic planning processes around the arts at this time? I assert that a variety of simultaneous currents have contributed to these Creative Campus efforts, including the sustained national conversation initiated by the 104th American Assembly conference, higher education's focus on interdisciplinary education, substantial investment from various funders, and the evolution of the role of the presenter.

Initiating a National Conversation

In March 2004 the 104th American Assembly met to discuss the topic, "The Creative Campus: The Training, Sustaining, and Presenting of the Performing Arts in American Higher Education." Alberta Arthurs, former Director of Arts and Humanities at the Rockefeller Foundation, and Sandra Gibson, President and CEO of APAP, co-chaired this gathering, which kick-started a national discussion on the topic of the intersection of the arts and higher education. A report from the Assembly suggests, "Arts presenters can provide educational opportunities to the general student body by exposing them to artists and artistic enterprises on campus and by providing contexts for understanding the work. Presenters should collaborate with faculty members to achieve this" and coordinate experiences that tie into curriculum.[3]

Steven Tepper, a leading Creative Campus thinker and Associate

Director of the Curb Center for Art, Enterprise, and Public Policy at Vanderbilt University, acknowledges that students should be the primary concern of university leaders and arts presenters. He argues that "as long as teaching and learning remain a central goal, students have to be the primary constituent for Creative Campus work. Other goals are important... but if students are not front-and-center, future Creative Campus initiatives will remain on the margins."[4] Tepper also asserts that three primary conclusions can be drawn from the American Assembly conference. First, American universities and colleges are likely the biggest single arts patrons in America. Second, artistic assets are underutilized on college campuses. Third, there is a need for new research on how the arts operate on a college campus. Given this assessment, he argues that university leaders need to recognize their defining role in the arts ecology and take responsibility for that role more deliberatively and assertively.[5]

Prioritizing Interdisciplinary Education

In addition to the momentum created by the American Assembly conference, colleges and universities are looking to develop a broader focus on interdisciplinary education as well as students with a diverse range of skills and knowledge. The American Association of Colleges and Universities (AACU) authored a project entitled Liberal Education and America's Progress (LEAP), which stresses the importance of a liberal arts education in the 21st Century. LEAP outlines its essential aims and outcomes as developing students with knowledge of human cultures and the physical and natural world, intellectual and practical skills, and personal and social responsibility. AACU emphasizes the importance of integrative learning in this project, as such experiences help students to develop intercultural skills, work in teams, and think critically. In addition, The LEAP project identifies an assortment of high-impact educational practices, including first-year seminars and experiences, common intellectual experiences, learning communities, collaborative projects, community-based learning, internships, and capstone projects and courses, among others.[6] All of these practices tie naturally into the work of the Creative Campus.

Funders Get On Board

Funding from a variety of entities has helped to facilitate and advance Creative Campus work. The Doris Duke Charitable Foundation (DDCF) has been a leading funder, collaborating with APAP on the Creative Campus Innovations grants. In 2005, Princeton University received its largest single gift ever—$101 million—to build a performing arts curriculum and to

support an artist-in-residence program.[7] Vanderbilt also held national research meetings in 2006 and 2008, supported by the Ford Foundation and the Mellon Foundation, to help set a research agenda to explore the relationship between art, creativity, and campus life. In the fall of 2005, the Ford Foundation supported a similar meeting at the University of Texas at Austin. At these meetings, "scholars have begun to offer potential research strategies for understanding how the arts add value to our campuses."[8]

The Evolving Presenter

Campus arts presenters have redefined their roles, developing a comprehensive approach to university arts engagement. Interdisciplinary collaboration and engagement have became a mandate of sorts, and the term "presenter" no longer seems to encapsulate the many responsibilities of a campus-based arts administrator in the 21st Century. The presenter has evolved into much more of a producer, an entity that collaborates with and fosters new work by artists, using these experiences to reach out to constituencies on a deeper, more meaningful level. "Historically, the role of the presenter has been that of facilitator: selecting the artists… advertising the performance, selling the tickets, and then moving on to the next project. Today, most presenters understand this as the most rudimentary definition of presenting."[9]

Presenters at an increasing number of universities are collaborating with upper-level administrators and faculty in an effort to define the types of desired impacts they want for their students and their communities, both through programming and curriculum-based learning. Numerous institutions have developed arts strategic plans and initiatives over the past few years, including Carleton College, Columbia, Duke, Emory, Harvard, Ohio State, Princeton, Stanford, and Virginia Tech, in addition to other schools. Another significant product of the Creative Campus discussions is the newly established Mike Curb Creative Campus Program at Vanderbilt University—the first national research program on creativity, the arts, and higher education. Such a commitment reflects a belief in the role of the arts in higher education.

MODELS OF THE CREATIVE CAMPUS

APAP's Creative Campus Innovations grant program, funded by a $1.5M grant from the Doris Duke Charitable Foundation announced in 2006, built upon this momentum and provided university-based presenters with large-scale funding to develop cross-campus interdisciplinary projects around the arts. The eight grantees received funding ranging from $50,000

to \$200,000 for one- to two-year projects that would help to better integrate the work of each school's presenting body into the academic environment on campus and the surrounding community. The grant program encouraged applicants to propose unique projects that featured innovative approaches and perspectives, attempted to stimulate debate and discussion, and connected diverse constituencies.[10] The grantees included: Hostos Center for the Arts and Culture, Hostos Community College, CUNY (Bronx, NY); Lied Center of Kansas, University of Kansas (Lawrence, KS); Lied Center for the Performing Arts, University of Nebraska-Lincoln (Lincoln, NE); Stanford Lively Arts, Stanford University (Stanford, CA); The Hopkins Center, Dartmouth College (Hanover, NH); Hancher Auditorium, The University of Iowa (Iowa City, IA); Carolina Performing Arts, The University of North Carolina at Chapel Hill (Chapel Hill, NC); and Center for the Arts, Wesleyan University (Middletown, CT). Each grantee worked with a consultant from the firm WolfBrown to assist in program evaluation. The consultants helped the grantees to conduct interviews, surveys, and focus groups to provide qualitative feedback, in addition to looking at more traditional quantitative measures, such as ticket sales. The goal was to provide a "road map" for assessment that the presenters could use for future projects.

Hostos Community College

At Hostos Community College in the South Bronx, the Hostos Center for the Arts and Culture, directed by Wally Edgecombe, has long drawn on the cultural and ethnic makeup of its community in the development of its programming. This community, composed largely of residents of Puerto Rican and Dominican descent, inspired Edgecombe to develop a biennial festival around Afro-Puerto Rican culture, called BomPlenazo, held in October. With the Creative Campus grant, however, he wanted to delve deeper, creating another festival focused on Afro-Dominican culture, and tying student coursework and study abroad programs into both of these festivals.

Basing his project on the roots of his community was an easy choice for Edgecombe. "These types of projects need to be organic to the institution at hand. You can't just invent something," he said.[11] Edgecombe began by collaborating with the college's Humanities department, which ran study abroad programs to both Puerto Rico and the Dominican Republic to examine the countries' respective cultures. Edgecombe worked with the faculty to gear the course of study more acutely to the festivals, having students go into communities to conduct interviews with artists and field

research on cultural practices still upheld by the peoples living there. The students from the study abroad programs would then be trained as cultural guides for groups that came to the festivals in the fall, teaching others about their fieldwork and the cultures being celebrated.

In the summer of 2007, students traveled to the Dominican Republic in preparation for the inaugural Quijombo festival of Afro-Dominican culture, to be held in October 2007. The Dominican artists that were invited to perform at the festival were denied visas, however, forcing Edgecombe to utilize Dominican artists based in the United States. The students were still employed as cultural guides for the festival, though, taking groups through an exhibition at Hostos that featured photographs and footage from their fieldwork. In the summer of 2008, students performed field research in Loíza, Puerto Rico, in advance of the BomPlenazo festival held in October 2008. The Puerto Rican festival will continue every other year in the even years, and the Dominican festival will continue every other year in the odd years.

University of Kansas

The Lied Center of Kansas developed a project entitled *The Tree of Life*, which focused on evolution. Karen Lane Christilles, Associate Director at the Lied Center, noted, "It was very exciting for us to be able to highlight that dialogue [at the American Assembly] and really use the project as a case study on all of the issues surrounding creativity and the arts at a major research university."[12] The topic of evolution included both what evolution means to the campus but also in Kansas in general, as the university's chancellor believed that the university needed to take more of a forward stance on evolution being taught in the schools. The Lied Center invited David Balakrishnan, founder of the Turtle Island String Quartet, to be artist-in-residence for this conversation and project.

Over the course of two years, Balakrishnan worked with the various fine arts faculty and students at KU to develop an evening of music, dance, and theater inspired by evolution and the interconnectedness of humanity. This event premiered in April 2009. Various workshops and colloquia were held throughout the process in which faculty presented their research on evolution and life. The artists working on the project attended the faculty colloquia to learn about their colleagues' research and then took this information and incorporated it into their own artistic work.

The Lied Center surveyed the entire faculty to see if the Creative Campus project was reaching into their disciplines and to understand any barriers that might be limiting such engagement. A significant barrier that emerged

was the notion of "publish or perish" for faculty members. Faculty felt that there was the constant expectation for them to publish their research and work, and they felt that it was hard to collaborate with the Creative Campus initiative unless incentives were provided for them. They wanted assurance that their involvement would be rewarded by the university administration for promotion and tenure, illustrating the importance of listening to the concerns of all stakeholders and developing innovative solutions.

University of Nebraska-Lincoln

At the University of Nebraska-Lincoln, the Lied Center for the Performing Arts developed a relationship with the Madonna Rehabilitation Hospital, the College of Fine and Performing Arts, and the student body at large to develop a Creative Campus project focused on rehabilitating victims of major injuries through art. In October 2009, Troika Ranch Digital Dance Company, a troupe based out of New York City interested in combining digital technology with dance, premiered a piece called *Loop Diver*, which developed from interviews with rehab patients at the Madonna Rehabilitation Hospital. Omaha-native and Troika Ranch artistic director Mark Coniglio's development of Artistic Rehabilitation Therapy (ART) technology also inspired this work. ART is a computer application that uses cameras to translate dancers' movements onstage into three-dimensional digital images. This software has tremendous implications for the hospital as well, as it can capture and analyze patients' movements, providing instant feedback for doctors and researchers. The hospital collaborated with Coniglio to combine his software with the hospital's pre-existing motion-capture technology to enhance both platforms in an effort to improve methods of physical rehabilitation.

Laura Kendall, former Assistant Director of Community Engagement and Learning, managed the project for the Lied Center and worked to develop partnerships with the UNL departments of theater, architecture, education, digital media, and computer engineering, along with NET Television and the Lincoln Arts Council. The Lied project feeds into the university's "Collaborative Academy," an idea of the dean of the College of Fine and Performing Arts to bring students and faculty from different departments together to form a think tank to confront various issues and topics relevant to the university and world community. Kendall stated that this type of project is incredibly demanding and requires a tremendous amount of time, resources, and work. Commenting on the complexity of this project, Kendall remarked, "We're trying to build the bike and ride it at the same time."[13]

Stanford University

Stanford Lively Arts artistic and executive director Jenny Bilfield learned firsthand the importance of being adaptive when managing a Creative Campus project. When she came on board at Lively Arts in 2006, the organization was developing a project proposal focused on bringing an internationally-based puppet company to be in residence. The company's manager, however, became concerned that it was not in the best interest of the company to be off the road for three months, instead proposing occasional campus visits by the artistic director. Lively Arts had to say no to the project in November 2007, as it did not want to compromise the sustained residency and engagement as they were originally envisioned.

Bilfield and Lively Arts responded to this obstacle, however, by conceiving a new project that combined the technological richness of Silicon Valley with Stanford's arts and technology resources. Trumpeter Dave Douglas and filmmaker Bill Morrison were ultimately commissioned to develop a piece, *Spark of Being*, which premiered in April 2010. This multi-disciplinary work combined the resources and inspiration of Silicon Valley with Stanford's Center for Computer Research in Music and Acoustics, as well as the university's faculty and students. One of Bilfield's main goals was to support a new work that made sense in the context of the Stanford community. "At Stanford people join high-tech companies and start-ups. It is an engaged, rigorous, and exciting intellectual environment. There's a buzz in this community," stated Bilfield.[14]

When transitioning to Lively Arts' new project Bilfield learned that it is important to activate one's campus around a concept from the beginning. It is especially important to engage with faculty interested in developing coursework that will help to get students motivated. At the end of the day, though, Bilfield asserted that one grant will not effect change on a campus—it is campus commitment that matters. It is up to institutions of higher learning to support this connective behavior and carry such support into the future. Bilfield stated, "APAP support gives rocket fuel to an engine and gears that are starting to lubricate and work. It's not moving as fast as it will move a couple years from now."

Dartmouth College

The Hopkins Center ("The Hop") at Dartmouth College completed a three-year Creative Campus project called *Class Divide*, which sparked dialogue on campus focused on class differences, both economic and social, through a broad series of programs and workshops. The Hop completed its first year of Class Divide without grant support from APAP and then continued

the project for two additional years with the funding from the Creative Campus grant. According to executive director Jeffrey James, it was felt that economic and social class differences were almost never discussed at a place like Dartmouth. "Class difference had a degree of discomfort or invisibility that we were noticing, and we felt that artists could take a look at these differences and frame them for people in a way that could help to overcome this resistance, both on campus and beyond," James said.[15]

The highlight of the project was a series of work-in-progress readings by the San Francisco-based playwright Anne Galjour, who was commissioned to write a play inspired by field research and interviews conducted in Hanover and other nearby communities. Galjour met with community members and held story circles to gain different perspectives on class in the area. James acknowledged, though, that a challenge to moving forward with this work is finding another subject matter that "resonates as loudly and persuasively" as class divide has. He asserted, though, that it is important to take risks in an effort to move students, faculty, staff, and community members out of their comfort zones.

The University of Iowa

In June 2008, flooding devastated parts of Iowa, and as a result, the University of Iowa's Hancher Auditorium was forced to adjust its timetable for its Creative Campus project, an interdisciplinary endeavor focused on the loss of vision entitled *The Eye Piece*. For the project Hancher collaborated with UI's Center for Macular Degeneration (CMD), the Writing Program of the College of Medicine, the Theatre Arts Department, and faculty in the English, Psychology, and Physics departments. The UI hospital is one of the largest hospitals in the country with a world-renowned Center for Macular Degeneration that is committed to the goal of curing blindness. Hancher invited artist Rinde Eckert—an actor, singer, writer, performer, and alumnus of the UI opera program—to write a play based on stories he captured from patients, family members, medical students, doctors, and fellows at CMD. Eckert worked with UI theater students to stage the production, which premiered in February 2010.

According to Hancher executive director, Chuck Swanson, "The project aims to help doctors and medical students become more compassionate when people lose their sight. Alternatively, it is a neat way for theater students to learn about the arts, healthcare, and healing."[16] Hancher invited the support of faculty members from the English, Physics, and Psychology departments to incorporate the subject matter into their classes, and

medical students in the Writing program at the College of Medicine, an elective program, helped to document the project.

The University of North Carolina at Chapel Hill

Carolina Performing Arts received one of APAP's Creative Campus grants for the 2007-2008 academic year. UNC's project, entitled *Criminal/Justice: The Death Penalty Examined*, focused on the issue of capital punishment. Guided by Executive Director for the Arts, Emil Kang, and Campus and Community Engagement Coordinator, Reed Colver, the death penalty project included a series of performances, lectures, exhibits, and seminars around campus in addition to several highlight events. These events included a performance of Tim Robbins' adaptation of Sister Helen Prejean's *Dead Man Walking* (which was staged by students in the drama department); a staged reading of Prejean's *The Death of Innocents* (which was the selected book for the Carolina Summer Reading Program in 2007); a premiere of the commissioned play, *Witness to an Execution*, by Mike Wiley at the Playmakers Repertory Theatre; and a major photography exhibit by documentary photographer, Scott Langley, which required the establishment of a cross-campus advisory board.

Colver was particularly gratified to see that events were cropping up around campus during the course of the project initiated by the various schools and departments at UNC without her prodding. This work energized the conversation on campus and allowed Carolina Performing Arts to support this organic work that was already happening.[17] Similar to several other projects, UNC was forced to adapt to unexpected events, including the passing of invited guest artist Sekou Sundiata as well as cancellations by major guest speakers that formed the core of several anchor projects. The project became even more grassroots as a result, as various smaller campus projects stepped up to fill the void left by those major events.

Wesleyan University

The Center for the Arts at Wesleyan completed a two-year exploration of global warming and climate change in a project entitled *Feet to the Fire*. Pamela Tatge, director of the Center for the Arts, stated, "The presenter should look at the strategic objectives of the university and see how the presenter's work can mirror that."[18] Aware that Wesleyan was interested in expanding the role of the sciences at the university, Tatge consulted with several scientists on campus, who emphasized the strong need for the community to understand the significance of climate change.

With the support of the Center for Creative Research, a multi-year

pilot project "designed to re-engineer institutional contexts for artists," Tatge worked with Environmental Studies professor Barry Chernoff and visiting artist and dancer Ann Carlson to develop a proposal for a project that related to climate change and the Earth.[19] Tatge noted that she and her colleagues wrote six months of planning into the grant timetable, as such projects cannot operate without planning time to get faculty together and to get "bureaucracy moving." The project was officially launched in January 2008.

During that spring semester, Carlson and Chernoff co-taught a class related to climate change where students conducted field research at a landfill in Middletown, where Wesleyan is located, resulting in a series of works based on text and movement. The Center for the Arts also commissioned Carlson to develop a dance piece, "Green Movement." At the beginning of the 2008-2009 academic year, Feet to the Fire was the focus of the freshman common moment program called "First Year Matters," in which approximately 550 new Wesleyan students came out to stage a dance based on climate change, led by the Liz Lerman Dance Exchange. In the spring of 2009, Chernoff took a group of students to the rainforests in Guyana to extend their scholarship from Feet to the Fire. Several Feet to the Fire modules were also co-developed by both arts and non-arts faculty to supplement courses across the university in architecture, anthropology, environmental studies, government, art, and dance. Culminating festivals took place in May of both years featuring work developed over the course of the project.

ANALYZING THE CREATIVE CAMPUS AND MOVING FORWARD

Colleges and universities are experimenting in the arts and interdisciplinary collaboration in ways they never had before. Through Creative Campus work, interdisciplinary partnerships are being formed and the arts are operating in new contexts. What lessons can we learn from this Creative Campus work happening around the country, and what are some implications for the future? In addition, what questions should arts leaders be asking to ensure that the arts remain central to these efforts?

Ownership

It is important for campus leadership and upper level administrators to buy in to the notion of the Creative Campus and the role of the arts in fueling creativity. University presenters have an opportunity to actively educate these administrators about this work and how it can align with their institutions' strategic objectives. Students, faculty, staff, and community

members must also feel a sense of ownership of Creative Campus projects and work. Silagh White, Director of Arts Lehigh at Lehigh University, holds annual Creative Campus caucuses of campus arts directors. White stated, "Campus arts administrators need to act as connectors and appeal to both arts and non-arts students. Change does not happen from a state of inertia. We need to work laterally in institutions that understand vertical structure."[20] Additionally, meaningful interaction and learning will only result if the topics of inquiry are of relevance to the context in which the university operates. As one presenter stated, "Whatever you do has to be true to who you are."

Adaptiveness and Collaboration

Creative Campus agents emphasize the importance of being adaptive and open to learning. Broad-based projects require time for planning and implementation, and it is important for presenters to develop partnerships and trust with various collaborators across the entire campus. Sandra Gibson acknowledged, "It is hard to develop partnerships. How do you get people out of their tunnels and silos?"[21] One must also occasionally respond to conditions that are out of one's control. It is important to be creative in one's thinking about how to proceed in a manner that will not drain an effort of its momentum.

Partnerships with Faculty and Artists

When developing programs and courses, presenters emphasized the importance of working with administrators to provide incentives for faculty, as many faculty members are expected to publish or otherwise contribute to their fields as a means toward tenure. Creative Campus work by faculty members should be rewarded to the same degree as publishing books, articles, or major research projects, easing any reluctance associated with taking on such projects. It is important for the university to find artists that are open to long-term residencies and engagement, and it is also imperative for universities to balance the work of visiting artists with that of resident arts faculty. Furthermore, evaluation of and reflection on these relationships between faculty, artists, and other Creative Campus agents are key to improving partnerships and learning.

The Future

Colleges and universities have a unique opportunity to embed the arts into their campus communities. In order to do so, arts administrators and educators will need to raise new funds, forge new partnerships, and

be insistent on long-term support from upper-level administrators. It will be important for arts leaders to carefully consider the implications of this work. There are a variety of questions that we should be asking to ensure that the arts and art-making remain central to these efforts, including:

- How does a university move beyond short-term themed projects to creating real campus-wide cultural change in the arts? In order for such work to be sustained, it cannot be shortsighted and solely program-driven.
- How can Creative Campus programs jumpstart broader strategic planning efforts around the arts that embed the arts into the life of an academic community and bring the arts from the periphery into the center of that community?
- Is Creative Campus work geared solely toward the instrumental purposes of the arts, or are institutions advocating for the intrinsic benefits of the arts on their campuses as well? I argue that it is essential (even amidst a simultaneous effort to promote interdisciplinary, cross-campus dialogue) to remember the importance of the arts for arts' sake. Much of the Creative Campus work to date used the arts as a means to reach a goal outside of the arts. What would programs look like that placed the intrinsic worth of the arts in the foreground? The RAND study, *The Gifts of the Muse: Reframing the Debate About the Benefits of the Arts*, is particularly helpful in outlining both the intrinsic and instrumental benefits of the arts and serves as an important resource in educating ourselves on how to think about achieving both in a higher education setting.[22]
- Are campuses creating an environment that fosters art-making and collaboration among students, faculty, and community members? In some Creative Campus programs, outsiders were brought in to make/perform art that others experienced as observers. How can the Creative Campus be re-tooled to make student, faculty, and community art-making primary or equally significant?
- Do Creative Campus programs truly enhance the creative capacities of students and other stakeholders? How might campuses gauge the creativity of their students and the growth of such a capacity? As individuals such as Steven Tepper and others have acknowledged, it will be important to continue our work to understand the impact of the arts on student learning and creativity on campuses, and develop new modes of evaluation and assessment.
- Are institutions of higher education genuinely embracing and honoring the arts, instead of simply advocating for new modes of creativity, which may be devoid of the arts and art-making

altogether? The arts must assume their rightful place at the table rather than simply being paid lip service by top university officials. Some grantees intimated that they continued to meet resistance from upper-level administrators who did not prioritize the arts at their research institutions. This orientation is not productive. The Creative Campus concept is incomplete without the arts, and it is our role to educate these administrators about the value of the arts in contributing to their institutions' overall mission.

It is important to locate and consider these and other blind spots of the Creative Campus movement and allow innovative arts professionals to address and build upon the incredible work that has already been done. To this end, I have several hypotheses as to where this movement is heading.

I believe that the higher education sphere as a whole, upon careful consideration of the momentum achieved to date and the potential of such work, will begin to explicitly acknowledge the arts as essential to the missions of colleges and universities across the nation, both for their intrinsic and instrumental benefits. There will be an increased demand for arts professionals who can work both as administrators and educators in higher education, advocating for a greater place for the arts in the fabric of their academic institutions and serving as the connective tissue among the diverse constituencies of those institutions. These individuals will author the next chapters of this movement, and they will be the ones who will know how to traverse and deconstruct the hierarchies of the academy and create more balanced, horizontal exchange on campuses. The arts will become a natural vehicle for exploring the wide-ranging issues that face a university community, and they will also give students an opportunity to express themselves in new ways.

In addition, this work will create new knowledge and best practices around interdisciplinary arts engagement and learning that can be applied to K-12 and other educational settings. There will be a need to research, synthesize, and document new thinking on arts pedagogy and learning, which will profoundly impact higher education, K-12 education, arts education, and other fields. In addition to those arts professionals studying this new work, there will be great demand for artists to collaborate and work with universities. As colleges and universities become even greater patrons of the arts, these institutions will provide new venues and sources of funding for artists who may not have explored such terrain. Ultimately, young arts professionals and institutions of higher education have an opportunity to develop a symbiotic relationship that will only continue to benefit one another. As Liz Lerman, director of the Dance Exchange and

frequent Creative Campus collaborator told me, "If done right, one could cause a revolution in academia of the kind that's needed."[23] I see that as our ultimate call to action.

Join the Conversation

Contribute to a dialogue pertaining to the concepts discussed in this chapter by directing your web browser to the following URL:

http://www.20UNDER40.org/chapters/chapter-14/

NOTES:

1. Gardner, H. E. *Art, Mind, & Brain: A Cognitive Approach to Creativity*. New York: Basic Books, 1984.
2. American Music Center. "Can Creativity Be Taught?" *NewMusicBox* (December 1999), <http://www.newmusicbox.org/first-person/dec99/8.html>.
3. American Assembly. "The Creative Campus: The Training, Sustaining, and Presenting of the Performing Arts in American Higher Education." (2004), <http://americanassembly.org/programs.dir/CCAMPUS_report_report_ file_C_Campus.pdf.pdf>: 12.
4. Tepper, S. J. "Riding the Train: Creativity and Higher Education." *Inside Arts*, (July/August 2006).
5. Ibid.
6. Association of American Colleges and Universities. "Liberal Education and America's Promise (LEAP)." (n.d.), <http://www.aacu.org/leap/index.cfm>.
7. Pogrebin, R. "Princeton to Receive Record Gift for the Arts." *The New York Times* (January 21, 2006), <http://www.nytimes.com/2006/01/21/arts/21prin. html?_r=2&oref=slogin>.
8. Tepper, S. J. "Riding the Train: Creativity and Higher Education," 2006.
9. Foster, K. J. *Performing Arts Presenting: From Theory to Practice*. Washington, DC: Association of Performing Arts Presenters, 2006.
10. Association of Performing Arts Presenters. "The Creative Campus Innovation Grant Program Guidelines." (n.d.), <http://www.artspresenters.org/services/ creativecampusgrants.cfm>.
11. Wally Edgecombe. Interview, July 21, 2008.
12. Karen Lane Christilles. Telephone interview, June 30, 2008.
13. Laura Kendall. Telephone interview, July 2, 2008.
14. Jenny Bilfield. Telephone interview, July 7, 2008.
15. Jeffrey James. Telephone interview, July 14, 2008.
16. Chuck Swanson. Telephone interview, June 23, 2008.
17. Reed Colver. Telephone interview, July 14, 2008.
18. Pamela Tatge. Telephone interview, August 29, 2008.
19. Center for Creative Research. "About." (n.d.), <http://www.centerforcreativeresearch. org/live>.
20. Silagh White. Telephone interview, May 29, 2008.

21. Sandra Gibson. Telephone interview, August 11, 2008.

22. McCarthy, K.F., Ondaatje, E. H., Zakaras, L., Brooks, A. *Gifts of the Muse: Reframing the Debate About the Benefits of the Arts.* Santa Monica, CA: RAND Corporation, 2004.

23. Liz Lerman. Telephone interview, April 7, 2010.

Riding through the Borderlands:
Sustainable Art, Education, and Social Justice

Marissa McClure
University of Arizona

In this chapter, the author shares the story of an ongoing collaboration between undergraduate and graduate art and visual culture education students at the University of Arizona and Bicycle Inter-Community Action/Art and Salvage (BICAS), an organization dedicated to social reconstruction, sustainable design, and integrated, community-based art and education. This chapter offers an example of how students develop a border consciousness in working as collaborators with a sustainable community-based organization that caters to a diverse clientele. It complements research that considers the potentials of university/community collaboration at the pre-service level, negotiated curriculum involving sustainable materials, and investigations of issues of community, human, and civil rights through engagement with art and visual culture education.

Currently, Arizona is embroiled within divisive and sweeping controversy over recent legislation regarding immigration and ethnic studies. Amid a swell of forceful, partisan rhetoric, accusations, fear, and suspicion flood border cities and towns and threaten to erode tightly woven social networks and communities. Within such a context, where might community-based art education be situated? How might it be both collaborative and sustainable? In this chapter, I define "sustainability" as the ability of an organization— and its work—to retain strength over time. This vigor may be visible in the fecundity of the organization and in the continued involvement of its staff and clientele in artful and engaged community life.

Here, I share the story of an ongoing, now three-year, collaboration between undergraduate and graduate Art and Visual Culture Education students at the University of Arizona in Tucson who are enrolled in ARE 520: Community, Culture, and Art Education, a course I teach in conjunction with Bicycle Inter-Community Action/Art and Salvage (BICAS). BICAS is a community-based organization and education center that describes its mission as promoting education, art, and a healthy environment while providing service and opportunity for those in need.[1] The unique fusion of re-use materials, bike mechanics, public art, style, and design allows BICAS to flourish within a vibrant downtown art and cultural center. It draws an eclectic assortment of artists, educators, environmental activists, and patrons to its underground, warehouse-style workshop, gallery, and classroom. Beyond this immediate context, BICAS serves 700 unique visitors per year from throughout Southern Arizona. Through art, activism, and the proliferation of artful re-use transportation, BICAS routinely crosses borders. These borders include—but are in no way limited to—those experiencing homelessness and those at the center of community life; cross-cultural borders and physical borders (e.g., between city neighborhoods and the ethnic communities they represent); gender-role borders (e.g., in the "Tools for Trans" educational program for transgender women); and in the case of this collaboration, borders between university and community.

My primary aim in this chapter is to demonstrate how the collaboration with BICAS can serve as a model for pre-service education for community-based arts educators. I share my class's experience as one that is pedagogically responsive to the particular assets and needs of our community, and as one in which students and future educators and researchers become "border crossers," bridging across cultural and physical barriers. To illustrate, I use Gomez-Peña and Garber's concept of "border consciousness" as a theoretical framework that reveals an understanding of the processes the students experience during their collaboration with BICAS participants and staff.[2] Garber explains that "border consciousness... necessarily implies the knowledge of two sets of reference codes operating simultaneously," Gomez-Peña adds that "[t]he challenge is to fully assume this bi-culturalism, develop it, and promote it."[3]

I propose that the efficacy of community-based programs depends upon both rigorous theoretical and practical preparation for pre-service educators. This preparation can be enhanced by curricular structures that position students and teachers as border-crossers and co-constructors of a site-oriented visual culture that functions to create, sustain, and redefine concepts of art, activism, and community.[4] This structure of

"border consciousness" and bi-culturalism assumes something more than a conventional idea of critical pedagogy. Rather than a consciousness-raising where an empowered group gives voice to an oppressed one, it implies a co-construction of bi-culturalism, where community members forge collective, sometimes contradictory, identities as they share equally and redefine definitions of assets and needs. This redefinition complements BICAS's initial mission of two-way sharing of skills (i.e., Bootstraps to Share, which I explain further in the next section) that allow each participant a greater sense of agency and identity within a collaborative.

Our Collaboration: Background and Goals-in-Process

Through this collaborative experience, pre-service art and visual culture educators are able to re-envision themselves and their future teaching practice as they collaborate with one another and with community-based educators to serve populations with whom they may previously have had little contact. These communities are composed of urban, low-income neighborhoods, and "at-risk" youth in a city often riddled with conflict over issues of social justice, educational rights, and human rights along the Mexico/US border.[5] As the instructor for this collaborative course, my initial questions about pre-service preparation for community-based arts educators were:

- What could effective pre-service education in community-based arts education look like?
- What do students need to know how to do and why?
- How might theory, like the concept of "border consciousness," describe the attitudes students develop through this experience?
- How do art and activism fit together in community-based settings?

As I have moved through the collaboration, I have become more interested in and motivated by understanding how my students experience the course and collaboration, and how their questions both reveal and challenge assumptions about teaching and learning in community-based, activist contexts.

BICAS was established in Tucson in 1989 as an organization called Bootstraps to Share, an outshoot of the Tucson chapter of Bikes not Bombs. Bootstraps to Share was incorporated as a nonprofit organization in the State of Arizona in 1990, and re-emerged as BICAS in 1996. A group of like-minded community members—primarily artists and educators—came

together to assist and empower one of the most sizeable urban homeless populations in the US, helping people attain work, shelter, food, and transportation. As BICAS's focus centered upon sustainable transportation (e.g., participants learning how to build bicycles from re-used parts) they emerged as a nonprofit collectively-run community education and recycling center that has restored thousands of bicycles, diverting them from the waste stream and providing transportation for hundreds of people a year.

BICAS has a vibrant educational division and engages young people and adults throughout the community via school visits, open studio art programs, and after-school programs. Their official description states that they, "[c]reate cottage industries to employ and empower homeless and working poor. Recycle used bicycles, sell to the public, ship ([as a form of] humanitarian aid) to developing countries." Their educational goal is "[t]o develop self-confidence, a positive self-image, and a degree of self-sufficiency in youths, and conversely reduce the likelihood of youths engaging in self-destructive and/or criminal behavior."[6] Art is woven into these aims, and is used interchangeably for the "A" (along with "Action") in BICAS's name. While the medium may be re-use bicycles, many BICAS staff and participants are also working artists who create and sell art, locally and nationally, and contribute to a visible activist art and DIY scene—an easily identifiable hallmark of the local art community.

The University of Arizona's collaboration with BICAS began in August 2008, at the encouragement of Dr. Elizabeth Garber, the Art and Visual Culture Education (AVCE) Division Chair, and with the support of Jo Edmondson, an AVCE alumnus and former Art Coordinator for BICAS. As a Division of four faculty members deeply engaged within communities in Tucson, AVCE sought to provide pre-service educators and graduate students in the university's Community and Museums Option with hands-on experience in collaboration with a successful, self-sustaining organization. The Community and Museums Option complements the Division's Teaching Option, which prepares students for teaching in traditional and non-traditional K-12 contexts. The Community and Museums Option further prepares students to work as educators in diverse non-traditional educational contexts, such as BICAS, and is responsive to students' increased and expressed desire to work in community-based and activist settings. For more than a decade, through required courses, students in the Division have been working in collaboration with community-based programs in the city. As an alumnus of the MA program, I knew this experience well. During my graduate studies, I worked collaboratively with other graduate and undergraduate students with children at the first elementary school in Tucson, *Escuela Bilingüe Davis* (a school with

deep roots in the community), on a darkroom photography project where students documented the school's history.

Beginning in the summer of 2008, I met with the BICAS Education Director, Daniela Diamente, and staff to outline potentials for our collaboration. In a grass-roots collaborative way, we negotiated a long-term partnership between BICAS and the Division. The proposals we developed reflect BICAS's institutional goals (e.g., increasing opportunities for funding by documenting educational outcomes in response to the increasingly outcome-driven nature of local and national grant-funding institutions), our Division's goals (e.g., providing ways for students to understand how community-based work is sustainable over time through funding), and my research questions (e.g., understanding pre-service preparation in community-based arts).

The goals within the proposals we drafted during our first meeting included:

- Integrating university student teachers into teaching roles in Friday drop-in art studio programs and with K-12 school visits and after-school programs;
- Correlating BICAS arts curriculum with state educational standards in art and literacy, and;
- Locating and applying for grants that support these proposals.

Throughout that first semester, the university students were as inspired by BICAS's history, mission, and activism as they were overwhelmed by bike parts, specialized tools, and small children within a charming, eclectic, chaotic, and potentially dangerous educational space.

During the summer of 2009 in meetings with Daniela Diamente, who had then left her position as Education Director, and Kylie Walzak, a high school Spanish teacher, who had recently assumed the role of Education Coordinator, we worked together to consider the advantages and disadvantages of the collaboration, as well as possibilities for the future.[7] Specifically, we hoped to better integrate university students within the day-to-day art education programming at BICAS, to redevelop curriculum in alignment with BICAS's mission, and to understand the impact of the curriculum in a way that might help BICAS obtain greater grant support for its arts education programs.

Students' Initial Questions and Working Outcomes

We began our work with students by providing them with an opportunity to share the questions they had about community-based arts education programs. They asked:

- Is it possible to affect social change through art?
- [What do you do] when not everyone in the community is trained to analyze everything critically through an arts-educated eye?
- How do you translate cultural codes, so everyone understands each other [in a collaboration]?

I posted these questions on our online class blog where students were free to return to and revise them throughout the semester in a threaded discussion forum. The questions, and subsequent discussion, helped me begin to understand the perspectives and assumptions with which students began their engagement with BICAS and with community-based art. These daily discussions helped me to plan in-class activities and engagements with BICAS that would provide opportunities for students to not only consider their assumptions but to also gain hands-on experience in the day-to-day workings of the organization. These engagements were both practical and theoretical. For example, when students realized that they would need to know about how bicycles and their parts function in order to take advantage of the parts' mechanical and aesthetic potentials, one student, Kate McHugh, developed a "bicycle anatomy" lesson to assist other students experimenting with the parts. At BICAS, staff member and accomplished sculptor/welder, Troy Nieman, helped students to weld parts to create jewelry and other art pieces for the BICAS Art Auction, an event that other students helped to coordinate and run. In helping to organize the auction, students were in constant contact with artists at BICAS, drop-in art-making studio programs on Friday afternoons, and local and regional artists who donated work for the Auction/Exhibition. Students helped to install the show, and to host its opening (the annual affair raises more than $10,000 for BICAS).

Theoretically, students needed to understand the potentials of re-use and sustainable materials beyond their aversion to "junk" or "craft" art—and of course, to consider the origins of these aversions, too. Because of the unique qualities of working with bike parts (e.g. grease, sharp pieces, the need to weld and use cutting tools), students also had to reposition themselves as learners in artistic processes that were new to them. This was a metaphoric border crossing for the students, whose sentiments expressed that they sometimes saw their roles as art educators as leading untrained learners through an understanding of accepted art forms. Further, in working with second grade students visiting BICAS on a field trip, university students had to translate their newly-found sculpture skills for a young audience in order to make clear the purposes and potentials of making art from re-use

materials. At the conclusion of this engagement, the group of second graders was eager to donate their musical bike part sculptures to the Art Auction. This surprised the university students, who assumed young children always want to take what they make home. Rather, the children, under the guidance of the university students and BICAS staff learned—through the two-hour afternoon trip—the instrumental purpose of making art that is not only pleasing to the eye (and in this case, ear) but whose medium communicates strategically ideas broader than self-expression that can be shared publicly. These ideas directly influenced the curriculum university students prepared for BICAS in 2009.

Throughout their engagement with BICAS, university students were asked to make extensive use of research in community-based arts, specifically through engagements with local and national cultural workers, through the Community Arts Network Reading Room, and in collaboration with BICAS. On several instances, community-based artists spoke in class about the students' research questions and their own experiences engaging with various communities in Tucson, including indigenous communities, refugee communities, and communities of ethnic minorities. Each of these discussions took an assets-based stance, and the community-based artists and educators were able to talk with the students about the concept of insider/outsider (the border crossing) they found so compelling.

As our collaboration with BICAS has solidified, students' engagement with the organization's staff and community has shifted toward a greater understanding of the nuances involved in community-based work. Particularly, students have gained empathy as they see themselves as learners engaged in an ongoing, sustainable process, rather than educators who drop in and out or who have something to give to a community in need. During the collaboration students worked in four small groups, which were developed in negotiation with BICAS's educational and administrative staff, including Walzak and Diamente. These groups included:

- *Curriculum*, whose task was to develop integrated art curriculum for school visits, afterschool programs, and Friday drop-in art programs onsite in the BICAS art area;
- *Art Auction and Advocacy*, whose task was to assist with the BICAS Annual Art Auction—the group's largest community-based fundraiser—by working with local artists and facilitating art-making workshops for the community on site at BICAS;
- *Grant Writing*, whose task was to research educational grants for which BICAS might be eligible and to develop a complete grant proposal, and;

- *Community-Building,* whose original mission was to assist with school groups onsite but whose purpose evolved into developing materials and curriculum for BICAS to use at schools. Part of this evolution was in response to decreased funding for field trips at the local school level.

Each group consisted of four to eight members and was facilitated by one or two MA level graduate students (dependent upon the group's work load) who were responsible for setting goals in collaboration with BICAS staff. Between one and four BICAS staff members worked with each group. However, because BICAS is a collective where staff members may be working on a variety of projects at once, various staff members assisted all the groups, collaboratively, throughout the semester.

At the beginning of the 2009 collaboration, groups set goals. Examples of these goals (which follow) reflect students' perspectives of what was significant for them and for future students in the collaboration, as well as the questions they earlier posed:

- Grant-Writing Group: "To create two identical three-ring binders full of materials.… The binders will contain as much information as we can collect about BICAS, general information for first-time grant writers, lists of grants for which BICAS does and does not qualify, and sections with instructions and guidelines for every step of the process."
- Curriculum Design Group: To "broaden student's definitions of art through lessons that incorporate concepts of bike culture and environmental sustainability."
- Community Building Group: "To assist in the development of an effective BICAS Outreach Program in support of future implementation."

Following the setting of group goals, each group member developed a personal plan of action in which they shared two individual goals that worked to support group goals. Throughout the course of the semester, each group member kept an in-depth documentation blog through which they documented their experience as an individual, as a group member, and with BICAS. During class meetings, students shared their group's goals and the challenges they faced; interacted with cultural workers who came as guest facilitators; and re-negotiated their ideas through co-mentoring one another, through conferences with myself as their instructor, and through meetings with BICAS staff. The process of continual reflection and redefinition of their goals and roles as community-based artists

and educators was central to pre-service preparation in this course and collaboration. From this, I learned that students need ample time to reflect and share their questions with one another, with instructors, and with community members.

Understanding Students' Questions about Community-Based Arts

The questions students have posted to our online forums and to their ongoing documentation blogs are acute: "will my work and relationships [with BICAS] be sustainable?" "are community-based art programs legitimate educational sites [for students and teachers]?" and, conversely, "are collaborations between academic institutions and community-based organizations viable?" There was a particularly interesting affinity between the two previous questions, which recurred frequently in students' conversations. While students were skeptical of non-traditional education settings' legitimacy they were also uncertain about the university's interest in community-based programs. They wondered if institutional "approval" might "tarnish" the experience of the community, and asked "[w]hat does it mean to be an 'outsider' in a community in which you hope to work for change?" This question reveals that students, as arts education researcher Karen Hutzel found, do not see themselves as members of the local community, but as temporary residents who occupy social milieus different from the communities in which they might be asked to work in collaborations like this.[8]

Yet, as students in arts education programs express increased interest in working with non-traditional spaces (community-based and nonprofit programs, charter schools, and other organizations and institutions), their teaching careers appear to be displaced from the traditional classroom structures they may have anticipated and experienced. For example, even though the students in the course expressed a desire to work as educators in non-traditional settings and were suspicious of these settings becoming over-institutionalized by contact with the university, students still saw "teaching" as an act of one-way information transmission through a closed lesson plan in a classroom-style setting. They were unsettled by the arts area at BICAS, with its mismatched chairs and one large table, bins of bicycle parts, graphic walls, and lack of a teacher-centered perspective (i.e., nowhere to stand at the front of the classroom). While new sets of problems arise for faculty and cultural workers preparing these students, multiple directions for teaching and learning are equally abundant.

Few clear pathways exist that describe how to begin and then sustain

community-based art programs, even within an organization firmly rooted in its local community. Even fewer accounts describe the intricate "wrenching, uneven process" of becoming part of a new community as an educator who sees him or herself as an outsider working for change.[9] As Hutzel notes, "In our culture of mobility, where college students and other young adults move particularly often, finding one's own place can be a challenge."[10] The challenge she describes seems amplified when students' own identities (or places) are multiple, sometimes-contradictory, and embedded within their shifting constructions of themselves as agents of change.

Discourse in contemporary educational theory fails to adequately describe either the visceral, dissonant experience of border crossing or the sense of shared purpose that site-oriented art experiences could produce. Students' worries that a university classroom is unimaginably far from the lives of a population of children and young adults characterized as "under-served" are as reasonable as their apprehension about labels they see as pejorative ("at-risk youth," for example). Throughout the arc of this semester, participants in this project have encountered the mottled realities facing community-based organizations as they vie for support, funding, and legitimacy within an irregular cultural and political landscape.

Research and theory in community-based art and visual culture education can assist pre-service educators in excavating the origins of their beliefs, including their ideas about art and visual culture and their hopes for change. Theoretical frameworks can be applied to deep analysis of the biases and structures that not only impose upon but also generate the field of art and visual culture education and the irreconcilable tensions within it. Such knowledge would be useful to pre-service educators apprehensive about the looming unknowns in school and community-based classrooms.

Strategic Materiality, Sustainability, and Curriculum Goals

In her discussion of contemporary artist Jean Shin, who collects refuse materials from communities and re-fashions them into broad, site-oriented installations, art historian Jaimey Hamilton introduced the idea of "strategic materiality" to participants in an invited lecture partially supported by an art access grant from the National Endowment for the Arts.[11] In her positioning of the way in which Shin re-uses materials, Hamilton's concept of strategy extends ideas of up-cycling or diverting materials from the waste stream that have gained popularity in contemporary art and visual culture education as well as in artistic practice. By invoking the lineage of Duchamp's ready-mades, Hamilton proposes that artists like Shin re-use

objects not only for what they once were (which is tied to the economic and political milieu of their production and their consumption) but for the materiality of the objects themselves. In this way, Shin's monumental installations are semiotic double-coded remnants of past lives, lived experience, and economic and social conditions but also embodiments of form, texture, and presence. Regarding a work of particular poignancy that Hamilton discussed, "Alterations, 1999," Shin explains:

> ...a colorful and dense cityscape is constructed of hundreds of cylindrical forms made from the leftover fabric of shortened pants and blue jeans.... At the same time, the cast-off cuffs refer to a population—predominantly Asian immigrants—who make up a large portion of the clothing industry's workforce, including sweat-shop seamstresses, tailors and dry-cleaners.[12]

The concept of strategic materiality, then, describes both the way in which students developed their curriculum for BICAS and how BICAS itself operationalizes the idea of re-use bicycles and ready-made art. It is essential to make this distinction because the goal for BICAS's educational programs—and my goals for students as well as the Curriculum group's goals—was to go beyond simply re-using materials to make take-away crafts (a practice that has historically been negatively associated with art education). Rather, we would like to see the students (and their students) engage with the materiality of the bicycle parts—understanding their initial purposes, functions, and the contexts of their production, consumption, and abandonment—and furthermore, to base their engagement in impulses of contemporary art that utilize this researched understanding of materials in an activist manner that calls attention to the particular injustices of such conditions. For example, both the re-use bicycles and objects—both artistic (sculpture, public art installations, jewelry) and utilitarian (furniture)—made at BICAS from re-use parts bring visibility to the amount of refuse created through everyday acts of consumption. The art-making, therefore, is a purposeful aspect of the activist culture at BICAS that makes visible social conditions otherwise hidden and encourages border crossing.

When one enters BICAS's ground-level warehouse workroom; the organization's culture and style are readily apparent. Elements of bike culture; a DIY style; and guerilla, grass-roots action, are evident. Workers at BICAS are often wearing garments they constructed, jewelry and accessories made from bicycle parts, and the space itself is completely covered by murals. It is clear that the connecting filaments between BICAS community members are not the labels that describe populations they

serve ("at-risk youth," "transgender," and "homeless"), but a collective identification with bike culture, artistic practice, and activism. Many BICAS community events provide a showcase for this—for example, ride-in movies, and Tuesday bike rides that showcase art bicycles. Further, curriculum developed in the collaboration considered how to "green your ride" with re-use parts, the proliferation (and subsequent city censorship) of "ghost bikes" (sculptures made from bicycles that are painted totally white) throughout the city (and especially in lower-income neighborhoods) that stand as memorials to those lost in bicycle accidents, bike safety and the creation of bike stickers and spoke flags, and a local BMX park made collaboratively by BICAS artists and other community members on land reclaimed in an industrial neighborhood in the city. Curriculum group members expressed their "common desire... for students to create new concepts of 'art' (and/or re-evaluate their current definitions of art)."[13]

In the Memorials for Cycles lesson, the group facilitator explained, "This lesson is connected to issues of social justice, fairness, and equity and takes into account learner's [sic] interests, ages, gender, ethnicity, special needs, and abilities."[14] For example, learners (in this case, elementary and middle school students) are asked to think about bicycle/city relationships and the correlation to the hierarchy between different modes of transportation and social class. In the lesson concerning the Lost Barrio BMX bike park and dirt jumps, the students are invited to answer the following questions: what are problems in your home community? and what can you do to help make those problems better?[15]

By positioning materials as languages and working conceptually, the pre-service educators developed curriculum pursuits that question superficial concepts of sustainability or community activism. They developed art-making pursuits that are rich, prolonged, and meaningful. Deep engagement with the potentials of materials for meaning-making holds promise for understanding the ways in which project-based art experiences support learning in other core academic areas. Further research in this area is needed in community-based arts education contexts.

BORDER CONSCIOUSNESS, SOCIAL ACTION, AND JUSTICE

Concepts of activism and the purpose of education—developed individually, collectively, organizationally, and institutionally—undergird this ongoing collaboration. These concepts are sometimes contradictory, and often generate more questions than answers for each of us who are involved.

Throughout the course and collaboration, students' engagements with theoretical writing about art, pedagogy, and change helped them to sculpt concepts and questions:

- Is it possible for curriculum to be socially just?
- Can (or should) pedagogy be emancipating?
- Can organizations sustain themselves without hierarchical structures?
- Is part of art lost when it becomes instrumental [to social goals]?

While there are certainly varied spokes of discussion embedded in these phenomenological inquiries, I would like to center this concluding discussion around the hub of the anxiety students felt when discussing their perception of the labeling of populations as "at-risk," or "under-served." I have purposefully invoked a metaphor of riding and the borderlands in the title of this chapter in order to make visible the process through which I see (and document with) students the experience of pedagogy and art in this collaboration. In so doing, I am hopeful that students begin to develop a "border consciousness," or understanding that community-based art and education are not one-way processes in which privileged educators support communities in need but rather collaborative, bi-cultural teaching and learning experiences that can be sustainable over time. In introducing this idea within this chapter, under the umbrella of action and social justice, I propose an expanded re-construction of a "border."[16] Certainly, many (including most of our students) associate our location near the US/Mexico border as a borderland between two countries and two cultures. This bifurcation, however, is perhaps over-simplified. Not only is this omnipresent border emphatic, it is complex and multiple. Extending this metaphor to our collaboration with BICAS, I am hopeful that pre-service community-based art and visual culture educators not only develop a nuanced understanding of overt borders but also of those borders that are erected between teacher and student, form and meaning, art and craft, and *us* and *them*. When students experience such bi- and multi-culturalism, their pedagogy becomes a participatory collaboration between social agents. This is not to state that complexity, power, economic, and political differentials do not exist or are erased but rather they are strategically made material and visible through action.

In a time when the most vulnerable populations of young students are often subjugated to the most impoverished curriculum, when the divisions between people are accentuated through political battles, this chapter offers examples of a systematic, theory-based approach to collaborative practice in a community arts context. The potentials of university/community collaboration at the pre-service level, negotiated curriculum involving sustainable materials and design, and documentation of teaching and learning are posed alongside students' investigation of issues of community,

difference, social justice, and human rights through engagement with art and visual culture education. Through these processes, students begin to develop a "border consciousness" that prepares them for their work as participants in a sustainable, collaborative, community-based education.

Join the Conversation

Contribute to a dialogue pertaining to the concepts discussed in this chapter by directing your web browser to the following URL:
http://www.20UNDER40.org/chapters/chapter-15/

I wish to express my gratitude to the students with whom I have worked in this ongoing collaboration and my appreciation for their honesty, especially those in Fall 2008 and 2009; to Tara Shultis and Kate McHugh, for their sharing of curriculum and continued commitment to the project and community; to Jo Edmonson for her vision, clarity, and support; to the staff and community at BICAS—especially Daniela Diamente, Kylie Walzak, Troy Neiman, and Ignacio Rivera de Rosales—whose generosity is as compelling as their mission; and to my colleagues in the Division of Art and Visual Culture Education—Dr. Elizabeth Garber, Dr. Lynn Beudert, and Dr. Ryan Shin—who initiated the study of community-based art and borderlands pedagogy into the institutional curriculum.

NOTES:
1. BICAS. "About BICAS." (2010), <http://bicas.org/about/>.
2. Gomez-Peña, G. "A New Artistic Continent." In Raven, A. (Ed.) *Art in the Public Interest.* Ann Arbor, MI: UMI Research Press, 1989: 105-117; Garber, E. "Teaching Art in the Context of Culture: A Study in the Borderlands." *Studies in Art Education,* 36, no. 4 (1995): 218-232.
3. Garber, E. "Teaching Art in the Context of Culture: A Study in the Borderlands," 1995: 223; Gomez-Peña, G. "A New Artistic Continent," 1989: 113.
4. Giroux, H. "Paulo Freire and the Politics of Postcolonialism," (1992), <http://www.henryagiroux.com/online_articles/Paulo_friere.htm>.
5. Throughout the course, students expressed their dissatisfaction with labels such as "at-risk," which they saw as limiting and pejorative. There was an ongoing discussion about the pressure students felt to use such labels when applying for grant funding delineated for specific groups. This discussion went unresolved, as some students felt that if the funding helped the greater good, the label was necessary while others supported the idea that even if it meant forgoing funding, they would choose not to use such labels.
6. BICAS. "About BICAS," 2010.
7. Like Wlazak, almost all BICAS staff have "day jobs" in which they're involved with art, education, and the community.
8. Hutzel, K. "Challenging Our Students' Place through Collaborative Art: A

Service-Learning Approach." *Community Arts Network Reading Room*, (2008), <http://www.communityarts.net/readingroom/archivefiles/2008/03/challenging_our.php>.

9. Jackson, A. "Multiple Annies: Feminist Poststructural Theory and the Making of a Teacher." *Journal of Teacher Education* 11, no. 52 (2001): 386.

10. Hutzel, K. "Challenging Our Students' Place through Collaborative Art: A Service-Learning Approach," 2008.

11. Hamilton, J. "Strategic Materiality: A Transcultural Aesthetics?" Lecture in "Transculturations: Cultural Hybridity in American Art." Visiting Artists and Scholars Series at the University of Arizona School of Art, Tucson, AZ, December 2009.

12. Shin, J. "Alterations, 1999." (2010), <http://www.jeanshin.com/alterations.htm>.

13. Curriculum Group. Personal communication, 2009.

14. Shultis, T. *Memorials for Cyclists: Memorials for Cycles*. Unpublished curriculum document, (2009).

15. McHugh, K. *Building a Community from Bikes*. Unpublished curriculum document, (2009).

16. Garber, E. "Teaching Art in the Context of Culture: A Study in the Borderlands," 1995: 223.

Creating a Fourth Culture:
Methods for Developing a Symbiosis Between the Arts and Sciences to Address Climate Change and Cultivate an Interdisciplinary Future

Rebecca Potts
Bronx River Art Center

The arts should play a larger role in addressing environmental and climatic issues to ensure that our species endures as creative animals acting in society for centuries to come. Arts and arts education practitioners can do this by developing a symbiotic relationship between the arts and the sciences thereby fostering collaboration between artists and scientists through the education system, cultural institutions, and informally. This symbiosis can create a "fourth culture," a term used by Jonah Lehrer to describe a future in which art and science exist in a positive feedback loop to propel human knowledge forward. Through this fourth culture, the arts can meaningfully participate in climate change solutions.

CREATING A FOURTH CULTURE

One of the major environmental, social, political, economic, and cultural issues of our times is climate change. Lucy Lippard, a prominent artist, critic, and curator, notes, "I can't imagine an issue more all-encompassing—or more challenging. Climate change... touches on every aspect of life as we know it, even when we don't know it's happening."[1] The effects of our changing climate are evident throughout our environment: rainfall and temperatures are shifting, changes in agricultural production have spurned food shortages, species migration has been altered and extinction rates are increasing, oceans are becoming more acidic, and sea-levels are

predicted to rise as glaciers and ice sheets melt. In addition to the physical changes to the world around us, we are living in a time of rapidly advancing technology that has already begun to alter not only the structure of society through globalization, but also the very structure of life through genetic modification.

As the world evolves, so too does the way we make and present both art and science. In order to not merely adapt to all of these changes, but to flourish among technological transformations and curb dangerous environmental effects, we must embrace interdisciplinary modes of thinking, learning, and creating. In such a dramatically changing world, science is often seen as a source of solutions, whether in the form of medical breakthroughs, engineering feats, or astronomical discoveries. Art's relevancy and the ability of artists to meaningfully participate in the movement towards a sustainable future have raised some interesting questions: Can artists contribute to changing societal perceptions about the problem of climate change or other issues that deeply affect our future? How can artists and scientists meaningfully collaborate?

We can look to philosophy to point us towards some answers. In *The Politics of Aesthetics* philosopher Jacques Rancière claims that art has the power to "redistribute the sensible," meaning art can alter that which can be sensed.[2] By creating new forms, images, and sounds, art can provide new ideas, new ways of thinking, and new ways of seeing that have the potential to change societal perceptions. As curator and writer Natasha Rivett-Carnac puts it, "it is this re-igniting of the imagination that is needed so desperately to spur the radical changes that are essential."[3]

Artists have been incorporating science into their work and reflecting on new technological and scientific breakthroughs for centuries, from Leonardo da Vinci to the Futurists to contemporary BioArt. Many writers and thinkers have articulated the idea of artists as society's canaries, observing and responding to what's going on in the world. From artists such as Carol Becker to environmentalists such as Bill McKibben, the importance of artists as "antibodies of the cultural bloodstream... sens[ing] trouble early, and rally[ing] to isolate and expose and defeat it" is pervasive.[4] The arts can and should participate in creating climate change solutions through a symbiotic relationship with the sciences.

Tensie Whelan, executive director of the Rainforest Alliance, understands the important role of artists in solving problems that are commonly within the realm of scientists: "the redesign of our world will need artists to provide imagination, creativity, and emotional connections— to both the mess we have created and to the possibilities we can create together."[5] The sciences cannot solve the world's climate problems alone,

but when conjoined with the ideas, sensations, and hopefulness of the arts, the sciences have the potential to propel us into a brighter environmental future.

Jonah Lehrer presents an argument for collaboration between scientists and artists: art, through metaphor, analogy, and the tangible experience thereof, can help scientists visualize ideas that are too complex to comprehend using mere scientific techniques.[6] He advocates for creating a "fourth culture" with the goal of "cultivat[ing] a positive feedback loop, in which works of art lead to new scientific experiments, which lead to new works of art and so on."[7]

Though he makes a strong case for the symbiosis of the arts and the sciences, Lehrer does not, however, provide insight pertaining to how to develop this fourth culture, nor how such a symbiosis may be applied in the real world. The goal of this chapter is to highlight some potential challenges and opportunities for closing the gap between the arts and the sciences for the purpose of establishing just such a fourth culture and applying it to climate issues. Before delving into these challenges and opportunities, however, it will prove helpful to first explain where the term fourth culture comes from and then expand on Lehrer's arguments for creating it.

THE TWO CULTURES… A THIRD… AND A FOURTH?

C.P. Snow, a physicist and novelist, coined the term *two cultures* in a 1959 lecture bemoaning the major gap in communication between the humanities and the sciences, "a gulf that impoverished both sides and impeded efforts to relieve suffering around the world."[8] Snow's lecture brought to the fore the divide between the arts and the sciences.[9] He described the divide as mainly a "mutual incomprehension," which extended beyond intellectual subject matter into individuals' quotidian lives and culture.[10] Incomprehension of the sciences, according to Snow, also extended into the "traditional" culture or general public, which was much more aligned with the humanities. To him, "this polarization is [a] sheer loss to us all. To us as people, and to our society."[11]

In a 1963 second edition of *The Two Cultures*, Snow envisioned a "third culture" made up of sociologists, economists, journalists, and other "curious non-scientists" who could act as translators, bridging the gap in understanding between the sciences and the arts.[12] With this third culture, the adversarial attitude between the two cultures would dissolve and dialogue would take its place. Both sides would benefit from learning about the other. Snow saw applied science as the solution to the world's problems, a simplistic view, but notable because this view is in large part

what led him to argue for increased understanding of and respect for science within "traditional" culture. Snow's third culture, then, would serve to promote and explain science to those more interested and knowledgeable about the arts with the hopes of eventually opening a dialogue between the two cultures. Yet, how can a vigorous dialogue spring from such one-sided views? Many criticized Snow's ideas, most harshly the literary critic F.R. Leavis, who accused him of advertising for science and denied him as a worthy novelist.[13]

John Brockman's book, *The Third Culture: Beyond the Scientific Revolution*, picked up Snow's idea, but suggested that scientists themselves were actually bypassing artists—specifically literary intellectuals—by writing about their work in journalistic prose for the general public.[14] Brockman claimed there was still a vast communication gap between the two cultures, but that a small number of "third-culture thinkers" from each side were gaining popularity with the general public.

Throughout Brockman and Snow's treatises, the underlying goal was to close the gap between the two cultures in order to not only advance knowledge, but to better serve society and the world. Both men envisioned the third culture as a translation of science to the general public through literary means (whether written by the scientists themselves or by non-scientists), which, in their eyes, would necessitate communication between the two cultures. While this translation is necessary, it is not enough. Lehrer's concept of a fourth culture calls for moving beyond third culture communication to collaboration. It also takes a broader view of the arts rather than focusing on the literary arts as Snow and Brockman did.

In order to deal with issues such as climate change, as well as to expand our knowledge of the world around us and within us, we need to embrace Lehrer's fourth culture. The arts and the sciences should coexist, feeding each other and propelling human knowledge and technology forward. David Edwards calls this combination of art and science "Artscience," which he defines as "a fused method... at once aesthetic and scientific—intuitive and deductive, sensual and analytical, comfortable with uncertainty and able to frame a problem, embracing nature in its complexity and able to simplify nature in its essence."[15] Edwards's book, *Artscience: Creativity in the Post-Google Generation*, provides many case studies of individuals whom he deems *Artscientists*. All of them have managed to blend artistic and scientific pursuits, often studying and earning degrees within each realm and holding jobs within each world before finding ways to combine the two. Different from Edwards's concept of the Artscientist, Lehrer's fourth culture would also include those scientists and artists who have devoted themselves solely to their own field, but are open and excited to share their specialized

knowledge and skills with each other. A fourth culture should embrace and encourage interdisciplinarity while also propelling collaboration between specialists in traditional fields. This robust interdisciplinary cooperation is necessary for tackling massive globe-spanning issues such as climate change.

What Lehrer and Edwards share in common is the belief that the arts need science and the sciences need art. Scientists have the capacity to provide artists with new technologies and materials to work with as well as data and discoveries that inspire artistic creation. Meanwhile, artists can assist scientists in visualizing complex ideas, translating scientific discoveries for the public, drawing attention to critical scientific issues, and developing new questions that serve as inspiration for further investigation. In essence, both cultures can benefit from learning to look and investigate an idea in the manner of the other. Lehrer tells the story of physicist Niels Bohr using cubist paintings to understand "the invisible world of the electron" and speaks of neuroscientists gaining insight into the human experience from the stories of Virginia Woolf.[16] In these examples, art has helped scientists visualize macro and micro worlds at comprehensible scales.

In addition to the immensely powerful potential outcomes of fourth culture collaborations, the process of engaging in such collaborations can be highly educative and greatly influential in teaching and learning environments. Everyone can benefit from educational curricula that call on varied modes of inquiry and combine disciplines to more closely approximate the "real world." As it is one of the primary arenas for developing the next generation's skills, knowledge, and expertise, our education system is also one of the most important venues for developing fourth culture collaborations and habits of mind.

DEVELOPING THE FOURTH CULTURE: METHODS AND CHALLENGES

There are many methods for developing the fourth culture as well as challenges to doing so. I have identified six challenges, each of which can be overcome. These challenges and methods apply mainly to higher education, where our next professionals are being groomed, research is being done, and there is great potential for the fourth culture.[17] While developing a fourth culture to address issues affecting climate change will take effort from both the arts and sciences, I will focus on how those of us in the arts can encourage such collaborations. Often, these suggestions for arts practitioners will apply similarly to those in the sciences.

Challenge 1: The Communication Gap Between the Arts and the Sciences

One of the main challenges to productive collaboration between arts and science practitioners is the communication gap between the two. This communication gap also alienates each discipline from the public, who may be largely unversed in the terminology of either domain. The solution to this communication gap, I believe, lies primarily in education.

Elementary & secondary education:

As our elementary and secondary education system has become more and more bogged down with standardized testing, it has lost the time and funding for vigorous arts, and often also science, curricula.[18] This makes it difficult for educators to provide their students with a basic understanding of the rich histories and practices of the two cultures. When budgets and schedules for both art and science are being cut, instead of choosing between the two, why not combine them? Arts teachers can share with their colleagues in other subjects ways of integrating art into those subjects—from drawing fractals in math class to photographing specimens in science. Hallway conversations can lead to collaborative lesson planning and even co-teaching interdisciplinary classes.

A science teacher at New York's Earth School, Abbe Futterman, is a graduate of Pratt Institute who teaches elementary level science using "life drawing techniques."[19] Futterman says that asking her students to "look a lot and draw a little; look a lot and draw a little more; to erase as needed; and redraw… gets [students] to slow down, observe, and notice the structure of things." This, Futterman suggests, leads her students to "the imaginative act of discovery and synthesis, which is… akin to a powerful aesthetic experience [and can] empower and enlighten children and adults similarly." Noting the power of these interdisciplinary encounters Futterman adds, "when children experience their own agency in this way, they learn that they can change the world."[20]

The drawings Futterman's students create are remarkably accurate and also stand alone as works of art.[21] Futterman teaches her class how to mix colors and regularly asks her students to consider colors carefully: "Is this plant the exact green that's in the paint set? Is the entire plant the same green?"[22] In this elementary science class, students learn some fundamentals of color theory. The context of Futterman's lessons ensures that her class is simultaneously thinking both aesthetically and analytically. This dual thought process is what Edwards calls Artscience and is vital for realizing big ideas.[23] While Futterman is lucky enough to teach in a small

magnet-style school that focuses on environmental science and the arts, her practices can be easily implemented elsewhere.

To propel this sort of teaching and learning forward, educators and administrators on both sides of the art and science aisle need to publicize such practices and their successes and turn individual classroom methods into flexibly replicable lesson plans and curricula maps—just as Anne Osbourn has done.

During a fellowship that allowed her to focus on writing poetry, biologist Anne Osbourn started the Science, Art, and Writing Initiative (SAW) to teach science and "break down barriers between science and the arts."[24] The program was born of her own Artscience explorations and has grown into a worldwide network of schools and educators implementing SAW projects. The concept is simple: using striking images relevant to a scientific topic, teachers prompt students to write or discuss what they see and respond with their own images and/or with poetry. This pedagogical approach not only "enables children of different abilities and with different learning styles to find their own way into learning," but also instills fourth culture thinking.[25] One of the strengths of the program is its flexibility. It provides guidelines for combining science, art, and writing with examples of how teachers have done so, but leaves decisions like whether to bring in a guest scientist or artist, which topic to focus on, whether students create artwork or poetry or both, and how much time to spend on the projects, up to the teacher.

There are other noteworthy fourth culture educational programs such as Edwards's 100k Artscience Innovation Prize and the Bronx River Art Center's Art and Environmental Studies Teen Institute. Edwards's Artscience Prize mentors teams of high school students over the course of one year to develop Artscience ideas around an annual theme such as "the future of water."[26] A jury selects "finalist teams to receive funding up to a total of $100,000 to further pursue realization of their ideas."[27] In addition to the funding, the top team travels to Paris for a workshop at Le Laboratoire, another of Edwards's Artscience programs. The "students learn to learn by pursuing an idea with passion, and discover that when learning carries them across the institutional boundaries between art and science, they often learn most."[28] The Art and Environmental Studies Teen Institute is a smaller scale summer program, focused on environmental issues around the Bronx River. In this program students learn from accomplished artists in a variety of media, explore the local environment, and "produce site-specific public 'green' art."[29]

Post-secondary education:

BFA and MFA programs housed within larger universities are fertile ground for increasing interdisciplinary work. Universities are research incubators producing many advances in both the sciences and the arts. There is great potential to develop innovative solutions to climate change within these centers of research and learning, but this must start with increasing collaboration across departmental barriers. At schools where a variety of disciplines are offered, it may be as simple as convincing a dean to allow art students into introductory science courses and letting them know that their students are welcome in introductory arts courses. If that solution is too taxing on schedules, perhaps a graduate student in the sciences would be willing to teach a workshop on science history and practice to art students (and/or vice versa).

Arts faculty and administrators can reach out to their counterparts in science disciplines to create interdisciplinary classes, workshops, and symposia. At Winona State University, Gretchen Cohenour, a dance professor, and Toby Dogwiler, a geology professor, have been teaching a course titled "Making Interdisciplinary Connections: Body and Water," investigating connections between the science of water flow in the earth and the fluid systems of the body through movement experiences in the dance studio, pool, and flume lab."[30] Dogwiler describes the beginning of their collaboration as a conversation between two educators with the shared belief that "collaboration would challenge our students to think more broadly about the scope and context of their studies." Dogwiler goes on to suggest that an additional learning goal for his collaboration with Cohenour was for students "to understand that all knowledge and learning is connected and that the individual silos erected in academics (i.e., departments) are meant to group similar topics rather than exclude other knowledge."[31]

Cohenour and Dogwiler realized that their seemingly disparate disciplines actually shared a common vocabulary: "words like texture, scale, space, time, energy, etc... we use them in very different—yet very related—ways to think about some of the fundamental concepts of our scholarship and teaching."[32] So in this case, the barrier wasn't in communication, but in a perceived difference. Because of their belief in the benefits of interdisciplinary education and willingness to jump into something new, these two professors succeeded in creating a fourth culture course. Exciting possibilities lay ahead for interdisciplinary courses focused on climate change that have the potential to help artists scientifically understand and communicate through their artwork complex issues such as changes in

species migration or increasing ocean acidity, while pushing scientists to approach a topic from a new vantage point.

Challenge 2: Earning Mutual Understanding and Respect

Beyond the gap in communication between the two cultures, is a smaller gap in respect and understanding between the fields. Lehrer discusses the popular view that science represents truth while art represents fiction and expresses concern over this lack of acknowledgement that both fields represent partial truths and partial fictions.[33] This is similar to the concern of scientists at the Climate Literacy conference at The 2010 American Association for the Advancement of Science annual meeting: the public's misconception about science as truth is leading to misconceptions about the validity of anthropomorphic climate change.

Today our "common habitat" is, for the first time in our species' known history, in real danger, yet there are still many Americans who do not "think there is solid evidence" of global warming, according to the Pew Research Center.[34] Scientists at the Climate Literacy conference articulated the public misconceptions about climate change as misconceptions about science itself.[35] Because people expect science to tell us absolute truths and facts, they become untrusting whenever scientists talk about open questions or the messy process of science. Uncertainty, although a major part of the scientific process, is not accepted as such by the public. Science as a collaborative research process that depends on peer review and consensus is not fully understood. Scientist and historian Naomi Oreskes suggests teaching science history as part of the general curriculum to better educate people about the process of science.[36] This could be part of the solution, but the arts can also participate in the re-education of the public about science, and about climate change. The arts can do so not only by translating science, but also through direct collaboration with science in education, research, and industry.[37]

To close the gaps in both understanding and respect, facilitated collaboration also has a role to play. At the Climate Literacy conference Dolly Ledin spoke with me about a program she facilitated at the University of Wisconsin, Madison that brought together scientists, artists, and educators to "share information about the impacts of climate change… and to encourage each of us to make thoughtful decisions to reduce greenhouse gas emissions" through art.[38] One example from the project is Bonnie Peterson's "Climate Change Globe" depicting data about sea-level rise in a simple visual manner (see Figure 16.1).[39]

When engaging with the project, there was an apprehension from both

sides about the collaboration.[40] Scientists were nervous about creating art in front of professional artists, while artists were worried they wouldn't understand the information that scientists were sharing. Both groups were asked to separately think about the project before they were brought together for an intensive three-day workshop. The scientists presented their data to the artists and the artists shared their work, but the real catalyst to successful collaboration was informal discussion. As Ledin and a few of the artists described, the campfire talks helped make the "lines that separated our careers vanish."[41]

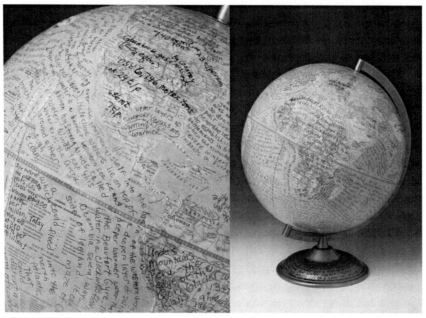

Figure 16.1: Bonnie Peterson, "Climate Change Globe," 2006, traditional 12" diameter school globe on metal stand, acrylic paint, marker, and paint pen. Reproduced by permission of the publisher. © 2006 by Bonnie Peterson (Photo: Tom Van Eynde).

The facilitator's role here was simple—organize formal presentations of both cultures' work, but leave plenty of time for the informal discussions that serve as the meat of collaboration.

Challenge 3: Institutional Structures Unaccustomed to Interdisciplinarity

Another challenge to developing the fourth culture in academia as well as other realms is institutional structure unaccustomed to and unprepared for interdisciplinarity. Cohenour and Dogwiler succeeded in part because they "bypassed the bureaucracy," avoiding the administrative issue of

splitting costs and resources across departments.[42] The "Body and Water" course was offered as a dance elective with Cohenour as the instructor and Dogwiler as a faculty guest, thus keeping it officially in one department. While such a solution may not be ideal, it allows the course to be offered, which not only benefits students, but also provides an example for the administration to take note of.

This issue of administrative buy-in is one of the most difficult to overcome for developing a fourth culture. In many cases, it's best to follow Cohenour and Dogwiler's lead and create exciting interdisciplinary courses under the radar or simply trade guest-lectures with colleagues in other departments. In order to make the fourth culture a pervasive concept, administrative support of such endeavors is needed. Arts administrators, curators, collectors, and senior faculty can have real influence here. A critical mass of students can also make a difference. At museums and galleries, thematic exhibits that expand the confines of the institution's traditions without bursting them can pave the way for more innovative fourth culture programming.

Technology is making it easier for artists, as well as scientists, to share and even sell their work to broad audiences without the help of institutions through the proliferation of blogs, self-publishing companies, artist-run spaces, personal websites, and the like. Artists and scientists can use the Internet to communicate and collaborate as well as to disseminate their ideas and projects and gain traction for controversial or avant-garde work. Yet, institutional support provides the recognition and resources to sustain individuals and projects, such as space and equipment to conduct scientific and artistic experiments.

Challenge 4: Increased Specialization and Narrowing Foci

Osbourn, the creator of SAW, articulates the need for interdisciplinary educational initiatives through the lens of another challenge to creating the fourth culture: increased specialization. She notes:

> The path to specialization of knowledge starts early. By the time children leave primary school, they have already been taught to view subjects like biology, art, and social studies as unrelated disciplines rather than as interlocking pieces that together lay the foundation for a deeper understanding of the world.[43]

While specialization is important and necessary for the advanced research that develops new technologies, life-saving medicines, and significant cultural breakthroughs, it can also be a hindrance to these eureka moments of discovery. As both Edwards and Lehrer mention, when

we are too long isolated in the laboratory or studio focusing our efforts for years on "studying one brick, one synaptic protein... one very particular question," it becomes difficult, if not impossible, to see the bigger picture.[44] This is especially important when working on issues as all-encompassing as climate change. By bringing someone from a different realm into the studio or lab, we can gain new insights to our research. Or, if we are educated to see the synergy between disciplines as Osbourn suggests, we may simply need to recall a lesson to spark that interdisciplinary innovation.

In addition to causing tunnel vision, specialization can consume so much time that there is little left for the tasks of daily life much less "explor[ing] connections."[45] There is no simple remedy for this, but I would add dedicated time for cross-disciplinary dialogue to a wish-list for administrative support of interdisciplinarity. This could come in the form of formal multi-department meetings, cross-departmental partnership programs similar to mentorship programs, mandated hours spent in dialogue with faculty from other departments, or simply exemption from certain other responsibilities for those faculty involved in interdisciplinary teaching or research. In proposing these ideas, it is important to remind administrators of the value of fourth culture learning for faculty, students, and the university. As Cohenour and Dogwiler found when bringing together geology and dance, the collaboration helped each of them see their own work in a new light and see broader connections to their work. Instead of focusing all of one's research on very specified study, an oceanographer studying currents and the rising sea levels and a painter dealing with the fluidity of paint may combine their talents to advance both of their work.

While science education pushes students further and further into a specialized field, many contemporary MFA programs almost do the opposite.[46] They assume that students have already grasped most techniques necessary to create art and instead focus on teaching artists to be intellectuals—to question, to read and write about art, to know the context of their work, to consider the big picture as a part of their art-making process. These programs also provide students with time, space, facilities, and mentoring to explore technical issues, but tend to focus on conceptual issues. Graduate programs in science often include some ethics, theory, or history classes, but most do not focus on teaching scientists to look at the big picture and how their work fits into it. Instead, they focus on the important task of "develop[ing] the capacity for independent and original research."[47]

Those pursuing graduate level education within both cultures should be trained to think of themselves as public intellectuals and to consider the responsibility that comes with that role to be aware of the world around

them and their place within it. As John Brockman states, "Intellectuals are not just people who know things but people who shape the thoughts of their generation. An intellectual is a synthesizer, a publicist, a communicator."[48] Barbara Matilsky, an art historian who has written extensively about art, nature, and ecology, says artists "can synthesize new ideas and communicate connections between many disciplines. They are pioneering a holistic approach to problem solving that transcends the narrow limits of specialization."[49] To address such an all-encompassing issue as climate change, we need a holistic approach.

Challenge 5: Lack of Fourth Culture Venues

A fifth challenge is an absence of venues for fourth culture activity, a "lack of creditable, high-quality, widely-read scholarly venues for publishing or otherwise documenting the collaboration."[50] Dogwiler brings up an issue often on the minds of academics: tenure and promotion. By working in uncharted interdisciplinary territory, professors may exile themselves into obscurity. On the flip side of that coin is the possibility of becoming the reigning expert in an obscure field. Yet, even such an accomplishment would be difficult without the ability to publish or exhibit. There are some journals and venues for fourth culture work, such as *Leonardo*, the journal of the International Society for the Arts, Sciences, and Technology (ISAST), which has a specific "Art & Climate Change" project, but more venues would encourage increased interdisciplinary work between the arts and sciences.[51]

Along with additional lesson plans, courses, and curricula emphasizing collaboration between artists and scientists, we need more scholarly journals, faculty positions, venues for exhibition, and commercial desire for fourth culture work. As arts professionals we can support and strengthen these resources by collaborating with scientists and sharing the process and results through writing, exhibitions, and teaching. Curators and others in the museum and gallery world can include works that highlight fourth culture ideas in their exhibition programs and collections. They can invite scientists to participate in collaborative residency programs or to give public lectures in relation to relevant exhibits. The pioneering residency program, "Human/Nature: Artists Respond to a Changing Planet," sent artists to sites around the globe, including Glacier National Park. There, artist "Dario Robleto spent much of his time with a prominent glaciologist [Dan Fagre] who is monitoring the park's melting glaciers... [and] participated in a glacier measuring expedition."[52] The resulting artwork, focused on the loss

of glaciers, may help elucidate one aspect of climate change for the public and bring prominence to Fagre's work outside the scientific community.[53]

Challenge 6: Lack of Funding for Fourth Culture Climatic Research

Alongside this lack of venues is a lack of funding for fourth culture programs and projects, especially geared towards addressing climate issues. There are some grants and well-funded organizations that focus on fourth culture ideas, such as Edwards's aforementioned 100K Artscience Prize, and others with enough flexibility in their criteria to potentially fund fourth culture work, such as the Wellcome Trust in the UK, but more would certainly help.[54] Those involved in arts advocacy and policy can push for federal and state funding specifically to support innovative programs of art and science collaboration that address issues of climate change, while those involved with foundations can do the same there.

In addition to government and foundation funding, there are many smaller organizations that provide other types of support such as publicity, research assistance, and manpower. A leader within climate change art is The Canary Project, which supports artists "working at the intersection of art and ecology" by producing climate focused projects and events in the arts.[55] One such project is HighWaterLine, created by Eve Mosher in partnership with The Canary Project. Mosher used chalk to mark a line at ten feet above sea level around lower Manhattan and Brooklyn, giving a clear visual sign of one effect of climate change: rising seas.[56] During the creation of this artwork, she "had a chance to engage in conversations about climate change and its potential impacts" and gave information packets about the project and its implications to anyone who asked.

As Edwards discusses, art and science collaboration can benefit industry and the environment by developing new products and technologies. Here lies the potential to generate funds for continued fourth culture climate research and for exhibitions, educational programs, and other nonprofit endeavors. In the UK, the National Endowment for Science, Technology, and the Arts (NESTA) provides significant seed investments for innovative companies and runs programs supporting innovation across the arts and sciences.[57] NESTA's mission is to increase innovation in order to solve the country's social, economic, and environmental problems and their endowment and continued investment supports this mission. The "demand of industry" for innovation, Edwards claims, shapes the agendas of universities by offering funding for interdisciplinary research and seeking graduates with wide-ranging skills and competencies.[58] Governments are also increasingly funding "green" technologies and research to help

find energy and climate solutions. The fourth culture should be a part of this research, pushing the engineers, designers, and climatologists in new directions.

Conclusion: Riding the Fourth Culture into A Promising Future

The challenges to creating a fourth culture—the communication gap, fissure in respect and understanding, lack of institutional structure, increasing specialization, and lack of venues and funding—should be seen not only as challenges, but also as opportunities for growth. Through education, we can not only propagate the fourth culture and close the communication gap between the arts and the sciences, but also design exciting new courses that holistically engage students in interdisciplinary studies. By encouraging collaboration between artists and scientists through opportunities, venues, and funding, we can increase respect and understanding while developing cutting-edge ideas. As such ideas take hold and institutions adjust to the fourth culture, altering their traditional structures to accommodate and encourage interdisciplinary work, the problems associated with increased specialization will diminish.

All of the barriers to creating a fourth culture discussed in this chapter can be overcome, and the benefits for doing so far outweigh the difficulties. As Edwards discusses, "the process of artscience creation... is critically relevant to culture today," and the results are improved innovation, benefitting industry and humanitarian causes.[59] Snow stated over half a century ago and Lehrer reiterated in 2007 that the two cultures together have the potential to alleviate many of the world's problems—from disease epidemics to poverty to climate change—and to unravel the mysteries of our minds and the universe.

Because climate change "remains an abstraction," there is an obvious need for bringing it more clearly into the collective consciousness.[60] Even the very mechanism causing climate change—the greenhouse effect—is literally invisible. Some symptoms of climate change, such as glacial melt, are very visible—but distant from our daily lives, and so have little influence on our actions.[61] There is a great potential for the arts to contribute to furthering public awareness and understanding of such issues as well as imagining solutions to multi-scalar climatic problems. Lehrer states, "as the string theorist Brian Greene recently wrote, the arts have the ability to 'give a vigorous shake to our sense of what's real,' jarring the scientific imagination into imagining new things."[62]

Through vigorous fourth culture research we can garner the societal

will to act and develop new technologies to help slow climate change, ensure our survival, and cleanly power a changing world. By pushing the nascent fourth culture forward, arts practitioners not only keep up with current scientific and technological innovations and thereby advance the arts, but also propel scientific fields forward with new ways of seeing and thinking, thereby leading society into a more sustainable future. Through symbiosis and interdisciplinary collaborations, the two fields together can help solve some of the most urgent and exciting problems of our time.

Join the Conversation

Contribute to a dialogue pertaining to the concepts discussed in this chapter by directing your web browser to the following URL:
http://www.20UNDER40.org/chapters/chapter-16/

NOTES:

1. Lippard, L. *Weather Report: Art and Climate Change.* Chicago: Boulder Museum of Contemporary Art, 2007: 4.
2. Rancière has written several essays and books about aesthetics and politics with a focus on equality. His use of "the sensible" refers to that which can be sensed: the visible, the audible, and the touchable. Rancière, J. *The Politics of Aesthetics: The Distribution of the Sensible.* Translated by Gabriel Rockhill. New York: Continuum International Group, Limited, 2006.
3. Rivett-Carnac, N. "Speaking from the Gut: The Artist's Role During Climate Change." *Global Environment Publication.* The Chartered Institute of Water and Environmental Management. (October, 2008): 34.
4. Becker, C. *Surpassing the Spectacle.* Lanham: Rowman & Littlefield Publishers, Inc., 2002; McKibben, B. "Four Years After My Pleading Essay, Climate Art Is Hot," *Grist,* (August 5, 2009), <http://www.grist.org/article/2009-08-05-essay-climate-art-update-bill-mckibben>.
5. Whelan, T. "People and the Planet," in Markonish, D. (Ed.) *Badlands: New Horizons in Landscape.* Cambridge, MA: MIT Press, 2008: 127.
6. Lehrer, J. "The Future of Science is… Art?" *Seed.* November/December (2007): 48-57.
7. Ibid: 57.
8. Snow, C. P. "The Two Cultures and the Scientific Revolution." Rede Lecture, University of Cambridge, Cambridge, UK, 1959; *Seed Magazine.* "Are We Beyond the Two Cultures?" *Seed* (May 7, 2009), <http://seedmagazine.com/content/article/are_we_beyond_the_two_cultures/>.
9. Snow's discussion of the arts was primarily focused on the literary arts because of his experience as a writer, but has been taken to apply more broadly to the arts.
10. Snow, C. P. *The Two Cultures and The Scientific Revolution.* New York: Cambridge University Press, 1960, c1959: 4.

11. Ibid: 12.

12. *Seed Magazine*. "Are We Beyond the Two Cultures?" *Seed* (May 7, 2009), <http://seedmagazine.com/content/article/are_we_beyond_the_two_cultures/>.

13. Leavis, F. R. *Two Cultures? The Significance of C.P. Snow.* New York: Pantheon Books, 1963.

14. Brockman, J. *Third Culture: Beyond the Scientific Revolution.* New York: Touchstone, 1996.

15. Edwards, D. *Artscience: Creativity in the Post-Google Generation.* Cambridge, MA: Harvard University Press, 2009: 7.

16. Lehrer, J. "The Future of Science is… Art?" 2007: 52-54.

17. Bowden, H. R. *Investment in Learning.* Baltimore: The Johns Hopkins University Press, 1997.

18. Darling-Hammond, L. "Reframing the School Reform Agenda; Developing Capacity for School Transformation." *Phi Delta Kappan* 74 (1993).

19. Fusaro, J. "Wonder-Igniters: An Interview with Abbe Futterman." *Art:21 Blog.* (January 20, 2010), <http://blog.art21.org/2010/01/20/wonder-igniters-an-interview-with-abbe-futterman/>.

20. Ibid.

21. To view some images of Futterman's students' work, visit <http://blog.art21.org/2010/01/20/wonder-igniters-an-interview-with-abbe-futterman/>.

22. Fusaro, J. "Wonder-Igniters: An Interview with Abbe Futterman," 2010.

23. Edwards, D. "Culture Lab: Catalyzing Innovation through ArtScience." Talk for TEDxBoston. (July 28, 2009), <http://tedxboston.org/videos/61-david-edwards>.

24. Osbourn, A. "A Meeting Place: The Science, Art, and Writing Initiative." *Current Science* 97, no. 11 (December 2009): 1548.

25. Ibid.

26. Edwards, D. "2010 Artscience Prize Theme: The Future of Water." (2010), <http://www.artscience100k.org/prize/theme.html>.

27. Edwards, D. "The Boston 100k Artscience Innovation Prize." (n.d.), <http://www.artscience100k.org/prize/index.html>.

28. Ibid.

29. Bronx River Art Center. "Teen Institute: Summer 2010." (n.d.), <http://www.bronxriverart.org/education-teen-institute.cfm>.

30. Gretchen Cohenour. Personal communication. November 11, 2009.

31. Toby Dogwiler. Personal communication. November 13, 2009.

32. Ibid.

33. Lehrer, J. "The Future of Science is… Art?" 2007: 48-57.

34. "Common habitat" is a term that describes the environment we share with all other species, but also a term used by philosopher Jacques Rancière to describe our "shared sensible world." Rancière, J. *The Politics of Aesthetics:* 42; In a 2009 survey, the Pew Research Center found that only 36% of Americans thought there was solid evidence of global warming due to human activity. See Pew Research Center. "Fewer Americans See Solid Evidence of Global

Warming: Overview." *The Pew Research Center for the People and the Press.* (October 22, 2009), <http://people-press.org/report/556/global-warming>.

35. Oreskes, N. "Living With Uncertainty." Opening keynote speech, AAAS Conference on Promoting Climate Literacy Through Informal Science, San Diego, CA, February 17, 2010, and; Caldeira, K. "Closing Keynote Address." Keynote speech, AAAS Conference on Promoting Climate Literacy Through Informal Science, San Diego, CA, February 18, 2010.

36. Oreskes, N. "Living With Uncertainty," 2010.

37. Edwards, D. *Artscience: Creativity in the Post-Google Generation,* 2009.

38. University of Wisconsin-Madison: Center for Biology Education, *Paradise Lost? Climate Change in the North Woods.* Madison, WI: University of Wisconsin-Madison, 2009.

39. For more information on the work of Bonnie Peterson, please visit <http://www.bonniepeterson.com>.

40. Dolly Ledin. Personal communication. February 18, 2010.

41. University of Wisconsin-Madison: Center for Biology Education, *Paradise Lost?* 2009.

42. Toby Dogwiler. Personal communication. November 13, 2009.

43. Osbourn, A. "SAW: Breaking Down Barriers Between Art and Science." *PLoS Biol* 6, no. 8, e211 (August 2008): 1638.

44. Edwards, D. *Artscience: Creativity in the Post-Google Generation,* 2009; Lehrer, J. "Chimeras of Experience," Interview by John Brockman. *The Edge Foundation.* (May 21, 2009), <http://www.edge.org/3rd_culture/lehrer09/lehrer09_index.html>.

45. Toby Dogwiler. Personal communication. November 13, 2009.

46. Based on a survey of ten of the top graduate programs in visual arts and ten in earth sciences, looking at the stated missions and curricula of the programs. Earth sciences in this case is meant to represent scientific fields, which are admittedly diverse.

47. UC Berkeley: Earth and Planetary Science Program. "Graduate Information." (n.d.), <http://eps.berkeley.edu/education/graduate.php>.

48. Brockman, J. "Edge: The Third Culture." (1991), <http://www.edge.org/3rd_culture/>.

49. Matilsky, B. *Fragile Ecologies : Contemporary Artists' Interpretations and Solutions.* Minneapolis, MN: Rizzoli International Publications, Inc., 1992: 3.

50. Toby Dogwiler. Personal communication. November 13, 2009.

51. See <www.leonardo.info> for more information; Leonardo Online: OLATS. "Art & Climate Change." (n.d.), <http://www.olats.org/fcm/artclimat/artclimat_eng.php>.

52. Human/Nature: Artists Respond to a Changing Planet. "Dario Robleto." (n.d.), <http://www.artistsrespond.org/artists/robleto/project/>.

53. Even small acts can spark a dialogue and encourage fourth culture research. While an undergraduate, I curated an exhibit of art by science faculty and students at Middlebury College. I was pleasantly surprised at not only how

many artistic scientists submitted, but how excited they were to finally have a venue for their artwork. The opening drew people from both cultures and was filled with lively discussion of fourth culture ideas.

54. Wellcome Trust. "Strategic Awards." (n.d.), <http://www.wellcome.ac.uk/Funding/Strategic-awards/index.htm>.

55. The Canary Project. "Mission Statement." (n.d.), <http://canary-project.org/old/html/mission.php>.

56. Mosher, E. "HighWaterLine." (n.d.), <http://www.highwaterline.org/>.

57. National Endowment for Science, Technology, and the Arts. "Criteria for Funding." (n.d.), <http://www.nesta.org.uk/investments/criteria>.

58. Edwards, D. *Artscience: Creativity in the Post-Google Generation*, 2009: 70.

59. Ibid: 175.

60. Lippard, L. *Weather Report and Climate Change*, 2007: 5.

61. The glaciers in Glacier National Park are expected to have melted completely by 2030. Striking repeat photography shows their change since the beginning of the century; "Modeled Climate-Induced Glacier Change in Glacier National Park, 1850-2100," U.S. Geological Survey: Northern Rocky Mountain Science Center. (n.d.), <http://www.nrmsc.usgs.gov/research/glacier_model.htm>; excerpted from Myrna H., Hall, P., & Fagre, D. B. "Modeled Climate-Induced Glacier Change in Glacier National Park, 1850- 2100." BioScience 53 (2003): 131-140.

62. Lehrer, J. "The Future of Science is… Art?" 2007: 48-56.

Half a Million Years of Art History:
How the Human Origins of Art Can Change
Arts Education Today

Jeff Lieberman
Plebian Design

Eric Gunther
Plebian Design

To move the arts and arts education into the future, we must look millions of years into the past, into the evolutionary history of our species and the role the arts have played in making us human. We are faced with unprecedented opportunities for a new symbiosis between the arts and sciences. For these two disciplines to assume their rightfully vital places in the education of future generations, they must acknowledge their mutual interdependence. Arts education must acknowledge and teach the science of beauty and science education, the beauty of science.

We cannot hope to understand these strange beginnings of art unless we try to enter the mind of the primitive people and find out what kind of experience it is which makes them think of pictures, not as something nice to look at, but as something powerful to use.
　－E.H. Gombrich[1]

At the age of 31, the French composer Olivier Messiaen was captured by the Germans and forced via cattle-car into a concentration camp. Borrowing a pencil from a guard, he composed a piece for himself and three musicians from the camp. Originally performed for guards and thousands of prisoners, the "Quartet for the End of Time" has become a celebrated work of art.[2] Under the constant threat of freezing, torture, and starvation, he spent his

valuable energy and time writing music. By no means is this rare—in dire situations from slavery to natural disasters to war, people make art. Why do we bother?

We bother because we have to. Art is a human instinct.

Infants behave artistically, yet by adulthood many Americans are embarrassed when asked to sing, dance, or paint. Third world cultures rarely exhibit this kind of inhibition. Americans don't recognize that art is a need and so it has been pushed to the edges of our culture and our educational system. If we can demonstrate that art is not a frill, but rather essential to life, we have the potential to fundamentally change arts education, and through that, our culture. But how can we do that?

To move art education into the future, we must look half a million years into the past. We must recognize art not as a job, hobby, or object, but as a human behavior. We know plenty about how art is made; it is time we knew *why*.

But why do we care about what happened half a million years ago? We have ample anecdotal evidence and intuition that the arts are important to our well being. The sciences deepen the story of art, with an historical account of how the arts were *pivotal* to our species' survival. But knowledge is not enough; if we don't foster the artistic instinct, it will disappear. Arts education is essential for keeping this primal essence of the arts within our cultural grasp. For hundreds of thousands of years, the arts honed our intelligence, driving the cultural and technological development of our species. We have no reason to doubt their potential now.

Mentioning science and art in the same sentence can lead to apprehension. People worry that a scientific approach to the arts will demystify the beauty, and remove the "art" from the arts. But it hasn't always been this way. Aristotle and da Vinci saw the deep connections between the arts and sciences. Modern science may substantiate these connections. How exciting would it be to trace Rembrandt's masterful use of *chiaroscuro* past the Greeks, all the way back to the funeral rites of early humans?

Our primary goal in this chapter is to make new developments in the science of art relevant to any discussion of the future of arts education. We begin by surveying theories on the evolutionary origins of art. We then explore the implications these theories have for arts education today. Finally, we suggest that as arts education opens its eyes to the science of art, science education can open its eyes to the art of science. This symbiosis is not only possible, but vital to education.

The Origins of an Artistic Species

As we surf the net, watch TV, and listen to the radio, we fail to observe the long stories behind everything we do. Aspects of our daily life that we take for granted have only been around for one ten-thousandth of humanity's history. Our evolutionary line separated from the great apes about 4 million years ago. For the first 3.9 million years, our ancestors lived exclusively in nomadic hunter-gatherer societies of a few dozen people. Since Darwin published *On The Origin of Species* over 150 years ago, we have learned that, whatever else we may have become, we are still animals. And evolution shapes us—not only our bodies, but our behaviors.

In the last 30 years the field of evolutionary psychology has begun to examine the evolutionary roots of our behavior. Though evolutionary psychology is still viewed as controversial by some, it nonetheless serves as an avenue of study that helps us ask important questions such as "why did human beings start making art?" If art can be shown to have evolved as a behavior, to have played a critical role in our development, the implications for our understanding of the arts are enormous.

How can we discuss the future of arts education without understanding what art *is* and why we make it? In art history class, we study paintings, sculptures, dance, music, and poetry from the last 2,000 years, but works of art have been experienced in museums, theaters, and concert halls for less than 1% of human history. What about the 300,000 years of ritual that led to these artifacts? How can we truly understand what art is without understanding the evolutionary forces that spawned it?

Figure 17.1: The history of art, an approximate timeline (BP = years before present). Note there are two lines representing the Renaissance and the present. Museums have been around for about the last millimeter of this figure.

Before we continue, a review of natural selection is in order. *Natural variation exists in any population*—look around you. *Traits are heritable,* that is, "you have your father's eyes, and your grandfather's male-pattern baldness." Finally, *some of these variations contribute to an organism's survival.* When leaves are dwindling, the giraffe with the longest neck wins.

The organisms with the beneficial traits (like our giraffe) will tend to reproduce slightly more often. Over many generations these traits tend to spread through the entire population. Even small advantages grow at an accelerating rate, like money in a savings account.

We tend to find pleasure in behaviors that aid our survival. The more your ancestors enjoyed sex, the more likely you were to be born. This applies everywhere. Play enables cats to practice hunting in a situation without serious consequences. The cats that enjoy playing become better hunters in real life because they enjoy practicing.

A behavior that is universally found in our species, especially one that costs energy and is pleasurable, probably served a critical role in our development. The behaviors we call "art" are found in every known human culture on the planet. We expend enormous amounts of energy on them. And without question they feel good.[3] If our logic is correct, this means *the arts were vital to our survival.*

Making such a statement, however, leads us to the question: how exactly did the arts help our species survive?

CURRENT THEORIES

Darwin himself believed in the evolutionary origins of art, attributing them to *sexual selection.*[4] The peacock tail provides a classic example. If a male can survive with such a "splendid monstrosity" it advertises to females, "see what a strong, healthy peacock I am."[5] Health is attractive.

The last 150 years have yielded many new theories on the evolutionary origins of art. Below are some of our favorites...

Edward O. Wilson

The cave paintings at Lascaux, estimated to be 16,000 years old, depict animals hunted by human weapons. They are not special simply because of their age. To understand these paintings we must put ourselves into the bare feet of the Paleolithic men and women who made them. These people believed that symbols influenced the objects they represented, and that by painting animals and killing their images, they would have control over the real animals. The arts were magic.

However, the real magic of the arts happened not on the hunt, but in the hunter. The arts alleviated the crippling side-effects of human intelligence: the understanding of the uncontrollability of nature and the recognition of our mortality. We are the only animal with an awareness of our inevitable death. The arts were spawned by the need to "impose order on the confusion caused by intelligence."[6] In diminishing this anxiety,

humans transcended the "fight or flight" instinct to give themselves a Darwinian selective advantage.

Wilson talks about reoccurring themes in the arts. As humans, certain thoughts and behaviors enter our minds more frequently than others and are more likely to stir our emotions. These behaviors bias cultural evolution toward the invention of archetypes. Looking at myths across cultures, we see the same underlying stories told in different ways.

For example, serpents are present in the mythologies and dreams of nearly every culture ever studied.[7] Looking at our distant ancestors, a reason immediately suggests itself: chimps were often killed by snakes. Chimps alive today are the ones whose ancestors developed an inherent fear of snakes. They are born afraid of snakes because it benefits their survival. To this day, a chimpanzee most violently fears the most poisonous snakes, even on first encounter.[8] This fear took on strange new forms through the evolution of human consciousness and culture. The images and mythology spawned by this fear continue to suit our survival, by honing our awareness of something dangerous.

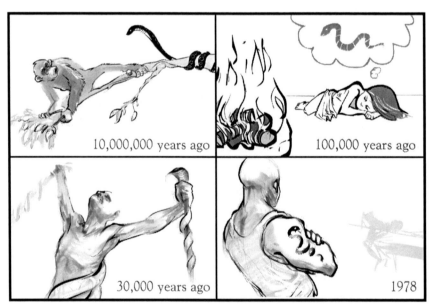

Figure 17.2: A Natural History of the Serpent: Chimps have a healthy fear of snakes. Through dreams and myth, the serpent has become a potent cultural symbol (Image courtesy of Fardad Faridi).

Wilson distills the arts into a process: *imitate, make it geometrical, intensify.* How we do this is based on our real, existing human nature, a picture of which is emerging in the evolutionary sciences. As Wilson

hypothesizes, the motivations for even the greatest works of art might be understood with knowledge of the biologically evolved rules that guided them.[9]

Ellen Dissanayake and "Making Special"

Almost 300,000 years ago we find evidence of one of the earliest seeds of artistic behavior: people covering their bodies with red ochre, a natural pigment. This tendency to make things special, to shape aspects of their world in a way that makes them extraordinary, represents the core of art to Ellen Dissanayake.[10] To her, the arts are ordinary behaviors and objects that are made special, through exaggeration, embellishment, repetition, inversion, and shaping. Normal movement is turned into dance. Spoken language is patterned into poetry. Intonation is shaped into song. Objects become the visual arts. These transformations are anything but arbitrary.

It is no coincidence that we perform artistic behaviors in potentially stressful situations: life transitions and events such as birth, puberty, marriage, curing the sick, and finding food. It is here where the selective value of the arts is most apparent, in three distinct ways.

First, as Wilson suggests, these actions fulfill our imperative to "do something" beyond the instinct of fight, flight, or freeze.[11] Whether these actions control the environment is secondary. They give us the illusion of control. We see the seeds of these behaviors in caged animals who calm themselves through pacing and repetitive rocking. We are their descendants.

Furthermore, when we make objects and activities special, we make them better. Archeologists find tools with exquisite markings on them, serving no direct utility. Dissanayake believes that those who felt the impulse to make the tools special with decorations instinctively spent more time and energy developing them.[12] Tools made special are tools made better.

Finally, rituals serve to pass cultural traditions from generation to generation. The arts make this transfer of vital cultural information effective. Picture a shiny ripe apple or a glossy supermodel. The natural human attraction to smoothness, symmetry, shine, color, and lack of blemish is no accident. These are indications of health. Works of art that embody these features become exceptionally compelling and memorable.

Dissanayake stresses the power of these artistic behaviors and rituals to solidify the tribe.[13] Natural selection works at the level of the group in addition to the individual. The whole can be greater than the sum of its parts and the health of the tribe translates to the health of its members.

The key is that *art is a behavior, rather than the results of that behavior.*
Engaging in the arts was crucial to human survival.

Figure 17.3: Dissanayake sees the evolutionary origins of music in the
baby-talk between mothers and infants (Photo: Jeff Lieberman).

Frederick Turner and Beauty

Look closely at a tree. At a leaf. A feather. A man. From atom, to molecule,
to DNA, to cell, to human, to society, and beyond, we are structures built
upon structures. Though they may differ on the surface, internally these
structures follow certain patterns. Frederick Turner believes that our ability
to detect such underlying patterns is what we often experience as beauty.[14]
The arts reflect this ability.

Just as we evolved a pleasurable feeling from eating as a reward
for acquiring food, we find pleasure in beauty. Like a drug, it triggers
neurotransmitters in our brains. But why is the *experience of beauty* useful?
Turner's answer is nuanced and complex, tying together anthropology,
neuroscience, chaos theory, mathematics, and ecoscience. Here is a brief
summary.

Try to remember this sequence of letters:

wethepeopleoftheunitedstatesofamerica

Figure 17.4: From trunk, to branch, to leaf, trees show
similar structures upon structures.

This is almost impossible, until you see the underlying structure of the information. As soon as you recognize the words instead of just the letters, your brain represents the information on a higher level, and it becomes easy to remember—and to share with friends. Now try this instead: fdbwyarpgtorwrtblmasdbhasalfah.

To Turner, the experience of beauty is this perception of structure.

Genetic changes take hundreds of generations, but culture can shift enormously within a single lifetime. Between 1 and 5 million years ago, the ability to transfer cultural information became a dominant force in evolution. We take it for granted, but it is an enormous challenge for an animal to transfer knowledge from one generation to the next. Imagine a hunting strategy 100,000 years ago, improving continuously through human ingenuity and innovation. As strategies evolved, those that could see the underlying structure would be able to understand them more easily.

Beauty is pleasurable because the better we can sense structure, the easier we can adapt to changes in the details. In this view, beauty and the aesthetic sense represent our "highest integrative level of understanding" of the world around us.[15]

The scientific search for the origins of art has just begun—and these three approaches represent only a sampling of a much larger conversation. However, regardless of the details, each of these theories points to the significant role the arts played in defining what it means to be human. If there is any truth to these claims, our current valuation of arts education is completely disconnected from our artistic heritage. Collectively, these theories scream out for a reevaluation of arts education in America.

It is time art education reflects the first 90% of the history of art.

To the Past, for the Future

There is typically a palpable resistance among arts and humanities communities to the application of science to their field. The skepticism towards Darwin's theory of evolution in some parts of the United States only stiffens this resistance. Pressing the scalpel of science into the warm clay of art becomes a delicate affair. For science to make its case, it must speak for the arts, not at them. However, the effort is worth it: the science of art has the potential to justify what many have been feeling by intuition for centuries, that the arts are vital.

How can such an evolutionary view amend current attitudes towards art? And how can it provide answers for the future of arts education? Let us consider the current *state of the arts* in America, and look at some familiar diagnoses for art education in light of the new science.

The Arts Are a Process, Not a Product

A painting, a performance, a poem—today, most people see art as a product. And we value that product: velvet ropes guard our sculptures. But the arts evolved hand in hand with human ritual. They were born as behaviors for the benefit of the participants, not of a removed third party. The arts are a process, inseparable from the social traditions that bred them.

The evolutionary view of the arts shows the need for people to *do* art, not just to *observe* it. As art historian Ernst Gombrich puts it, there really is no such thing as Art. There are only artists.[16] In our current museum culture, we revere the object on the pedestal. But the object was only made because *making it* served a purpose.

Art Is for Everyone

Remember feeling the cold sweat of terror at a high school dance? Today, many of us are scared to express ourselves artistically. We fail to see ourselves as artists. But 100,000 years before anyone sat still in a theater to watch a dance performance, we danced together.

The evolutionary view of the arts shows that art is a behavior that belongs to every human, akin to laughing, learning to walk, or eating. This is still evidenced in many developing countries, where participation in the arts is ubiquitous. Without being coaxed, infants in every culture sing, dance, and scribble. A central goal of arts education should be to extend this instinct throughout our lifetimes. To be human is to be an artist. When we deny our artistic impulse, we diminish our humanity.

Art Appreciation Is for Everyone

How many people feel qualified to have an opinion about a Rothko painting? The "high arts" of today are often "more occasions for perplexity than avenues to insight."[17] It seems as though an extensive education in the arts is required to emotionally connect with much of contemporary art.

Figure 17.5: "I do not think there are any wrong reasons for liking a statue or picture."[18] (Image courtesy of Fardad Faridi).

Taking an evolutionary view of the arts shows that our gut reactions to works of art are legitimate and need not be justified with words. Whether or not you consider it "Art," you can certainly remember the last movie that hit you in the gut.

The Arts Are Therapeutic

Americans are not as happy as their superpower status may lead one to believe.[19] Perhaps the dwindling of the arts is partly to blame. But in giving form to and controlling our worries, the arts evolved primarily to alleviate our anxiety as a species.

Hopefully we have all experienced, at least once, the ecstasy of dancing. Communal pleasures "ranging from simple festivities to ecstatic rituals" have alleviated and even cured depression in a variety of cultures. For example, Barbara Ehrenreich directs our attention to case studies such as "Christian Uganda in the 1990s, [where] dance rituals were used to help rehabilitate severely withdrawn children traumatized by their experience

as captives of the murderous guerrilla movement known as the Lord's Resistance Army."[20]

We tap our toes and drum our fingers when we are impatient or worried, and our chimp ancestors rhythmically run about, slap the ground, and scream in thunderstorms. From the Great Depression to 9/11—and all the way back through the Pleistocene epoch—we turn to the arts in times of trouble. In the modern age, many are explicitly turning to art for therapy. Maybe the cure to our depressed, anxious society is staring us in the face.

Art Is Not Arbitrary

The arts express the common themes of the human species. As shown by our myths and archetypes, our brains and bodies are biased towards certain aesthetic experiences. For example, studies have shown that newborn infants have similar artistic preferences.[21] Furthermore, research in poetics and neuroscience suggests that much of the world's poetry universally has a three second line length that corresponds to the three second short-term acoustic memory in our brains.[22] Poetry is what it is because it leveraged this biological fact.

Figure 17.6: Art comes from our biology. Across cultures, the length of a line of poetry is roughly three seconds, corresponding to the short-term processing length of the audio cortex.

We evolved with the arts; and the arts evolved with us. The evolutionary view shows us that art is defined by its ability to affect us. The arts stem from our biology.

The Arts Develop Unique Forms of Intelligence

In America, the arts are not properly appreciated as a valid form of intelligence. The presence of the arts across all cultures, however, indicates that they very likely provided a cognitive advantage.[23] Frederick Turner suggests that our sense of beauty is no less than our ability to sense the fundamental organizing principles of the universe.

The arts function as an orthogonal means of knowing the world, vital to our survival.[24] They uniquely amplify a child's understanding of self and the world, expanding what it means to "know" something—you cannot learn to dance, for example, by reading a book.[25] Of the eight forms of intelligence originally identified by developmental psychologist Howard Gardner, roughly half are correlated with artistic behaviors, a fact further bolstered by brain imaging studies.[26] For example, neuroscience research suggests that musicians "show engagement of a broader area of the same parts of the brain used by those less able."[27]

To make the case for the arts in education, Charles Fowler believes that we will have to show both schools and industry that the arts can serve our country in ways that will enhance education, life, and the ability of people to be productive citizens.[28] The arts might not lend themselves to standardized testing, but for hundreds of thousands of years, they have played a role in cultural and even technological evolution. As Dissanayake suggests, those with an artistic attitude towards their craft tended to be most successful. If the arts enabled the success of both tribes and individuals throughout the history of human evolution, they can continue to do the same for us today.

For many arts educators, the above arguments are intuitively obvious. By tracing these arguments to our human origins, the science of art can rewrite the story of art education in America. But where do we start?

POETIC SCIENCE

Imagination is more important than knowledge. For knowledge is limited, whereas imagination embraces the entire world, stimulating progress, giving birth to evolution. It is, strictly speaking, a real factor in scientific research.
 –Albert Einstein[29]

Our popular view of the daydreaming artist covered in paint, and the analytic scientist with her petri dishes illustrates an exaggerated dichotomy. They have different methods and different goals, but both seek truth. Both draw from the same "subconscious wellsprings" and both seek elegance.[30]

From Aristotle to da Vinci, the early sciences were intimately tied to the arts, and many artists have foreshadowed major scientific discoveries.[31]

As much as the sciences may reinvigorate arts education, the arts have the potential to revitalize science education. Though science education is clearly well funded in America it is a relatively new and often unfamiliar way of thinking. Quantum physics, for instance, isn't the easiest thing for our 200,000-year-old caveman brains to process.

On one hand, the sciences, as Wilson explains, are intended to generalize, to distill the laws of nature. On the other hand, the arts have evolved to share knowledge in a way that intensifies aesthetic and emotional response.[32] The arts are defined by their ability to compel us and by our ability to remember them.[33]

Artistic "knowing" represents a truly different form of intelligence, one that is often ignored—even distrusted—by scientifically-minded individuals. In retrospect, scientific discovery might look like a clean, forward-moving procession of experimentation and discovery. In reality, accidents and subsequent insights lead to major scientific revolutions.[34] While we often teach the "facts, facts, facts" of science, the revolutions come from intuition, from creativity, from speculation, from leaps of imagination.[35]

Figure 17.7: Cosmic Fruit: If the earth were an orange and the moon a cherry, they would be ten feet apart. Visual metaphor allows us to comprehend numbers like 400,000,000 meters, the real distance between Earth and the Moon.

Science teaches us about the universe around us—but the universe of the atom, the DNA strand, and the supernova is not the universe of direct experience. Our bodies are not emotionally tuned to information on these microscopic and cosmic scales. Perception has been with us for millions of years, science for thousands. It is only through metaphor that we can understand these colossal concepts. Einstein, for example, grasped the theory of relativity by imagining himself on a moving train.

Analogy is the common human origin of science and art. It is in fact a fundamental mechanism of mind, the "consequence of spreading activation of the brain during learning."[36, 37] Everything we know, we learn by analogy with what we already know. Analogy allows us to concretely grasp abstract concepts, relating them to direct experience, just as art allows us to express the universal through the particular. This means that the arts train the fundamental abilities of the sciences.

Figure 17.8: MIT professor Walter Lewin, teaching pendulum physics with gusto (Photo: Markos Hankin).

Some of the brightest scientists, including Albert Einstein and Carl Sagan, showed us the emotional depth of science. Five hundred years ago, Francis Bacon advocated for the use of illustrations, stories, and fables to give science the same emotional punch as the arts.[38] As much as demonstration improves learning over mere explanation, our emotional participation considerably improves our understanding.[39] Our brightest science teachers give us drama.

By turning towards what interests us as humans, the arts can generate excitement about science.

Beauty and Truth

The greater one's science, the deeper the sense of mystery.
 –Vladimir Nabokov[40]

Remember the last time you stood before a canvas at a museum and took one step back. A squint of the eyes—the brush strokes fade and figures emerge. Another step—the scene begins to coalesce, the colors blend. The painting changes, not because the paint has changed, but because your perspective has. The science of art does not take away the mystery, it deepens our perspective. It allows us to step back further than the walls of a museum can ever allow.

How can we live with an educational system that denies a fundamental piece of what it means to be human? What greater argument can we make for supporting the arts than to show that it is essential to the long-term health of our species?[41] Given this, are the arts somehow less important than the sciences, than social studies, than math?

It is ironic that the very traits of our nation that steer us away from art—an obsession with reason and quantifiable progress—can steer us back toward art, toward an ancient well of emotional and spiritual well being. And what deeper message of tolerance and oneness can we send to children than that of the arts as a behavior that unifies humanity?

When will there be a *Natural History of the Arts*, a textbook addressing not only the physical origins of art, but its biological and mental underpinnings? Students will never hear of such theories until art educators become familiar with an evolutionary view of the arts and incorporate this perspective into their curricula. By doing so we have the opportunity to encourage an anthropological spirit in young art students. The study of arts practice as well as the study of art history can begin with a new first chapter, one that starts 300,000 years before the cave paintings.

Scientific developments present an opportunity to soften the boundaries between art and science education. We should not be hesitant to bring science into the arts classroom. Imagine an art and science month at every high school, where art and science teachers work together, covering the intersections between their subjects. Imagine a biology teacher discussing how human Gestalt theory influences our perception of Monet's work, or a ballet teacher explaining how ancient Indian dance rituals strengthened the communal ties of the tribe.

Lobbying efforts to expand art education in America can be reinvigorated by the science of art, and by a reevaluation of the biological history of the arts and the development of our species. The evolutionary view of the arts gives educators and lobbyists a new source of evidence to draw upon in their advocacy efforts. But like scientific discoveries, education reform can take decades to find its way into public policy. Now is the time to plant the seeds.

Art education can blossom with science. Science education can thrive with art. New developments in the science of art should be part of every discussion of the future of arts education.

Join the Conversation

Contribute to a dialogue pertaining to the concepts discussed in this chapter by directing your web browser to the following URL:
http://www.20UNDER40.org/chapters/chapter-17/

The authors would like to thank Ellen Dissanayake, Frederick Turner, and E. O. Wilson, not only for their useful feedback, but for their refreshing visions of the past and the future. Thanks to Fardad Faridi for the beautiful illustrations, Markos Hankin for the photo, and to our friends and family for their insightful feedback.

NOTES:
1. Gombrich, E. H. *The Story of Art: Pocket Edition.* New York: Phaidon, 2006: 38.
2. Paulnack, K. "Karl Paulnack Welcome Address." The Boston Conservatory (2004), <http://www.bostonconservatory.edu/s/940/Bio.aspx?sid=940&gid=1&pgid=1241>.
3. Dissanayake, E. *Homo Aestheticus: Where Art Comes from and Why.* Seattle: University of Washington Press, 1995.
4. Darwin, C. *The Descent of Man, and Selection in Relation to Sex.* London: John Murray, 1871.
5. Dutton, D. *The Art Instinct: Beauty, Pleasure, and Human Evolution.* New York: Bloomsbury Press, 2010: 136-138.
6. Wilson, E.O. *Consilience: The Unity of Knowledge.* New York: Random House, 1998: 225.
7. Ibid.
8. Ibid.
9. Ibid.
10. Dissanayake, E. *Homo Aestheticus: Where Art Comes from and Why,* 1995.
11. Wilson, E.O. *Consilience: The Unity of Knowledge,* 1998.
12. Dissanayake, E. *Homo Aestheticus: Where Art Comes from and Why,* 1995.

13. Ibid.
14. Turner, F. *Beauty: Value of Values*. Charlottesville: University Press of Virginia, 1992; Turner, F. "An Ecopoetics of Beauty and Meaning," in Cooke, B. and Turner, F. (Eds.) *Biopoetics: Evolutionary Explorations in the Arts*. Kentucky: ICUS, 1999: 119-138.
15. Ibid: 125.
16. Gombrich, E. H. *The Story of Art: Pocket Edition,* 2006.
17. Dissanayake, E. *Homo Aestheticus: Where Art Comes from and Why,* 1995: xiv.
18. Gombrich, E. H. *The Story of Art: Pocket Edition*, 2006: 21.
19. Veenhoven, R. "World Database of Happiness." Erasmus University Rotterdam (2010), <http://worlddatabaseofhappiness.eur.nl>.
20. Ehrenreich, B. *Dancing in the Streets: A History of Collective Joy*. New York: Metropolitan Books, 2007: 151.
21. Smetz, G. *Aesthetic Judgment and Arousal: An Experimental Contribution to Psycho-aesthetics*. Leuven: Leuven University Press, 1973.
22. Turner, F. "An Ecopoetics of Beauty and Meaning," in Cooke, B. and Turner, F. (Eds.) *Biopoetics: Evolutionary Explorations in the Arts*. Kentucky: ICUS, 1999: 119-138.
23. Cooke, B. "Biopoetics: The New Synthesis," in Cooke, B. and Turner, F. (Eds.) *Biopoetics: Evolutionary Explorations in the Arts*. Kentucky: ICUS, 1999: 3-26.
24. Ibid.
25. Kagan, J. "Jerome Kagan on Why the Arts Matter." The Dana Foundation (2009), <http://www.dana.org/news/features/detail.aspx?id=21740>.
26. Gardner, H. *Frames of Mind: The Theory of Multiple Intelligences*. New York: Basic Books, 1993.
27. Wilson, E.O. *Consilience: The Unity of Knowledge*, 1998.
28. Fowler, C. *Strong Arts, Strong Schools*. New York: Oxford University Press, 1996.
29. Einstein, A. *Einstein on Cosmic Religion and Other Opinions and Aphorisms*. New York: Dover, 1931: 97.
30. Wilson, E.O. *Biophilia*. Boston: Harvard University Press, 1984: 62.
31. Lehrer, J. *Proust Was a Neuroscientist*. Boston: Houghton Mifflin Harcourt, 2007; Onians, J. *Neuroarthistory: From Aristotle and Pliny to Baxandall and Zeki*. New Haven: Yale University Press, 2008.
32. Wilson, E.O. *Consilience: The Unity of Knowledge*, 1998.
33. Dissanayake, E. *Homo Aestheticus: Where Art Comes from and Why*, 1995.
34. Kuhn, T. *The Structure of Scientific Revolutions*. Chicago: University of Chicago Press, 1996.
35. Judson, O. "License to Wonder" *New York Times* (November 11, 2009), <http://opinionator.blogs.nytimes.com/2009/11/03/license-to-wonder/>.
36. Lakoff, G. *Metaphors We Live By*. Chicago: University of Chicago Press, 1980.
37. Wilson, E.O. *Consilience: The Unity of Knowledge*, 1998: 218.

38. Ibid.
39. Cooke, B. "Biopoetics: The New Synthesis," 1999: 3-26.
40. Nabokov, V. *Strong Opinions.* UK: Vintage, 1990: 45.
41. Cooke, B. "Biopoetics: The New Synthesis," 1999: 3-26.

The Conflicted Brain:
The Impact of Modern Technologies on Our Cognition and How Arts Education Can Be the Keystone to Whole-Mindedness

Jennifer Groff
Fulbright Post-Graduate Scholar, FutureLab (UK)

In an effort to increase student learning and achievement in today's world via standards, accountability, and high-stakes testing, arts education has suffered considerably. Ironically, new research in cognitive neuroscience—intersected with the current proliferation and presence of digital media and communication—supports the critical need to emphasize and extend opportunities to engage in the arts during the K-12 experience. Emerging research is identifying the multiple cognitive processing systems we posses, and how our own aptitude with these systems impacts performance and achievement, demonstrating the importance in learning how to develop and leverage all our cognitive processing systems—leading to whole-mindedness. This chapter explores current methods for achieving this, and includes recommendations for strategies to develop whole-mindedness in students through the arts and other forms of media, content, and experiences.

INTRODUCTION

Education, as a field, is an unusual institution. From a systems view, it has changed incredibly over the last 50 years—yet in many ways is just the same. Instruction still generally takes place in individual classrooms, led by one teacher, with academic content arranged into the appropriate disciplines. Yet in an effort to improve the system for all and ensure increased student

learning and achievement, the education system has evolved to a place where standards, accountability, and high-stakes testing have become the system drivers and have considerably changed everyday teaching and learning.[1] As a result, arts education has suffered considerably. Many schools and districts have pared down their instructional time on everything except traditional literacy and math—and in some cases have completely removed instructional time on subjects such as music and art.[2]

This undoubtedly has caused upheaval throughout the arts education community, and stakeholders across the field have continued to question the effectiveness of this system.[3] This re-questioning of the system design comes at an opportune time, when the rapid digital transformation of our world is changing everything, and colliding with powerful new research from cognitive psychology and neuroscience is supporting the critical need to emphasize and extend opportunities to engage in the arts during the K-12 experience. Even more critically, emerging research in neuroscience from the last several decades (and particularly the last several years from the burgeoning interdisciplinary field of Mind, Brain, and Education) is illuminating powerful evidence on human learning and cognition— providing critical evidence as to why arts education is pivotal to robust cognitive development.[4] Such evidence serves as a foundation for designing educational policy, curricula, and learning experiences that are diverse in orientation and medium. Leveraging this knowledge of the multiple facets to human cognition to design learning experiences will not only help to connect with all learners, but also cultivate, sharpen, and utilize each of the cognitive processing systems through which each learner engages with the world—so that each learner might approach *whole-mindedness*.

In this chapter, I will describe this research, starting with the heart of education—*learning*—and recent advances in cognitive psychology and neuroscience that underpin the educational decisions we make. Building on this, I will explore the behaviors and learning styles of today's students, the opportunity this creates for all areas of arts education—from the visual arts, to the performing arts, to new media arts and more—and examples of innovative pedagogies leveraging arts education to intersect with traditional academic instruction.

LEARNING: HOW DO WE PROCESS INFORMATION?

Every second our minds are inundated with information that comes in multiple formats—spoken language, visual stimuli, tactile touch, and so on. Yet how does one use this information to make sense of the world?

As we take in this information, it is stored in our limited capacity

short-term memory (known as "selecting") and is then manipulated via two channels known as *verbal* and *imaginal* ("organizing"); these channels take this information and create longer-term structures known as mental representations, which can then be recalled later for use ("integrating").[5] One can think of these processing systems as the "voice inside my head" or the "pictures or movies I 'see' in my head." They are the workspaces through which we maneuver information we have taken in via the various sensory channels.

Language has been a primary mode of information processing. As a result of this influence in our culture, language processing has largely dominated the research of informational processing in cognitive psychology and neuroscience. Since the 19th century we've known that language is largely held by two areas of the brain, now known as Broca's and Wernicke's areas—responsible for language production and for hearing and processing spoken words, respectively.[6] In the past century, neuroscience and the use of Functional Magnetic Resonance Imaging, or fMRI (a machine able to capture the blood flow in the brain associated with neural activity), has shown how these two major areas are central to the distributed circuitry for language in the brain.[7]

But what about our brain's other means of processing information? Over the last several decades there has been a steady increase in the attention paid toward understanding the non-verbal means for processing information, propelled by notable figures like Jean Piaget and Stephen Kosslyn.

Towards the end of his career in the 1970s, world-renowned developmental psychologist Jean Piaget became increasingly concerned with imaginal symbols and the development of mental imagery in the child. Piaget's research emphasized the concern that verbal symbolism alone is insufficient and must be augmented by a system of imaginal symbols to represent figural and conceptual aspects of objects, concepts, relations, and transformations.[8] He noted that by around six to eight years of age, children begin to use these cognitive functions more frequently and effectively to represent the physical and social environment, and these systems are developed through interaction with the child's environment.[9] Allan Paivio's work has supported Piaget's notions, demonstrating the complementary nature of the verbal and imagery processes in the child's thinking—where imagery allows for the concrete representation of the child's environment and verbal representations help account for the more abstract.[10] Paivio's work led to his development of Dual-Coding Theory, which describes how humans process information through two systems: the *verbal* (language, including all spoken and written text) and the *non-*

verbal (objects and events), also referred to as the *imaginal* processing system.[11]

Over the past several decades, research on the imaginal, or nonverbal, processing system has helped us to identify and understand the nature of the imaginal processing system. This system has been linked to the capacity to perceive, remember, and problem-solve, and as a critical component to creativity—including exceptional scientific-breakthroughs, by manipulating and transforming existing mental images.[12] The fascination with and examination of Einstein's cognitive patterns lead much of the research in this area. Known for his exceptional scientific breakthroughs, Einstein derived many of these through imagery and mental image manipulation. Interestingly (yet perhaps not coincidentally), Einstein's verbal processing system was severely delayed.[13] Authorities on visual thinking like Stephen Kosslyn have examined Einstein's tremendous facility with his mental images through visual, spatial, and motoric representations, all of which are components of the non-verbal processing system.[14]

Of these two systems, Piaget saw them as serving separate but complementary roles in cognition. Paivio offers a clear picture of how these two systems operate:

> The verbal system is a necessary player in all "language games" but it is sufficient in only a few. In the most interesting and meaningful ones, the verbal system draws on the rich knowledge base and gamesmanship of the nonverbal system. Conversely, the nonverbal system cannot play language games on its own, but it can play complex nonverbal "solitaire." The verbal system dominates in some tasks (crosswords is a simple example) and the nonverbal imagery system in others (e.g., jigsaw puzzles). Cognition is this variable pattern of the interplay of the two systems according to the degree to which they have developed.[15]

The supporting research of Dual-Coding Theory has demonstrated that we do indeed have two processing systems—one for verbal stimuli and one for non-verbal stimuli—and these two processing systems work together in an ebb-flow dynamic, depending on the cognitive stimuli and task at hand.

DOMINANT COGNITIVE PROCESSING SYSTEMS

Common sense says that the more you exercise a processing system, the more refined and developed it becomes—hence the purpose of instruction on the fine arts, literature study, etc. Yet, recently, cognitive science research in this area has shown that different cognitive tasks can stress these individual processing systems, that the imaginal system can be further broken down into "object" and "spatial" visualizers, and has further demonstrated

specific preferred cognitive styles of individuals.[16] Figure 18.1 depicts these cognitive styles in relation to Dual-Coding Theory. Object visualizers tend to be strong at constructing static representations or images in the mind while spatial visualizers tend to be strong at manipulating images or working with the relations between objects. With this in mind, The Group Brain Project at Harvard University set out to understand if certain patterns of activity (such as video-game play, creating representational art, word games, etc.) correlated with an individuals' dominant cognitive style (verbal, object visualizers, and spatial visualizers).

Cognitive Style	Cognitive Processing Systems		
	Non-verbal		Verbal
	Object Visualization (static images)	**Spatial Visualization** (moving/manipulating images)	**Verbal** (language-based)

Figure 18.1: Cognitive processing systems.

Using online questionnaires with over 3,800 participants, Chabris et al. found that the dominant cognitive style of more than 80% of the participants was some form of visualization, with around half of all participants identifying as object visualizers.[17] That is a significant portion of the population whose dominant cognitive processing system is *not* language. According to the survey data, people with experience playing video games scored higher on the spatial visualization scale and those with experience in representational art scored more strongly on object visualization assessments. The study curiously also found that teams composed of individuals with differing cognitive styles, with each team member assigned to roles that align with their cognitive styles, outperformed homogeneous teams (i.e., teams of two spatial visualizers or two object visualizers).[18]

Of course, in everyday problem-solving and learning, one of these systems never works solely independently; rather, cognition is the synthesis of knowledge codified via both channels, where both the verbal and non-verbal systems work complimentarily and both are critical to comprehension. Yet the research of Chabris et al. denotes how processing will play out differently in each individual. This has real-world implications for how we create collaborative learning experiences in the classroom and at work. How are we to be teaching when the vast majority of learners prefer visual over verbal cognitive processing? If we are not aligning students with tasks, and then combining them in teams leveraging their cognitive

styles, are we really able to capture their true abilities in a given task or domain? Likewise, if we are not offering learning experiences that leverage all of these cognitive styles, are we under-developing all students' cognitive capacities?

TECHNOLOGY AND YOUR BRAIN

Given that video games are a relatively new technology, it is interesting to consider how many of the spatial visualizers in the Harvard Group Brain Project study were intrinsically strong at this cognitive style; or is it that they are strong at this cognitive style as a result of interaction with video games? Given the unprecedented influx, and influence, of digital technology in our world, the question is worth considering. The old neuroscience adage, "the neurons that fire together, wire together" exists for a reason; it's meant to capture one of the brain's most powerful abilities, *plasticity*—the ability to change, strengthening some neural connections while eliminating others.[19] In other words, depending on your experiences, learning and interaction with stimuli over time, different cognitive capacities will strengthen and increase, while others will decrease. It has been extensively demonstrated that experience shapes our neural networks.[20] Small and Vorgan explain that with "enough repetition to any stimulus [the brain] will lay down a corresponding set of neural network pathways in the brain, which can become permanent."[21] It's common sense in many ways—if you practice the violin, over time your ability to hear correct pitch, place your fingers properly, and so on, will increase; yet if violin practice has taken away from the time you would be spending on writing and constructing complex narratives and sentences, you might be less good at that. But it's important to note that this occurs at the neural level—the structures and networks of the brain physically change as a result of your interacting with certain stimuli. A good reflective learner might then ask, "what stimuli am I interacting with mostly?" In today's rapidly changing world, that's a very important question.

Neuroscientists and cognitive psychologists have long been interested in trying to understand how the technologies we are shaping, are actually shaping us. While this research is slowly developing—with many more questions than we have answers—initial studies have shown that interacting with new digital technologies such as the Internet and video games does affect the processing patterns of our brains. Small and Vorgan have cited some of these effects—including quickened reaction time, pattern recognition, increased executive function, and some forms of attention.[22] Some of these skills are directly transferable to real-world activity. Researchers at the

New York Beth Israel Medical Center have demonstrated this in their examination of surgeons (specifically laparoscopic surgeons, who make tiny incisions in the body and use video camera scopes displayed on a monitor to complete the surgery) that played video games more than three hours per week had over 40% fewer errors in surgery, when compared to their non-playing peer surgeons.[23] That's a remarkable number given the gravitas of the task! This notion of transferability has serious implications given the exponentially growing public engagement with digital technologies—particularly digital games, and particularly with the developing minds of adolescents and pre-adolescents.

Yet studies on the effects of our interaction with technology do not always paint such a rosy picture. Paradoxically, other research has shown that too much exposure to these digital technologies can have numerous negative effects—both *in the moment* (such as fatigue and loss of focus) but also *long-term*, including addiction to the activity from the chemical reactions in response to the stimuli, reduced executive function (responsible for judgment and decision-making), and diminished capacity for patience and delayed gratification.[24] Many find these last two effects particularly concerning, as the capacity for patience and delayed gratification produce engaged citizens capable of behaving in a way that benefits the overall system rather than solely choosing self-serving actions. Other negative effects include "video-game addiction"—a very real phenomenon, attributed to the release of dopamine in the brain in response to "flashy graphics and rapidly changing visual stimuli" which causes the user to develop a very real physical addiction.[25] While it is unclear as to how prevalent this phenomena is in modern culture, given that 31% of teenagers alone are playing video games every single day, it certainly is critical to understand this as part of a spectrum of effects, both positive and negative, of digital technologies on the brain.[26]

This research begs the question, how does this type of digital technology use compare with extensive use of computer applications for the visual and media arts? As a result of this emerging research, the spectrum of effects paints a mixed picture. While there have been demonstrable benefits to digital experiences, there are countless negative affects as well. It seems that the key lies in finding the right balance, and appropriate time/experiences with these technologies. So then, *what interactions with technology are beneficial, and how does this impact how we think and learn?*

Perhaps the key lies in purposefully designing and implementing the right types of digital experiences for learning. Research on digital simulations is helping to make this situation clearer, with some preliminary success in demonstrating one's ability to improve visio-spatial processing.[27] Using

simulation programming tools, like Microworlds and StarLogo, students program a turtle on the screen to move in a certain direction or complete a specific action, often tracing a shape with their path.[28] Clements and Burns found that students using these tools experienced "spatial weaning" whereby they no longer needed to make physical gestures to determine what shape the turtle would make, with the assumption that the students had internalized the capacity to visualize these mental models, thereby influencing the development of their non-verbal processing systems.[29]

Our Digital Brain

Our highly digital world presents an interesting scenario for learners, both young and old. It goes without saying that people interact with digital technologies exponentially more than they did five or 10 years ago. Digital participation has been on a steady rise. The 2008 Pew Internet and American Life Project study found that 97% of teenagers play some kind of video game and one in five teenagers play games three to five days a week; and on any given day, 50% of teenagers will be playing games, with one quarter of those individuals playing for two hours or more. We are near digital-saturation in our society, with just 6% of the overall American adult population yet to become Internet users.[30] If we then consider the difference between the types of leisure activities of the youth of just a decade ago compared to the youth of today, how do they differ? And what implications does this have for the structure and function of their brains?

As each new generation displays more and more digital behavior and activity, we will be able to gather more information on these effects. Like any muscle or region in the brain, that which is used and stimulated becomes further developed than those that are not. Some assert that video games, by their very nature and design, develop spatial skills.[31] According to Small and Vorgan, with emerging research showing increased visual acuity, today's learners are developing and utilizing their imaginal processing systems in ways never imagined.[32] If Small and Vorgan are right, does that mean that today's youth fundamentally and structurally think differently than previous generations? If so, then in what ways are today's learners inclined to use their verbal and imaginal processing systems differently?

A Brain Conflicted

Classroom instruction is still largely verbal-based, particularly in our current climate of curriculum narrowing as a result of high-stakes testing. Despite the obvious capacities of both verbal and non-verbal systems, each has not been emphasized equally in instructional practices in education.

This is evidenced in the course of a typical school day. Children are given textbooks for their classes, asked to write essays and papers for their final projects, and take notes with pens and notebooks. Students are constantly employing their verbal information processing abilities to make sense of the abstract. While visual props and digital media are increasingly making their way into the classroom, verbal-based instruction (through lecture, note-taking, and traditional textbooks) is still a dominant form of instruction in many schools. Although some educators do make an effort to include more images and visualization in the presentation of information, they are used much less frequently as problem-solving tools—where some of their greatest capacity lies.[33] Educators have long known that multimedia instruction is engaging, but what if the students' complaints about "boring instruction" and lack of digital media use go beyond their general preference for multimedia—what if they cognitively (structurally and functionally) are less able to engage with written text and lecture classes? This disconnect can be a challenge not only when attempting to learn new information, but also when trying to apply it or demonstrate mastery during assessment.

And thus the conflict: for many students two areas of their lives are going in diverging directions—students spend their personal lives interacting with a rich world of both verbal and non-verbal stimuli, with a dramatic increase in how their imaginal system is shaped through digital media; yet they spend the other part of their lives in the classroom, where instruction and cognitive tasks are increasingly becoming language- and logic-based. How can we bridge this gap?

DIVERSIFYING PEDAGOGIES

Stakeholders across and beyond the educational system already feel that the status quo of schools cannot continue.[34] Yet this illuminating interdisciplinary research on cognitive styles and new digital media only adds fuel to the fire. Some researchers believe that the verbal dominance of schools can have serious implications for cognitive development. According to Robert McKim, it causes "Visual Atrophy"—where the imaginal processing system is left behind, and visual cognition is underdeveloped.[35] He goes on to argue that schools do not help students understand their own ability for mental imagery, and provides little opportunity to develop this capacity. Students differ vastly in their capacity and efficiency to employ both of these systems.[36] Helping to identify a learner's aptitude in both systems, and developing instructional experiences and opportunities to nurture both of these systems is of critical importance.[37]

Our cognitive processing systems are the foundation for our

engagement with the world. Helping learners to develop these, and more critically, understand how to *use* and *leverage* these processing systems as tools through which to engage with the world is central to healthy, rich, and balanced cognitive development for what I refer to as *whole-mindedness*— the robust development of all cognitive processing systems, as well as the awareness of these systems, enabling an individual to leverage these diverse capacities to meaningfully engage with and produce materials borne of one or more modalities.[38] Educators elicit the verbal system—teaching learners how to properly annunciate, spell, communicate complex thoughts, and so on. Yet how much time is spent attending to visual-spatial processing, and teaching students how to leverage their capacity in this area of their cognitive processing systems, as McKim suggests?

While digital media certainly is an appealing tool here, it would be irresponsible to advocate for schools to jump to a full-time digital regime— there is not enough sound research to understand the effects of this type of long-term exposure on cognitive development, as well as the already cited negative effects associated with extensive video-game play. How do we leverage the benefits of these tools for all students, while avoiding the unhealthy effects documented as well? Research suggests that this is a manner of *balance*—that even high-quality, educational digital technologies should be just one component of an array of cognitive stimuli with which young minds engage.

This is where the visual arts play a critical role, bridging the gap in the diversity of learning experiences and opportunities for developing minds and young learners. The verbal processing system already gets significant attention and development, both in and out of school. The non-verbal or imaginal processing system only gets partial development—in general, minimally in school, but partially (in varying degrees for each student) outside of school. But in greatest contrast to the verbal processing system, the non-verbal gets *very* little if any instruction on how to be leveraged as one of our dominant cognitive processing systems. Like language and linguistic ability, so too must images, image manipulation, and visualization be leveraged. This skill set lies at the heart of visual arts instruction. Traditional visual arts training focuses intensively on training the eye to "see" shape, form, positive and negative space, and so on. This correlates to the functions of the object visualization cognitive style. This discipline is a vital part of the critical array of learning experiences, which must include a diverse range of modalities, needed for all learners' healthy cognitive development. Not only to provide opportunities to engage with the learner's dominant cognitive style, but to develop all of their processing systems.

Whereas digital technologies may help meet the needs of spatial visualizers, visual arts education often speaks more directly to the object visualizers. Autism research is shedding further light on this learning style. While Autism is a spectrum disorder, many diagnosed strongly align with visual thinking, where some describe that they "think in pictures."[39] Some autistic individuals have shown far advanced drawing abilities, able to render natural scenes with near flawless perspective from memory at a very young age.[40] Research in this area has also shown that rapid shifting of attention and stimuli is difficult for those with autism—suggesting that digital media and video games may be negative experiences for these learners. While Autistic learners may represent a small subset of the population, they embody an exaggerated view of a style of cognition—one that may be still existent but less extreme for other parts of the population that have not been identified or labeled as such. Autistic individuals demonstrate for us how certain ways of engaging with and processing information may be effective, while others may be detrimental.

Of course, not all students will have such sensitivities to certain modalities, and this will vary with each individual student. Yet this demonstrates the need for each student to become aware of their dominant cognitive style—be it verbalizer, object visualizer, or spatial visualizer—and master it, knowing when to leverage one cognitive style for appropriate problem-solving and communication, and when to spend time trying to grow and build another. This, indeed, is *whole-mindedness*. And this is where education plays the critical role. It starts by ensuring that all learners have the *opportunity* to engage with their dominant, as well as non-dominant, cognitive processing systems.

FRAMING WHOLE-MINDEDNESS

Whole-mindedness is not an end-state but a framing of the cognitive capacity to develop and employ the verbal, object- and spatial-visual processing systems, and the meta-awareness of one's ability to do so. The whole-mindedness approach to education is a pedagogy that seeks to cultivate this in each learner. In this sense, whole-mindedness differs from the popular theory of Multiple Intelligences.

Howard Gardner, who re-framed the notion of intelligence nearly 30 years ago, described the notion that all individuals possess to varying levels "intelligences" in roughly eight domains. He has described an "intelligence" as a biological potential that allows us to process information to make things or fashion products that are valued in a culture or community.[41] For Gardner, what makes an intelligence is the capacity to employ one's

cognitive power with specific content and domains in the world to produce something valued by other humans; in other words, it is the leveraging of one's cognitive processing systems with existing mental representations to produce products and performances valued by society. This is of the highest level of construction and cognitive analysis. Whole-mindedness focuses at a lower level of analysis; specifically on just the cognitive processing systems themselves and their distinct and intentional development as the cognitive tools that they are.[42] This foundational approach to education emphasizes the cultivation, refinement, and facility with these processing systems, with the belief that as one does so, it increases his/her capacity and facilitation with all intelligences.

APPROACHING WHOLE-MINDEDNESS

With our new understanding of cognitive styles, processing systems, and how they relate to different media present in our world, demonstrates the need for a rich array of learning experiences required for robust cognitive development—which must include multiple media formats that engages all processing systems. Schools must not ignore this understanding but embrace it. Figure 18.2 presents a framework for finding that desired balance of instructional modalities targeting specific cognitive styles, so that learners may verge towards whole-mindedness.

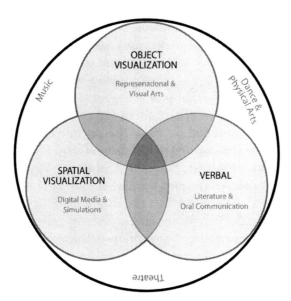

Figure 18.2: Framework for whole-mindedness: targeting the three central cognitive styles creating a spectrum of instructional modalities, augmented by additional modalities.

The digital revolution has already begun to pave the way for such an approach. The sub-set of the education community focused on the impact and leverage of digital media advocates for multiple forms of media being integrated into instruction, commonly referred to as "multimodal learning." This discourse and study of multi-modal learning supports the whole-mindedness approach, asserting that:

> ...all modes are partial. Each contributes to the production of knowledge in distinct ways and therefore no one mode stands alone in the process of making meaning, rather each plays a discrete role in the whole: hence the need to attend to all.[43]

This emerging body of research is showing that "significant increases in learning can be accomplished through the informed use of visual and verbal multimodal learning."[44] Connecting this discourse more strongly with our new developing understanding of the cognitive processing systems of the brain will help focus creating instructional materials, curricula, and policy directly to the individual cognitive abilities, strengths, and challenges of each learner. While multimodality efforts tend to focus on digital media, this push for multimodal learning has also advocated for other modalities and learning experiences less present in cognitive psychology literature, such as movement, dance, and theatre. As cognitive psychology and neuroscience continue to evolve, it's likely that these too will become more integrated into our understanding of how people think and learn.

In practical terms, whole-mindedness doesn't necessarily mean visual arts and non-verbal modalities in learning have to be a separate add-on (or in many cases an "add-back-in") component to the curriculum. And for some, it may appear that this is just describing "visual literacy" strategies. However, vigorous instruction producing robust cognitive development comes from the integration of disciplines and cognitive systems—not just from stand-alone instruction on visual literacy development. Within the past few years, several intriguing models have emerged that integrate these learning modalities together. Since 2004, Harvard Medical School has been offering the course "Training the Eye: The Art of Physical Diagnosis" seeking to improve the examination and diagnosis skills of their soon-to-be doctors. The curriculum for the course includes training on formal art observation strategies and drawing techniques, through weekly visits to the Museum of Fine Arts in Boston, which are then connected to traditional medical school classroom instruction on various medical diagnostic exams. Evaluators of the course found that by the end of the semester, students had increased sophistication in their descriptions of artistic and clinical imagery and improved their capacity to make accurate observations of art

and physical findings.[45] Splitting time equally between the art museum and the medical school can seem disparate to the average eye, but it is beautifully integrated as a result of a collaboration between medical school instructors and museum educators, leveraging a pedagogy known as VTS (Visual Thinking Strategies). VTS, developed by Philip Yenawine, Director of Education at the New York Museum of Modern Art, is based on Abigail Housen's Aesthetic Development theory. This innovative approach to arts education uses the discussion of art as a means for developing critical thinking and visual literacy skills. Together, Yenawine and Housen have found that VTS catalyzes aesthetic development and develops critical thinking and cognitive abilities in people of all ages, and has been shown to transfer to problem-solving in other fields, such as reading, writing, and mathematics.[46] Their findings reinforce the research that has been discussed thus far, explaining that these processing systems work in concert, and mutually reinforce one another over time.

Outcomes such as this are impressive and underscore that we need to rethink learning experiences in light of evidence from neuroscience, and that education needs to be critically concerned about the cognitive structuring of such learning experiences. An excellent example of an alternative approach to instructional strategy in younger students is the work conducted by Artis Education—a UK-based organization that helps schools achieve their core curriculum aims through a blend of the arts, including music, drama, and movement. Through their intensive training program, Artis prepares professional artists to deliver these learning experiences in the school with which they are collaborating. It is their belief that through the integration of these disciplines students not only learn more deeply, but further generate the critical capacity for creativity.[47] Programs like Artis are supported by the growing interest of multimodality and multimodal learning design, which seeks to "interconnect the modes in dynamic relationships and involves the whole body in making meaning."[48]

RECOMMENDATIONS FOR PRACTICE

Teaching for whole-mindedness means seeking not only to identify your students' cognitive processing strengths—be they dominant object visualizers, spatial visualizers, or verbalizers—but also proactively cultivating all processing system capacities, while teaching students how they can continue to develop and leverage these capacities in their life experiences. Working towards this end doesn't necessarily require much extra effort. Here are some strategies for building whole-mindedness in your students:

Get to Know Your Students' Cognitive Processing Strengths

Is Johnny a verbalizer or a spatial visualizer? How does Susie like to spend her free time at home? A teacher is commonly familiar with each student's verbal abilities, but it's important to learn their non-verbal abilities as well. Most importantly, set out to determine what are students' dominant cognitive processing styles. How can you determine this? Start by finding out how they spend their free time—is it reading, talking on the phone, playing video games, or drawing? Of course, knowing that students like to spend a good deal of their free time playing video games does not automatically define them as "spatial visualizers," but how they spend their time is indicative of which processing systems they are engaging most, and therefore developing the most. You can also give your students tasks that help identify their dominant cognitive processing systems, such as image manipulation tasks, where students are given geometric images and asked to select the appropriate reflected or rotated image.[49]

Help Students Become Aware of, Cultivate, and Leverage all of their Cognitive Processing Systems

Schooling aside, one's cognitive processing systems—the verbal, the object-visualizer, and the spatial-visualizer—are an individual's most basic toolset. They are the processors through which we take in our world, digest it, and subsequently interact with it. Helping students become acutely aware of their abilities with consuming, processing, and working with various sorts of information is critical in being able to make these strengths work for them. You can begin by helping students grasp the differences between the systems: read the students a word problem and then ask them to think through it in their head only (no writing, doodling, or talking). Then ask them to think about *what* they thought about—did they build a logical story in their head? was it a series of changing pictures that ultimately produced the solution picture? or was it an action video? A class discussion around this can help all learners become more aware of what students' dominant processing systems are, but also what other dominant processing systems are like for their peers.

Allow for Varying Performances and Assessments

Understanding your students' cognitive processing strengths is important for designing appropriate performance assessments. As the research from The Harvard Group Brain Project suggests, aligning tasks with students' dominant cognitive processing styles dramatically affects their performance. When possible, allow students to demonstrate their knowledge using

their dominant cognitive processing styles. This might mean a written essay, or developing a visual "story" using a simulation-building platform like *StarLogo* or *Scratch*.[50] By first identifying your students' dominant cognitive processing styles, you can collaboratively determine the best performance or assessment for them to complete on a given topic or unit of study; and since you co-defined what that is with the student, you are helping them increase their metacognitive awareness of their cognitive processing capacities.

Create Group Learning Activities that Require Intersecting Tasks that Use All Cognitive Processing Systems

Providing diverse social learning experiences is important for helping students to cultivate dominant as well as non-dominant cognitive processing systems through mirroring, modeling, and collaboration with other students. Therefore, students should have opportunities to be working in groups that consist of differing cognitive tasks, where each learner is assigned the task that leverages his or her dominant cognitive processing style. At the same time, students should also have opportunities to engage in tasks that require them to employ their non-dominant cognitive processing styles, and work alongside other students who are doing the same. Diverse learning experiences, which vary in employing each of the cognitive processing systems as well as times where two or more are employed together, helps students to employ their strengths while giving them the opportunity to develop their non-dominant cognitive processing capacities as well.

Simply Provide Lots of Diverse Learning Experiences, Media, and Content!

The aforementioned suggestions can become a hefty challenge when working with an entire class of students. Yet if you can't diversify your instructional design to this degree, working towards whole-mindedness at its most basic level supports providing multimodal learning experiences for students so that they have the opportunity to engage in activities that help build their dominant and non-dominant cognitive processing systems. That means providing not only language-based content, but also static visual stimuli and dynamic activities such as simulations and digital games. Neuroscience suggests that just the interaction with these varying stimuli aide in developing each cognitive processing system, but more critically it is the *instruction around this content* (such as graphic design, visually displaying data, fine arts instruction, etc.) that further refines the mind, particularly when it comes to the non-verbal cognitive processing systems.

WHY THE IMPERATIVE FOR WHOLE-MINDEDNESS

The past several decades have brought us inspiring advancements in understanding how we think, learn, and interact with the world. While recent cognitive psychology research and neuroscience may leave us with more questions, it already provides enough answers to support the broadening of our instructional horizons and the expansion of the curriculum—rather than its systematic pruning. Some of these reasons are quite clear: the spoken and written word is receiving increasingly fierce competition from static and dynamic images, and image manipulation will become an increasingly critical skill in our digital world.[51] Multimedia principles are built on the evidence that learners perform better on transfer tests when they receive text and pictures combined over just text alone.[52] Some reasons are less intuitive: such as training the eye, and mind, via media such as fine art and digital games for critical analysis and performance in skills such as medical diagnosis and surgery. While the evidence in this area is just emerging, it is indeed compelling. With a 40% difference in errors during surgery, will you be asking your surgeon if he/she plays video games? Finally, there are compelling reasons to approach whole-mindedness pedagogy based on research we are only beginning to understand: a recent study of over 6,000 middle school students demonstrated that those who received formal musical instrument instruction significantly outperformed their peers in algebra scores.[53] While the connection between the two is not evidently clear, it reminds us that we are just beginning to uncover more and more profound connections in cognition and performance; although we may not yet fully understand them, we need to see these connections as more support for multimodal learning.

Regardless, there's one thing we know for sure—everyone has a different dominant cognitive processing system. Based on the sample from the Harvard Group Brain Project, the mean of the population is not the verbal processing system. Whole-mindedness is an approach to solving the "Visual Atrophy" problem that McKim describes. If we seek to effectively maximize cognitive processing capacity in *all* learners, then we must provide them with opportunities to *meaningfully* engage and employ all cognitive processing systems, and develop an awareness of their capacity with these diverse systems that grows over a lifetime.

CONCLUSION

Education is entering a critical period where current policy must, and is, being reconsidered—in light of the serendipitous paralleling of research from multiple fields and innovative models of teaching and learning. This

confluence paints a picture for a framework of how cognition occurs and develops, and how the spectrum of media and modalities must be leveraged synergistically in education to create the capable and developed learners we desire. As neuroscientists and cognitive psychologists progress in their research in the areas of cognitive processing and the impact of digital technologies on cognition, educators must be working in tandem with them to produce effective pedagogies that leverage old and new media and disciplines for all learners.

Join the Conversation

Contribute to a dialogue pertaining to the concepts discussed in this chapter by directing your web browser to the following URL:

http://www.20UNDER40.org/chapters/chapter-18/

NOTES:

1. Teachers Network. "Survey Reveals that Only 1% of Teachers Find No Child Left Behind an Effective Way to Assess the Quality of Schools and 69% Report It's Pushing Teachers Out of the Profession." (2007), <http://www.teachersnetwork.org/aboutus/pressreleases/nclb_survey.htm>.

2. Jennings, J. & Rentner, D. "Ten Big Effects of the No Child Left Behind Act on Public Schools." *Phi Delta Kappan* 88, no. 2 (2006): 110-113.

3. Hoff, D. "Debate Over Curriculum Narrowing Continues." *Education Week Blog.* (2009), <http://blogs.edweek.org/edweek/NCLB-ActII/2009/03/the_argument_that_nclb_is.html?qs=nclb>; Teachers Network. "Survey Reveals that Only 1% of Teachers Find No Child Left Behind an Effective Way to Assess the Quality of Schools and 69% Report It's Pushing Teachers Out of the Profession." (2007), <http://www.teachersnetwork.org/aboutus/pressreleases/nclb_survey.htm>.

4. For more on this new field, see the website for the International Mind, Brain, and Education Society: <http://www.imbes.org/>.

5. Mayer, R. "Learning with Technology," in OECD (Ed.) *The Nature of Learning: Using Research to Inspire Practice.* Paris, France: OECD, 2010.

6. Broca's area is a small region on the left inferior frontal cortex (or the bottom of the left hemisphere of the brain near the front) and Wernicke's area is found in superior posterior temporal lobe (or the upper part of the back side of your left hemisphere). There is a nice explanation of the Broca-Wernicke's language loop at <http://thebrain.mcgill.ca/flash/d/d_10/d_10_cr/d_10_cr_lan/d_10_cr_lan.html>.

7. Center for Educational Research and Innovation & OECD. *Understanding the Brain: The Birth of a Learning Science.* Paris: OECD, 2007.

8. Piaget, J. & Inhelder, B. *Mental Imagery in the Child.* New York: Basic Books, 1971.

9. Greeson, L. & Zigarmi, D. 1985. "Piaget, Learning Theory, and Mental Imagery: Toward a Curriculum of Visual Thinking." *Journal of Humanistic Counseling, Education and Development* 24, no. 1 (1985): 40-49.

10. Paivio, A. *Imagery and Verbal Processes.* New York: Holt, Rinehart and Winston, 1971.

11. Paivio, A. *Mental Representations.* New York: Oxford University Press, 1986.

12. Kosslyn, S. *Image and Brain.* Cambridge, MA: MIT Press, 1996; Shepard, R. "Externalization of Mental Images and the Act of Creation," in Randawa, B. & Coffman, W. *Visual Learning, Thinking, and Communication.* New York: Academic Press, 1978: 133-190.; Paivio, A. *Imagery and Verbal Processes,* 1971; Rothenberg, A. "Artistic Creation as Stimulate by Superimposed Versus Combined-Composite Visual Images." *Journal of Personality and Social Psychology* 50 (1986): 370-381; Campos, A. & Gonzalez, M. "Effects of Mental Imagery on Creative Perception." *Journal of Mental Imagery* 19, nos. 1-2 (1995): 67-76; Forisha, B. "Patterns of Creativity and Mental Imagery in Men and Women." *Journal of Mental Imagery* 5, no. 1 (1981): 85-96; Greeson, L. "Mental Imagery and Creativity," 1981: 215-230.

13. Patten, B. "Visually Mediated Thinking: A Report of the Case of Albert Einstein." *Journal of Learning Disabilities* 6, no. 7 (1973): 415-420.

14. Kosslyn, S. "Einstein's Mental Images: The Role of Visual, Spatial, and Motoric Representations," in Galaburda, Kosslyn, S. & Yves, C. *The Languages of the Brain.* Cambridge, MA: Harvard University Press, 2002: 271-287.

15. Paivio, A. "A Dual Coding Theory." Draft Chapter for the Conference on Pathways to Literacy Achievement for High Poverty Children, The University of Michigan School of Education, September 29-October 1, 2006: 3.

16. Ungerleider, L. & Mishkin, M. "Two Cortical Visual Systems," in Ingle, D., Goodale, M., & Mansfield, R. *Analysis of Visual Behavior.* Cambridge, MA: MIT Press, 1982: 549–586; Haxby, J., Grady, C., Horwitz, B., Ungerleider, L., Mishkin, M., Carson, R., Herscovitch, P., Schapiro, M., & Rapoport, S. "Dissociation of Object and Spatial Visual Processing Pathways in Human Extrastriate Cortex." *Proceedings of the National Academy of Sciences* 88 (1991): 1621–1625.

17. About one quarter of the participants split between "spatial visualization" and "verbalizers," and the remaining one quarter of participants were "non-classified" as their preference between object and spatial visualization was too close to be delineated. Chabris, C., Jerde, T., Wooley, A., Gerbasi, M., Schuldt, J., Bennett, S., Hackman, J., & Kosslyn, S. "Spatial and Object Visualization Cognitive Styles: Validation Studies in 3800 Individuals." Technical Report No. 2. Cambridge, MA: The Group Brain Project, Harvard University, 2006.

18. Woolley, A., Hackman, J., Jerde, T., Chabris, C., Bennett, S., & Kosslyn, S. "Using Brain-Based Measures to Compose Teams: How Individual Capabilities and Team Collaboration Strategies Jointly Shape Performance." *Social Neuroscience* 2, no. 2 (2007): 96-105.

19. Paul Howard-Jones offers an explanation as to where to learn more about the genesis of this phrase, see: "Philosophical Challenges for Researchers at the Interface between Neuroscience and Education." *Journal of Philosophy of Education* 42, nos. 3-4 (2008); OECD. *Understanding the Brain: The Birth of a Learning Science.* Paris: OECD, 2007; Small, G. & Vorgan, G. *iBrain: Surviving the Technological Alteration of the Modern Mind.* New York: HarperCollins, 2008.

20. Singer, W. "Development and Plasticity of Cortical Processing Architectures." *Science,* 270 (1995): 758-764; Doidge, N. *The Brain that Changes Itself: Stories of Personal Triumph from the Frontiers of Brain Science.* New York: Viking Adult, 2007.

21. Small, G. & Vorgan, G. *iBrain: Surviving the Technological Alteration of the Modern Mind,* 2008: 5.

22. Ibid.

23. Rosser, J., Lynch, P., Cuddihy, L., Gentile, D., & Klonsky, J. "The Impact of Video Games on Training Surgeons in the 21st Century." *Archives of Surgery* 142 (2007): 181-186.

24. Small, G. & Vorgan, G. *iBrain: Surviving the Technological Alteration of the Modern Mind,* 2008.

25. Ibid: 38.

26. Pew Internet Society and American Life Project. *Digital Divide,* 2005. <http://www.pewinternet.org/pdfs/PIP_Digital_Divisions_Oct_5_2005.pdf>.

27. Klopfer et al. define digital simulations as a modeled or modified version of a real world situation, which lack game dynamics or the "win state" that exists in digital games: Klopfer, E., Osterweil, S., Groff, J., & Haas, J. 2009. *Using the Technology of Today, in the Classroom Today: The Instructional Power of Digital Games, Social Networking, and Simulations, and How Teachers can Leverage Them in the Classroom.* An Education Arcade white paper. (2009), <http://education.mit.edu/papers/GamesSimsSocNets_EdArcade.pdf>; McClurg, P. "Investigating the Development of Spatial Cognition in Problem-Solving Microworlds." *Journal of Computing in Childhood Education* 3, no. 2 (1992): 111-126.

28. Microworlds is an education technology that is a programming environment in which students can explore and test their ideas as they create science simulations, mathematical experiments, and interactive multimedia stories. See <http://www.microworlds.com>; Starlogo is an educational technology that is a programmable modeling environment where one can build models of many real-life phenomena, such as bird flocks, traffic jams, ant colonies, and market economies. See <http://education.mit.edu/starlogo> or for the new 3D version, go to <http://education.mit.edu/starlogo-tng>.

29. Clements, D. & Burns, B. "Students' Development of Strategies for Turn and Angle Measurement." Paper presented at the meeting of the American Educational Research Association, Montreal, Canada, April 1999.

30. Pew Internet Society and American Life Project. *Digital Divide,* 2005.

31. Smith, G., Morey, J., & Tjoe, E. "Feature Masking in Computer Game Promotes Visual Imagery." *Journal of Educational Computing Research* 36, no. 3 (2007): 351-372.

32. Small, G. & Vorgan, G. *iBrain: Surviving the Technological Alteration of the Modern Mind*, 2008.

33. Rieber, L. "A Historical Review of Visualization in Human Cognition." *Educational Technology Research and Development* 43, no. 1 (1995): 45-56.

34. Levine, A. "Waiting for the Transformation." *Education Week* 28, no. 2 (2009); Groff, J. "Transforming the Systems of Public Education." Nellie Mae Education, 2009.

35. McKim, R. *Experiences in Visual Thinking*. California: Brooks/Cole Publishing Company, 1972.

36. Bell, N. "The Role of Imagery and Verbal Processing." Presentation for the M.I.N.D. Institute Lecture Series on Neurodevelopmental Disorders. (2008), <http://www.youtube.com/watch?v=tarroahIHks>.

37. For a deeper examination of the reasoning behind the critical need for developing skills in visualization and guided imagery in education, see Drake (1996) who offers an extensive review of the discourse in psychology, philosophy, and education: Drake, S. "Guided Imagery and Education: Theory, Practice and Experience." *Journal of Mental Imagery* 20, nos. 1-2 (1996): 1-164.

38. I am purposefully framing "whole-mindedness" as a term to refer to the aforementioned capacity and approach to human development. While this word has been used in a casual context as a colloquial reference to the notion of being both "left-brained" and "right-brained," cognitive science generally considers this a false view of brain capacities. Rather I seek to use it as a professional term, specifically defined, supported by sound research.

39. Grandin, T. *Thinking in Pictures: And Other Reports from My Life with Autism*. New York: Doubleday, 1995.

40. Snyder, A. & Thomas, M. "Autistic Artists Give Clues to Cognition." *Perception* 26, no. 1 (1997): 93-96.

41. Gardner, H. "Multiple Intelligences." Course video lecture. Cambridge, MA: Harvard Graduate School of Education, (n.d.).

42. Groff, J. "Dimensions of Cognition." Unpublished Master's thesis. Cambridge, MA: Harvard Graduate School of Education, (n.d.).

43. Jewitt, C. "The Visual in Learning and Creativity: A Review of the Literature." Internal report for Creative Partnerships, 2008, <http://www.creative-partnerships.com/data/files/the-visual-in-learning-and-creativity-168.pdf>: 13.

44. Fougnie, D. & Marois, R. "Evidence from Attentive Tracking and Visual Working Memory Paradigms." *Psychological Science* 17, no. 6 (2006): 526-534.

45. Naghshineh, S., Hafler, J., Miller, A., Blanco, M., Lipsitz, A., Dubroff, R., Khoshbin, S., & Katz, J. "Formal Art Observation Training Improves Medical Students' Visual Diagnostic Skills." *Journal of General Internal Medicine* 23, no. 7 (2008): 991-997.

46. Housen, A. "Aesthetic Thought, Critical Thinking and Transfer." *Arts and Learning Research Journal*, 18 (2002): 99–132; Housen, A. "Validating a Measure of Aesthetic Development for Museums and Schools." *ILVS Review: A Journal of Visitor Behavior* 2 (1992): 213–237; Yenawine, P. "Thoughts on Visual Literacy," in Flood, J., Heath, S., & Lapp, D. (Eds.) *Handbook of Research on Teaching Literacy Through the Communicative Visual Arts*. New York, NY: MacMillan Library Reference, 1997: 845–860.

47. To learn more about Artis, see <http://www.artiseducation.com>.

48. For more on this, see Kress, G. & van Leeuwen, T. *Multimodal Discourses: The Modes and Media of Contemporary Communication*. New York: Oxford University Press, 2001; Mills, K. 2008. "Multiliteracies and a Metalanguage for the Moving Image: Multimodal Analysis of a Claymation Movie." Paper presented at the *AARE* 2008 International Educational Research Conference, Queensland University of Technology, Brisbane, November 30-December 4, 2008.

49. For an example, see <http://bjornson.inhb.de/?p=55>.

50. See <http://education.mit.edu/starlogo and http://scratch.mit.edu>.

51. The New Media Literacies Project gives a strong foundation as to why, and how, our paradigm of "literacy" is shifting in the 21st century due to digital technologies.

52. Mayer, R. "Learning with Technology," in OECD (Ed.) *The Nature of Learning: Using Research to Inspire Practice*. Paris, France: OECD, 2010.

53. Helmrich, B. "Window of Opportunity? Adolescence, Music, and Algebra." *Journal of Adolescent Research* 25, no. 4 (2010): 557-577.

The New Fundamentals:
Introducing Computation Into Arts Education

Kylie Peppler
Indiana University

Given the advent of digital experimentation in the arts, this chapter conceptualizes the role that media arts can play in educational settings by looking to the ways that professional artists manipulate digital media. This chapter argues that learning to creatively code constitutes the new fundamentals of arts education in a digital world. The chapter presents a survey of contemporary projects that use computation as a way to manipulate the medium of the computer, outlines core programming concepts for the novice reader, and showcases what inner-city youth are already creating through the use of computer programming.

The arts are incorporating new domains and artistic genres at impressive speeds, enabled largely by contemporary artists' use of new digital technologies as tools for communication, distribution, and creativity—constituting a field that might be broadly described as the new media arts or digital arts. With the advent of digital experimentation in the arts, new technologies are increasingly being introduced in higher education as well as K-12 arts classrooms. As a sign of the times, large schooling districts like Los Angeles Unified Schooling District (LAUSD) are already adopting media arts as a new official content area. However, current proposals for the media arts curriculum do little to teach youth the fundamentals of the new emerging field—instead focusing on introducing youth to video, sound, and image editing. While manipulating digital media is important, current proposals largely overlook the role of computation or computer programming in the K-12 media arts curriculum. By contrast, post-

secondary media arts programs allot a great deal of time to learning about computer programming, considering it one of the core fundamentals of expression in digital media.

This chapter conceptualizes the role that media arts can play in educational settings, looking to the ways that professional artists utilize digital media and the methods of preparation that can be used to foster related skills in K-12 classrooms. Specifically, the practice of manipulating the computer through the act of programming deserves special attention. Often perceived as a narrowly technical skill with applications only to math and science, the ability to computer program is a fundamental proficiency of today's media artists, many of which use programming languages—artificial languages, like Java, C++, Processing, or Arduino, designed to control the medium of the computer—to creatively code unique and expressive work. Additionally, as evidenced by burgeoning online communities of tween/teen game designers, animators, and digital artists, learning to code creatively is becoming to today's generation what learning to read and write was to those growing up in the 20th Century. This type of creativity with technology is at the core of what media artists are able to do with new media and can, and should, be made accessible to even the youngest media artists.

This chapter argues that learning to creatively code constitutes one of the new fundamentals of arts education in a digital world. As evidence, a survey of contemporary tools and youth-designed projects is presented here that use computation as a way to manipulate the medium of the computer, followed by an outline of core programming concepts for the novice reader with examples of how a group of inner-city youth among others are already creating their own software and tools in much the same way that professional media artists go about this task—through the use of computer programming. This chapter further uses examples from youth engaged in one particular media arts software, Scratch, as a way of illustrating the vital role of computation in new media.[1] While several tools exist to help young artists learn to creatively code, including Alice, Logo, StarLogo TNG, and others, this chapter focuses on Scratch because of its widespread popularity and its use in and outside of the schooling system, making it a tool that is amenable to communities interested in learning to creatively code for the first time. Scratch is a media-rich programming environment that allows young designers to learn and use essential programming skills while also learning how to expressively manipulate the medium of the computer.[2] Furthermore, Scratch is one of the few tools that allows designers to pull in almost any image or sound file into a project, which presents strong

opportunities to connect to youth's cultural interests as well as opens up their artistic palette for a greater degree of expression.

The New Media Arts: An Introduction

Art that makes use of electronic equipment, computation, and new communication technologies comprises the emergent field of "media arts" (also called digital arts or new media). Media arts, because it is a new field that is still being defined, can be situated as being distinct from traditional disciplines (such as visual art, music, dance, and theatre) but includes some overlap that arts educators may recognize, such as visual arts, animation, film, and, at times, electronic music. Because of its complex history, the field of media arts shares concepts and terminology with a number of other fields, including the sciences (e.g., gravity, mass, and acceleration), animation (e.g., tweening and motion paths), visual arts (e.g., color, perspective, and shape), and film (e.g., vocal intonation, visual style, and direction).[3,4] In this sense, media arts could be described as a "meta-medium" that spans many different types of artistic practice. Central to most work in new media, however, is the role that computer programming plays in allowing the artist to have a fuller range of control over the artistic product.

Many educators may initially feel as if they need to choose between engaging youth in media arts or traditional arts as the central focus for their arts education programs. Arguably, this is not the case. Conceptually, this tension is important to recognize when designing a K-12 arts education program, suggesting that we don't need to think about replacing traditional arts education or even subsuming some of the goals of the arts to new media, rather to think about media arts and its techniques, skills, and concepts as building on and extending traditional concepts and ideas into a new medium—one that is already highly valued by youth, as evidenced by the proliferation of youths' digital expressions of creativity in online spaces. In fact, media arts at its core is still about pursuing aesthetic sensibilities in a digital medium but controlling other aspects of experience that can only be made possible through computer programming. However, as we begin to incorporate this new discipline into the schooling curriculum, it's important to rethink the K-12 arts education curriculum with particular attention to how we define the foundational practices of the discipline.

Creative Coding

In order to control various aspects of the interactive medium of the computer, artists have turned to applications that allow them to manipulate

the medium of the computer. While a large number of programming tools have been around since the inception of the computer, few of these environments have traditionally appealed to the visual artist. This has been in part because prior languages were difficult for novices to learn and because they did not appeal to the visual nature of artists. As a result, media artists have introduced new tools into the landscape that have reshaped the fundamentals of artistic practices in new media. Computer programming, in this context, is another tool that has been added to the palette for artists. In the milieu of media arts, learning to computer program is often an important component of becoming "software literate" or having the ability to create novel user interfaces with the computer. Media artist Casey Reas argues, "software is the medium that controls this flow of bits traversing the air and surface of our planet. Understanding software and its impact on culture is a basis for understanding and contributing to contemporary society."[5] And, yet, this capability is controlled by the few who understand and use programming languages to design software. Using the societal implications of widespread literacy (in the traditional form of reading and writing), Reas argues for the potential of technological literacy on a societal scale, and the reasons why programming should be a central component of media arts education today.[6] This overlaps with what researcher, Brian Smith would describe as "computational flexibility."[7] Being computationally flexible builds upon literate practices involving knowing how to use computationally rich software (e.g., word processors, spreadsheets, and presentation tools) as well as develop fluency (i.e., knowing how and why existing tools do not meet current needs), but extends this to include the ability to create the tools that one can otherwise only imagine. This type of creativity with technology is at the core of what media artists are able to do with new media.

Much of the practice of computer programming in the context of the arts begins with an intention (be it visual, audio, gestural, or interactional) and then seeking out commands or groups of commands that help to realize this idea, often letting the two co-evolve. This stands in stark contrast to the way many computer science classes are typically taught, where new programming commands are presented in the contexts of math or science problems that are introduced by the instructor. While most popular conceptions of computer programming involve users typing lines of equations and formulae onto an empty screen, numerous visual programming languages scaffold the programming environment with graphical interfaces that assist in choice-making and debugging. Especially considering the development of visual programming environments, youth don't need to gain an in-depth proficiency in computer programming before they can produce

media art for the first time. The field has produced several shortcut tools that allow youth (and adults alike) to use programming concepts such as loops, conditionals, data types, and numerical representations in a way that is more conducive to visual artists and novice programmers.[8] There are a host of new tools available in today's landscape to aid artists of all ages in producing media art. One such popular tool is Processing, created by Ben Fry and Casey Reas. Processing is an open-source programming language and environment for people who want to program images, animation, and interactions. It is used by students, artists, designers, researchers, and hobbyists for learning, prototyping, and production. Processing was created to teach the fundamentals of computer programming within a visual context and to serve as a software sketchbook and professional production tool. Other popular programming environments, like Arduino, enable users to create programs on a computer to facilitate interaction with an external object, like a robot or a machine, for those that wish to take digital media beyond the screen. While these tools target professional artists and the DIY crowd, other tools are available that are more amenable to the K-12 context, including Alice, LEGO Mindstorms, and StarLogo TNG, amongst others.[9]

The technology in focus here, Scratch, represents a particularly engaging medium for K-12 programmers. Due to its media-rich capabilities and novice-friendly design, Scratch has the potential to impact youths' arts learning in a number of ways. Additional incentive to examine the use of Scratch more closely concerns the program's immense popularity in both in-school and out-of-school settings. Translated into 50 languages, as of mid-2010 over a million Scratch projects have been uploaded to the www. scratch.mit.edu community by over 500,000 members. Scratch is the only programming language to utilize a building block command structure, saving users the burden of memorizing bits of code to program and instead providing several pages of commands that users drag to a central screen to control objects or characters.[10] Being a media-rich environment, objects can include any graphic image either created in the program's paint editor or imported from a file. Designers can also incorporate existing sound or video files, as well as integrate other input/output devices into new design projects. Youths' projects run the gamut of incarnations, from art objects to animated stories. These projects can run uninterrupted in their entirety (e.g., like a music video) or can require the user to interact with the pieces through keystrokes (e.g., like a videogame).

Many of the widely available tools used to introduce programming concepts to youth tend to only allow creators a limited number of choices in their creations, placing restrictions on the amount of creativity and

flexibility afforded by the software. This "platform approach" to media art making restricts youth unnecessarily. By contrast, this chapter's interest is in advocating software that allows for a great deal of flexibility, enabling users to express themselves in a wide variety of modalities even when basic rules of coding apply across all modes.

Figure 19.1: Full screenshot of the media arts programming environment, *Scratch*.

To illustrate how coding can begin to take on various creative forms, a range of projects are presented below, including an interactive dance video, videogame, and animated art. This work was created within the context of a design studio found within the Computer Clubhouse community in South Los Angeles.[11] The Computer Clubhouse is a community technology center that moves beyond notions of a computer lab to engage youth in an after-school digital arts studio setting where youth can use applications that encourage skills beyond typing and web browsing, allowing participants to more deeply invest in the process of designing and critiquing their work. The data presented here was collected as part of a three-year ethnographic study researching literacy and learning in the media arts practices of urban youth.

Making Interactive Art, Dance Videos, and Lowriders Using Creative Code

To help dispel the myth that harnessing the medium of the computer using tools like those described above would be inaccessible to all but top-level students, the projects examined here were made by a mix of young artists varying in age, gender, and ability. The range of expertise demonstrated in the coding underscores that users along the programming spectrum can not only create personally meaningful work using technology that accommodates varied ability levels, but that those rewards can even be realized early on in the process. Across these cases, however, all young designers utilized programming in service of realizing a higher aesthetic aim, demonstrating youths' envisioning of computation as a type of tool at an artist's disposal and not merely a computer science exercise.

Figure 19.2: Screenshot of Brandy's project, "Ranbow."

A case in point can be found in a piece of media artwork created by an emergent reader and writer named Brandy who was 9 years-old.[12] Brandy created the piece, titled "Ranbow" [*sic*], over the course of a couple of days. Interestingly, Brandy, a special education student, learned to computer program before she learned to read and write, relying on a combination of mentor support and self-guided help resources to assist in her navigation of the programming environment.[13] "Ranbow" features a picture of an eight

ball, a toaster, flowers, and a clip art image of berries all on a plain white backdrop (see Figure 19.2). At the click of a button, the images change colors at dizzying speeds. This piece was intended to be a birthday card for the artist's cousin and is particularly interesting because, though the designer was unable to read or write, she was able to successfully tie together several different modes of communication (images and animation) in order to create a personally meaningful and expressive project using a visual programming language. While she had pulled together several images that were a collection of memories and objects shared with her cousin, she extended the expressive capabilities of the art work beyond those of a static collage by using programming commands to animate the onscreen objects—this was in an effort, so said the artist, to make the piece seem like a "party."[14]

"Ranbow" illustrates what Mitchel Resnick would call the "low floors" of learning to creatively code.[15] Resnick argues that design tools that allow for novice users to create something for the first time have "low floors," making it accessible to even the most novice user. He also argues that flexible software also allows for a wide variety of project genres (i.e., "wide walls") as well as "high ceilings" for youth wanting to push the upper boundaries of the medium. These are the type of attributes that we should look for in the 21st century arts classroom to allow the greatest degree of expression for a wide spectrum of abilities—following much in the tradition of tools like paints, clay, and other media that have similar properties.

Figure 19.3 features a work of a 15 year-old Latina named Alejandra titled "M-Seventeen2." In the creation of this media art "dance video," Alejandra extended the mechanics of stop-action animation into a digital realm, as well as explores user interactivity in addition to synchronization between audio and image. Her piece features a highly stylized self-portrait that can either be controlled by the keystrokes of the viewer, or made to dance automatically in a pre-programmed series of gestures that move in time with an imported song, "Asereje" by Las Ketchup. "M-Seventeen2," with its vast collection of over 25 hand-drawn images created in the program's paint editor (as seen in the "costumes" column of Figure 19.3), represents a more comprehensive combination of skills pulled from traditional arts (drawing), film (synchronization), as well as computer science (interactivity). Alejandra's project ties together bits of code with visual images so that the two seamlessly fit together. Additionally, she included two major branches in the logic flow, enabling the viewer to experience the art piece by either passively watching the pre-programmed animation sequence, or taking control of the keyboard to create their own sequence of "dance steps."

Figure 19.3: Screenshot of "M-Seventeen2" by Alejandra.

Beyond developing the ability to computer program, through the creation of this work, Alejandra learned about several aspects of digital media production, such as stop-action animation, in the aim of creating a realistic depiction of dance. The process of shaping this piece within a computer programming environment helped develop Alejandra's ability to sequence movement and separate this into individual steps. Learning to animate pushes youth to think about and abstractly model their perceptions of events, mostly with the goal of making them seem more realistic. Alejandra learned to render a single image as well as how to combine these images to simulate movement and gesture, each informing the other in a cyclical process of trial and error.

The next project, titled "lo-rida" by Alberto, a 12 year-old Latino male, is an example of a genre of the interactive art projects that originated at this site. Perhaps most importantly, the media-rich aspects of the Scratch technology fueled the cultural significance of the genre for this community of largely African-American and Latino youth. Inspired by the customized cars principally associated with the Mexican-American community (and made popular nationwide by media representations, such as MTV's *Pimp My Ride*), designers would import their favorite images of lowrider cars into their projects, and customize them through paint editing and animation (coding).[16] Alberto's "lo-rida" project depicts a lowrider racecar in front of a

city skyline. In this project, the artist has created a degree of interactivity by allowing the hydraulics of the car to be controlled by the viewer's pressing of the arrow keys (see Figure 19.4).

Figure 19.4: Screenshot of "lo-rida" by Alberto.

Representing a mix of genres (perhaps of videogames, lowrider cars, and cartoons) that are interactive (by requiring the viewer to operate the hydraulics in most cases, similar to games or web-based art), performative (as showcasing one's lowrider project within the community is particularly important), and artistic (as each member strives to customize their project), the lowrider arsenal of projects were seen within the youth community as meaningful, viable modes of expression that are inextricably linked to the designers' out-of-school identities. This type of mixing of the local context into new, interactive digital media creates new genres of work. Lowriders, pulling from the history of the car customization movement, represent a conscientious and literate practice that stands in opposition to the pressure to assimilate into the American mainstream culture. As educators plan to include a wider variety of genres in the arts education curriculum, it becomes important to question whose genres are being included and excluded in the curriculum. Rather than deciding on this *a priori*, creative production provides an exciting opportunity for youth to share out-of-school literacy practices with media educators so that these practices can

be leveraged to meet the larger goals of education. Additionally, media-rich computer programming tools allow youth to invent their own genres of work rather than confine them to particular project types.

YOUTH REFLECTIONS ON THEIR MEDIA ART PRACTICES

While it's clearly demonstrated above that youth exhibited a range of expressionate potential through their use of Scratch, we turn to a series of interviews with the Clubhouse youth to determine where they would situate their work in Scratch within the range of their prior academic and/or artistic experiences.[17] When asked whether creating media art in Scratch reminded the youth of anything at school, all of the youth said it was at least like one subject matter, and most cited more than one subject that they thought connected to their experiences. Overwhelmingly, youth associated their experiences in Scratch with their prior arts education experience, followed by language arts, and then far fewer with their experiences in mathematics, science, and computer class. When probed further about the connections to which art forms, youth cited a variety of answers, including drawing or sculpture, drama, dance, and music. The connections that youth made in all subject areas seemed to be dependent upon the extent of their experience in each subject area or art form. Further, when asked, "if Scratch had to be something not on the computer, what would it be?" the most common response was "paper" or "a sketchbook" because Scratch allows one to "do anything that you want with it, just like paper."[18] Based on these insights, it appears that youth, while making connections to subject areas across the curriculum, see their work most in line with the arts—creating a natural home for this type of computer programming work. This is a thought-provoking finding given that, at face value, youth could be seen as merely learning to computer program and/or mixing existing media—areas that might be most well suited for computer science or media education courses. Instead, youth who engaged in computer programming saw themselves as artists, demonstrating the creative and communicative potential that work in a digital domain can have given the appropriate tools. Furthermore, most youth did not see their programming experiences as being connected at all to computer classes. This underscores the differences between media art making and narrowly technical experiences that the youth had in their computer classes, such as typing and direct instruction on word processing, digital presentation, and spreadsheet tools.

THE NEW FUNDAMENTALS

When we step back and examine the curriculum of prestigious post-

secondary programs in media arts, we begin to see that the courses spend approximately 1/3 of their time on computer programming, 1/3 on traditional visual aesthetics, and 1/3 on the intersection of programming of aesthetic design. This ratio represents a guiding proportion for arts educators, one that emphasizes cultivating aesthetic awareness in addition to introducing a new fundamental of arts education, media arts—where programming (and not just digital media manipulation) plays a leading role. Learning to computer program in the context of the arts has a number of advantages, including moving away from the narrowly technical approach to computer programming to emphasizing the means or ends of programming to create a particular effect. Some, however, may question whether youth engaged in media art making will be learning the fundamentals of computer programming while engaging in tools like Scratch. Prior research, however, indicates that youth intuitively learn the "big ideas" of computer programming through media art making in Scratch over time and without explicit instruction.[19] The big ideas or fundamentals of programming concepts that confront every Scratch user when they begin writing scripts include: User Interaction (use of keyboard or mouse input), Loops, Conditional Statements, Communication and Synchronization (*broadcast* and *when-receive*), Boolean Logic (*and, or,* and *not*), Variables, and Random Numbers. For example, in the projects described above, youth utilized user interaction whenever they asked the viewer to press a key to initiate an action (e.g., key presses to control the hydraulics on the lowrider) and/or utilized loops when there were repeated actions (e.g., a quick sequence of colors to create a flashing effect in the Ranbow project). It's important to note that, in the current approach, youth utilized certain commands in service of the larger needs of their project and they gave their onscreen objects "powers" that they wouldn't otherwise have on paper. The youth became interested in meaningfully manipulating the code to create the desired effect—not to learn programming as an ends of itself.

To give the reader a better idea of how these fundamental programming concepts are manifested in Scratch, we can further analyze the use of command blocks in any particular project. For example, Figure 18.5 shows a script from a simple paddle game in which a ball falls from a random place along the top of the stage and must be caught by a paddle controlled by the mouse. This script uses the concepts of sequential control flow, a loop, conditional statements, variables, and random numbers. The overall game also uses the concepts of user interaction (the paddle tracks the x position of the mouse) and threads (the paddle has its own script that runs in parallel with the ball script). Over time, youth even in informal learning

environments begin to use a larger number of programming commands as they seek to further control their on-screen objects. In the context of media arts, it's less important that youth can name such programming constructs but that they can use them in the context of their own work.

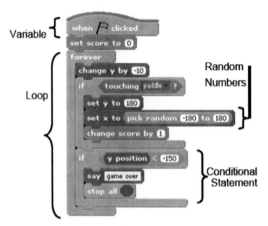

Figure 19.5: Scratch script for a ball in a simple paddle game.

There are, additionally, instrumental and intrinsic benefits of creative coding. The instrumental benefits are the ways in which students transfer what they learn through using programs like Scratch into other domains or life skills. The intrinsic benefits of creative coding describe the benefits of learning to creatively code in and of itself. For the art educator wanting to incorporate creative coding into their arts curriculum, it is important to (a) have software like those mentioned above loaded onto the classroom computers, (b) to become a member of one of these communities and to produce some work, themselves, even at a very novice level, (c) to introduce introductory projects into the curriculum that allow for a great deal of personalization (e.g., a "name" project, where students import letters of their name and use commands to animate each letter in unique ways); and (d) allow longer periods of time for youth to explore this media toward particular ends of their choosing. It has also been demonstrated in prior research that youth have access to popular media that can be incorporated in their projects, as it is key to prolonged engagement in projects across the spectrum of ages. This also connects art educators to the visual culture curriculum.

CONCLUSION

The advantages of this emphasis on the new fundamentals are at least

twofold: (1) computer programming is an essential component to artistic expression in a digital era—a tool that has an arguably increasing importance for youth and society at large; and (2) media art projects emphasize graphic, music, and video—media at the core of youths' technological interests—and thus could provide new opportunities to broaden participation of under-represented groups in the design and invention of new technologies.

Additionally, there are several reasons why arts educators, in particular, should be interested in the incorporation of the field of media arts into the schooling curriculum. Among others, current conceptions of schooling envision new technologies being integrated across the curriculum in all K-12 school subject areas in order to keep up with the demands of preparing youth for the 21st century. Rather, it is important to argue for an expansion of the curriculum to include teaching youth how to work with new technologies as an expressive medium, becoming software literate, and enabling youth to produce new tools and modes of communication. The arts perspective on new technologies is unique in the schooling landscape. Other curricula, such as technology or computer courses, have the tendency to focus on narrowly technical activities. Creative coding, on the other hand, offers an opportunity for youth to explore the full potential of the computer as an artistic medium and consider the implications of learning to communicate in a time when multimodal discourse is becoming increasingly important. Accordingly, the study holds implications for informing policy by placing central the need for arts in today's schools. In light of the increased mediation of our society, many feel that there is an urgent need for arts education to develop youths' ability to be critical about the messages that they receive and transmit. This study encourages and informs policy aimed at meeting technology fluency and creative thinking goals by emphasizing the critical role of producing one's own media texts in any arts education program.

Schools, then, can play an important role in this new landscape, as they are poised to address the limitations of ongoing free play in the after-school hours. Within schools there is an opportunity to systematically introduce core media arts concepts and go into greater depth that otherwise is not possible within after-school spaces. While youth make important discoveries through unstructured learning experiences like those fostered at the Computer Clubhouse, such environments are carefully constructed and are reliant on the availability of high-quality interactions with adults or more expert peers, which are oftentimes scarce resources. Arts educators, by contrast, can reliably provide access to high-quality dialogues during critiques with youth engaging in digital media, and potentially go into greater depth into a media arts curriculum. For educators fearing that the

tools required to produce media art require too much training before any real projects can be realized, learning to computer program within the context of media arts does not necessarily involve an extensive and time-consuming introduction and many helpful resources already exist that can be easily leveraged in the classroom. It's important to note that these efforts in introducing creative coding into the context of arts education are not geared towards replacing the traditional arts or turning all youth into programmers. Rather, learning the language of creative coding is essential to communicate in a digital age.

Join the Conversation

Contribute to a dialogue pertaining to the concepts discussed in this chapter by directing your web browser to the following URL:
http://www.20UNDER40.org/chapters/chapter-19/

NOTES:

1. Resnick, M., Maloney, J., Hernández, A. M., Rusk, N., Eastmond, E., Brennan, K., Millner, A. D., Rosenbaum, E., Silver, J., Silverman, B., & Kafai, Y. B. "Scratch: Programming for Everyone." *Communications of the ACM*, (forthcoming). The Scratch community was awarded the Eliot Pearson Award for Excellence in Children's Media in 2008, an Honorable Mention for the Scratch Community in the 2008 Prix Ars Electronica Competition, and the Kids@Play award for Best Informal Learning Experience in 2009.
2. Maloney, J., Peppler, K., Kafai, Y. B., Resnick, M., Rusk, N. *Programming by Choice: Urban Youth Learning Programming with Scratch*, (March, 2008). Proceedings published by the ACM Special Interest Group on Computer Science Education, Portland, OR.
3. Nalven, J., & Jarvis, J. *Going Digital: The Practice and Vision of Digital Artists*. Boston, MA: Thomson Course Technology, 2005; Paul, C. *Digital Art*. New York, NY: Thames & Hudson, 2003.
4. Ibid.
5. Reas, C. "Processing: Programming for the Media Arts." *AI & Society* 20, no. 4 (2006): 526-538.
6. Ibid; Reas, C. "Media Literacy: Twenty-First Century Arts Education." *AI & Society* 20, no. 4 (2006): 444-445.
7. Smith, B. K. "Design and Computational Flexibility." *Digital Creativity* 17, no. 2 (2006): 65-72.
8. Maeda, J. *Design By Numbers*. Cambridge: The MIT Press, 1999; Maeda, J. *Creative Code*. New York: Thames & Hudson Inc., 2004; Reas, C. "Processing: Programming for the Media Arts." *AI & Society* 20, no. 4 (2006): 526-538; Resnick, M., Maloney, J., Hernández, A. M., Rusk, N., Eastmond, E., Brennan, K., Millner, A. D., Rosenbaum, E., Silver, J., Silverman, B., & Kafai, Y. B. *Scratch: Programming for Everyone*, (forthcoming).

9. For a complete history see Kafai, Y. B. "Constructionism," in K. Sawyer (Ed.), *Cambridge Handbook of the Learning Sciences*. Cambridge, MA: Cambridge University Press, 2006.

10. Guzdial, M. "Programming Environments for Novices," in Fincher, S. & Petre, M. (Eds.) *Computer Science Education Research*. London, UK: Taylor & Francis Group, plc., 2004: 127-154; Resnick, M., Maloney, J., Hernández, A. M., Rusk, N., Eastmond, E., Brennan, K., Millner, A. D., Rosenbaum, E., Silver, J., Silverman, B., & Kafai, Y. B. *Scratch: Programming for Everyone*, (forthcoming).

11. Kafai, Y.B., Peppler, K., & Chapman, R. (Eds.) *The Computer Clubhouse: Creativity and Constructionism in Youth Communities*. New York, NY: Teachers College Press, 2009.

12. Pseudonyms are used for all youth mentioned throughout this chapter.

13. Peppler, K. & Warschauer, M. "Lessons from Brandy: Creative Media Production by a Child with Cognitive (Dis)Abilities." Paper presentation at the American Educational Research Association (AERA) Annual Meeting, Denver, CO, April 30-May 4, 2010.

14. Ibid.

15. Resnick, M., Kafai, Y., & Maeda, J. "ITR: A Networked, Media-Rich Programming Environment to Enhance Technological Fluency at After-School Centers in Economically Disadvantaged Communities." Proposal submitted to National Science Foundation, 2003.

16. See Cowan 2004 for a fuller account of its emergence amongst migrant workers during World War II; Cowan, P. "Devils or Angels: Literacy and Discourse in Lowrider Culture," in Mahiri, J. (Ed.), *What They Don't Learn in School: Literacy in the Lives of Urban Youth*. Oxford & N.Y.: Peter Lang Publishing Company, 2004: 47-74.

17. Peppler, K. "Media Arts: Arts Education for a Digital Age." *Teachers College Record* 112, no. 8 (2010).

18. Maloney, J., Peppler, K., Kafai, Y. B., Resnick, M., & Rusk, N. *Programming by Choice: Urban Youth Learning Programming with Scratch*, 2008.

19. Ibid.

Handprint Turkeys and the Cotton Ball Snowman: Is There Hope For an Artful America?

Bridget Matros
Boston Children's Museum

In this chapter the author takes a critical look at what's going on amidst the pom-poms and glitter glue of pre-school arts and crafts and points to implications for individuals and the arts at large. Drawing on experience as a children's museum visual arts educator, the author cites problematic practices and beliefs held by arts-phobic parents and teachers and provides practical examples of what can be done to nurture creativity during the often overlooked and undervalued period of early learning. Ultimately, the author argues that educating and empowering parents, caretakers, and teachers to support creative development during early childhood is an essential strategy to impact more children with a wider set of benefits than arts programs alone provide. She contends that this early intervention would additionally prime learners for arts enrichment in later years—ensuring fertile grounds for a generation that grows up fluent in, comfortable with, and expectant of the arts in all forms in their communities.

INTRODUCTION

One might see finger-pointing at craft projects in early learning settings as gratuitous snobbery. Make no mistake, my realm is one of crayons and glue sticks, and I'm surely unqualified as an elitist in any arts discipline. I claim only to be a well-positioned observer who has discovered and watched a glaring disconnect for so long that I finally have to step into the arts-advocacy ring and sound an alarm—hopefully for the benefit of both the

field of arts advocacy and its constituents—society at large. My intention is to share an insider's view of what kids are learning (and unlearning) about creativity and art before kindergarten, and to shed light on how the situation creates an uphill battle for individuals working towards an arts-rich culture. I'll do a bit of theoretical connect-the-dots, explain myself by sharing (in gory detail) my experiences with families and teachers of young children during my time at Boston Children's Museum (BCM), and just when the picture becomes horrendously bleak, I'll offer some simple suggestions on how we can change the status quo for the better.

What Is It You People Want, and Why Isn't It Working?

I presume that the *big-picture* goal for arts advocates is a cultural shift where the days of arts-in-the-margins are over—the art-cart would be an extinct species. The middle school field trip to the theatre would not be such a foreign experience that the kids would remember only "the dude in tights." Our love for music would be reflected in an abundance of live performances by and for everyone, in schools, at home, and in public. Cities and suburbs would be more beautiful, not only infused with public art, but also architecturally, as aesthetically aware tax-payers reject ugly buildings and foreboding environments with the same enthusiasm that small towns crack down on neon signs on Main Street. People of all ages would dance. In public. In broad daylight. For fun. The outer world would reflect the inner world of individuals who never had the artist within extinguished at an early age. Not to mention, our economy would reap the benefits of a more creative populace, having regained footing as globally competitive innovators.

Details aside, if you're with me on the above as some kind of ultimate goal, indulge me in a metaphor I'll be using to illustrate my take on early childhood, creativity, and the roles of adults both in and outside of the arts advocacy field. Visualize this dreamy cultural vista as a lush, magnificent garden, overflowing its boundaries and teeming with infinite diversity: hardy plants that weather the seasons, fragile flowers that flourish with heedful watering, new species of flora proliferating. Like the rain forest, growth evolves to sustain itself over time—roots to canopy.

We don't have that.

We have every ounce of *potential* for that, in the form of tens of thousands of seeds in the soil (I'm talking about babies, here), just waiting to sprout into who-knows what. Some water, some light, nutrient-rich soil, and *voila*: seedlings joyfully pronouncing themselves to the world everyday, each with unique characteristics to be witnessed and tended.

In the following pages I share my opinions on why we *don't* get from fertile soil to the uber-garden of our dreams.

Art for At-Risk Kids vs. Supporting the At-Risk Artist in Every Kid

It's hard to argue with the well-known quote attributed to Picasso: "Every child is born an artist. The problem is how to remain an artist once we grow up." The how-to question is most often answered with bringing experiential arts programs to kids in school, afterschool, and in community centers. As a teaching artist myself, I know first-hand how transformative this work is for the participants and the environments we work in. However, *this supplemental approach is not enough*— at least not for young children whose creatively-challenged-adult influences vastly outnumber their weekly "artist-friend." The programs-delivery approach may bring joy, expressivity, self-esteem, and arts-specific skills and awareness to beneficiaries, but it falls short of cultivating the long-term habits of mind and creative capacities advocates claim the arts provide.[1]

A second disadvantage of program-delivery is that with limited resources to go around, there can only be so many programs. With all the initiatives resources will allow, the majority of kids desperately in need of "the lessons the arts teach" simply won't get more than fleeting access to arts programs in school or otherwise.[2]

The last and most critical shortcoming of current arts interventions is that they come too late: *the vast majority of arts funding and programming is directed at grades K-12.*[3] By neglecting early childhood, arts advocates are actually *creating* a deficit with one hand while struggling to repair it with the other. By refocusing resources toward early creative development, we would be tending to the arts *in* young (pre-school) children, before there is a deficit to be filled. This shift toward *preserving* the creative being in every child, versus *rehabilitating* the artist in a few, is the golden opportunity to "save" Picasso's proverbial artist-child.

Creative Development—Tilling Soil, Protecting the Roots

When I say "creative development," I'm referring to the *pre-school*, constructive development of motor skills, perception, cognition of cause and effect, and familiarity with the properties of materials, as well as a sense of efficacy, self-acceptance, and safety when making choices and expressive gestures. Constructivist learning theory tells us that young children explore, discover, and build on what is known in sequential steps—one can't skip over a period of mostly self-directed skill building and expect a child to make up for it later, no matter how gifted Johnnie is.[4]

Some of the hallmarks of this preparatory period are mastering efficient ways of holding different tools, discovering the effects of different "moves" with different materials (swishing versus stabbing with a paintbrush), and the widely studied, universal evolution of scribbling.[5] Behavioral tendencies such as curiosity and exploring materials with all of the senses (glue eating included) and choosing colors and materials out of general interest (versus choosing with a preconceived product in mind) are also a part of this critical period. These are all building blocks for later use of materials with communicative or expressive intention, or "art making," as I define it.[6]

We need to focus on helping adults get this stage of development right, not only as "first-stage arts intervention." The emphasis on *developing creativity* versus a focus on delivering arts programs has effects across a wider range of activity than just the arts. Investing in creative development also has the potential of reaching many more children, as a shift in approach all adults can manage, versus programming not everyone can secure or pull off themselves.

Or, we could keep on doing what we're doing: non-creatives producing more non-creatives by the millions, while the Arts People toil desperately alongside to change an arts-resistant/arts illiterate/art-phobic culture. Without addressing the issue at the roots, these efforts are unsustainable and the big-picture goals unachievable. In other words, we're transplanting flowers into spoiled soil. It may make for a prettier view in the short term, but a ground-level perspective reveals the potential that's getting trampled in the wake of botched creative development. I'd like to share some of my day-to-day experiences to illustrate my view that the harrowing death knell to the Arts is not "we don't have funds to continue these programs," but rather, "draw a pretty flower for Mommy."

CONSTITUENCY REALITY-CHECK: OBSERVATIONS FROM THE LAB

Children's museums are designed for learning-by-doing, specifically through play. Exhibits range from spaces devoted entirely to playing with bubbles, to kid-sized ethnic grocery stores. As an educator at BCM, one of the country's largest and most renowned children's museums, I create informal educational experiences that need to work for large numbers of families (the museum hosts 2,000 people on an average summer day) from a wide range of backgrounds. Most children that visit with their families are under the age of five; older children come on school or camp field trips. All of them are accompanied by adults, and the museum's exhibits and programs are designed with adult-child interaction ("family learning") in mind. Given the kinetic energy and size of the place, people

are often zipping around with very short attention spans, hoping to see the whole museum before naptime hits. Amidst these challenges, I engineer meaningful experiences based on my observations of everything from visitors' responses to environments to what beliefs and habits they walk in the door with. My piece of the museum's mission: *supporting the "Creative Kid" in every child.*

Boston Children's Museum formalized their commitment to the arts in 2001 by adding a visual arts department to its existing science and culture programs. When my colleague and I were hired to create the program, we had lofty ideas about what art education at BCM would look like. Our first order of business was to reject the museum's suggestion that we facilitate themed crafts, and so we began our job of schooling the institution itself on art-for-art's-sake—an interesting bump in the road, but not a huge deal. What really caught us off guard was discovering our opponent: *adults' fear of art making.* The two of us stood waiting in our aprons with jars of paint, brand new brushes, and giant pieces of paper while parents literally pulled their children past the Art Studio door way:

"No, we can color at home."

"We're not artistic types."

"No thanks—I'll wait out here!"

We made the assumption that "everyone loves art" and that our space would be an instant hit. Instead, many parents saw the clearly-labeled Art Studio as powerfully intimidating. One could literally watch pairs of visitors respond to the space—the little person would pull toward the door, and the big person attached would pull back. Our arts-education goals collapsed to one very simple bottom line: give our visitors, kids and grown-ups, a positive experience related to art making. Period.

This follows the model of informal learning at children's museums: while having fun, visitors' ideas are changing and new ones are coming in. In order to create *fun* experiences, across ages, cultures, and subject matter, *one has to meet people where they are.* The kids in the studio, for the most part, were fine. The adults, for the most part, were uncomfortable and therefore unreachable. After much observation, eavesdropping, experimentation, intuition, and conversation, we concluded that in order to replace a negative (or possibly traumatic) association with a positive one, our adult visitors needed to feel relaxed, un-judged, and unpressured. Creating this most basic foundation of safety and comfort for our adult visitors primes them for learning more during later visits to the Art Studio or elsewhere, just as we do for our youngest visitors.

By the end of our first year, the Art Studio was one of our museum-members' favorite features. We had mastered the art of addressing the

fear factor head-on, focusing on (1) the design of the exhibit, literally a "welcoming home" for those adults so long estranged from their creativity, featuring a cheerful house-façade complete with picket fence, large open doors, and windows revealing a sunlit interior bedecked with houseplants and cozy furniture; and (2) facilitation style—a smiling staff person greeting guests with a cache of low-pressure invitations and scripts that keep a step-ahead of every art-fearing or creativity-defeating behavior imaginable. While other museums' family programs delve into art history, learning techniques of "the masters," and sequential classes for kids, we were affirmed that our younger constituents and their mostly non-art-consumer parents and teachers simply needed a "gateway" experience that was process-focused, in a setting where it felt good and comfortable to explore materials.

Reaching our bottom-line goal of getting people in the door and happy, leaving with a mental note that "doing art" was relaxing and fun, the way was paved to meet a secondary goal: *nurturing kids' creativity by modeling supportive behaviors for their parents and teachers.* This approach to family learning makes a lasting impact that reaches beyond museum visits. Children's museums make the most of the rare opportunity to transform parents' beliefs and habits that affect their kids. In this case, we needed to show parents that their children knew exactly what they should be doing (a primary concern of parents in public with their kids) and that the best thing for the adult to do was watch, learn, and enjoy.

We now see members of the museum whose children have grown up with us proudly show off their new habits. Parents gladly accept their own materials and joke about "backing off" and letting their kids do their thing. Satisfied children let their parents know if they want to take their artwork home or leave it behind (satisfied with the process alone). It's gratifying to see these changes in our repeat-visitors. But BCM has approximately 550,000 visitors annually, and only 35% of them are members. The rest are mostly "strangers"—a steady stream of them—allowing us a front-row seat to telling interactions between young children and the influential adults in their lives when presented with creative opportunities—many of them for the first time.

The less-rosy picture one comes away with when focusing on this majority? Between, "Wow, cool! Let's do this!" at the entrance of the Studio and, "I could stay here all day! That was great," departure, we still see a consistent set of unfortunate anti-art behaviors by adult visitors (these include meddling, insulting, and prohibiting), and witness the related effects on children. I'd like to share this rare view into the lives of our constituents; I believe there's a lot going on here that shapes not only the

individuals we hope to reach, but the larger atmosphere in which we work. Especially motivating are the differences among children's experiences and abilities, depending on their parents' or teachers' actions.

CREATIVE DEFICIENCY: SIGNS AND SYMPTOMS

The observation from my time in the field that seems most important to share is the lack of creativity exhibited by most of the adults I interact with, and the cluelessness about what creativity *is,* even by those who *are* creative. Adults who are really uncomfortable around art, art making, and creativity are not just thorns in the sides of some of us "in the business." They show symptoms of a larger cultural condition with widespread implications. I call it a *creative deficiency:* the inability to imagine, to "think out of the box," or to problem solve; a censoring of self-expression, and a lack of confidence in a wide range of activities that truly cannot be done wrong.[7]

My wake-up call to a serious problem for both the arts and for children as healthy beings was my first encounter with art-phobic children *under age four.* We've all seen the mortified adolescent, the shot-down free spirit of a second grader, and even the kindergarten student who has reigned in their exuberant tendencies in exchange for the novelties of rule-following and peer acceptance. All are difficult to behold, but none hold a candle to the sight of a joyful pre-K child who seems to emotionally fold up as materials are offered, their enthusiasm transformed into fear and self-doubt. Some pout and twist into their parents' bodies saying "I can't," while others stare at the materials waiting for further instruction or ask their accompanying adults to "do it for them." When playing games such as "What's This?" (a passed-around egg carton becomes a school bus or a monster mouth), I see children who struggle to imagine. This, to me, is astounding, and gravely problematic. The proverbial uninhibited, imaginative young child so many of us refer to in our work is becoming an endangered species... in some populations.

Look at the creative processes and work produced in the Art Studio for evidence of a worrisome disparity across socio-economic backgrounds. Images produced by most of our American, publicly schooled child visitors when familiar materials are used are limited to a handful of adult-condoned representations.[8] These include: the sailboat, the rainbow, the smiley-face, a single star or heart, the six-petal flower, the square house with triangle roof and chimney on green grass below blue sky (sun in corner), stick figures, and writing one's name (see Figure 20.1).

Figure 20.1: A sample of left-behind paintings accumulated over a month at the Art Studio. Most of the hundreds of representational paintings are limited to three subjects, conveyed in specific, parent-approved formats. You may or may not be able to spot the adult masterpieces among these, serving as examples of what a successful painting looks like to the children they accompany; art has become craft.

So what? There are *infinite possibilities* when combining art materials and young children's imaginations, from things that words simply can't express, to chair-eating creatures with trees in their ears. But with such unpracticed representations and an adult who is sure to confirm failure by asking "what is *that*?" why wouldn't one stick with what consistently gets the thumbs-up? At a very early age, giving a grown-up something they can handle/understand is positively reinforced; in an unspoken lesson, art is a matter of right and wrong just like almost everything else. Most kids in cities have never even *seen* a house like the one they robotically reproduce. That configuration of shapes is essentially a pre-writing symbol for "make me feel special. Tell me I did a good job," achieved by suppressing the ideas and expressive impulses that actually make that child special and unique.

Not to worry, the furniture eating plant-monsters still have some safe havens! *Some* young artists in the US and abroad and their absurd, garish, and intuitively composed work are uncensored. Art Studio staff can tell a progressively schooled child by their artwork from across the room: abstract designs, imaginative use of color, unrecognizable forms, filling the page with a newly discovered technique, using both sides of (or even folding) the paper—all done without getting "corrected" by their caretaker, who is more likely to be contently doing their own experimenting alongside the child.

The cards, in my opinion, are stacked against the low-income kids who need the creativity and tools to self-express the most. But on *both* sides of the tracks, something seems to happen to the majority of Americans during childhood that puts them on-path to be precisely what Picasso pointed to: the creatively-disabled adult.

How Did This Happen?

If we go back to our image of the "artful community" as a lush garden, dense with a variety of flowers and greenery, I can describe countless ways tender sprouts are regularly mowed down and weeded out. Interference during the "pre-art" stages of development and the squashing of creative tendencies during early art making are the culprits here. Both are the outcome of enthusiasm-without-information; a lack of resources perpetuates the problem.

Stifling Scribblers

When we first opened the doors to the Art Studio, we realized quickly who and what we were dealing with—many of the children were so young (0-4), art making wasn't even on the table, so to speak. These little ones were

doing science experiments—synapses multiplying with every stunning streak of the brush—and their parents had no idea. Rather than watching the phenomenal process of their baby's learning unfold, parents look to the paper for any sign of art to comment on or "help with."

Our museum has a separate exhibit designed specifically for toddlers that features a "Messy Sensory Area"—a distinctly pre-art activity area where the developmental building blocks that will ready these tykes for making art are established in multi-sensory, exploratory ways that are appropriate for littles (BCM terminology for children aged three and under). Waterplay, colored shaving cream, a light table, and finger paint are typical offerings.

Parents will nevertheless bring their toddlers across the museum to the Art Studio, unaware (or resistant to the idea, as we do try to inform adults in both spaces) that there is a necessary and sequential development of motor skills and concepts that ready a child for art making. Although the Art Studio exhibit is set up for kids around age five and older, we have an area with lower chairs around a large table, with a developmentally appropriate adaptation of the "big kids" activity. Alongside our paper sculpture activity, we offer the "cutting corner," featuring long strips of paper and a variety of small scissors. When painting with bamboo calligraphy brushes and ink, we provide littles with big-handled brushes, larger paper (for broad arm movements), and black tempera paint. Many adults are dissatisfied with these offerings, perceiving a down-graded version for their second-class citizen, the Very Young Child. Some, insulted, respond that their child is gifted, and lift them onto the backless stools at the large tables and berate the child for not making a sculpture. Instead, the toddler blissfully pastes and piles the paper, just as we'd expect and encourage them to do (with less expensive paper).

Snipping a large paper down to smithereens, smearing glue across smooth surfaces, and turning an entire white paper black with slick paint are immensely satisfying to a young child in the "sensory-motor" stage of development.[9] Littles take whatever materials are within reach and embark on experiments that are precisely what they need to be learning at that time.[10] The ideal role for an adult during these instances would be to enjoy the show, interpret what discoveries are being made, and put words to them. Instead, we see adults speaking as though the child were creating products—works of art. It's endearing enough to hear a proud parent announce that they are going to take home the sopping wet black "picture" to hang on the fridge, if the misunderstanding had no other implications for the child. Unfortunately, Junior is soaking up some critical messages about art making (examples to follow).

The actions parents, caretakers, and teachers take while young children use art materials show not only confusion about cognitive and motor development, but also a lack of understanding that the very essence of art making is *creativity*. We see parents who in one breath would reject having their own piece of paper, declaring "I'm no artist," gripping their three year-old's hand and painting a heart. The disengaged child's eyes wander around the room, blinking at the surrounding stimuli, while the parent continues their supposed art making spree—exclaiming after each, "a masterpiece!" While derailing the child's sequential physical mastery and understanding of the materials, they also "build the box" around the child's innate tendencies to explore, invent, and create freely. In short, the artist Picasso spoke of preserving in every child is being squashed, just as they stand on the threshold of applying their new skills to create with intention.

These unwitting box-builders are stifling would-be intuitive artists long before preschool and will continue to do so, even as they supply them with art materials and experiences as their child grows up. At the "big kids" tables in the Art Studio, parents are more directive with their kids, if we don't do an adequate job of expressing the exploratory, open-ended nature of the activity.

Here are the top ten most frequently heard anti-art comments by parents and other influential adults in the Art Studio:
1. "No, not like that. Like this."
2. "Draw Mommy a flower."
3. "Stop playing around and make something good."
4. "Pink!? No, you don't like pink. Take a blue one."
5. "What is that supposed to be?"
6. "That's the prettiest picture ever! I love it!" (Without looking at artwork.)
7. "You know who would love this? Your Aunt. *She's* good at art."
8. "Show the teacher what you made."
9. "Stop [practicing skills/being creative]. Follow the directions!"
10. "Nice gig—sit around and make art with kids all day. Are you a volunteer?"

Here we've got a steady stream of self-described artistically-challenged/creatively disabled adults implicitly teaching their young children that art making is precisely what it is not:
 Art making can be done wrong.
 Art making is done for the approval of others.
 Skillful art making happens without practice.

Art making should produce predictable, recognizable imagery that
can be verbalized.
Art making is about the art made, not about the maker.[11]
Art making is exclusive—not everyone can do it.
Art making is child's play and is of little value in the adult world.

I attribute the disconnect between caregivers' "I'd give you the moon" intentions and the scarred-for-life outcomes to simply not understanding creativity. Parents want to see signs of their kids' competence. Knowing how to read and write, they can gauge and guide their child's literacy development pretty easily. On the other hand, many parents and teachers are out of touch with the nature of creativity and are unable to find it in themselves, let alone nurture it in others. Unfortunately, most of them still try. Children's art making is seldom seen by Americans as having value beyond novelty, making decorations or "taking a break" from learning, so it makes sense that they would be less careful with it as subject matter.[12] The notions of art making as one of the "hundred languages of children" to be regarded as a means of communicating and processing experience, and as an ideal site for developing critical creative abilities are lost on many adults.[13]

Arts 'n Crafts... Only, Without the Art

A clear indicator of confusion about creativity in our culture is the common lack of distinction between art and crafts activities for kids. I don't mean to get into the can of worms that is the distinction of art versus craft in the adult world—that's an entirely different essay. For *children*, I see two distinct types of activity that I define as follows:

Art making:

Art making is a process-oriented activity that values an individual's natural instinct to explore and experiment with materials, done for the satisfaction of the action itself, or as a means of self-expression, resulting in products that are uniquely the creator's. Although level of technical skill may be evaluated, success is determined exclusively by the creator, as each artist is making up and breaking their own set of rules as they go along (e.g.: manipulation of clay. A child under age four who is new to the material explores it with all of her senses, enjoying discovering its responsive qualities and learning the effects of pinching, poking, pounding and squishing it. With more experience, a child learns basic techniques such

as rolling "snakes" and balls and combines these skills with imagination, first led by the materials ("now it's a hot dog") and later by ideas ("I'm making a basket of eggs")).

Craft:

Craft is a product-oriented activity that values following directions and guided skills development, sometimes done to share a cultural tradition or activity, with the goal of creating a particular object. Each artist may bring a mark of uniqueness to their object, but success relies on the replication of a basic sample with a set of matching characteristics (e.g.: creating a "God's Eye" with yarn and popsicle sticks).

I think crafts, when done in an informed, contextualized way that allows for improvisation and uniqueness, can be a great way for kids to learn about other cultures and traditions for older kids who are secure as artists or free thinkers. For early childhood, I'd have to agree with Susan Striker, who rants, "Assembly-line 'art' is worse than none at all."[14] To facilitate a craft, intervention in the form of "correcting" or "helping" in order to "do it right" all send messages that will be hard to reverse. I'd go so far as to say that crafts are poison in the soils of delicate sprouts. It's therefore pretty unfortunate that most parents and teachers are more acquainted or comfortable with crafts to the *exclusion* of art. Once I differentiate the two, they show a clear aversion toward Art-with-a-capitol-A. "Oh God, I'm not creative. I can't draw. I can't do art with my kids. Crafts, I can do." (Again, the engrained entanglement of creativity and mastery of art skill rears its head.)

These art-deprived craft-lovers come into the Art Studio and scan the room as staff welcome them and introduce the materials. They are looking for an example. Occasionally someone will even ask staff, "aren't you going to show her how?" when the offering is to explore the materials of the day. At least twice during my tenure at BCM exasperated adults have stormed out of the Art Studio (dragging their children with them) when staff insisted that there were no samples, and that there was no right or wrong way to use the materials. Comments such as, "oh she loves art. She makes bracelets with this Princess Jewelry Kit we got her all the time," and "listen! The lady is going to tell you what to make," illustrate the extent to which the typical American adult we see in our museum has lost touch with the open-endedness of art making and become consumers of crafting products and resources that misrepresent themselves as art-related, while allowing

for little to no creativity. We can't blame the adults here. Those inspired to reverse the curse and find ways to bring creativity into their classrooms or homes are likely *not* to come up empty-handed, but rather bombarded with products and activity-recipes for crafts, disguised or mislabeled as art making. The available resources, especially those online, do *not* point the way to supporting creative development. If anything, "art for kids" websites exemplify the creative deficiency I've described and spread the confusion like weeds.

How *Does* Your Garden Grow? Some Solutions

Many early childhood educators, childcare professionals, and parents I meet are desperate (not my word—theirs) for "more craft ideas." Once we talk through the terminology a bit, what they really want is to provide experiences that allow their kids to express themselves while developing creativity. These social workers, home-visitors, volunteers, teachers, and parents want to nourish the wild flowers springing up around them, even though they may feel completely unqualified or uncomfortable dealing with "art." What can those of us who *are* versed in the arts do to support them?

"Put Down the Glue Gun—Your Job Just Got Easier"

Early childhood educators, childcare professionals, and parents of little ones have enough on their plate. It would be fantastic if a windfall of arts-integration professional development and support of the caliber the Wolf Trap Institute provides were available to everyone working with littles.[15] But it isn't. Luckily, for this age group, caregivers and teachers just need some redirection to adequately support creative development.

At BCM, I create a stimulating atmosphere that's conducive to age appropriate, child-centered and -directed exploration of materials, while encouraging creativity with supportive behaviors. As stuffy as that sounds, it's not rocket science—and in most cases, it means that adults, free from managing outcomes, literally have to do *less*.

When it comes down to only having two hands, no time for prep, and an insecurity complex about art skills and fancy materials, what we have for these folks is nothing but good news. For some role models, not surprisingly, we look overseas...

Atelierista—*Italian for "Back Off and Watch"*

Well, not really. The role of the *Atelierista*, the artist-educator in a Reggio Emilia school's art studio, is a bit more complex than that. This highly

revered professional works with all of the teachers in a school to document and discuss what students are working on; how their process unfolds, the dialogues and interactions between children and the *atelierista*, and the child's own interpretation of what his or her artwork is "saying" are all valued as windows into how kids learn and evolve. The adults in the school act as guides to help children follow their interests and answer their own questions by backing off enough to let them do their own thing, while at the same time, watching for cues on how to best support what the child is learning. Use of what psychologist Lev Vygotsky called the "Zone of Proximal Development" requires an adult to ascertain where a child is at with regard to a skill or concept, and look for the moment "when a child is about to see what the adult already sees," and appears ready and able to "make the jump."[16] In other words, to assist without "doing for." To intervene only when the child seems to be poised to take what they are doing to the next level, but needs something from the adult (a material, a probing question, a suggestion, or a reconfiguration) to do so.

Most early childhood educators are familiar with this practice of "scaffolding" but few apply it to art-time, either because they are "backing off" to the point of abandoning the scene while children "just play and get messy," or because they themselves aren't familiar with art concepts and techniques to know "what's next."

Parents and care providers may be less familiar with the practice of scaffolding and swing from leaving a child to use materials unattended, to authoritatively "assisting."

The last thing I would do is present *any* of these adults with the burden of "how the real experts do it, in Italy." The enormous dissonance between conceptualizations of the child alone is exhausting. Even referring to "another model" sounds snobby and difficult, and I avoid it altogether. However, we can take best practices from this model, combine them with what early childhood experts know about development and creativity, and what we know adults with young children are good at, can appreciate, and enjoy.

Some examples of tips for creativity cultivators:

1. *Materials: simplify, simplify.* Skip "kits" and novelty products and stick to the basics: glue, scissors, paint, crayons, and markers can and should be used over and over again.

2. *Let the child lead (back off).* This pretty much takes crafts off the table and points to open-ended activities with appropriate materials presented to the child. Take note of your expectations for what "should" happen or be created and let go of them. Those are *your* ideas. There are no "examples" in creative work![17]

3. *Focus on the process.* "Process over product" seems to be a bit too vague for many to practice. It sounds like a way to excuse art that isn't very "good." With children three years-old and under, use words to describe exactly what you see. "Is the paint slippery? You are painting the whole paper black!" "You drew a circle!" "The paper is getting smaller every time you cut it!" These children are not making a "picture" for you—you'll have to wait for that. Enjoy watching your child's discoveries for now. For older children presenting finished products to be praised, invite them to tell you about their work. Don't ask what it *is*, or tell them how "pretty" it is! Talk with them about what you see and ask about how they did it: "I see you used almost all warm colors—especially red. How did you get these swirls to happen?"[18]

4. *Respect the product.* Kids don't "have to" do anything to their artwork, including writing their name on it. It's their choice. They may choose to write it on the back, or you can ask permission to do so if needed. Always ask permission to touch the surface of a collage or sculpture—it is not yours, it belongs to the artist. Resist tweaking a button for symmetry, adding anything, cutting, or folding it. Follow a child's direction regarding the fate of the piece. Was it practice? Should it be kept for looking at later? Hung up? I find that older kids are relieved to be given permission to "just experiment and practice" and choose what, if anything, they'd like to keep. For artwork a child is especially proud of, consider actually framing it and then hanging it up.

5. *Take notes, teach parents.* No more pandering to uninformed parents' pressure for holiday crafts and cute projects at the price of arresting a child's creative development. Educate them. Now that you're no longer scrambling to dispense pairs of googley eyes, you have a moment to sit down, watch, and write down a sentence about the process—a quote from the child or your observations. Send a note home at the beginning of the year to set expectations.[19]

6. *Different is better, "weird" is good.* Positively reinforce any and all out-of-the-box thinking! Adults often habitually say, "no!" or "not like that" when there is no harm being done, just a new idea being expressed. Creative people are the first to try something different with something familiar, like crumpling up their nice white paper and seeing what it's like to draw on a textured surface. Point out and celebrate differences between choices, preferences, and styles whenever a number of children are working together. Indicating that a child is being "weird" when they are being imaginative or

expressive, like making up a nonsensical song, is first-class artist-squashing.

7. *Artful questions, all the time.* There is no moment when a child cannot exercise his or her imagination (and blow your mind while doing so). Create these opportunities by asking simple, open-ended questions: "What do you think that is? What makes you say that? What if...? I wonder how...?" Enjoy the ensuing dialogue, validate ideas, and rejuvenate your own wonder while your kids become more confident, creative, flexible thinkers.[20]

We can all help spread the word to parents and teachers: kids under age six don't need an "art teacher." Although it may seem a daunting task to reach this target audience because care providers and preschools are not systematized the way K-12 is, early childhood learning networks (formal and social) are teeming with activity. For that reason, I'm optimistic that the lowest-cost efforts here will have widespread impact. I've seen ripple effects in schools and organizations after one-shot training sessions or simply sharing some printed resources, and get feedback long after the fact about lasting changes in practice. However, we need to keep this information clear and simple, presented as ways to make things easier, more enjoyable, cheaper, and more beneficial to the child.

Where to Look, What to Do...

Practical resources (in print and online) aimed toward parents and teachers need to be created or compiled that are free, accessible, and appealing to the average-Joe, detailing how-to basics of supporting creative development. Some examples include:

- Activities that are clear and practical, in recipe-formats similar to the abundant craft-activity instructionals any over-burdened teacher would prefer to a wordy, abstract description. Marianne Kohl does a great job of creating fun, illustrated one-pagers that highlight materials, age appropriateness, learning, and how to facilitate the process.[21]
- Lists of must-have's for art making at home or in the classroom is a relief for many parents, early childhood educators, and care givers, as they often feature cheaper, longer lasting alternatives to the bedazzled craft kits and devices marketed to kids.[22]
- Lists detailing how to use the same materials over time in developmentally beneficial ways is seen as another budget-

friendly alternative that is actually more conducive to mastery of materials.[23]

- Tips on how to support kids' work, including appropriate, encouraging language "cue cards" and "creativity killers" to avoid.[24]

Free At Last! A Snapshot of Success

I was recently involved in a well-funded, intensive, long-term arts-intervention program that I believe failed to make a sustainable impact on the school we partnered with (but boy, was the closing reception/art show/performance a brilliant display). The "visiting artist" model fell flat, without total buy-in or adequate professional development for the teachers. In numerous roles, I've been a part of "arts from the outside" making a splash in the grade school or after school organization involved, but fading fast once the curtain closed on the program.

In contrast, working with preschool teachers I have trained in a one-shot seminar and supported afterwards with visits modeling new ways to interact with kids has had long-term, significant effects on what is happening in those classrooms and how creativity is nourished there. Years later, I'm greeted with reports along the lines of, "Sajhad thought that cardboard box looked like a robot so I gave him some materials and boy, he went to town!" versus, "check out our pretty garden of egg-carton flowers." When under the gun to produce crafts for an "art show" for potential sponsors and parents (masterminded by the school's administration), the staff instead displayed what the kids really created, and with some help, developed Reggio Amelia-style signage that explained the processes that the featured works were evidence of. In my eyes, this is a huge indicator that this school is versed in creative development and actively rebelling against the all-too-common demand from headquarters (or parents) for some "nice artwork." Feedback from two-hour professional development programs with day care and home visit professionals include:

> I'm going to break the cycle! I don't want my kids to feel like I do about art.
> I liked how you talked about "building the box" we want kids to think out of. I do that.
> No more crafts! This way is good for me too because I get to enjoy the kids more.
> From now on, the kids are in charge of the projects!

Conclusion

Howard Gardner is one of several influential theorists taking a serious look at creativity. Although much of his work focuses on tracking the creative processes of adults, he agrees with Picasso and very likely the rest of us that "the mind of the five year old represents... the height of creative powers."[25] In describing a formula for preserving this state of being he briefly refers to a taken-for-granted "period of open, untrammeled exploration in early childhood."[26] I've shared my experiences here in order to sound an alarm that the archetypal artist-child is "at-risk." Addressing the major misunderstandings endangering the creative development of children by educating the adults in their lives, we would not only benefit individuals, but over time, grow an arts-receptive culture where the arts are less likely to be questioned, marginalized, or trivialized.

It's my hope that all artists, advocates, and educators will find ways to reach out to this new student body, assured that they are a highly motivated constituency: parents committed to "breaking the cycle," and even more so, those who work with disadvantaged kids for whom creativity is a survival skill. These teachers are quick to drop their notions of art as "making pretty things" and passionately answer the call to break old habits so that their kids develop the self esteem, flexibility, and ingenuity to meet the challenges that await them. They take very seriously the task of capturing their kids' creativity as both an aptitude to develop and a life-long attitude to "lock in" early in life.

These individuals are the actual gardeners of our society, committed to doing everything in their power to give every fragile seedling more than just a chance at survival, but the most ideal atmosphere for each to flourish. As arts advocates, our endless transplanting, fertilizing, and fretting may be over, once we teach this generation of gardeners when to put down the pruning shears and step back.

Join the Conversation

Contribute to a dialogue pertaining to the concepts discussed in this chapter by directing your web browser to the following URL:

http://www.20UNDER40.org/chapters/chapter-20/

NOTES:

1. Booth, E. "The Habits of Mind in Creative Engagement." (n.d.), <http://www.espartsed.org/resources/>.
2. Eisner, E. "Ten Lessons the Arts Teach." In *The Place for Art in America's Schools*. Getty Center for Education in the Arts, 1985: 69.

3. Americans for the Arts. "Information and Services." (n.d.), <www. americansforthearts.org/information_services/research/impact_areas/ arts_education/001.asp>.

4. Piaget, J. *The Origins of Intelligence in Children.* New York: International University Press, 1952.

5. Gardner, H. *Artful Scribbles.* New York: Basic Books Inc., 1980; Kellogg, R. *Analyzing Children's Art.* Palo Alto, CA: Mayfield Publishing Company, 1970.

6. Although my conceptualization of creative development applies to all of the arts, for this chapter I'm illustrating the concept specifically with adventures in visual art, due to my personal experience in that domain.

7. Although I give a sense of what "creativity" means to me here and throughout this chapter, I'm sidestepping *defining* creativity—there are plenty of experts in academia tackling that task. I will say that my favorite, practical description of creativity related specifically to children is given by Reggio Emilia guru Loris Malaguzzi, in *The Hundred Languages of Children.* See Malaguzzi, L. "History, Ideas, and Basic Philosophy: An Interview with Lela Gandini," in Edwards, C., Gandini, L., & Forman, G. (Eds). *The Hundred Languages of Children: The Reggio Emilia Approach to Early Childhood Education.* Norwood, NJ: Ablex Publishing Corp., 1983: 75.

8. I believe these choices reflect heavily the role of adult expectations. In the Art Studio setting, kids may feel under the gun to "perform" for their adult, sitting inches away, watching and waiting for the product. The adult in turn projects their own judgmental stance onto the unwitting staff person, who in more cases than not, is not artistically inclined.

9. Piaget, J. *The Origins of Intelligence in Children,* 1952.

10. Susan Striker, *Young At Art.* New York: Henry Holt & Company, LLC., 2001: 15.

11. The opposite needs to be true during earliest arts experiences. A focus and judgment of the product, even positive, sends the message that the child's worth may be dependent on their artistic ability (as judged by someone who very likely has no business assessing visual art).

12. Rosemary, A. Johnson, M. H., & Mitchell, S. T. *The Colors of Learning.* New York: Teachers College Press, 2003: 10

13. Edwards, C., Gandini, L., & Forman, G. (Eds). *The Hundred Languages of Children: The Reggio Emilia Approach to Early Childhood Education.* Norwood, NJ: Ablex Publishing Corp., 1983.

14. Susan Striker, *Young At Art,* 2001: 12.

15. Nationally renowned for best practices in creating long-term impacts through professional development, Wolf Trapp Institute for Early Learning Through the Arts offers books, workshops, seminars, and artist-residencies. See (n.d.), <http://www.wolftrap.org/Education/ Institute_for_Early_Learning_through_the_Arts>.

16. Vygotsky, L. S. *Mind in Society: The Development of Higher Psychological Processes.* Cambridge, MA: Harvard University Press, 1978; Malaguzzi, L.

"History, Ideas, and Basic Philosophy: An Interview with Lela Gandini," 1983: 84.

17. Art-in-the-style-of-[insert "Master" artist here] is hugely popular among adults as a great way to create a hands-on, personal connection with art history. This approach is inappropriate for young children for a number of reasons, not the least of which is that it teaches that there *is* a "right" way to do art.

18. For a checklist of "art talk" vocabulary and concepts see Appendix B in Rosemary, A., Johnson, M. H., & Mitchell, S. T. *The Colors of Learning*, 2003.

19. Wurm, J. P. *Working in the Reggio Way: A Beginner's Guide for American Teachers*. St. Paul, MN: Red Leaf Press, 2005.

20. See Project Zero's "Artful Thinking" approach at <http://www.pz.harvard.edu/tc/routines.cfm>. A more in-depth questioning model than Visual Thinking Strategies, both of which were designed for interpreting artwork with equal effectiveness across the curriculum. It's a K-12 program. My personal research found effective adaptations for preschoolers during snack time, while lying in the grass, and discovering squashed some-things on the sidewalk.

21. Kohl, M., Ramsey, R., & Bowman, D. *First Art: Art Experiences for Toddlers and Twos*. Beltsville, MD: Gryphon House Inc., 2002. See also <http://www.brightring.com> for free activities and full list of publications.

22. See <http://www.everykidsanartist.com>. This is actually a website I was moved to create myself, after endless searching online for resources that don't exist or are nearly impossible to find. I've posted my own materials, free for downloading, alongside tips and links to the best resources found during my research.

23. Ibid.

24. Goleman, D., Kaufman, P., & Ray, M. *The Creative Spirit*. New York: Penguin, 1992; Bos, B. *Don't Move the Muffin Tins: A Hands-Off Guide to Art for the Young Child*. Roseville, CA: Turn the Page Press, 1982.

25. Gardner, H. *Five Minds for the Future*. Cambridge, MA: Harvard Business School Press, 2006: 84.

26. Ibid: 86.

RESEARCH REPORT

Becoming Un-Tongue-Tied:
An Informal Review of the *20UNDER40*
Submitting Authors & What They Had To Say

Andrea Sachdeva
The ArtScience Prize

The 20UNDER40 anthology sought views on the future of the arts and arts education from leaders in the field under 40 years of age, a group traditionally underrepresented in previous publications. In this study the author biographies and abstracts of the 304 chapter proposals submitted to the anthology were mined for data and informally reviewed to identify common and notable themes. Author demographic characteristics were analyzed, as were anecdotal findings about the artistic disciplines and the people, environments, functions, tools, purposes, and seminal challenges proposed in the abstracts. Implications for the field and areas for further study were identified based on common themes among the abstracts.

INTRODUCTION, OR—*WHAT HELD MY TONGUE?*

The initial "Call for Chapter Proposals" for the *20UNDER40* anthology, released on June 15, 2009, solicited innovative ideas about the future of the arts and arts education from forward-thinking arts leaders under the age of 40. In considering my own thoughts about preparing a chapter proposal for the anthology, I began to feel that my youth and inexperience made me woefully unqualified to have a voice in the conversation about envisioning the future of the arts sector. I wondered if I actually had any thoughts or opinions that would be interesting or relevant to other practitioners in the field, no matter what their ages. I shared these doubts with other friends and colleagues who were considering submitting to the anthology—artists,

researchers, and other young arts professionals throughout the field—and felt both relieved but also disheartened to hear my colleagues echo my uncertainties.

I am usually a confident person, one who will speak up in any high-powered board meeting or arts education conference, and I felt that my under-40 friends and colleagues fit into this description as well. So I began to wonder: *why do we, as young arts professionals, feel unqualified and unequipped to have a place in conversations about the future of our field?* Soon after, I started to see similar expressions of self-doubt appear in other discussion forums including a highly-subscribed-to online exchange about *20UNDER40* on the listserv of the New England Consortium of Artist-Educator Professionals.[1] Eventually, the concept of *20UNDER40* had stirred up so many raw feelings within the field that project director Edward Clapp was compelled to write *This is Our Emergency,* a widely-distributed essay addressing the startling phenomenon of young leaders' feelings of irrelevance and self-doubt that was based on countless e-mails he had received and conversations he had engaged in with under-40 arts practitioners who repeated the same sentiments.[2]

When *20UNDER40*'s Call for Chapter Proposals was released, many questions circulated about whether or not anyone would submit to the anthology or have any interest in reading the perspectives of young leaders published therein. But over the course of the three-month proposal submission period, public attention from landmark national organizations including Americans for the Arts helped to answer these questions via a series of online discussions, conference workshops, and published interviews. These forums to discuss the project and its seemingly-arbitrary age cap publicly recognized that input from young arts professionals *did* matter, and that people of all ages in the field were interested in hearing their voices.

As noted in the discussions fostered by these forums, much has been written about the arts and arts education by veterans in the field, many of whom have acquired their expertise and developed visions for the future through decades of working as arts and arts education practitioners. But the *20UNDER40* project sought, in Clapp's words, to introduce younger voices into the discussion of the arts in order to "[legitimize] the talent of young leaders by bringing their ideas out of the margins and into the forefront of… dialogue."[3] The more than 300 chapter proposal submissions that poured in as the submission period drew to a close in August 2009 affirmed this vision, as submitted proposals demonstrated nationwide and international interest in the project and highlighted the reality that under-40s working in the arts have strong opinions, bold visions, and do indeed

require an increased presence in conversations about the future of the field.

Following the submission deadline, Edward Clapp approached me and asked if I would consider being a research assistant for *20UNDER40*. The only concrete goal of the assignment was that I would look through all of the biographies and proposal abstracts of submitting authors to honor the 280+ ideas that wouldn't be published and to see if there was anything interesting we might learn by looking at the group as a whole. After several months of conversations over $2 beers, late-night e-mails between both of our living room offices, and many, *many* readings and re-readings of the submitted biographies and abstracts, both Edward and I felt that there was a lot of important conversation to be had about the group of submitting authors and their proposal submissions. We decided to take a closer look at the ambitious group of people who stepped up as young and emerging leaders to submit chapter proposals—some of whom had surely, like myself, overcome their own self-doubts about submitting their ideas to the project.

After months spent reviewing this material, I began to feel that the overall cohort of submitting authors had its own special voice. The very act of submitting a proposal outlining personal perspectives on the arts and arts education—in some cases by authors as young as 18 years-old—was a formidable show of power; these applicants were embracing young leadership and looking toward the future. Their submissions represented the viewpoints of young leaders who were deeply interested in the future of the arts and who foresaw themselves working in the field now and for decades to come.

What was the story told by the *20UNDER40* proposal submissions, and who were the submitting authors who wrote this story? Rather than approach this question in a traditional, scientifically-based research study, the analysis that follows seeks to offer primarily anecdotal and informal observations made from a review of the proposal abstracts and author biographies. Piecing together the 304 submitted abstracts from across the United States and several nations around the globe yielded a wide diversity of characteristics describing the future of the field. Some discussed the jobs that submitting authors expect will play a key role in their visions of the field's future, and the stages on which they expect these visions to play out. Others discussed the resources that will enable cutting-edge work in the field. Still others talked about the overarching purposes that will drive them in their work. The submissions presented a worldview for the future of the field—a multifaceted vision of enduring challenges to be tackled and

innovative strategies to be implemented. This constructed worldview was one surely worth contemplating to consider its potential implications for the role of the arts in the future.

Process

The *20UNDER40* Call for Chapter Proposals requested a 100-word biography, a 100-word proposal abstract, a two-page chapter proposal, and the submitting author's date of birth and contact information. When reviewing the proposals for this analysis, only the abstracts (rather than the full two-page proposals) were examined.[4] Author biographies and proposal abstracts were reviewed with three broad questions in mind in order to identify salient themes about the cohort of submitting authors and the content of submitted chapter proposal abstracts. The three overarching questions that guided this review process were:

1. *Who are the people who offered their perspectives about the arts and arts education?*
2. *What repeated themes were identified across the entire group of proposal abstracts?*
3. *What was surprising or unexpected about the visions expressed in submitted abstracts?*

Descriptive statistics about submitting authors were first mined from the brief professional biographies and demographic information included in author submissions. No specific format was requested for biographies in the Call for Chapter Proposals, and therefore authors did not submit uniform information about themselves or their professional and educational backgrounds. Information mined from the author biographies included each submitting author's gender, current and previous professional affiliations and the locations of these affiliations, current and previous job titles, level of educational attainment, and number of educational degrees received along with corresponding degree-granting institutions. Six submitting authors did not include biographies with their submissions.

Proposal abstracts were first reviewed and coded by the genre of art discussed in each abstract (see Figure RR.1), and then were read several times to help identify overarching and commonly-mentioned themes. A set of six categories was identified to encompass the themes proposed by submitting authors' visions of the future of the field:

People—WHO are the people (characterized by their professional roles) that will implement proposed visions for the future of the arts and arts education?

Tools—WHAT are the new models, frameworks, and strategies that will break new ground in the arts?

Environments—WHERE will ideas for the future of the arts and arts education take place? What environments and institutions will cultivate these ideas?

Purposes—WHY will society and field practitioners continue to engage with, participate in, and work in the arts and arts education?

Functions—HOW do the arts and arts education function in submitting authors' views of the future?

Challenges—What are key CHALLENGES that will need to be addressed by the next generation of arts leaders?

Distribution of Proposal Themes

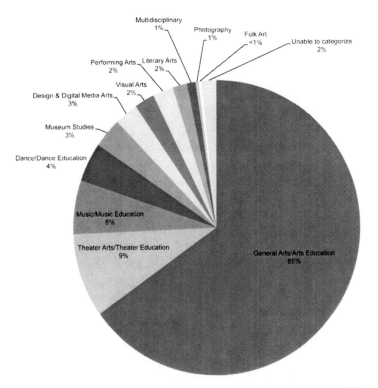

Figure RR.1: Distribution of arts and arts education genres addressed in submitting authors' chapter proposal abstracts.

Once these six category themes had been identified, all abstracts were reviewed again and coded for inclusion in one or more categories. Following this categorization, an effort was made to anecdotally identify

discussion topics commonly mentioned in the arts and arts education fields that were absent or infrequently mentioned by the *20UNDER40* submitting authors.

FINDINGS

Author Biographies

Applications were submitted to the anthology's Call for Chapter Proposals by 319 authors from four countries (the United States, Canada, Portugal, and the United Kingdom). Six submitting authors did not provide information about their home addresses, and therefore could not be categorized under a geographic region. The geographic distribution of proposals received is shown in Figure RR.2.

of Submissions by State/Country

■ no submissions
■ <5 submissions
▓ 5-10 submissions
▒ 14-20 submissions
▧ 31 submissions
▓ 49 submissions
■ 84 submissions

Figure RR.2: Map of geographic distribution of the 319 *20UNDER40* submitting authors, collected from author submission information.

The youngest submitting authors at the proposal submission deadline (August 31, 2009) were two 18-year-olds, and the closest to the 40-year-old age cap was 39 years, 11 months. The average age of submitting authors was 30.4 years (see Figure RR.3). Two hundred fifteen submitting authors were female (67%), ninety-eight were male (31%), and six were unidentifiable as "male" or "female" from their submitted biographies (2%).[5] In addition to the personal and professional interests that these applicants shared, some *20UNDER40* authors also expressed an interest in diverse activities including computer science, entrepreneurship, mechanical engineering, yoga, business plan development, psychobiology, clean energy, Zen living, neuroscience, artificial intelligence, and martial arts.

of Submissions by Age
(Total 319 Submitting Authors)

Figure RR.3: Age distribution of authors who submitted to the *20UNDER40* project anthology, collected from author submission information.

Submitting authors have collectively attended at least 153 institutions of higher learning and have earned or are currently in the process of earning at least 359 higher education degrees (ranging from bachelor's to doctoral degrees) and 12 types of other educational certifications.[6] At the time of the proposal submission date, submitting authors were professionally affiliated with 369 different organizations, projects, or collaborations. Whether or not they were employed as such at the time of proposal submission, 108 submitting authors (34%) described themselves in their biographies as artists (including performers, musicians, etc.), and 90 described themselves as educators (28%). Other frequently-cited job titles included professor, assistant professor, or lecturer (35 individuals, or 11%); consultant (15 individuals, or 5%); and researcher (13 individuals, or 4%). The biographies

also showed that many *20UNDER40* submitting authors have assumed leadership roles or have taken on opportunities to use their professional knowledge to advise others. Seventy-four submitting authors (23%) had the word "director" and 21 submitting authors (7%) had the word "manager" in their current job titles at the time of proposal submission; 38 submitting authors (12%) described themselves as founders of programs, organizations, online networks, etc.; and 18 submitting authors (6%) listed affiliations as board members or steering committee members.

Proposal Abstracts

Submitted proposal abstracts addressed a variety of themes and genres in the arts and arts education field. The majority of proposals (198 submissions, or 65%) did not address specific artistic genres, but instead dealt with general issues in the arts and arts education ranging from arts practice to administration, and from general purposes of the arts in society to the logistical and pedagogical issues that will help the arts to flourish in the future. Some genre-specific proposals were submitted, including those relating to: theater arts and theater education (28 submissions, or 9%), music and music education (18 submissions, or 6%), dance and dance education (13 submissions, or 4%), museum studies (10 submissions, or 3%), and design and digital media arts (8 submissions, or 3%). Other artistic genres that were each mentioned in seven or fewer proposal abstracts included the visual arts, performing arts, literary arts, multi-arts initiatives, photography, and folk arts.[7]

Grouped into the categories of people, tools, environments, purposes, and functions of the arts and arts education (the "Whos," "Whats," "Wheres," "Whys," and "Hows"), as well as seminal challenges in the field identified through submitting authors' chapter proposal abstracts, the total group of submissions in each theme category is shown in Figure RR.4.[8] Many abstracts fell under multiple categories or themes, and therefore are listed multiple times.

OBSERVATIONS

When the *20UNDER40* Project began, project creator Edward Clapp defined a very broad sense of "when" for potential authors, soliciting their visions of the arts and arts education in *the future*. On the whole the strategies and challenges identified by submitting authors echoed those that have driven leaders in the field for decades, if not centuries. This was most noticeable in the category of Purposes, where issues of past generations like appreciating "art for art's sake" and engaging in artistic practice to enrich and better the human condition remained key drivers for submitting authors.

Within other categories, many of the job roles (e.g., funders, artists, arts administrators), functions of the arts (e.g., arts to teach academic subjects, arts as a universal language, arts to teach social skills), environments that support the arts (e.g., schools, arts organizations, museums, institutions of higher education), and seminal challenges (e.g., lack of diversity in the field, lack of universal access to high-quality arts education for all) also emulated those noted by past generations. Rather than reiterate these concepts, the observations that follow instead concentrate on submitted ideas that demonstrated change or innovation in the field, and those aspects of the submitting authors' worldview that are fundamentally different from those championed and confronted by previous generations of arts and arts education practitioners. These areas of difference are often intrinsically linked to the onset of the 21st century, the coming into adulthood of "digital natives," and the questions that inspire, challenge, and plague the future of the arts in the minds of next-generation arts leaders.[9]

People

According to submitting authors, one notable 21st century job role that will be critical in implementing next-generation approaches to the arts and arts education is that of the Teaching Artist. Creators of high-quality in-class learning opportunities as well as artists and educators with the freedom to travel and absorb new professional experiences through exchange with others in both the local and global communities, Teaching Artists were described as driving forces of change in the future of the field.[10]

Tools

Many submitting authors discussed using tools employed by earlier generations in new ways, suggesting modern-day revisions of everything from the management and function of organizations (7 submissions, or 2%), to the role of arts in society (8 submissions, or 3%), to artistic practice itself (5 submissions, or 2%). Proposed strategies with more of an arts education bent included previously-untested approaches to teaching and learning in the arts and applications of arts education pedagogies specifically molded to address the changing demands of living and working in the 21st century (35 submissions, or 12%). Other tools each mentioned by a handful of submitting authors included novel approaches to evaluation and assessment in the arts (4 submissions, or 1%), fresh perspectives on leadership development in the field (6 submissions, or 2%), and concepts dealing with innovative methods of collaboration (4 submissions, or 1%), among others.

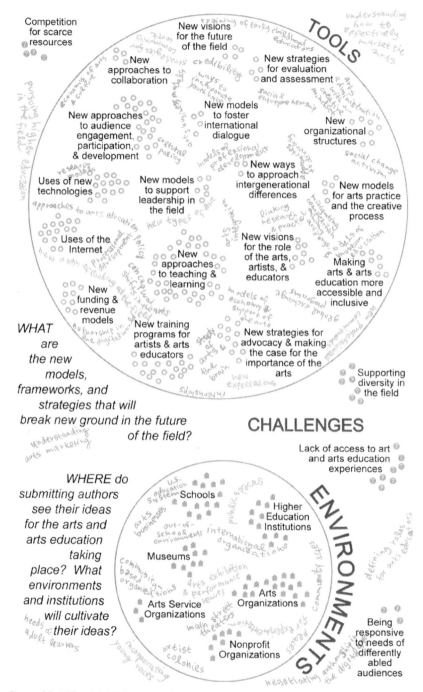

Figure RR.4: The *20UNDER40* worldview shows the distribution of proposals by theme categories of People, Functions, Environments, Purposes, Tools, and Challenges addressed in proposal abstracts; many proposal abstracts are categorized under more

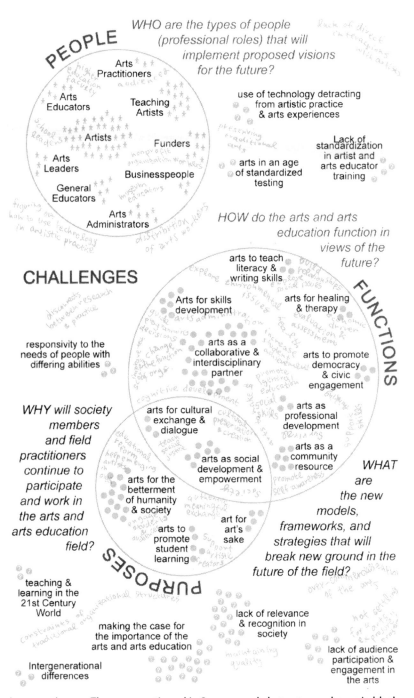

than one theme. Themes mentioned in 3+ proposal abstracts are shown in black typewritten text, while themes mentioned in <3 abstracts are shown in light gray text.

While a diverse set of tools was mentioned briefly by some submitting authors, a few new strategies and models were talked about at length by others. Revised models of traditional artist training programs were frequently mentioned as pathways to cultivate new directions in the field. Instead of viewing these training programs as a means to send artists out into the world prepared to practice their crafts and impact society through creative endeavors, *20UNDER40* submitting authors primarily viewed these programs as vehicles to create a more dynamic and multi-talented force of future arts and arts education practitioners. Many of those who submitted believed that the artists and arts educators of the future should emerge from their training with the capability to market themselves, understand the role of the arts in learning, and apply business sense to sustain their work in the field.

Submitting authors also recognized the urgent need to develop innovative advocacy strategies and to combat the lack of arts and arts education experiences in the lives of today's young people—the would-be arts audiences of tomorrow. In the Do-It-Yourself (DIY) culture described in many of the proposal abstracts, submitting authors expressed an expectation that audiences will no longer be passive recipients of artistic experiences, but will instead be deeply engaged and integrally involved in these experiences.[11] Far from sitting at the back of a concert hall and waiting between movements to applaud, the relationship between performer and audience was described as far more interactive, mutually-rewarding, and personally relevant for both parties.

While the aforementioned approaches and strategies were recognized in a significant number of proposal abstracts, the use of the Internet and new technologies was discussed far more often than most other categories of tools—appearing in a total of 29 chapter proposal abstracts, or nearly 10% of the total pool of submissions. Applications of unique Internet interventions included:

- Developing new models of funding and promotion.
- Promoting new ways to support arts integration in classrooms.
- Exploring untested waters in communication and information-sharing.
- Fostering innovative approaches to changing people's relationships to the world around them.
- Providing new venues and expectations for institutional culture and artistic creation itself.

While described in the context of this analysis as a "tool," a more appropriate label for the Internet in these applications might be *Lifelong*

Partner: a friend and colleague with the capacity for communicating and generating information in ways that have shaken the arts and arts education field to its core and brought about possibilities for the arts that would have never been dreamed of a mere 20 years ago.

Equally relied-upon in novel frameworks and future models for the arts were new technologies including social media and computerized electronics. These tools were called upon by submitting authors to serve an impressive range of functions, including (but certainly not limited to) a vehicle for artistic exhibition and creation, an integral part of arts education pedagogy, an avenue to gain increased audience numbers and find new ways of funding arts organizations, and new models for marketing in the arts.

Functions

Perhaps reflecting the recognition of the 21st century world as a venue for global communication and intercultural exchange, proposal abstracts were saturated with ideas about collaboration and cross-disciplinary fusion. Addressed in a total of 24 proposal abstracts (8%), submitting authors discussed the wealth of possibilities created by multidisciplinary creative ventures and learning environments integrating the arts with non-arts academic subjects (i.e., arts integration settings). Authors proposed incorporating the arts with other subjects (in both educational and non-academic settings) including science and math, health education, literacy development, and environmental studies. Some suggested using the arts as a way of teaching the "real" subjects, while others envisioned a kind of perfect fusion of the arts and other subjects that would equally incorporate the unique values of multiple disciplines.

Continuing this theme of collaboration, several submitting authors also recognized the ability to collaborate with other professional sectors and non-arts educational approaches as key to how the arts will function in the 21st century. Others built on past uses of the arts to bring cultures together, noting that the arts can be used for cultural diplomacy and can function as a universal language.[12]

Environments

Institutions of higher education were addressed to a notable extent by submitting authors both as places where the arts and arts education are present and as places where next-generation leaders and artists are trained. Some *20UNDER40* submitting authors emphasized that the work that takes place in higher education environments filters down into other aspects

of the field—how artists practice, how individuals sustain viable careers in the arts, how the arts are taught to children, etc. Other submitting authors envisioned wild creative spaces and environments, suggesting the creation of colonies of improvising musicians and the reinstitution of cultural assembly spaces and theaters to revitalize the main streets and town centers of the 21st century.[13]

Challenges

While many of the challenges that were discussed in chapter proposal abstracts have been seen in past generations, other struggles that relate to "hot topics" in today's political and educational realms were also presented. Challenges such as making a case for the arts in an era of standardized testing, dealing with decisions made by leaders and policymakers who grew up without access to arts education, and challenges specifically related to the infusion of technology and the Internet into the arts were all mentioned by submitting authors.[14]

Discussed in 43 submitted proposal abstracts (14% of total submissions) was a dynamic power trio of issues related to a lack of recognition and valuing of the arts by broader society. The first was the challenge of making the case in society for the importance of the arts and arts education, discussed in 18 proposal abstracts (6%). Next was the lack of arts participation and audience engagement in today's society, discussed in 8 proposal abstracts (3%). Finally, the art sector's inability to be recognized as a relevant part of society was noted in 17 chapter proposal abstracts (6%).

IMPLICATIONS

If one were to view the previous observations as a "slice of life" of the not-so-distant future in the minds of *20UNDER40* submitting authors, then what implications can be drawn that help to encourage reflection, inspire action, and begin new discussions about the field? Several key points of interest are discussed below in an effort to address this question.

The Role of the Teaching Artist

Although the job title of "Teaching Artist" is said to have originally been coined by June Dunbar as early as the 1970s, the overall identity of the field of teaching artistry as a profession with defined job responsibilities has only gained momentum as the subject of intense discussion far more recently.[15] Notably, the creation of the *Teaching Artist Journal* (identified by editor Eric Booth as the "first national publication for and about Teaching Artists") and the founding of professional associations focusing on Teaching Artists

in today's world have helped to develop a collective persona that cannot be ignored.[16] Though it has often been noted (including by a handful of the *20UNDER40* submitting authors) that the field of teaching artistry lacks across-the-board qualifications and definitions of practice, the working definition of the term posited by Booth is telling. He defines Teaching Artists as those who make explicit connections between their art forms and real-life contexts, those with the capacity to engage audiences and teach through modeling in the arts, and those with a passion for exploring unique pedagogical approaches with an in-depth focus on process and inquiry-based strategies.[17] While the exact definition and role of the Teaching Artist remains to be further developed and discussed (or perhaps even rejected entirely), it is clear that many young arts professionals envision the torch of the future of the field being held not by lone artists in their studios inspiring others with their work, but rather by arts professionals who can create personal interactions and engagement at the intersection of arts practice and education.

Technology: Friend or Foe?

Though it is impossible to predict exactly what the future will bring, it can hardly be disputed that society's use of new technologies and the Internet are here to stay. While many submitting authors discussed the opportunities for innovation that this technological presence could create, others noted technology-based red flags such as the downgrading and fundamental altering of artistic experience through the over-use of technology, and the complex negotiations and ethical decisions of intellectual property in the digital age.[18] These concerns point out the potential dangers of relying too heavily on the Internet and emerging technologies as the pathways to the future of the arts, obligating artists and arts educators to confront the reality that our greatest partner and tool in moving the field forward may also present the greatest risks and challenges.

Sustaining Hope

In gauging the psychological pulse of submitting authors' visions of the future, it is clear that there is a major self-esteem problem among many young arts leaders. While those who submitted chapter proposals clearly feel hopeful about exciting new avenues for the future of the field, underlying their optimistic proposals are constant mentions of anxiety about the arts sector's survival. If at a young age emerging arts leaders already feel that their field is seen as socially-irrelevant and that career paths in the arts will continue to be paved with hardship and constant

struggle, then one must question how practitioners in the field (of all ages) will sustain the future of the arts and the vitality of those who will lead and work within this industry. Already, two of the tools most frequently mentioned by the submitting authors dealt with the need for new audience engagement and participation strategies as well as the need for new models of arts and arts education advocacy work. This is a clear sign that, in the minds of submitting authors, the work and the tools that will help move the field further into the 21st century will increasingly be founded in the ability to justify the importance and relevance of the arts in society as a whole. Perhaps the greatest implication of these repeated sentiments is the importance of asking *why* emerging arts leaders feel this way. What is it about the arts sector that makes the entire field feel so out of synch with society?

LIMITATIONS

While this essay seeks to describe the future of the arts and arts education in terms of the ideas proposed by the 300+ *20UNDER40* submitting authors, a variety of limitations about the nature and content of its qualitative analysis must be recognized.

A significant limitation in this analysis is the lack of consistent information about submitting authors. Because the guidelines for the submission of author biographies was left mostly open-ended, the analysis of information about submitting authors is largely incomplete. This lack of available information makes it unrealistic to assess many diversity characteristics that could help to identify *who* crafted the *20UNDER40* worldview outlined in this essay.

Limitations relating to the distribution of the Call for Chapter Proposals are also significant, as the perspectives of submitting authors are confined to those reached by the published Call. For example, the vast majority of submitting authors were from the United States, likely limiting the global perspectives that may have appeared had more international applicants submitted proposals.

The fact that this essay was prepared as an informal review of proposal abstracts rather than a full-scale research study also limits the observations made above to the *20UNDER40* cohort, rather than young leaders in the arts on a broader scale.

RECOMMENDATIONS FOR FURTHER STUDY

The preceding analysis and its limitations point to further questions to be asked in the field and further avenues for study about the future of the arts.

Some of these areas for continued discussion relate to points of view that were not included in the *20UNDER40* discussion, while others deal with questions of how to act upon some alarming implications of submitting authors' views of the future.

Silent Voices

While the perspectives of well over 300 submitting authors combined to form a *20UNDER40* worldview that was multifaceted and complex, the conversation created through submitted proposal abstracts clearly would have been even more diverse with the inclusion of many others that did not (or could not) take part in the conversation. For example, if a far-reaching call for submissions to *20UNDER40* anthologies were released in other countries, attracting international authors, would the environments, purposes, functions, tools, people, and challenges of this global association of authors be different than the ones described above? How would perspectives about new directions for the field compare and contrast across continents, and what do these similarities and differences have to tell us about the future of the arts and arts education in an increasingly globalized world?

Another easily-recognizable dividing line between those who did and did not have their voices included in the *20UNDER40* submission process was that of age. As several of the *20UNDER40* authors themselves mentioned, an enduring challenge for the field of the arts and arts education will be to continue to incorporate the voices of young people. While two 18 year-old authors submitted to the anthology, further study needs to solicit even younger individuals' visions of the future. Those who could not submit to the anthology due to the 40-year age cap were also left out of the proposal submission process. As many critics of the *20UNDER40* project suggested, a logical next step for the lines of inquiry talked about in this essay would be to convene the voices of practitioners of *all* ages to discuss leadership and the future of the field.

Many commonly-discussed topics in the arts and arts education also did not appear (or rarely appeared) in the group of submitted proposal abstracts. Significant topics in the field including the roles of policy and government, out-of-school/after-school arts programming, and the role of research as a tool for advancing innovation were infrequently discussed as key areas of the field that will pave the way towards the future. Interestingly, topics such as these did not have a significant presence in the group of submitted abstracts even though many authors described themselves as working in these areas of the field in their submitted biographies.

In addition to the topics and areas of the field that were not heard in the group of *20UNDER40* proposal abstracts, readers might also assume that there are incalculably more perspectives from under-40 individuals who (like the author of this essay) wanted to submit a chapter proposal, but were held back by self-doubt or fear of professional consequences. One can only imagine the innovative perspectives, new strategies, and unique 21st century challenges that might have been articulated by these young voices in the field. Future areas of study to address this issue could involve investigations to figure out *why* young leaders are so tongue-tied: is it their fear of stepping over the bounds of their professional roles, concerns that they lack the experience and credibility to speak out, or other reservations that keep young leaders' voices out of the conversation? Is it the lack of professional opportunities in the arts that welcome young voices, or an inferiority complex among young leaders, that prevents them from speaking up? Either way, further study is needed to determine how to create the professional platforms (in conversations among young leaders *and* those for people of all ages) that are both comfortable for, and open to, the voices of under-40s in the field.

Not-So-Silent Voices

Even if the conversations among the above "silent voices" never end up being published in an anthology or engaged in discussion, members of the field and of society as a whole can begin to think right now about the questions and areas for suggested study that arose through the initial discussion about the future of the arts that was ignited by the *20UNDER40* project. Perhaps the most substantial questions in this regard relate to how society will support the survival strategies for the arts identified by the cohort of submitting authors, and how to set up the scaffolding today that will ready the field to support the people, tools, and strategies that will foster the future of the arts.

In thinking about the need for sustaining hope for emerging and established arts professionals—a need that was acutely recognized through the many sentiments of societal irrelevance expressed in submitted proposal abstracts—a critical area for future study will be figuring out the best ways to support practitioners in all capacities throughout the field. To combat the all-too-frequent syndrome of "burn-out" in the arts sector and the field's great need to do better at communicating the importance of the arts in society, new methods must be explored to find ways to work together, to nurture one another, gain strength from existing resources, and reach out

across sectors, geographical regions, and professional fields to sustain the challenging and vitally important work of the arts and arts education.

Conclusion, or—*What Gave Me a Kick in the Pants*

Considering the implications of ideas and questions posed by the *20UNDER40* submitting authors leads me back to my own story and my personal worldview of what the future of the field holds for myself and others working within it. When we last left this story, I was grappling both with my own difficulties in speaking up in conversations about the future, and also with the realization that I was not alone in my apprehensions and feelings of doubt about submitting to the *20UNDER40* anthology.

Eventually, I did decide to submit a chapter proposal: a piece about my own line of work in evaluation and assessment in arts education settings. While it was not accepted into the anthology, I believe that the very exercise of valuing my own voice and using it to address the "emergency" (as Edward Clapp would call it) of the need for young perspectives in the field was the most valuable part of the whole experience. Rather than being a passive participant in the field, a practitioner alone, I began to feel a responsibility to innovate, to learn from others and to place importance on sharing my own experiences, and to challenge myself and others of *all* ages in the field in new ways, as others challenge me. But this renewed sense of empowerment that I felt made me wonder who did *not* submit to the *20UNDER40* anthology, and what might have held them back. Were there other under-40s that, due to their own doubts about their validity as speakers and societal perceptions of the work they do, decided not to submit?

As a young practitioner and, dare I say, an emerging leader in the arts education field myself, reading over and over again the feelings of irrelevance expressed by so many of the submitting authors made me feel exhausted, demoralized, and downright depressed. Even worse, with the heightened awareness of having read through the proposal abstracts, I began to hear many of these same feelings echoed in the tales of work frustration, struggles to make ends meet, and professional disillusionment of my colleagues—not just those who had told me that they didn't feel worthy of submitting to the anthology, but others of all ages who I worked with day-to-day in my professional life. Listening to these stories made me think that providing the people-based supports—those founded on creating interactions between individuals and enabling us to think deeply about who we are as practitioners and leaders in the field—should be the new wave of "professional development" in the arts. Perhaps supports like mentorship,

communities of practice, and opportunities for open and honest dialogue about how to feed our hearts, minds, and bank accounts through long-term work in this field are what will help our multigenerational cohort of arts and arts education leaders to continue working with passion, purpose, and a sense of community that reminds us that our work *is*, at its least, relevant.

Though it may not be representative of all points of view, I believe the collected *20UNDER40* proposal abstracts illustrates that many of the purposes and goals that drive emerging leaders are the same that have motivated and sustained veterans in the field for generations. If we are indeed all going after the same goals, then how can we come together as a whole cohort of people committed to the arts and actively searching for innovative solutions to its enduring challenges? If the controversy surrounding the genesis of the *20UNDER40* project is any indication, providing opportunities for artists and arts educators to connect with each other, across generations, age ranges, disciplines, sectors, geographic locations, lifestyles, and more, is crucially important. Only by coming together can we all benefit from the multidimensional tools, the hybrid environments and job titles, and one another's unique ways of thinking about the role of the arts in society, and work towards the great "when" that Clapp has proposed—the *future* of the arts and arts education.

NOTES:
1. "NECAP Listserv Comments July 1-8, 2009." Retrieved from <http://www.20under40.org/NECAP_Listserv_Web.pdf>.
2. The essay published by Clapp, entitled "This is Our Emergency: An Open Letter to Young Arts Professionals" was published online on August 22, 2009. It can be accessed at <http://www.20under40.org/Emergency.pdf>.
3. This description is cited from the *20UNDER40* Call for Chapter Proposals.
4. Full proposals were not reviewed for the purpose of this analysis in order to retain the confidentiality of ideas still under review for the anthology and in an attempt to limit the data under review in the coding process.
5. The Call for Chapter Proposals did not ask submitting authors to specify their genders in their proposal submissions. Therefore, gender was determined by name and/or by self-references in submitted author biographies that indicated gender identification.
6. These numbers are cited as the *least* possible number of institutions attended and degrees attained because not all submitting authors provided this information—therefore, these numbers in actuality may be larger. Eighty authors did not specify degree attainment in their submitted biographies.
7. Three submitting authors did not provide proposal abstracts, and two abstracts did not provide enough descriptive information to be categorized in terms of artistic genre discussed.

8. Three submitted proposal abstracts did not provide enough descriptive information to be categorized within the coding structure of this analysis.

9. Digital natives are individuals who were born in a world where digital technologies were already in commonplace use, and therefore have grown up within the context of a digitized world.

10. The concept of Teaching Artists being involved in international exchange was proposed by submitting author Jennifer Kessler in a proposal abstract titled, "Expanding Learning Opportunities in a Global Economy: A Call for an International Teaching Artist Exchange Program."

11. Although this observation was derived by the author from review of the submitted proposal abstracts, a similar idea was also expressed by submitting author Julia Gualtieri in an abstract titled, "DIY and Open Source Principles in Practice." Also see "The 'Why' of Arts Organizations in the DIY Era: Institutional Support for the Do-It-Yourself Artistic Generation" by Claire Rice, Michael Mauskapf, Forest Juziuk, and Charlie Hack in this anthology.

12. The concept of cultural diplomacy was discussed by submitting author Shawn Renee Lent in a proposal abstract titled, "Beyond the Exchange: New Options for the Art of Cultural Diplomacy," and by submitting author Marisa Benson in an abstract titled, "Cultural Diplomacy and Arts Education: The American Journey at Home and Abroad."

13. These ideas were proposed, respectively, by submitting author Aaron Staebell in an abstract titled, "Creating Economic Viability for Improvising Musicians," and by submitting author Sheryl Davis in an abstract titled, "ReMuse: Re-Imagining the Creative Utility of Historic 'Main Street' Theatres and Cultural Assembly Spaces for 21st Century Arts Advocacy, Education, and Community Revitalization."

14. The consequences of leaders growing up without access to arts education was discussed by submitting author Deborah Vaughn in a proposal abstract titled, "The New Generation Gap: The Arts Education Haves and Have Nots."

15. Booth, E. "Seeking Definition: What is a Teaching Artist?" *Teaching Artist Journal* 1, no. 1 (2003): 5-12.

16. Ibid: 5

17. Ibid.

18. Ideas related to the challenges and potential pitfalls of relying on technology in the art world were mentioned by submitting author David Harland Rousseau in the proposal abstract titled "Rise Again! Restoration or Revolution?" and by author Shannon Preto in the abstract for his chapter in this anthology titled, "Choreographing Embodied Anatomy as a Method for Igniting Kinesthetic Empathy in Dance Audiences." A discussion of the challenges of intellectual property in the digital age was proposed by author Casey Lynch, see "Ctrl C + Ctrl V: The Rise of the Copy and the Fall of the Author" in this anthology.

MICHAEL BELLINO (BORN 4-18-1974)

Michael Bellino graduated from Rhode Island School of Design with a BFA in Film and Animation. He spent twelve years working in the MTV On-Air Promotions Department where he wrote, produced, and directed several award-winning campaigns. He is currently a freelance writer and director, working on various TV commercial projects, as well as a part-time producer for Luxurious Animals, a motion graphics design company based in New York City.

MICHELLE BELLINO (BORN 3-5-1980)

Michelle Bellino is a doctoral student in the Culture, Communities, and Education concentration at the Harvard Graduate School of Education. Her work centers on adolescent historical understanding as constituted through formal and informal education processes. In particular, she studies the role of popular film, coupled with media literacy, in shaping historical consciousness. She received an MA in cultural anthropology in 2007 for her research on postwar history education in Guatemala. Michelle's work has appeared in *International Journal of Social Education, Women's Policy Journal of Harvard, Reflections*, and *Anthropology and Humanism*.

ERIC BOOTH (BORN 10-18-1950)

Eric Booth is a consultant to arts organizations and arts learning programs around the U.S. and in other countries. He currently consults with six of the ten largest orchestras in the U.S., with five national service organizations, six school districts and dozens of organizations. A frequent keynote speaker, he is the author of five books, including *The Everyday Work of Art* and *The Music Teaching Artist's Bible*, he was the Founding Editor of *The Teaching Artist Journal*, and he was on the faculty of Juilliard for 13 years, and at Lincoln Center Institute for 25 years.

EDWARD P. CLAPP (BORN 2-14-1974)

Edward P. Clapp is a writer, educator, arts education/leadership consultant, and doctoral student at the Harvard Graduate School of Education.

Edward's poetry and fiction have appeared in journals and anthologies in the US and UK and his plays *Run the Maze, Burn the Maze*; *Tucker in a Box*, and; *Appetite for Destruction* have appeared Off-Off-Broadway in New York. Edward holds a BFA in painting from the Rhode Island School of Design, an MLitt. In Creative Writing from the University of Glasgow/ Strathclyde, and an Ed.M. in Arts in Education from the Harvard Graduate School of Education. Originally from Long Island, NY, Edward now lives in Somerville, MA.

MARIAH DOREN (BORN 5-15-1970)

Mariah Doren holds an MFA in photography from Pratt Institute, and will receive her Ed.D. in art education from Teachers College, Columbia University in 2011. An Assistant Professor of Art at Central Michigan University from 2002-2007, she now teaches photography, teaching methods, and foundations at Teachers College, Parsons, and SUNY Purchase. Mariah's research centers on the role of dialogue in assessment. She has presented papers at the College Art Association's National Conference in 2007 and 2010, and has published articles on teaching methods. Her artwork has been exhibited most recently at Umbrella Arts in New York City and a solo exhibition at the Yonkers Public Library.

ANN GREGG (BORN 4-3-1973)

Ann Gregg has experience as a music administrator, educator, and performing artist. Ann is currently the Director of Community and Professional Programs of the Weill Music Institute at Carnegie Hall. Ann has also been the Director of Education with the NPR and PBS phenomenon *From the Top* for four years. Ann has provided interactive performances to public schools in Los Angeles, Chicago, Indianapolis, and in conjunction with the Philadelphia Symphony Orchestra and the Ravinia Festival. She has also taught instrumental music in the Madison, Wisconsin public schools. She is published in the *American String Teacher* and *American Music Teacher*, and has served as Managing Director and Education Specialist with the Lake Tahoe Music Festival Academy. As violist of the San Francisco based Cypress String Quartet for three years, she toured internationally, recorded at George Lucas's Skywalker Ranch, and was featured on NPR's "Performance Today." Ann has participated in the Spoleto Festival dei Due Mondi, the Juilliard Quartet Seminar, and the Isaac Stern Chamber Music Seminar. Ann holds degrees in Music Education from the University of Wisconsin and Viola Performance from Indiana University.

JENNIFER GROFF (BORN 5-22-1980)

Jennifer Groff is a Fulbright Scholar in the UK for the 2009-10 academic year, where she will be conducting research in partnership with Futurelab, an independent not-for-profit organization that is dedicated to transforming teaching and learning with innovative practice and technology, as well as a variety of schools across Scotland. Her research focuses on innovative learning environments, how school systems can innovate and redesign their programming to meet the cognitive needs of all learners, and the nature of individual and collaborative innovation in systems to better equip educational institutions to be dynamic, innovating organizations.

ERIC GUNTHER (BORN 8-16-1978)

Eric Gunther was born in New York in 1978. He studied Computer Science and Electrical Engineering at MIT, where he also did his Masters in tactile composition. He lives in Cambridge, Massachusetts, where he is co-founder of the art and design firm Sosolimited. For seven years, Eric was Art Director at Small Design Firm, where he created interactive installations for clients around the world. He builds vibrotactile sculptures and is interested in creating new aesthetic experiences for the body using technology. Eric has done sound design for radio and documentary, and is a prolific musician. He is half of the band gloobic and an artistic collaborator with Jeff Lieberman and Plebian Design.

CHARLIE HACK (BORN 2-6-1991)

Charlie Hack is currently pursuing an undergraduate degree in Mathematics at Columbia University and working as an intern at Nonesuch Records. He is a working musician, performing regularly on the double-bass, and is a radio programmer in the Jazz and New Music Departments at WKCR, 89.9 FM in New York. While in high school, Charlie interned in the Programming Department of the University Musical Society in Ann Arbor and produced Breakin' Curfew, a collaboration between UMS and local teens culminating in a sellout performance at the 1,300-seat Power Center.

FOREST JUZIUK (BORN 3-17-1980)

Forest Juziuk is co-creator of experimental film society Hott Lava, a psychedelic rock & soul DJ, publisher of outlaw lit, and founder of the vinyl-only record label Hall Of Owls. An underground culture obsessive, Forest

promotes the dark but rich corners of culture past and present. From 2008 to 2010, he served as a screener for Ann Arbor Film Festival and in 2010 he served as a final programmer. Forest also manages the second-oldest record store in the U.S. His work has been published in *The Minus Times* (Drag City) and *J&L Illustrated #1* (J&L Books).

DANIELLE LA SENNA (BORN 3-16-1976)

Danielle La Senna holds a Bachelor of Music in Voice Performance from Indiana University. She spent eight years after graduation performing musical theater, jazz, and classical music in New York City. Danielle has worked as an administrator at two graphic design firms as well as The New School in New York. Danielle additionally holds a Master of Education in Arts in Education from the Harvard Graduate School of Education. After completing her master's degree, Danielle served as a research assistant with Project Zero, studying learning in Harvard Art Museums' study centers. Danielle is currently Director of the Evening Division (adult continuing education) at The Juilliard School.

ELIZABETH LAMB (BORN 6-22-1983)

Elizabeth Lamb works to make art things happen. With a background as a practicing artist, an MS in Arts Administration, and a breadth of experience with various cultural organizations in the Pacific Northwest, Elizabeth is an arts creator, promoter, and advocate. Elizabeth's passion lies in providing access and opportunity to diverse sectors of working artists and the greater public. She currently works as the White Box Exhibitions Coordinator for the University of Oregon in Portland, specializing in critical contemporary creative arts presentation.

SUE LANDIS (BORN 1-19-1978)

Sue Landis is the Elementary School Programs Associate at Carnegie Hall's Weill Music Institute. She received her Bachelor of Music Education from Westminster Choir College in Princeton, NJ. Sue taught general music and choir in the New Jersey public school system before moving to New York to become opera singer Marilyn Horne's personal assistant. With Horne, Sue first participated in the field of artistic administration while traveling to many festivals, colleges, and performance venues around the world. Sue Sings with the Grace Church Choral Society and is an active member of Sigma Alpha Iota International Music Fraternity.

JESSICA RIVKIN LARSON (BORN 6-9-1983)

Jessica Rivkin Larson is currently pursuing her MBA at New York University's Stern School of Business, where she specializes in strategy and marketing. Prior to graduate school, Jessica coordinated six arts education programs as the Secondary School Programs Associate for Carnegie Hall. In New York, Jessica worked for the Manhattan Theatre Club and for the Executive and Managing Producers of the Tony Awards. In London, Jessica worked with the Royal Festival Hall. Jessica has produced for the New York International Fringe Festival and trained as a classical singer. She received her BA with distinction in American Studies from Yale University, where she focused on cultural history.

JEFF LIEBERMAN (BORN 3-17-1978)

Jeff Lieberman was born in Miami in 1978. He has degrees from MIT in physics, mathematics, mechanical engineering, and robotics, and spends most of his time exploring ways in which the arts and sciences can be brought together. He hosts the Discovery Channel television show "Time Warp," using modern technologies such as slow motion video to show the extraordinary world beyond the normal range of human perception. He publishes photography, builds kinetic sculpture internationally, and makes music, primarily as half of the duo gloobic. He collaborates extensively with Eric Gunther and is a co-founder of Plebian Design.

CASEY LYNCH (BORN 3-27-1980)

Casey Lynch is adjunct Faculty of Sculpture at Savannah College of Art and Design, Atlanta Campus. He graduated from Rhode Island School of Design, having recently received his MFA in Sculpture. Casey also holds a BFA in Sculpture from the Atlanta College of Art as well as a BS in Psychology from Columbus State University. Casey's work has recently appeared in group shows in Rhode Island, Connecticut, New Jersey, Utah, Texas and New York, including shows at the Grounds for Sculpture in Hamilton, NJ, Creative Arts Workshop in New Haven, CT, and LeFlash in Atlanta, GA. Some of Casey's recent awards include the International Sculpture Center's Outstanding Student Achievement Award and RISD's Award of Excellence.

BRIDGET MATROS (BORN 2-17-1976)

Bridget Matros brings her background in sociology and psychology to her

work developing art programs and exhibits, teaching families, and training educators at Boston Children's Museum (BCM), where she co-created BCM's first arts program nine years ago. Today, the Art Studio program serves diverse families (many, "non-art-consumers") by the thousands and is a national source of informal arts education best practices. A "late-to-identify" visual artist, musician, and performer, Bridget now serves as visionary and developer for all arts programs at BCM, while independently serving as a consultant to nonprofits working to bring creative and expressive opportunities to homeless and low-income children.

MICHAEL MAUSKAPF (BORN 1-26-1985)

Michael Mauskapf is a Ph.D. candidate in musicology at the University of Michigan, where his research concerns the intersections between musical and organizational practices in various settings, including the American orchestra. From 2008–2010 Michael was Executive Director of Arts Enterprise@UM, an initiative that explores the intersections between the arts and business. A graduate of the University of Pennsylvania and an amateur trumpet player, Michael has worked with and for performing arts organizations from around the country.

MARISSA MCCLURE (BORN 8-24-1976)

As an Assistant Professor at the University of Arizona, Marissa McClure, Ph.D., directs outreach programs and works with pre-service teachers and preschool children on a photography project, *Amigos en el Jardín*. Marissa has taught in schools and museums throughout the US. Her interests lie in children's art and visual and media culture; critical theory; and sustainable design. Marissa has presented her work locally, nationally, and internationally. She has written for *Studies in Art Education, Visual Arts Research, Cultuur & Educatie, Visual Culture and Gender,* the *International Encyclopedia of Early Childhood Education, Digital Visual Culture,* and *Practice Theory.* Marissa is President of the Early Childhood Issues Group of the National Art Education Association, columnist for the Caucus on Social Theory in Art Education, and 2010 recipient of the Charles and Irene Putnam Award for Excellence in Teaching.

DAVID J. MCGRAW (BORN 11-8-1972)

David J. McGraw leads the Performing Arts Entrepreneurship program at the University of Iowa. He teaches courses in arts management and new business formation for both the Division of Performing Arts and the John Pappajohn Entrepreneurial Center. He began his career in the arts

as a stage manager and continues to be a proud member of Actors' Equity Association. David earned an MA in Arts Administration from Goucher College and an MFA in Theatre from the University of Iowa.

IAN DAVID MOSS (BORN 6-14-1980)

As Research Director for Fractured Atlas, Ian David Moss is leading pilot phase development of the Bay Area Cultural Asset Map, an initiative of the William and Flora Hewlett Foundation to better understand who is making art, who is engaging with it, where it's happening, and how it is funded in the region. Ian is also the founder of Createquity, an acclaimed arts policy blog that is read by more than 700 arts professionals around the world. He holds a BA and an MBA from Yale University, and has an extensive background as a composer, ensemble leader, and choral singer.

BRIAN NEWMAN (BORN 6-19-1971)

Brian Newman is a consultant focusing on business development projects in the cultural industries as well as on helping artists and organizations to distribute content and to connect with audiences through innovative uses of new technology. Brian was most recently CEO of the Tribeca Film Institute (TFI), and previously served as executive director of Renew Media and IMAGE Film & Video Center. He held positions at the IFP and the South Carolina Arts Commission, serves on the boards of Muse Film & Television, the International Film Festival Seminars, and on the editorial advisory board for *Art Papers* magazine. For five years Brian was an officer of the board of Grantmakers in Film & Electronic Media (GFEM).

REBECCA NOVICK (BORN 4-2-1972)

Rebecca Novick is a theater director and arts consultant in the San Francisco Bay Area. She was the founder of Crowded Fire Theater Company and served as its artistic director for ten years. Her directing has been recognized with many awards including the Goldie Award for Outstanding Local Artists. Rebecca has also held a number of arts management positions including most recently serving for five years as Theatre Bay Area's Director of Development and Strategic Initiatives. She is currently working as a freelance director and as a consultant to a number of foundations and nonprofits. Rebecca has a BA in theater and anthropology from the University of Michigan.

ERIC OBERSTEIN (BORN 10-15-1985)

Eric Oberstein is an arts administrator, producer, musician, educator, and consultant. Eric earned Master's degrees in Arts Administration and Arts in Education from Columbia University and Harvard University, respectively. He also earned his undergraduate degree with distinction from Duke University. Eric has worked at Jazz at Lincoln Center, Alvin Ailey American Dance Theater, Duke Performances, the Office for the Arts at Harvard, and the Research Center for Arts and Culture. Eric currently serves as Executive Director of the Afro Latin Jazz Alliance, which supports the work of the Grammy Award-winning Afro Latin Jazz Orchestra, directed by Arturo O'Farrill.

KYLIE PEPPLER (BORN 8-1-1979)

Kylie Peppler is an Assistant Professor in Learning Sciences at Indiana University, Bloomington. An artist by training, Kylie's research focuses on the intersection of arts education and new technologies. She has received grants from the National Science Foundation, the MacArthur Foundation, and the Spencer Foundation to support her work. Kylie's recent articles have or will appear in the *Cambridge Journal of Education, Teachers College Record*, and *Learning, Media, and Technology*. In 2009 Kylie's first book *The Computer Clubhouse: Creativity and Constructionism in Youth Communities* was published by Teachers College Press.

REBECCA POTTS (BORN 2-2-1982)

Rebecca Potts received her MFA in Visual Arts from Washington University in St. Louis and her BA in Geography and Studio Art from Middlebury College in Vermont. Her work has been exhibited throughout the US and internationally. Rebecca has taught various arts courses, coordinated community murals, and curated an exhibition entitled "Science Makes Art." Rebecca has also campaigned for clean energy in Vermont, worked as a community organizer to improve water quality in Camden, NJ, and helped start a small public school in Brooklyn, NY. She is currently the Visual Arts Editor for www.ClimateChangeEducation.org and the Education Manager at the Bronx River Art Center.

SHANNON PRETO (BORN 9-27-1973)

Shannon Preto is a choreographer, performer, producer, and teacher. He has an MFA in dance from the University of Colorado at Boulder and a BS in dance from Kent State University. Preto teaches dance in the Theater Department at the San Francisco School of the Arts. He has additionally taught dance and somatic-based classes at Dance Mission Theater, the

ODC/School, Sonoma State University, the SOLA Contemporary Dance Festival, and the University of North Carolina, Greensboro. Shannon is the artistic director of Dance/Theater Shannon, which has presented its work in San Francisco, New York City, Chicago, and Denver.

DANIEL REID (6-28-1979)

Daniel Reid is currently a management consultant based in Chicago. He has done pro-bono strategic work in program development and evaluation with UNESCO and the Illinois Humanities Council. A graduate of Yale Law School and member of the National Book Critics Circle, he spent several years as a book editor in New York.

CLAIRE RICE (BORN 8-19-1976)

Claire Rice is the Interim Director of Education and Audience Development at the University Musical Society (UMS), a 131 year-old performing arts presenter in Ann Arbor, Michigan. She is responsible for over 100 context-building and community engagement activities each season. Claire graduated with a BA from the College of William and Mary in 1998. Following a career as a management consultant for Accenture, she joined UMS in 2003. She supervised a Grammy-Award winning performance of William Bolcom's Songs of Innocence and of Experience and a month-long 2006 residency with the Royal Shakespeare Company, the largest project in UMS's history.

ANDREA SACHDEVA (BORN 5-16-1982)

Andrea Sachdeva is the Director of Evaluation + Curriculum for the Cloud Foundation and The Boston 100K ArtScience Innovation Prize, where she leads all program evaluation and collaborates on curriculum and professional development for the ArtScience Prize and its program replication sites. She is also a freelance program evaluator and a founding co-chair of the Continuing the Conversation series of arts education events hosted by the Harvard Graduate School of Education's Arts in Education Program. Andrea holds a BM from Boston University's School of Music with a major in Musicology and an Ed.M. from the Harvard Arts in Education program.

Acknowledgements

The book you hold in your hands (or on your mobile device) today would not have been possible without the support and hard work of dozens, if not hundreds, of people. I am deeply indebted to Eric Booth for saying *"yes!"* to the concept of the anthology when it was just a nascent idea, for mentoring me throughout the process, busting my chops when I needed it, opening whatever doors he could, and always having my back. I couldn't have asked for a more committed, more enthusiastic, more generous, and down-to-earth project advisor. I am also greatly indebted to my academic advisor Steve Seidel for likewise exhibiting unwavering support for this project, even when the idea was so new I could barely articulate it myself.

It goes without saying that I greatly appreciate all of the hard work and persistence exercised by the *20UNDER40* authors: Brian, David, Sue, Jessica, Rebecca Novick, Rebecca Potts, Ian, Daniel, the Bellino Wonder-Siblings, Casey, Shannon, Elizabeth, Claire, Michael, Charlie, Forest, Marissa, Mariah, Jeff, Eric Gunther, Eric Oberstein, Jen, Kylie, Danielle, and Bridget. I am especially grateful for all of the cerebral-sparring, paring-down, and long-term devotion exhibited by my co-author Ann Gregg, whose camaraderie and intellectual partnership have been invaluable to me since we met so many moons ago. In addition to the published authors, I am also grateful to "The 284" whose work was not selected for inclusion in the anthology—especially the authors who wrote full-length chapters, Sangbin, Kaya, Susan, Jill, and Kristin, during the final round of review.

It goes without saying that on a grassroots project like this there are many players behind the scenes who selflessly go to great lengths to make things happen. In this sense, I owe my gratitude to website/graphic designer, and incredibly good friend Margaret McKenna, who somehow found a way to translate the color scheme of my apartment into HTML; Amanda "Trouble" Young, who came up with the first attempts at what later became the *20UNDER40* logo; Michelle Bellino, the "gift to the project," who served as a hearty cognitive support, essential co-decision-maker, and hard core rock climbing partner and friend during the early stages of the project and onwards into the future; Andrea Sachdeva, who continues to be one of my closest colleagues, one of my most trusted peers—and one of my absolute favorite people to hug; Kenneth Kwok whose resilience and brilliance from so far abroad have served as a psychological safe-harbor and an ongoing inspiration; Josh Warren who provided extraordinary legal counsel just for

the thrill of it, and; my brother-in-law-to-be, Ryan "Stupid Guy" Kidney, who somehow knew when to whisk me away to go snowboarding or mountaineering just when I needed fresh air the most.

I additionally owe my extreme gratitude to the editors who stepped in to assist the authors during the final revision process: Arnold April, Thomas Cabaniss, Hilary Easton, Arlene Jordan, Marlinda Menashe, Susan Miville, Carol Ponder, Georgia Popoff, and John Shibley. I likewise wish to thank everyone at the Harvard Graduate School of Education who urged me to think more deeply about the ideas behind this anthology, including professors Jerry Murphy, Robert Kegan, Jal Mehta, Helen Haste, and Shari Tishman as well as my colleagues Julia, Tiffanie, James, Karen, Kim, and my fellow teaching fellows Paul and Lauren. My thanks and gratitude are also due to Scott "Arrgh!" Ruescher for keeping me on my toes and for all of the AiE cohorts I've worked with, past and present.

I would like to further thank all of the people throughout the arts sector who have helped push the project forward and inspire my thinking, especially Stephanie Evans, John Abodeely, Nancy Kleaver, Heath Marlow, Richard Bell, Phoebe Eng, Christine and Matt Weinberg, and the "Creativity Curmudgeon" Dr. Michael Hanchett Hanson.

Special thanks is also due to all of the individuals and institutions who have invited me to speak on behalf of the *20UNDER40* project or otherwise organized events that brought dialogue or visibility to the anthology, including Aliza Greenberg and her crew at Young Educators in the Arts; David Shookhoff of the New York City Roundtable on Arts Education, Rebecca Novick and her colleagues at Theatre Bay Area; Ebony McKinney at the San Francisco Bay Area Emerging Arts Professionals; UNESCO and the Korean Government; Sherburne Laughlin with the Association of Arts Administrator Educators; Jonas Cartano at Chorus America; Jamie Boese and Mara Walker at Americans for the Arts; Barry Shauck at Maryland Institute College of Art; David and Victoria Plettner-Saunders, the San Diego Foundation, and the San Diego Emerging Leaders Group; Rosanna Flouty, Monica Garza, and David Henry at the Boston Institute for Contemporary Art; Julia Propp and her colleagues at Emerson College, the A.R.T., and Oberon; Dewey Schott of NAMAC; Jasmine Mahmoud of *The Arts Politic*, and; Frumie Selchen of the New England Consortium of Artist-Educator Professionals.

I must also thank my old skool peeps in the NYC: William K Scurry, Jr., Stacey C. Rivera, and Rebecca V. Nellis for sharpening my editorial teeth during my formative years; my family for their unconditional support, and; all of the friends and colleagues I am leaving out—as well as all of the fans of the project I've met online, in questionable taverns around the country,

or under the fluorescent lighting of a conference room somewhere in America. One person, however, whom I absolutely cannot forget—nor thank enough—is Angela "Miccio" Mittiga, whose generosity, thoughtfulness, discerning eye, intelligence, and warmth have been constant sources of strength, energy, compassion, and courage for me throughout the making of this anthology. It is by no means an exaggeration to say that this project would not have been possible without her help and support. –E.P.C.

Lightning Source UK Ltd.
Milton Keynes UK
UKOW02n1351190117
292447UK00002B/20/P